# The Tate Britain Companion to British Art
## Richard Humphreys

Tate Publishing

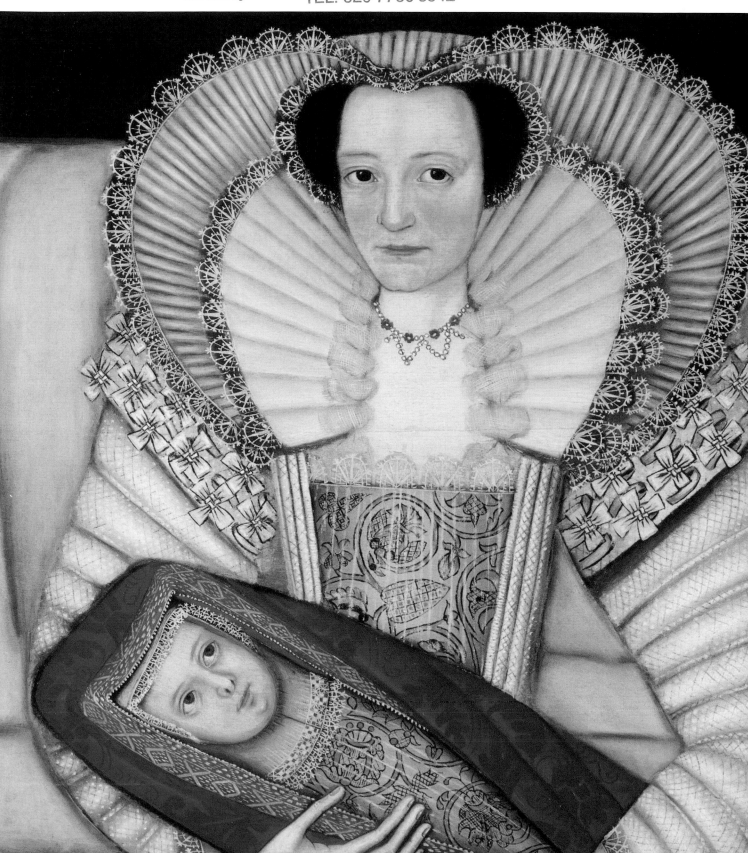

Published by order of the Tate Trustees
by Tate Publishing, a division of
Tate Enterprises Ltd, Millbank,
London SW1P 4RG

© Tate Publishing 2001

The moral rights of the author
have been asserted

ISBN (cloth) 1 85437 373 0
ISBN (paper) 1 85437 369 2

A catalogue record of this publication
is available from the British Library

Designed by Esterson Lackersteen

Printed and bound in Great Britain
by Balding + Mansell, Norwich

Measurements are given in
centimetres, height before width.
All works illustrated are from the Tate
Collection unless specified otherwise

16.99

For Cat
*with green thoughts*

# Contents

# Foreword

This companion is a guide to British art in general, in the context of its presentation at Tate Britain in particular. Its refreshingly wide frames of reference are characteristic of the new ways in which twenty-first-century commentators and gallery goers alike are beginning to address and celebrate the history of British visual arts and culture from the Middle Ages to the present day. Much of what is here, and at Tate Britain, is a far cry from the one-dimensional history of style that once characterised mainstream art history and museum display. Yet our renewed focus at Millbank today on art made in, about, and with reference to Britain is in some senses inspired by the same spirit that in the 1890s led Sir Henry Tate to donate his private collection of modern and contemporary British art to the nation and to build a gallery to house it, the Tate Gallery at Millbank, which opened to the public in 1897.

The launch one hundred years later of the Centenary Development programme to expand the building as the home of British art, and the creation in 2000 of Tate Modern and Tate Britain as distinctive entities within the Tate organisation, were initial steps towards the renaissance of Millbank. Now, with many new galleries for displays and exhibitions, and with a future programme setting our collections within a plethora of new contexts, national and international, our role here as the world's centre for the study and enjoyment of British art may emerge with fresh clarity. As the new national gallery of British art, we are not so much restating but re-focusing the vision of our Victorian founder. Much has changed in a century about Britain's place in the world, and so the purpose and role of such a gallery is necessarily now quite different. We no longer choose to relate a single narrative of British art and culture, but to explore a network of stories about art and about Britain, with our collections at its core. I hope that Richard Humphreys' book – both accessible and scholarly, richly revealing and provocative too – thus articulates the emerging spirit of Tate Britain itself.

Stephen Deuchar
*Director*
*Tate Britain*

# Acknowledgements

I am indebted to three main groups for the contents of this book. Firstly, it could not have been written without the dedicated scholarship of Tate curatorial and conservation colleagues past and present. The detailed catalogue entries on individual works written by them over the years are remarkable resources. Secondly, my bibliography indicates my gratitude to the many art historians and other academics and writers who have transformed our understanding of British art, history and culture, in particular over the last twenty years or so. Finally, I should give thanks to all the artists in Britain over the last half millennium who have struggled in often unpromising circumstances to create something so rich and powerful and worthy of our attention.

On a more immediately institutional note, I should like to thank all my colleagues at Tate Britain and in Tate Publishing who have encouraged and helped me to write this book. The writing was also made so much easier by the wonderful Tate Library and its ever-helpful and patient staff.

A final word should be reserved for my mother, Mary Humphreys, and my daughter, Olivia. They should both know that, among the many family members and friends who supported me through a distressing period, their strength and love in particular made it possible to finish this book and to reach the uplands.

# Introduction
## In Pursuit of Rare Meats

'Do you see, Madame, a narrative in these apparently unrelated episodes?'
(The artist Mr Neville to Mrs Herbert,
*The Draughtsman's Contract*, Peter Greenaway, 1982)

You are sitting in the Tate Britain restaurant pondering the menu. Not sure which dish to choose, you begin to look at the mural paintings that cover the walls (fig.1). They seem to show a fantasy journey through a landscape, with elegant figures depicted setting out from a city on horses, bicycles and in a red cart, from a portico like that of Tate Britain on Millbank. As your eye follows the figures through the landscape you see them pass by a seashore, through a small jungle with wild beasts, past a drowning boy near a watermill and a ruined palace with a Palladian bridge. The entrance to the restaurant interrupts your reverie and reality briefly intrudes in the form of a real diner arriving through a ruined gateway. The artist has painted this gateway with two grotesque caryatids to represent greed. You continue your gazing down the other side of the room, its three windows suggesting similarly fantastical visions – the Great Wall of China and a mermaid's cave, for instance, punctuating scenes from Cathay. Here the travellers find a broken cross on a cliff edge with the initials of an earlier explorer, 'D.A.W', and they replace it with an urn.

On the wall with the entrance to the kitchen, painted as if it leads into a stone belvedere, the party is shown returning to their city via a park with a Corinthian arch, fountains and statues. The cart is by now loaded with spoils as it passes an old gardener. His son poses before a statue of Venus. On the right a reception in front of a triumphal arch awaits the travellers. They are home.

The murals were executed in a wax medium on canvas in 1926 and 1927 by the young painter Rex Whistler on the recommendation of his teacher at the Slade Shool of Art in London, Professor Henry Tonks. His fee, £500, was paid by a major Tate Gallery benefactor, Lord Duveen, as part of an initiative to encourage young British artists. Whistler's dreamlike painted narrative nods very gently towards Surrealism, the Parisian art movement which sought social revolution through the unconscious mind. It

was a personal tale for which he wrote a children's story with his friend the society hostess, writer and occultist Edith Olivier, whose grand home, Wilton House, appears at moments throughout the mural. The tale, full of characters with punning or anagrammatised names ('Dr. Knots' is Tonks, for instance, and 'Joisigonne' is Inigo Jones, the architect of Wilton), tells of the 'pursuit of rare meats' by residents of the Duchy of Epicurania. This small state is ruled by a benign aristocracy with some of the nobility, however, obliged by penury to convert their mansions into flats, but where the entrepreneurial capacities of the citizens are evident in the thriving Biscuit Manufactory.

The expedition was the brainchild of Miss Jessie Toring (playing on Girton College, Cambridge and, perhaps, Tory) who, 'not ignorant of the modern word "Propaganda"', had introduced some love of culture to the Epicuranians. By the success of the expedition , supported by the Prime Minister who feared a Revolution by Epicuranians fed up with a diet of pork, 'the dwellers of this small Principality have made themselves renowned throughout the civilised world and America'. Among the party is Krol Dudziarz (Whistler's name in Polish), the son of an impoverished Polish nobleman. He is an 'odd-job man' and fairly idle artist whom the Palace Librarian and Public Orator, Count Brendar Wahs (Bernard Shaw), said was obsequious and unthreatening to his elite employees and who could be 'treated like the Plumber'. On a note which now jars, 'Gilabia' ('Abigail Omelette') 'captures a little negro boy who proved a useful acquisition to the party'.

Whistler began painting his mural at the time of the General Strike in Britain which threatened the social and political status quo. It was the year that A.A. Milne published *Winnie the Pooh*; of Franz Kafka's novel *The Castle*; of Le Corbusier's modernist manifesto *The Coming Architecture*; of the founding of the Council for the Preservation of Rural England; of Baird's first demonstration of television in Soho; of Fritz Lang's film *Metropolis*; of the birth of Queen Elizabeth II and the death of Claude Monet. The following year, when Whistler completed the work, saw the first sound films, Virginia Woolf's novel *To the*

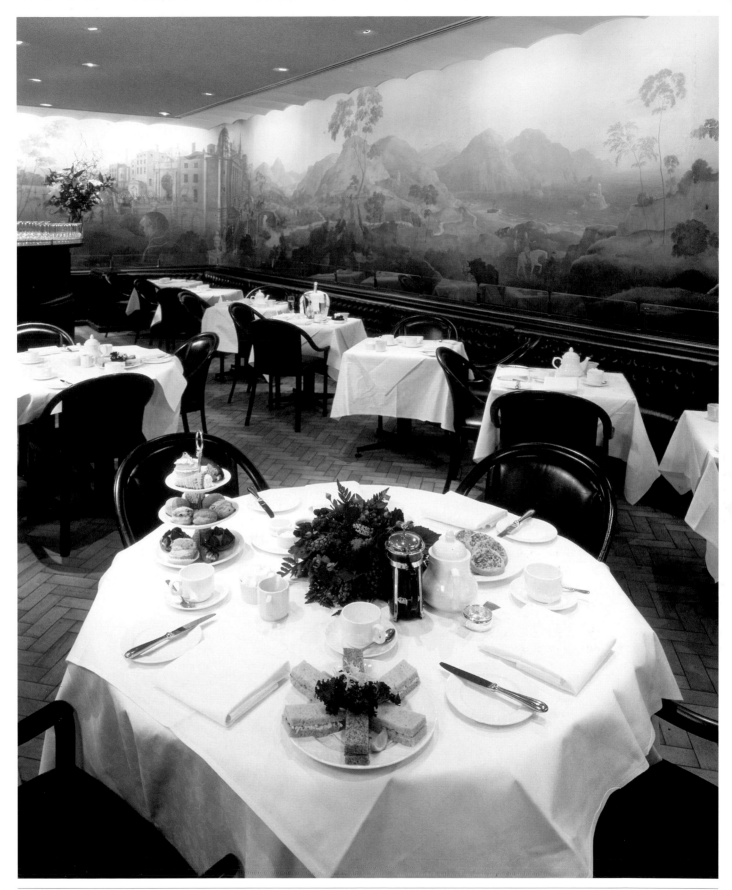

Fig. 1 **Rex Whistler**
1905–1944
**'The Expedition In Pursuit of
Rare Meats' mural in the Tate
Britain restaurant,** 1926–7
Oil mixed with wax and
turpentine on plaster and canvas

*Lighthouse* and the outbreak of the slow foxtrot dance craze. Not quite finished by the artist, the waxy murals were slightly damaged by over two metres of water during the notorious Tate Gallery flood of 1928.

Many of the themes we shall be observing in British art are lightly evoked by Whistler's absorbing period piece, so reminiscent of the humour of P.G. Wodehouse and A.A. Milne and the brilliant high society play-acting of the Sitwells: the connections between art, pleasure and duty, and between art, fashion and the journey into the self; the decline of an aristocratic caste and the bewildering intricacies of class and taste; the role of the artist, whether as rebellious bohemian or servant of the ruling classes, or neither; the educational function of art and the relations between adults and children; the nature of Britishness – or is it really Englishness we are talking about at Tate Britain?; the link of word and image; the landscape as a site of innocence and escape and of experience and knowledge; the spirit of place; the recurrent secret garden; art and architecture; town and country; exploration and the rise and fall of Empire; the question of Europe and/or America; the strange way art moves through warps of time and imagination and never feels quite comfortable straitjacketed into chronology; tradition and modernity; the curious role of religion in the first secular society; the presence of death in Arcadia – 'D.A.W' was Whistler's elder brother who died in childhood. Whistler himself was killed while acting as a tank commander in Normandy in 1944.

From the first public displays of art in the supper boxes and alleyways of the pleasure gardens at Vauxhall and at the Foundling Hospital for street orphans in the 1740s, to the Festival of Britain in 1951 and on to the rise of the modern art museum with its cafés, restaurants and shops, and its appeal as a good place for romantic encounters of all sorts, there is a long tradition of art as pleasure and improvement, as a useful 'pursuit of rare meats', animal, vegetable or mineral. Yet Britain is a nation which, for urgent religious and political reasons, has often struggled to accommodate the visual arts, be it the transfigured saints of Baroque painting or the bracing modernism which is so absent in Whistler's murals. Art has been smashed by iconoclasts, viewed with suspicion by the righteous, ever-rising middle classes, welcomed as a badge of social arrival by the same in their cultural rituals, and used as a weapon of class war by those for whom Epicurania is a cruel deceit of knowing irony.

This book attempts to look at particular works of art in detail, to consider why artists have made them, and to suggest the significance of the settings in which they are seen. The photograph of Henry Tate's

Fig.2 **Interior of Henry Tate's house, Park Hill, Streatham, London, in the 1880s**
Tate Archive

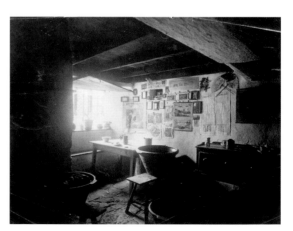

Fig.3 **A.E. Emslie**
1848–1918
**A Cottage Interior** (detail)
1883
Albumen print, 15.1 x 20.2
Victoria and Albert Museum

Fig.4 **James Boswell**
1906–1971
**The Fall of London: Museum**
1933
Lithograph on paper
13.3 × 9.5

Fig.5

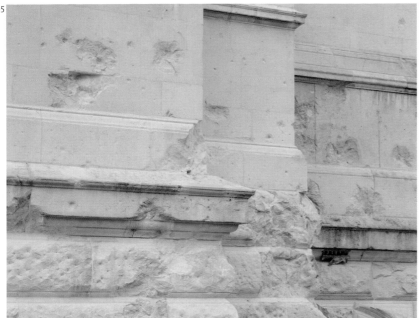

imposing house in Streatham (fig.2) containing his collection of British art, makes a poignant contrast with that of the interior of a cottage taken at about the same time (fig.3). The prints and pious words tacked to the cottage wall are the imagery of a different place and time. We might even be in the seventeenth century.

James Boswell's powerful image of a museum in *The Fall of London* (fig.4) was made in 1933, the year of

Hitler's rise to power, by an artist who supported the General Strike, which Whistler seems to have painted through without a care. And yet why shouldn't he have? After all, the bomb damage sustained by the Tate stonework along the kitchen walls during the Blitz in 1941 is now listed, its violent mark classed as of aesthetic as well as historical value (fig.5). A work of art, even, courtesy of the Luftwaffe.

Fig.5 **Bomb damage caused in 1941
to the Atterbury Street side
of Tate Britain**

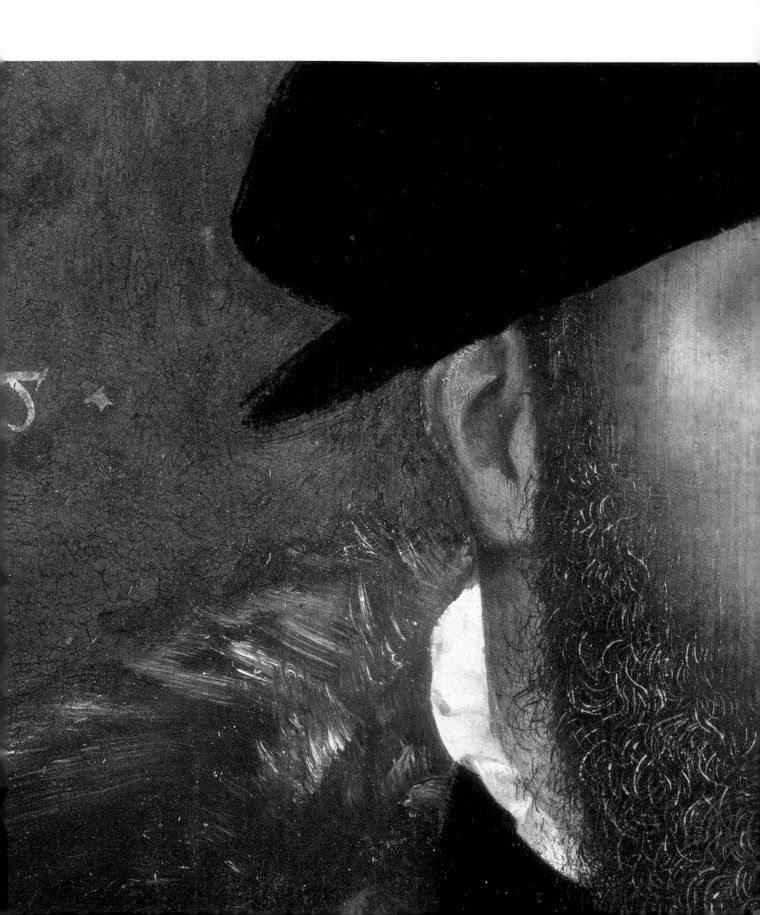

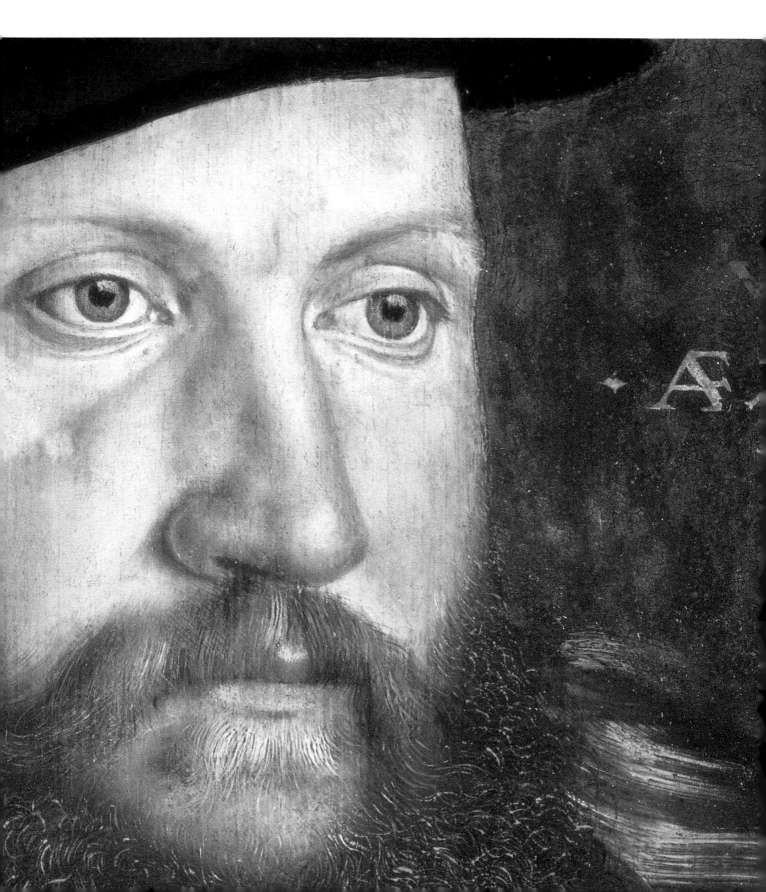

# The Eve of Destruction

By way of introduction we shall look first at two works of art from beyond the Tate Collection, of different scales, techniques and purposes. They date from the period prior to the beginning of our main narrative. One is on a very large scale and intended for a fairly wide public, the other is small and quite private in function. Significantly, they have in common that they are the works of northern European artists and that they both directly reflect a Roman Catholic religious context which had been much 'degraded', as military spokesmen say nowadays, by the mid-sixteenth century.

## The Eton College Chapel Whodunnit

'Dots are believed by many writers to be a good substitute for effective writing. They are certainly an easy one. Let us have a few more.'
(M.R. James)

Let us start at the top end of the market, in the days before mass education and 'bog-standard comprehensives'. Eton College Chapel was built between 1469 and 1482 for use both by the new school's pupils and by local parishioners. As with all such major ecclesiastical building programmes, its construction was much determined, and impeded, by the wishes of the Pope in Rome. The large series of wall-paintings in the chapel celebrating the miracles associated with the Virgin Mary was eventually completed by 1487, by at least two different artists (no.1). They have many of the technical and stylistic characteristics of the work from the Flemish studios of Rogier van der Weyden and Hugo van der Goes, reflecting the strong economic and cultural links between England and northern Europe in this period. Accounts which survive link the purchase of paints to a certain 'William Baker', but who he was and how he relates to the '*diversi pictores*'

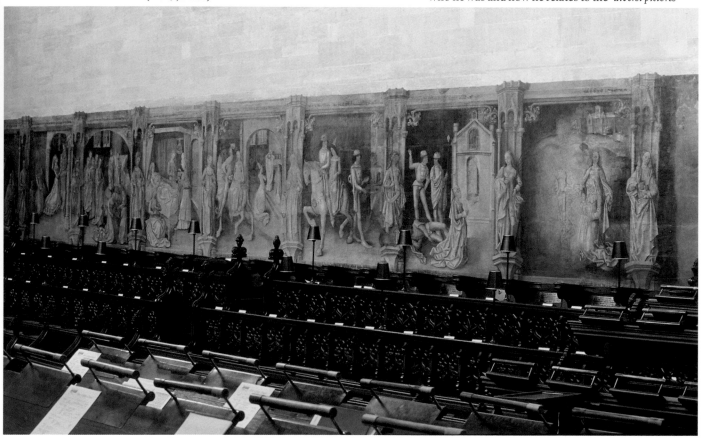

1 **Eton College Chapel North Wall**
c.1477–87
Wall painting in oil

(divers painters) also mentioned is unclear. He could be a great undiscovered native genius of late medieval art in England or just a 'colourman', involved at a modest technical level on the scheme. Taking possible spelling eccentricities into account, he might even be 'Willem Beckers', a Flemish artist. As with most of our information for this period, the evidence is highly fragmentary and inconclusive.

Rather unusually the mostly grisaille (grey-toned) colours are applied with linseed oil to the primed stone wall-surface. The imagery has a sculptural effect and the sophisticated lighting and perspective makes the series one of the outstanding examples of such art anywhere in Europe. The twenty-three stories, derived from a possible sixty or more found in two thirteenth-century texts, are mainly simple in moral terms and uncontroversially suitable for a youthful audience. Latin inscriptions allow for a full understanding of the narrative and refer the viewer to other texts which would be consulted later, rather as a priest's sermon might do.

One story, however, may have been rather more controversial. An Empress is saved from execution, exiled to an island and escapes, bearing curative herbs against leprosy whose powers are revealed to her in a vision by the Virgin. Although reconciled to her husband, she nevertheless becomes a nun. One of the villains wears a pendant, which may allude to his being a Yorkist and therefore suggests the possibility that the paintings, at any rate those on the south side of the chapel, were partly a criticism of the regime that deposed the College's founder Henry VI in 1461. The evidence is shaky, but points up the degree to which such an image can frequently carry a political motive as well as its more ostensible theme. Eton schoolboys at the time, on the eve of humanist learning with its emphasis on the teacher's love, might more ruefully have noted that the Virgin's name was close to the frequently used *virga*, or rod of discipline.

We should also take interest in the fact that the Eton paintings were whitewashed in 1560 as part of the destruction of religious imagery which took place in the wake of the Reformation. Mary only reappears in British art as a serious force in very different circumstances in the Victorian period. Uncovered in 1923, the murals reappeared like phantoms from a world largely lost to view. They were therefore hidden for almost the entire period covered by the Tate Collection. Fittingly, the earliest research into them was undertaken by the antiquarian, ghost story and thriller writer M.R. James. Art history is often a splendid sort of fiction based on such spectral scraps and dots …

We'll fast forward from the end of the Wars of the Roses and the founding of the Tudor dynasty to a quiet room in Chelsea in the 1520s.

### The Scholar, the Fool and the Monkey

Chelsea has always been fashionable. One of the most remarkable intimate images of pre-Reformation Britain is the German painter Hans Holbein's drawing of Sir Thomas More and his family preparing for their devotions (no.2). More was a lawyer, a devout Catholic, the famous humanist author of *Utopia* and Chancellor of England from 1529 until his execution by Henry VIII in 1535. The drawing shows him with his family in a room in his large new house in Chelsea, and was made as a study towards, or a copy of, an oil painting which was probably made to celebrate his fiftieth birthday. The figures represented are More, his three daughters and only son, his foster daughter, his ward, his father and, intriguingly, his fool Henry Patenson. To the left is a canopied sideboard with a salver, a vase of flowers, a bottle and cups and a viol. On the wall above More is a weight-driven clock and pendulum. To the right, a porch leads into another room where a seated figure, probably More's secretary John Harris, can just be seen. To the right of the porch is a latticed window and sill upon which sit books, a salver, a candlestick and a jug. These domestic details are fascinating in themselves, but what is particularly moving is the human interest of the drawing, from the individual expressions of the figures to the almost uncanny, though certainly contrived, snapshot effect that captures the character of the sitters and their mutual interactions. No other image of the period in Britain has this power. We seem to be watching a particular moment in a particular room in London in 1527 as Margaret Giggs, the foster daughter, leans over More's father and points out a passage in a book; as a pregnant daughter, Elizabeth Dauncey, looks down on the scene and as More's wife, Alice, sits reading to the right at a prie-dieu.

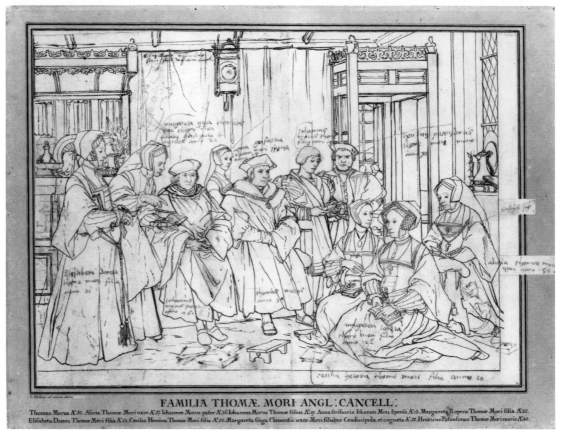

**FAMILIA THOMÆ MORI ANGL: CANCELL:**

Thomas Morus A'.50. Alicia Thomæ Mori uxor A'.57. Iohannes Morus pater A'.76.Iohannes Morus Thomæ filius A'.19. Anna Grisacria Iohannis Mori Spensa A'.15. Margareta Ropera Thomæ Mori filia A'.22.
Elisabeta Dancea Thomæ Mori filia A'.21. Cæcilia Heroina Thomæ Mori filia A'.20. Margareta Giga Clementis uxor Mori filiabus Coudiscipula et cognata A'.22.Henricus Patensonus Thomæ Mori morio A'.40.

Holbein was a friend of the great Dutch humanist Erasmus in Basel, Switzerland, and is likely to have had a letter of introduction to More from a mutual acquaintance. He may have stayed, even, in this very house in Chelsea before moving to Cornhill in the City. More was a great admirer of Erasmus's *In Praise of Folly*, and the inclusion of his fool in a cap staring straight out of the drawing is telling. Erasmus had seen the foolish as truly wise and More himself considered his own folly as a kind of divine gift. The fool adds here a rather modern sense of the vulnerability and imperfections of the other figures. The lightly chained pet monkey who climbs up the skirts of Alice More may be linked to the irrational forces embodied in the fool as well as to More's concept of the ape as an image of heresy.

We see, then, a wealthy, learned man of great spiritual and worldly power, in his discreetly fashionable mansion surrounded by his family and household. The scene is lively but disciplined, animated by conversation but tempered by a scholarly atmosphere of bookish interest and calm religious intelligence. If an image captures the critical moment of humanism in Catholic early Tudor London, this is it. One of the questions posed by this confident new world was how far art worshipped man-made things, something for instance the Book of Micah in the Old Testament forbade but which was fast becoming a feature of the early modern period. Within a few years More was dead and so was much of the spiritual and political world he had inhabited.

2 **Hans Holbein**
1497/8–1543
**The More Household at Chelsea**
c.1527
Pen on paper
38.9 x 25.4
Kunstmuseum Basel

### Painting in Search of a Subject

Identity, as ever, is the mystery here (no.3). The Tate Collection's earliest work is a small oak panel, originally comprising three boards, each about 25 centimetres wide, glued together with butt joints, but at some time between 1545 and 1897 cut down along the sides and bottom. The surface of the panel is covered in layers of gesso (a mixture of chalk, gypsum and animal glue size) and over that a variety of pigments mixed with linseed oil. Much of the surface of the top half of the panel is a blotchy brown, having once been a deep translucent blue created by using smalt, a cheap substitute for ultramarine.

This sounds like an unpromising start. However, what we actually see is the brightly lit face of a bearded man in a fur-trimmed jerkin and a black cap, painted with a remarkable, even hallucinatory, naturalism. He is shown in three-quarter view and stares steadfastly ahead. To the left and right of his head are gold inscriptions under which we may just make out 'shadow' words. Together these tell us that the panel was painted in 1545 and that the subject was twenty-six years old. On the back of the panel is a section of one of those parts that were cut down later, with a pair of identically worded inscriptions in old French which read: 'faict par Johan Bettes Anglois' (made by John Bettes Englishman).

John Bettes the Elder, who came from a dynasty of English painters, was active c.1531 to c.1570, and records suggest he lived in Westminster, rather than in the City where most painters were based, and therefore was likely to have been closely associated with the Court. It is probable that he received some training from Holbein, as his technique and approach suggest. Holbein, who as we have seen first came to England from Basel in 1526, and who settled in London in 1532

3 **John Bettes**
active c.1531–c.1570
**A Man in a Black Cap**
1545
Oil on oak panel
47 × 41

until his death in 1543, introduced an entirely new style of painting to the court of Henry VIII, which quickly became fashionable with those who could afford his services. It was a regular complaint at the time, and both before and well into the eighteenth century, that royalty and aristocracy in England were obsessed with an idea of the superiority of foreign artists, to whom they seemed to pay exorbitant fees and whom they favoured over their English rivals. In 1531, for example, the great scholar and education theorist Sir Thomas Elyot (whose portrait was painted and drawn by Holbein) complained in his *The Boke of the Governour* that the English 'be constrayned, if we wyll have any thinge well paynted, kerved, or embrawdred, to abandone our own countraymen and resorte unto straungers'.

In the sixteenth century this predilection, as we have probably seen at Eton College, usually meant recourse to Northern European artists such as the German Holbein. The fiercely nationalistic Painter-Stainers' Company in London, of which Bettes may well have been a member, made frequent complaints about the negative impact of foreign artists, who seemed to elude their otherwise tight control over all artistic practice, on the economic and training prospects of native artists. Members of the Painters-Stainers' Company ('stainers' refers to craftsmen who painted on cloth), for example, were among those who rioted on the notorious Evil May Day in 1517 against the threat to their livelihood posed by foreign workers.

There was undoubtedly a form of class distinction at work in the relationship between English and foreign painters throughout much of the sixteenth and seventeenth centuries, and even the grant to the Painter-Stainers' Company of a royal charter by the nationalistically alert Elizabeth I in 1581 could not hide this awkward fact. The extraordinary success of the Italian artist Giorgio Vasari's *Lives of the Artists* when it was published in 1550 suggests a world of status, glamour and renown for modern Italian artists of which their English counterparts could hardly dream. Even when William Aglionby translated parts of it into English, belatedly in 1685, he bemoaned the fact that by contrast with Continental cultures, including the Dutch 'in the midst of their boggs and ill Airs', England was the only nation which wanted 'Curiosity for Artists'. Most artists in any other country, in fact, were employed as much in decorating buildings, barges, coaches, tents and furniture and with creating heraldic devices and stage scenery for court entertainments, as in painting portraits or other subjects. Rates of pay in the mid-sixteenth century for painters in England compared with other craftsmen give some idea of their general status: £4 per year with meat and drink as against £5 for carpenters and £8 for goldsmiths. The Painter-Stainers' Company, indeed, spent much of its time trying to prevent other trades undertaking work which was legally the preserve of their members. The exceptions, such as Holbein, were almost always foreign.

Returning to Bettes' portrait, then, we are looking at a fairly rare luxury item produced by a skilled English craftsman in the style of his German master. Eighteenth-century accounts of the coats of arms on the now missing parts of the panel suggest that this is a portrait of Edmund Butts, a son of William Butts who was Henry VIII's physician and who had himself been painted by Holbein. Dr Butts died in 1545, the year of this portrait, and thus the year Edmund would have inherited considerable wealth. The fragmentary historical evidence suggests, therefore, that this portrait marks a significant moment in the subject's life which would have merited the cost of its commissioning. The portrait seems to do far more than this, however. The almost photographic precision and delicacy of the image suggests, when compared with most earlier portraiture, a new kind of man, or at least a new sense of the unique characteristics of a particular but not especially eminent man.

Holbein is usually associated with a form of Renaissance humanism which, in returning to the texts of classical Greek and Roman authors, also emphasised the significance of the individual in a way that seems 'modern' to us. His relationships with Erasmus and Sir Thomas More underlines this milieu in which the German artist moved. A recent literary historian has characterised the much-contested humanist outlook as one in which there is 'an increased self-consciousness about the fashioning of human identity as a manipulable, artful process'. While for many, including More for example, this 'self-fashioning' was based on a pious emulation of Christ, increasingly it was cut free from such powerful traditional models. Of course there could be no complete freedom from these models, but the will to achieve autonomy was intense – as we shall see, among artists as well as their clients. Increasingly aware of the forces which help to shape the self – educational, economic, cultural and so on – sixteenth-century men found in visual and literary representations great opportunities to forge new images of themselves.

This sense of the tension between the fluid power of the human self, as it seeks to realise itself and the powerful constraints on that impulse, gives portraits such as that by Bettes a certain charge and significance belied by their often anonymous status. The political and religious battles of the period, of which Sir Thomas More, the celebrated 'man for all seasons', is one of the most famous tragic victims, are marked

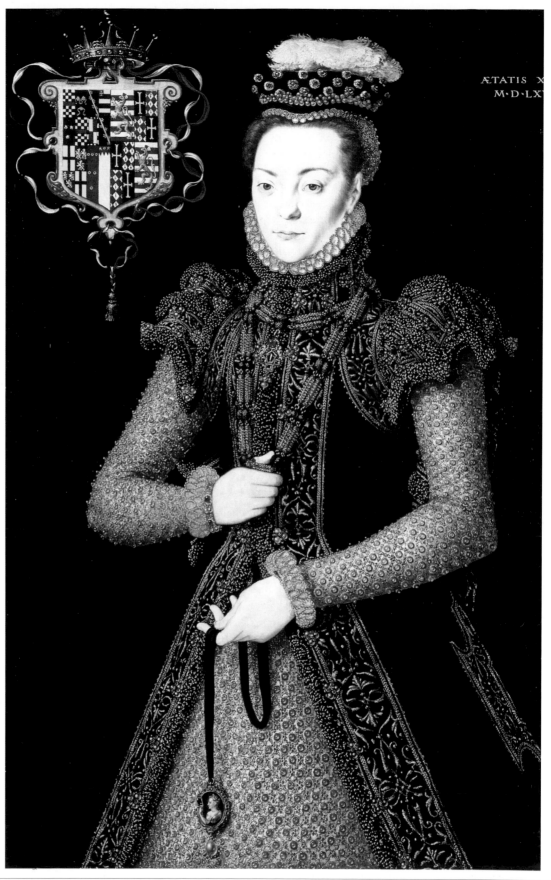

ÆTATIS X
M·D·LXV

4 **Hans Eworth**
active 1540–1573
**Portrait of an Unknown Lady**
c.1565–8
Oil on oak panel
99.8 × 61.9

Hans Eworth was a versatile Netherlandish painter who arrived in England a few years after Holbein's death. Possibly made for a new husband, this painting is a fine example of the ornate portraiture of the period. Her face is pale, signifying her high status, an effect achieved with lead-based make-up and lotions made from substances such as rose, cherry, egg-white, beeswax, hog lard and honey. Under carefully pencilled eyebrows, her wide-set grey-blue eyes are heightened with kohl. Her open balloon 'wing' shoulders, highly fashionable in the late 1560s, are, like the cap and dress, elaborately studded with jewelled buttons and pearls. In her hand she holds a black ribbon with a gold, chalcedony and diamond-set cameo. This shows Prudence holding a mirror, symbol of truth.

precisely by violent and contradictory relations between the usually upwardly-mobile 'middling' individual and secular and religious authority. The very real danger to the freedom of these new men is well expressed by one of them, William Shakespeare who, in his 'Sonnet XVI', complains about 'Art made tongue-tied by authority'. Painters such as Holbein and Bettes played a critical role in articulating this struggle.

## Gloriana and the Phoenix

Piety and power conjoined has a particular look. Hans Eworth's painting *Unknown Lady*, painted c.1565–8 (no.4) has much in common with the portrait of Elizabeth I in her early forties (no.6), which is attributed to the miniaturist, or limner, Nicholas Hilliard, the first native-born English painter to gain an international reputation. The delicate underdrawing over a carefully worked smooth ground, and over which in turn oil paint is applied 'wet on wet' with fine brushes, gives Elizabethan panel painting such as this the brilliant luminosity and intricate detail we associate with the miniature. This portrait, painted in the mid-1570s, is known as the '*Phoenix Portrait*', after the jewel hanging at the breast of the queen who was to become the cult-figure Gloriana or Astraea.

Elizabeth's status as the Virgin Queen was the product of the political and religious strategy that we call the Elizabethan Settlement. While Elizabeth and her principal adviser William Cecil, Lord Burghley, sought to defend England's new Protestant status against the threat of Catholicism and the power of Spain, they also strove to ward off the excesses of the increasingly influential Puritan faction on the home front. Elizabeth's role was maintained by a combination of complex symbolic spectacle, occult speculation and literary spin-doctoring as well as by parliamentary statute, espionage and, frequently, torture and terror. We are looking at a formidably well-defended and ruthless monarch whose cold stare was carefully contrived and maintained.

The extraordinary cult around her image, created by writers such as Sir Philip Sidney and Edmund Spenser and artists such as Hilliard and her Serjeant Painter Sir George Gower, was backed up by legal enforcement. A tight control over the images of the queen, such as this, which might be circulated through the kingdom, was attempted in a proclamation drafted by Cecil in 1563 that forbade any artists from drawing her until 'some speciall conning payntor might be permitted by access to hir Ma/ty to take ye naturall representation of hir Ma/tie wherof she hath bene allweise of hir owne … disposition very unwillyng'.

The aim of this was to provide an officially approved pattern, available to subjects 'both noble and mean',

5 **Crispin de Passe Senior**
**Elizabeth I**
1596
Engraving
British Library

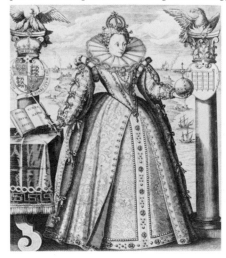

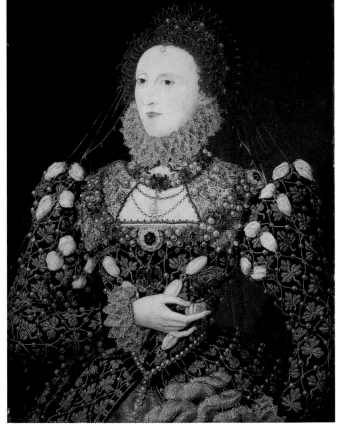

6 **attributed to Nicholas Hilliard**
c.1547–1619
**Queen Elizabeth I**
**(the 'Phoenix Portrait')**
c.1575
Oil on wood
78.7 x 61

which all other artists would be compelled to follow. Whether this intention was achieved in full is not known but certainly as Elizabeth, who apparently disliked being painted, grew older, the images of her did not keep pace with her ageing face and body. Descriptions of her later in life vary, but one highly unflattering account by the French ambassador speaks of her face as 'very aged, and her teeth are yellow and unequal'. Another account even more cruelly describes her teeth as like 'defence-works'. Obviously not enough turpentine and hog's lard was being used by her make-up assistants. Concern about loss of control over regal imagery can be seen in a Privy Council order of July 1596, which commanded unacceptable portraits to be destroyed or defaced and all subsequent portraits to be submitted to the Serjeant Painter, Sir George Gower.

The *Phoenix Portrait* carries two dominant devices or symbols – the red rose held by the queen in her hand, which is a traditional symbol of the Virgin Mary, and the Phoenix itself. This legendary bird inhabited the Arabian Desert and every few years burnt itself to ashes on a funeral pyre and then arose youthful once more. The relationship of such symbolism to the English queen, head of church and state, and in effect the centre of a Protestant virgin cult is, and was, obvious. The extreme pallor of the face, while no doubt due in large part to make-up to mask her age, was also intended to suggest a virtually shadowless world inhabited by the immortal queen and also a spiritual light which seems to radiate from rather than onto her body.

The labyrinthine connections between the various symbols associated with Elizabeth – phoenix, pelican, sieve, ermine, rainbow and so on – and their relationship to court entertainments and tournaments, to art, literature and politics are endlessly fascinating. Crispin de Passe's engraving of 1596 (no.5) shows Elizabeth between two columns, on which are perched a pelican and a phoenix. She holds an orb and sceptre, and behind her an island with smoking forts refers to the country's successful defence against the Spanish.

The phoenix, carrying alchemical meaning like virtually all imagery connected with Elizabeth, was often associated with the onset of a new golden age in reborn societies, and Elizabeth became the focus not only of the court's 'heretical' virgin cult, but also of a broader ambition to forge a heightened sense of national purpose. In effect a whole myth of national origin, history and destiny pivoted on this one woman.

The defeat of the Spanish Armada in 1588 was both a sign that God was on the side of Protestant England and that the world was soon to be dominated by the growth of a new sacred empire on a scale not seen since that of Rome. From the visionary imperial prophecies of Elizabeth's court adviser, astrologer and mathematician, the peripatetic occultist John Dee, to the densely worked imagery of Spenser's *Faerie Queene*, the fantasy world that grew around the idol of Gloriana energised a small island's real and earnest sense of newly empowered direction.

**Posing to Death**
To be a loyal servant of Elizabeth might not, of course, guarantee worldly success. The self-fashioning we have discussed was often conducted by 'new men' of a rather naive sort, who misjudged their position and tactics entirely. One spectacular full-length portrait, the first in the Tate Collection on canvas rather than on panel, shows Captain Thomas Lee, who seems to conform to this type (no.7). It was painted in 1594 when, as the inscription on the right tells us, Lee was forty-three. The painter was the Bruges-born Marcus Gheeraerts II. He came from a major dynasty of Netherlandish painters who settled in London in the 1560s. His father, a Protestant and contemporary of Pieter Breughel, fled Bruges as a result of religious persecution and may have been part of the mysterious underground sect called the Family of Love. Gheeraerts was thus part of that complex world of Dutch merchants, publishers, scholars, writers, craftsmen and artist refugees who were so highly influential in Elizabethan London. He was the sort of foreign painter popular in court circles who was probably not so popular with the members of the Painter-Stainers' Company. It seems likely that he was the first painter in England to use canvas, in use for some decades on the Continent, which allowed him to create entirely new effects on a grander scale than previously possible.

Captain Thomas Lee was something of a soldier of fortune who spent most of his career as part of Elizabeth's long struggle to subjugate the unruly Catholic population of Ulster. He was a cousin of the influential courtier and leading patron of Gheeraerts, Sir Henry Lee, the queen's Champion of the Tilt. Thomas Lee, described by a recent historian as a reckless opportunist and former highway robber, 'a soldier, marauder, squatter, debtor, poseur, pamphleteer, mediator, conspirator and jailbird', depended greatly on the goodwill of his cousin.

Being stationed on the frontier in Ireland was an arduous and dangerous existence and involved intimate, often compromising, contact with Irish clan chiefs. Like the poet Edmund Spenser, an administrator in Ireland during the same period, Lee also wrote 'reform treatises'. In Lee's case, however, these were highly individual pleas for personal

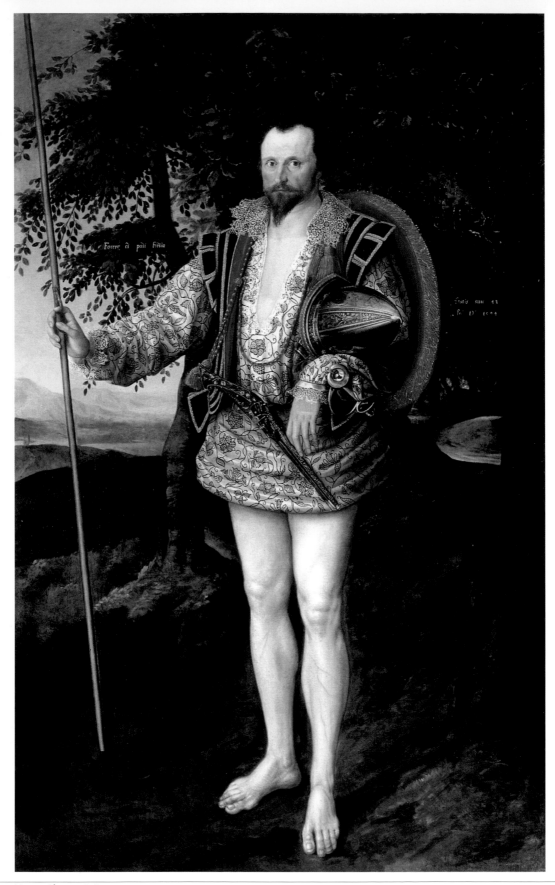

**7 Marcus Gheeraerts II**
1561 or 2–1636
**Portrait of Captain Thomas Lee**
1594
Oil on canvas
230.5 x 150.8

preferment and financial support alongside stinging attacks on corrupt governors and other officials. Of particular significance in understanding the purpose of Gheeraerts' portrait is Lee's *A Brief Declaration of the Government of Ireland*, presented in book form to Elizabeth in the autumn of 1594. It is largely an attack on his bitter rival Lord Deputy Fitzwilliam and also a proposal for a solution to the political crisis in Ireland, based on his own personal connections with many of the leading figures among the Ulster warlords. Chief amongst these was his boyhood friend Hugh O'Neill, 2nd Earl of Tyrone.

It is against this labyrinthine background that Gheeraerts' portrait, painted on one of Lee's trips to England, must be seen. It is also significant that it was formerly in the collection of Sir Henry Lee at his family home in Ditchley, one of the many places, as well as Whitehall, where the queen's Champion organised spectacular entertainments for Elizabeth as she travelled around England establishing her national authority. Artists such as Gheeraerts, incidentally, would have contributed their skills to the realisation of such events.

The most striking aspect of the image is that Thomas Lee is shown as an Irish foot soldier or 'kerne', bare-legged and in an open shirt, ready to wade through water. The costume is very elaborate, in fact, and is typical of the fine attire that might be worn at a court spectacle or 'masque'. It was also intended to be physically alluring, and it is hardly an exaggeration to say that at one level the portrait is an attempt by the recently widowed Lee not only to attract a new wife but also to seduce the queen's affections and support. The bare flesh, scarred left hand and impressive inlaid 'snap-haunce' pistol are all designed to achieve this end through the fairly straightforward means of a sexually-charged male pin-up.

The painting's full political purpose is elaborated through other devices, likely to have been conceived by Henry Lee for his desperate cousin. Lee stands in the 'lee' of an oak, suggesting both the protection of his cousin, whose motto was '*Fides et constantia*' (trust and constancy) and the likelihood that such a position might also attract lightning. The oak is also a traditional symbol of England and therefore of the queen. The water in the background (notice also the sinister shadowy figures holding pikes in the woods) probably refers to an action at Erne Ford in Fermanagh which Lee had taken part in the previous year. The Latin inscription on the left of Lee is a quote from Livy's *History of Rome*, '*facere et pati fortia*'. This learned reference is a fragment from a slightly longer phrase which can be translated as 'Both to do and endure valiantly is the Roman way'. They are the words of Gaius Mucius Scaevola after he had been captured in the camp of Etruscan rebels, where he had been sent with the Senate's approval to kill the leader Lars Prosena. Significantly, Scaevola was captured disguised as an Etruscan and, in order to prove his bravery, thrust his hand into a fire. This action impressed his captor so greatly that he immediately concluded a lasting peace with Rome and Scaevola was granted lands by his own political masters. If only, Lee may have thought!

This strange mix of contemporary news, male sexual display, fancy dress, classical allusion and evocative exotic landscape failed as propaganda however. Along with his *Brief Declaration* and other political manoeuvrings, Lee managed to arouse the anger of Lord Burghley, a big mistake, and he returned to Ireland in 1595 still as a vulnerable captain of horse. In spite of some impressive military successes, the maverick captain, heavily in debt, eventually met a dismal fate. Precisely because of his close connection to Essex he was hanged at Tyburn in 1601, following his master's failed coup d'etat and his own misjudged attempt to gain entry to the queen's presence to force her to sign a warrant for the Earl's release. Self-fashioning had lead to self-destruction.

### 'Josiah his Zeale'

Sir Thomas More's execution by Henry VIII in 1535, following a dramatic trial, came as a direct result of his refusal to acknowledge the king's spiritual authority over that of the Pope in the wake of Henry's dispute about his divorce from Catherine of Aragon. The following year the onset of the Dissolution of the monasteries under the direction of Thomas Cromwell, who had drawn up the document indicting More, inaugurated more than a hundred years of intermittent iconoclasm, the destruction of religious art and artefacts in England. It is interesting to note that More himself had defended images against 'the pestilent sect of Luther and Tyndale'.

The effect of this destruction and of the dismantling of Roman Catholic authority and liturgy which initiated it on the visual arts in England can hardly be exaggerated. Some commentators estimate that up to ninety-five per cent of religious art was destroyed by 1650. Although Henry was himself a devout Catholic, at least theologically, he and his successors were unable to fully contain the destructive instincts of the Protestant extremists who became increasingly powerful in matters both sacred and secular. The battle over imagery commenced and left a deep scar on the canvas of British art history.

Although historical, religious and other forms of painting were produced during the later sixteenth

century, much of which is now lost, it is evidently true that portraiture dominated English art at this time and that it became an almost over-determined form, which struggled to bear the weight of the significance demanded of it. In fact there is a further twist to these circumstances – even portraits of monarchs, aristocrats and others at the top of the social pyramid were held in deep suspicion by the most pious iconophobes. The Second Commandment, clearly visible on the new screens of every reformed church in the country, seemed to such zealots quite unequivocal: 'Thou shalt not make unto thee any graven image, or any likeness of any thing that is in heaven above, or that is in the earth beneath, or that is in the water under the earth'. These words from Exodus xx were followed by terrifying threats from the jealous God of the Old Testament. Any serious-minded puritan, from the humblest peasant to a figure as elevated as the soldier-poet Sir Philip Sidney – a great enthusiast for the visual arts – would find it hard to ignore the threat. They might even wish to emulate King Josiah in the Bible in his destruction of false idols – 'Josiah his zeale' were prominent words at the top of the page in the Authorised Version of the Bible (1611), where the young king's reforming efforts are described in 2 Kings, Chapter XXVII. The enthusiasm often exceeded official sanction, however, and as early as 1563 the

government issued a decree denouncing those who had not only wrecked images of saints but also defaced the tombs and monuments of the great and the good.

It is important to understand something of the complexity of the debate about images, as it not only casts light on how they were viewed and understood but also underlines how deeply entwined art and power were, and indeed always are. Sir Thomas More's Catholicism and classical culture could, for instance, be seen to embody one set of problems for the reformers. Although classical Rome was one of the major intellectual sources for the assault on the papacy, it was also its home and therefore contaminated.

Furthermore most Roman culture was pagan. A writer in 1549 equated the worship of Catholic saints with pagan practice and asserted that the 'Englishman that trusteth in St George … differ nothing in this point from the heathen or gentile' who trusted in Juno or Neptune. The use of classical prototypes for the composition of portraits was an added complication, even though many writers tried to draw a distinction between the idolatry and paganism of religious portraits and the use of secular portraits as decoration and memorialisation. What about images of the heroic reformers themselves? Christopher Hales, an English gentleman who in 1550 had tried to commission a series of portraits of the great Zurich Protestants such

8 **Artist Unknown**
**Edward VI and the Pope:**
**An Allegory of the Reformation**
Oil on panel
62.2 x 90.8
National Portrait Gallery, London

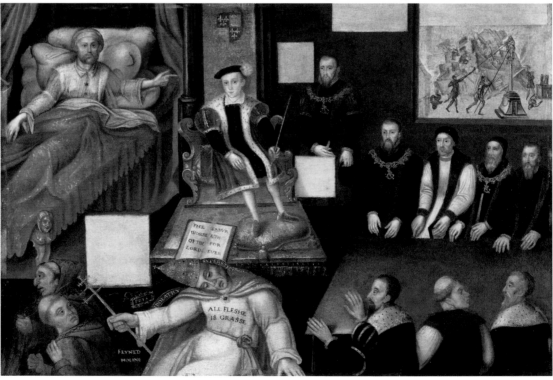

as Zwingli, faced resistance to this request from his contact in the Swiss city, on the grounds that such images might themselves become idols. Even though Hales specified that each portrait should show the sitter holding a book, thus stressing the pre-eminence of the word in paintings intended for display in the contemplative atmosphere of the library, the commission was frustrated. Similarly the first edition of The Great Bible of 1568, with an introduction by Archbishop Parker, had full-length engraved portraits of its patrons the Earl of Leicester and William Cecil before the books of Joshua and the Psalms. These caused offence and were removed from later editions. Even Elizabeth's image was eventually removed from the frontispiece.

The debates were intricate and endless, and frequently changing political circumstances meant that their outcomes were acted upon in different ways as the decades wore on. The intensity and spread of the iconoclasm of Edward VI's reign reflect a particular combination of theological discourse and realpolitik very different from that which led to the Dissolution of the 1530s, or that was to inform the perhaps even more destructive phase of the Civil War and Interregnum in the mid-seventeenth century. Although painted some years after the event to reinforce anti-papal feeling during Elizabeth's reign, the anonymous painting on

panel of *Edward VI and the Pope* (no.8) gives a clear image of the political and religious questions involved. On the left Henry VIII lies on his deathbed and points to his son Edward, who sits enthroned on a dais. A book at Edward's feet is open to reveal a text from the Book of Isaiah of particular significance to Puritans: 'The worde of the Lord Endureth Forever.' The book has been thrown at the Pope on whose chest are the words 'All Fleshe is Grasse' and on the infulae of whose tiara are the words 'idolatry' and 'superstition'. Two monks seek to draw Edward away from his commitment to the reformed religion by pulling his dais along with chains. To the right of Edward are his Privy Councillors, including the Lord Protector the Duke of Somerset and the Archbishop of Canterbury, Thomas Cranmer. Of special interest in the right-hand corner is a scene of iconoclasm, a reference to the policies against images of the 'young Josiah', Edward VI. The purpose of the blank sections is unknown, although they presumably contained further improving texts and, rather neatly, remind us of the whitewashing of the Eton murals that took place at this time.

### Art and Martyrdom

The intensity of anti-Catholic propaganda from the 1560s is evident in one of the most widely seen set of religious images in Britain for the next three centuries

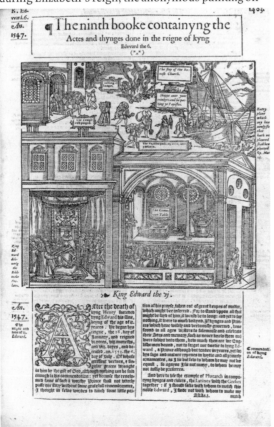

9 Woodcut from 'The Actes and Monuments' by John Foxe, London
1570
11 p.1483
British Library BL 4705 h 4

25

– the woodcut illustrations to a new edition of John Foxe's *Actes and Monuments* of 1563, which became known as *The Book of Martyrs* on account of the gruesomely detailed descriptions of the deaths of Protestant martyrs during Mary I's brief reign (1553–1558). One of the woodcuts (no.9), from the enlarged two-volume edition of 1570, shows in the upper half images being burned while Catholics rescue what they can from their church and board it onto a boat. One captain shouts at them: 'Shippe over your trinkets and be packing ye Papistes.' In the lower half of the plate, a clergyman preaches to a book-carrying congregation from a pulpit. The church with two of its key features, the communion table and font, is whitewashed, bare and free of Catholic 'superstitious idols' and relics.

Similar imagery, upon which such visualisation of the religious revolution in England was based, was abundant in northern Europe and reveals an almost universal vocabulary of figures, symbols and references used by the propagandists of reform. As we have stressed, the links between England and the seaboard across the North Sea, strong for many centuries, were now tightened by a broad new religious sympathy. The artists commmissioned for this new edition of Foxe's book just examined were in all likelihood Netherlanders who had fled persecution by Catholics in the 1560s. In spite of a law forbidding printers to employ more than four foreigners, these skilled men were preferred for such major projects. It is likely, for example, that Marcus Gheeraerts the Elder was one such immigrant contributor to the 1570 edition of Foxe.

### The True Self-Portrait

Against this unpromising background, it is hardly surprising that few English religious paintings from this period survive – and of course all earlier medieval art suffered just as badly. On the Continental mainland, the Counter-Reformation set in motion by the papacy and the leading Catholic powers following the Council of Trent of 1545–63 sought to reassert the authority of Rome. It aimed to do this precisely by re-enchanting those who had strayed from the faith, as well as those who had remained loyal, through a renewed emphasis on visual experience. The evidence of this campaign is to be seen in magnificent religious works in churches by major artists such as Tintoretto and Caravaggio, the 'idolatrous' masters of the Baroque in Italy and the Mediterranean region.

Where the Counter-Reformation produced vast architectural exercises in colour and emotional religiosity, in England the devotional painting, where it occurred, was far more modest. *An Allegory of Man*

(no.10), thought to have been painted about 1596, reminds us, though, that the situation regarding religious art was far from simple. This oil painting on oak panel by an unknown artist was probably made for private use by a Protestant client, either in a chapel or perhaps as part of a funerary monument. The lengthy English inscription, reminiscent of the popular engravings and woodcuts we have briefly looked at, describes man as a 'wretched creature' who must fight the temptations of all worldly things by fasting and praying continuously to Jesus.

The painting is equally divided between heaven and earth and shows at the centre Man in classical military costume, praying directly to the resurrected Christ who is identically featured – that is without the Roman-style intercession of saints – while an angel invests him with a shield of Christian virtues. Around these main protagonists a woman, a winged devil and a man of business fire arrows at the central figure who represents the seven deadly sins. Death as a skeleton hurls his spear and carries a shield reminding Man that he stalks him 'like a thief'. Every detail supports the message of spiritual vigilance – from the jewel in an hourglass suspended from the waist of the richly attired lady denoting the time wasted by sloth, to the nails at the back of the settle behind the businessman ironically echoing the nails of the Cross. The most earnest reformers would have perhaps rejected even this imagery, but for many wealthy Protestants such an aid to prayer and right thinking would have been acceptable. Even they, however, would have placed such a painting on a side-wall in a chapel or in a small room set aside for their devotions.

This is art with a deadly serious purpose, for people who may well have felt no inconsiderable trepidation about their new reformed circumstances. They may also have feared attack from Catholic traitors ('recusants') within the country and from the combined forces of the great Catholic powers without. The certainty of death and, except for the few, the uncertainty about salvation, gave this kind of unassuming painting a personal and religious meaning – self-fashioning would continue beyond the grave.

### 'Divers Little Pictures'

We have been concerned so far with 'painting in large', yet Elizabethan art is most usually associated with the miniature. This was a form which found its natural habitat within the secrecies of the court. (The term 'miniature' in fact refers not to the small size of the object but derives from minium, a red pigment that was used by a 'miniator' to highlight capital letters in manuscripts.)

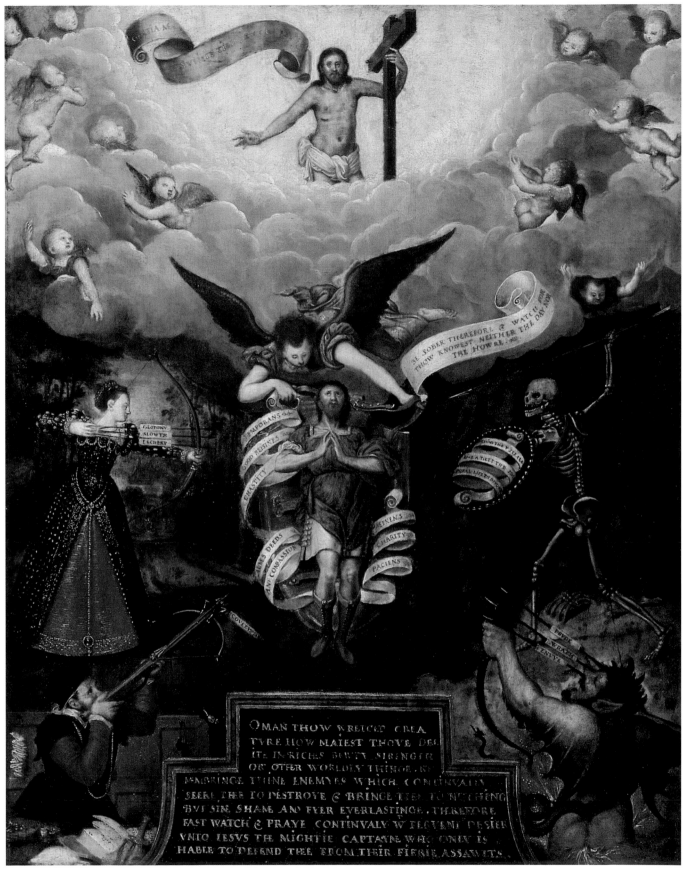

**10 British School**
16th century
**An Allegory of Man**
c.1596
Oil on wood
57 × 51.4

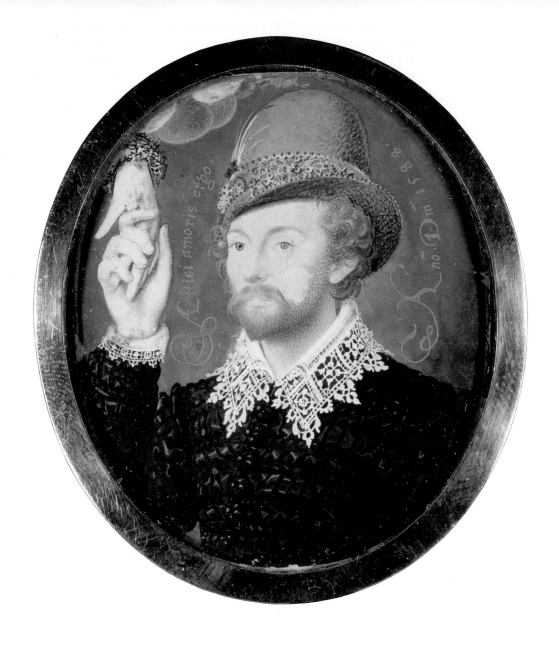

**1 Nicholas Hilliard**
c.1547–1619
**Young Man Clasping a Hand
from a Cloud**
1588
Watercolour on vellum, 6 x 5
Victoria and Albert Museum

'A hand ... /By Hilliard drawne, is worth an history/By a worse painter made', wrote the poet John Donne. One of the most enigmatic of Hilliard's miniatures, this image, painted in the year of the Armada, shows a young man clasping a hand issuing from a cloud. We are not sure who he is, whose hand he is holding or what the exact meaning of the Latin inscription is. It is a good example of an 'impresa' or motto and image, which depend upon one another for their secretive meanings and reveal the thoughts, some aspect of the character or life or even soul of the subject. It may be an image of true friendship, with Shakespeare as Mercury, holding the pure white hand of 'W.H.', the 'lovely boy' of his Sonnets, as Apollo, his divine and healing inspiration. 'Attici Amoris Ergo' can be translated as 'Athenians for [or 'because of'] love'.

A fascinating insight into the mysterious resonance of the miniature within court circles can be gained from Sir James Melville's description of his privileged access to a private room of the queen at Whitehall Palace in 1564. Elizabeth invited him to see a portrait of her current favourite, the Earl of Leicester, whom Melville was negotiating with over a possible marriage to Mary Queen of Scots:

> She took me to her bed-chamber and opened a little cabinet, wherein were divers little pictures wrapt within paper, and their names written with her own hand upon the papers. Upon the first she took up was written, 'My Lord's picture'. I held the candle, and pressed to see that picture so named. She appeared loath to let me see it; yet my importunity prevailed for a sight thereof ... I desired that I might have it to carry home to my Queen; which she refused, alleging that she had but one picture of his. I said, your Majesty hath here the original; for I perceived him at the farthest part of the Chamber, speaking with Secretary Cecil. Then she took out the Queen's picture and kissed it.

This haunting description evokes the clandestine atmosphere surrounding the cult of the miniature, in which the jewel-like image of an individual, kept hidden in a cabinet or gold locket, is part of a subtle play between politics and self, public and private, appearance and reality. Miniatures were painted on vellum stuck to playing cards and although this was for practical reasons, it also seems entirely appropriate for an art form so connected with the often fateful game-playing and dissimulation of courtly life. The organisation of the royal apartments at Whitehall would have meant, for example, that Melville would have moved through a range of ante-chambers, from the public gallery, the Presence Chamber and the Privy Chamber to the royal bedchamber where the miniatures, kept in their cabinet box, might well be seen as secrets of state.

The artist responsible for the greatest miniatures of the Elizabethan age, Nicholas Hilliard, was first trained by the Queen's goldsmith and also practised as a jeweller. This background would have given him unique skills in the use of metallic pigments – note, for instance, how the gold inscriptions seem to 'float' on their blue background in his miniature *Young Man Clasping a Hand from a Cloud* (no.11). Hilliard made a point of linking the limner's colours to precious stones. 'There are besides white and black but five perfect colours in the world', he wrote, listing these as amethyst murrey, ruby red, sapphire blue, emerald green and topaz yellow. A kind of forensic magic

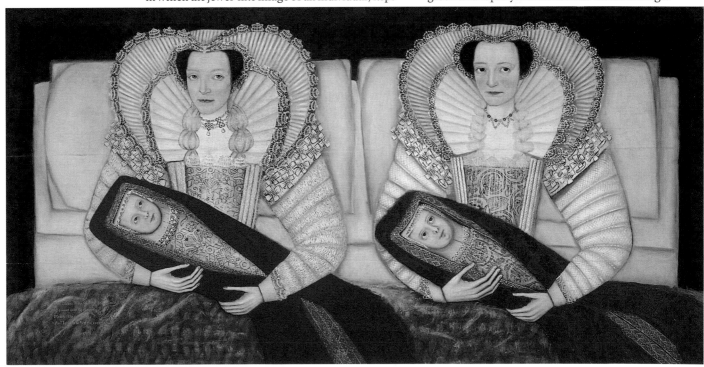

12 **British School**
17th century
**The Cholmondeley Ladies**
c.1600–10
Oil on wood
88.9 x 172.7

An unusual example of a painting by a regional artist working in Cheshire. The two women are presumably sisters, and an inscription tells us they were born on the same day, married the same day and 'brought to bed' the same day. The exact circumstances of the production of the panel, which has something in common with tomb monuments of the time, remain a mystery.

seemed to be involved, and in his book *The Art of Limning* (unfinished and unpublished at his death in 1619), Hilliard describes the ideal conditions for painting miniatures – the artist should wear silk to avoid transferring dust and should work in a large studio.

Although there had been important miniature painting, imported from the Continent by Lucas Horenbout and Holbein during Henry VIII's reign, Hilliard, who had travelled in France, brought to the practice a focus that was new in England. He achieved this in part by his extraordinary technical skills, by his imaginative use of abstruse emblematic imagery and through his belief in the miniaturist's status as a 'gentleman'. The miniaturist had an arcane knowledge of the sort which fascinated Elizabeth and Hilliard refers to the art as 'a kind of gentle painting … it is secret'. He was thus distinguishing his art from that of the panel painter and, in *The Art of Limning*, spoke of the artist's aim as being to 'catch' the 'lovely graces, witty smilings' and 'stolen glances' of his subjects. From the grinding and washing of expensive colours, through the application of a pale flesh colour as his ground, to the three-dimensional building up of ruffs and other details, the artist was engaged in a craft 'mystery' and sanctioned by royal patronage. Hilliard thus saw himself on a par with the poets who, so to speak,

scripted the rarefied cult of 'Gloriana' and her magic island. In an age that assumed the truth of astrology, perhaps as we do the laws of gravity, the miniature had talismanic power.

The idea of the miniature as creating an idealised, aristocratic world of fantasy was underlined by Hilliard's stress on the unshadowed rather than the 'grosser' line of oil painting. His oft-quoted anecdote about the queen's aesthetic preferences is telling – Elizabeth, he said, insisted on being limned 'in the open alley of a goodly garden, where no tree was near, nor any shadow at all'. Hilliard then goes on to make a moral point: 'For beauty and good favour is like clear truth, which is not shamed with the light, nor needs to be obscured.' He also views shadowing as 'like truth ill-told, signifying an ill cause'. It is not recorded what the Painter-Stainers' Company thought of such claims, but given their strong rivalry with the Goldsmith's Company, to which Hilliard was closely connected, they might well have taken some offence.

### Paper, Walls and Wallpapers

So far we have dwelt upon paintings, large or small. The wider visual culture included a myriad other forms – English or Flemish tapestries, maps of Britain by Christopher Saxton and John Speed, sculptures,

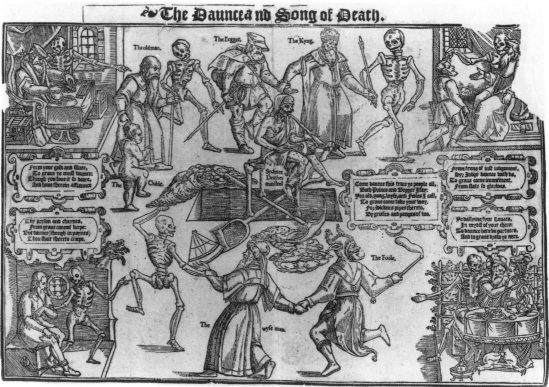

13 **Artist Unknown**
**The Daunce and Song of Death**
1568–9
Woodcut published by John
Awdeley
British Library London
Huth.50 (41)

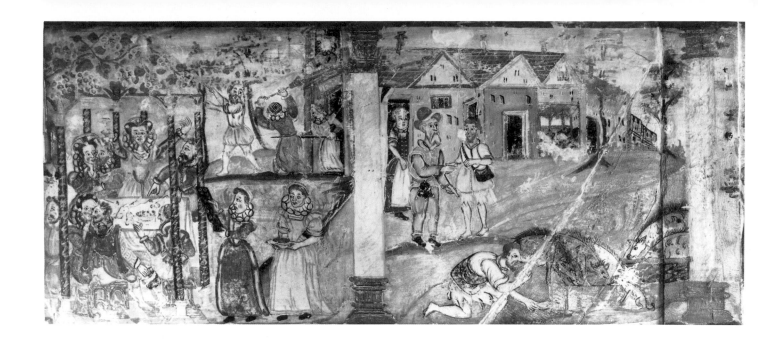

tombs, fine and not-so-fine prints and so on would have filled the homes and chapels of the well-to-do alongside furniture and wall paintings. The Lumley Inventory of the 1590s, for example, a list of works of art and other property owned by the Catholic Lord Lumley, gives a detailed account of such objects within one such household. But what about the less socially elevated? Many people would have seen the stirring anti-papist pictures in Foxe's *Book of Martyrs* in churches, but what visual material was on the walls of a modest household or inn?

Popular, or widely available, imagery has survived in the form of cheap or 'penny' prints, xylographed lining paper (printed from woodblocks), 'black letter' sermons (using large black typeface to present biblical or religious quotations), wall paintings and illustrated broadsides, ballad-sheets and chapbooks. There was no simple social and cultural apartheid at work in the consumption of this material, with ballad-sheets being hawked in markets and ale-houses, while wealthy citizens had the same songs sung in their houses by minstrels, and aristocrats collected such 'ephemera'. Of course education and literacy, wealth and leisure time were all major factors in this hierarchically ordered society. But in a nation forging its own identity, through a reformed religion, war and empire, the momentum towards some sort of shared culture was

not inconsiderable. The result was a complex set of circumstances in which old and new, conservative and radical elements were used in highly individual and unexpected ways. The main themes in this material were religious and moral ones, although often inflected by political, sensational or miraculous events such as murders, which would catch the eye of the potential purchaser. A large trade in this printed matter, of which only a fraction remains, was conducted by printers and publishers, artists, writers, travelling salesman and hawkers across the country. Images from a wide range of sources would be pirated, cannibalised and variously re-used over decades, and formed a visual flow which circulated at street level.

A typical print of the period is *The Daunce and Song of Death* of 1569 (no.13), published by a London specialist in ballads, John Awdeley. The dance of death was a very popular theme, and here death is shown as a skeleton escorting a man from birth to death in a branle or basic choral round, of the sort performed at every level of society. The folk 'ring' dance was a levelling form, which reminded the highest as well as the lowest in society of death's unavoidable, indeed desirable, presence in the midst of life.

Such a print might have been framed, or pinned directly onto a wall or wall-hanging. Larger and more permanent imagery could be found on wall paintings

14 **Artist Unknown**
   **The Prodigal Son story,**
   **Knightsland Farm, near South**
   **Mimms, Hertfordshire**
   *c.*1600
   Wall painting

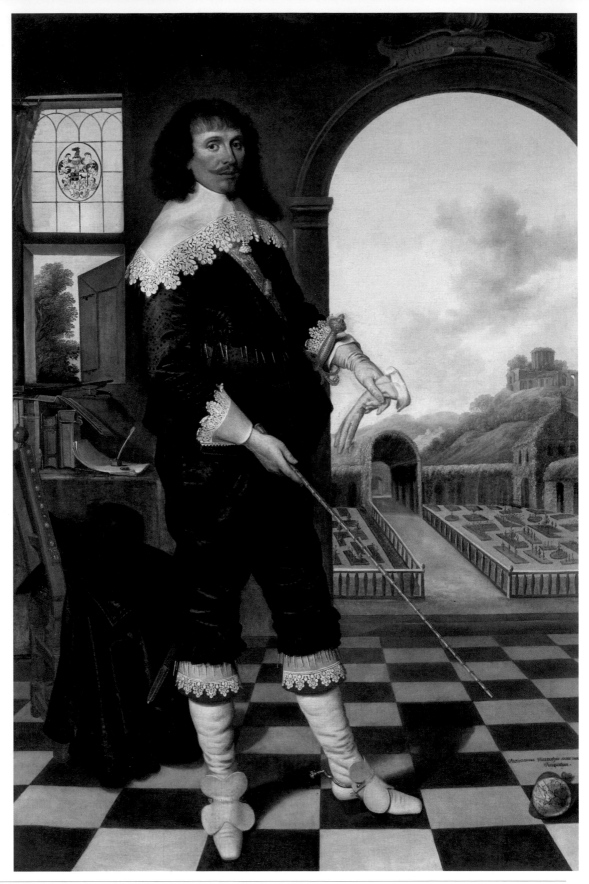

15 **British School**
17th century
**Portrait of William Style**
**of Langley**
1636
Oil on canvas
205.1 x 135.9

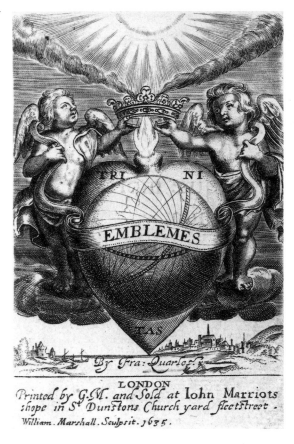

in houses and inns. For the very pious Protestant, only black lettering was permissible, with images being a sign of popish leanings – for example in 1638 Richard Brock of Bunbury in Cheshire and his wife had their alehouse suppressed for keeping 'popish reliques'. As we have seen, however, the debate surrounding words and images was contradictory and inconsistent and a wall painting such as that at Knightsland Farm, near South Mimms in Hertfordshire, is quite typical of what could be seen (no.14). Painted about 1600, it shows the story of the prodigal son, one of the most popular biblical stories among Protestants, as Falstaff's bedroom at the Garter Inn, Windsor reminds us in Shakespeare's *The Merry Wives of Windsor*: ''tis painted about with the story of the Prodigal, fresh and new' (Act IV, Scene V, lines 6–8). Such pictures would have circulated through areas by word of mouth and the passing round of prints. The South Mimms wall painting is probably derived from a popular print series by the Blackfriars publisher Gyles Godet. Crude as it is by comparison with the oil paintings we have looked at, it also has a humour and directness typical of the popular art of the time. Unfortunately we know even less about the itinerant artists responsible for such efforts than we do about their more fashionable contemporaries who painted for the top end of the market.

## I see better, I follow worse

The complex symbolism of the high Elizabethan portrait survived well into the seventeenth century. An outstanding and enigmatic example is the portrait by an unknown artist of the Inner Temple lawyer, William Style of Langley (no.15). He is shown standing in a room with a black and white chequered floor. Beyond him to the right an arched opening reveals a formal garden and a temple on a distant hill. Behind him on the left is an open window with a family crest on which is written 'I scarcely call these things my own'. Beneath the window is a table with books and a dancing master's violin, and by the table is a chair with a hat and cloak on it. Style points with a cane to the bottom right-hand corner of the painting where there is an image of a globe in a burning heart with text immediately above it.

Like much Elizabethan and Jacobean painting, this portrait demands to be read like a metaphysical poem. Style was a devout man – probably a High Anglican loyal to Charles I – and he translated a Latin book by a German Lutheran writer Johann Michael Dilherr, which was published in 1640. The book, which first appeared in Jena in 1536, had the title *Contemplations, Sighs and Groanes of a Christian*, and was an exhortation to abandon worldly ambition for the simple Christian life. The crude frontispiece for the translation shows a man holding a copy of Dilherr's book and uttering

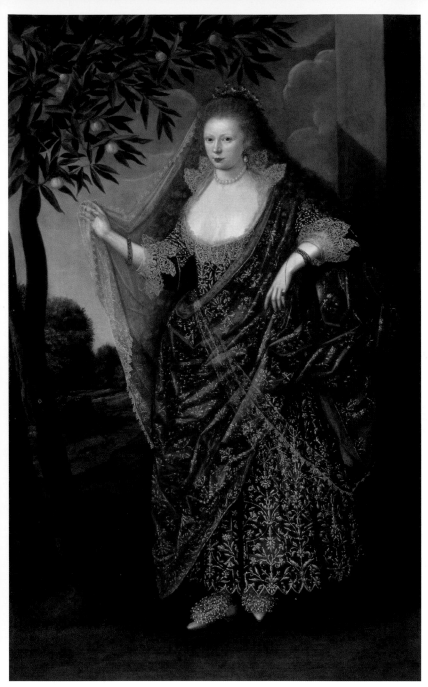

7 **British School**
17th century
**Portrait of a Lady, Called**
**Elizabeth, Lady Tanfield**
1615
Oil on canvas
222.2 x 136.5

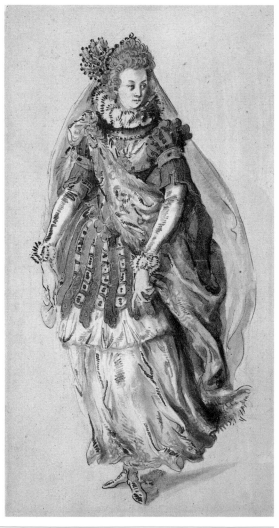

18 **Inigo Jones** 1573–1652
**Lady Masquer: A Transformed**
**Statue,** 1613
Pen and ink and watercolour
heightened with gold and silver
on paper, 27.5 x 14.8
Chatsworth Collection

words from Ovid's *Metamorphoses*, 'I see better, I follow worse', as he looks up towards heaven. In front of him is a table with objects representing the senses, including a lute, and behind him is a geometrically arranged garden.

If we return to the painting, perhaps by one of the many Flemish artists still living in London at the time, we see Style apparently also turning his back on worldly things and pointing to the globe and burning heart. Above this emblem are the words '*Microcosmus Microcosmi non impletur Megacosmo*' (The microcosm of the microcosm is not filled, even by the megacosm). The sense of this is that the heart of man cannot be satisfied even by the whole world, and it matches the imagery of the emblem beneath, with its globe based on a contemporary Mercator/Hundius map on which the ecliptics and ships suggest exploration and empire. The self-fashioned Renaissance man, that is, cannot satisfy his desires in this age of discovery because those desires are the wrong ones. The garden seen through the arch, following the frontispiece of Dilherr's book, might thus be seen as the '*hortus conclusus*', or walled garden of rosary contemplation, as opposed to the more usual view of land owned by a sitter.

It is possible that the popular book *Emblemes* (1635) by the Anglican poet Francis Quarles (no.16) was used to construct the idea of the painting, as the title page to Quarles's book shows a globe within a flaming heart.

### Painted Masques

The courtly nature of much Elizabethan portraiture, with its literary allusions and dramatised presentation, becomes pronounced, but in new ways, in the early seventeenth century. Many portraits during the early Stuart period represent the sitters in costumes worn at masques, the symbolic entertainments developed in particular by the poet Ben Jonson and the architect and designer Inigo Jones. Court masques brought together, at great and often controversial cost, scenery, music, drama and sophisticated special effects to produce a powerful, ritualised spectacle. Typically, a masque celebrated the divinely ordained power, and the benign and indeed magical effects of the monarch on his land and subjects. In contrast with the more aggressively nationalistic and Protestant-biased Elizabethan military entertainments organised by Henry Lee, the Stuart masque was concerned to present the new monarchy and 'united kingdom' as a source of international peace. Militant Puritans were deeply suspicious of the purposes, as well as resentful of the huge costs, of the masques at Whitehall and the Inns of Court. Designs for sets and costumes by Inigo Jones survive to give us some idea of the lavish nature of the masques which, derived from the festivals and

intermezzi, or short entertainments, of the Florentine and Fontainebleau courts, anticipate the full-blown opera of the later seventeenth century.

Jones travelled widely in Europe, for example to Italy with the homosexual James's favourite, the connoisseur and collector, the Earl of Arundel. Jones introduced the Palladian style into English architecture, and was a talented draughtsman and an enthusiastic and eclectic copyist from many artistic sources. The artist fashioned both his art and his personality by example. In a margin in his copy of Vasari's *Lives of the Artists*, he wrote, 'gudd manner coms by copiinge ye fayrest things'. His later much-publicised dispute with Jonson over the relative importance of the visual artist and the writer hinged in part over the question of invention and illustration and the painter's claim to originality.

One of Jones's elegant costume drawings (no.18) for Thomas Campion's *The Lord's Masque*, performed at Whitehall in 1613, can be usefully compared with the unattributed *Lady Tanfield* portrait of 1615 (no.17), which almost certainly shows a woman in a masque costume. Campion's masque celebrated the ultimately tragic marriage of Princess Elizabeth to Frederick of the Palatinate, and Jones's drawing shows his debt to Italian designers such as Bernardo Buontalenti. It also shows how similar masque costumes and court fashions were during this period. It is sometimes difficult to tell whether a portrait represents a participant in a masque or simply a subject wearing a fashionable item of clothing. Lady Tanfield, possibly a grand-niece of Sir Henry Lee whom we have already come across, wears a deep-cut green dress embroidered with silver and trimmed with yellow lace, with a dark red cloak and a transparent scarf known as an Irish mantle. Her dress is short enough to reveal her shoes, suggesting she may be about to dance. Her hair is loose and she wears a wreath of heart's-ease or wild pansies. She stands in a landscape with an orange or peach tree, and the highly stylised look of the background adds to our sense of looking at a performer on a stage. Masques concluded with the costumed audience, themselves attired in symbolic roles, joining the performers in a dance. It has been suggested that this portrait commemorates such an event as well as celebrating a marriage.

### Catholic Tastes

James I's son, Charles I, was an Anglican married to a Catholic foreigner, and an avid collector and patron of the visual arts. During his reign, the efforts of Pope Urban VIII, who was the uncle of Charles's queen Henrietta Maria, to win back England to Rome, were often conducted through art and related transactions

between papal nuncios and Stuart courtiers. William Prynne, a figure we shall meet again shortly, noted these illicit activities and their 'corruption', and the attempt to 'seduce the king himself with pictures, antiquities, images and other vanities brought from Rome'. Prynne accurately identified the power of the Counter-Reformation strategy which saw art as a leading weapon of the Catholic cause. While this was mainly a question of creating a powerfully affective art, the trade in art objects remained a conduit for such political interchange for many years. Through his carefully cultivated personal aura and the activities of his courtiers and diplomats, Charles attracted two renowned and rival artists from the Low Countries who made a lasting impact on British art.

Peter Paul Rubens (1577–1640), a wealthy land-owner and diplomat in his own right, as well as one of the greatest painters of his time, was invited to decorate the ceiling of the new Banqueting House, built in the early 1620s by Inigo Jones in the revolutionary Palladian style (no.20). It was the venue for many masques and, by deliberate cruel irony, the blacked-out site of Charles's execution by Parliament in 1649. The central image of Rubens' scheme is of the Apotheosis of the Protestant James I, who first invited the possibly reluctant painter to realise the project in 1620. It is a brilliant baroque summary of the

symbolism and awe-inspiring magnificence of the concept of the divine right of kings – the very concept whose perceived abuse led Charles to the scaffold. Rubens, whose efforts won him a knighthood, created on the ceiling an allegory of good government, wisdom and universal peace, which mirrored the new style of royal prerogative introduced by James, an attitude which was to alienate so many of his son's subjects.

Anthony Van Dyck, who had first visited London during James's reign, settled there in 1632 in a house in Blackfriars given to him by Charles I, whom he painted on horseback on a scale and with a confident swagger quite new in British art (no.19). (Blackfriars, incidentally, was outside the jurisdiction of the Painter-Stainers' Company. Charles's support of foreign, often Catholic, painters was a contributing factor in his loss of support in the City.) Van Dyck transformed the visual style of the court and aristocracy through a new approach to portraiture. While the painter he displaced as leading royal artist, Daniel Mytens, had brought to England a new chic Continental simplicity and realism, Van Dyck's art was of a different order of sophistication. Even a relatively modest subject such as the unknown lady, probably of the Spencer family (no.21), shows Van Dyck's absorption while at work in Italy of the example of Titian. The master Venetian was also a favourite artist of Charles, whose collection amply

19

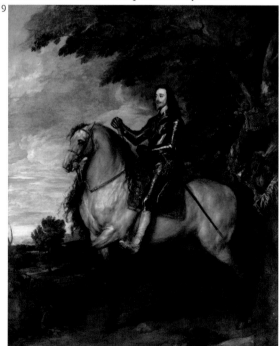

20 **Peter Paul Rubens** 1577–1640
**'Apotheosis of King James I'**
on the ceiling of the Banqueting House, Whitehall, London
c.1633–5

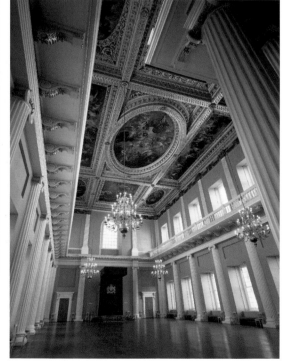

19 **Anthony Van Dyck**
1599–1641
**Charles I on Horseback**
c.1637
Oil on canvas
367 x 292.1
The National Gallery, London

Horsemanship was identified with power and superior breeding. This painting is based on a tradition of images going back to a fourth-century AD Roman equestrian statue of Marcus Aurelius, thought in the

seventeenth century to be of the first Christian emperor Constantine. Here baroque illusionism conjures up an image of power and culture for a monarch who hoped to rule through taste, but whose

imperfect political skills led him to the scaffold outside the Banqueting House in Whitehall in 1649. A related equestrian statue of Charles by the French sculptor Hubert Le Sueur, from the 1630s, has stood at the

north end of Whitehall, on the opposite side of Trafalgar Square to the National Gallery, since 1674.

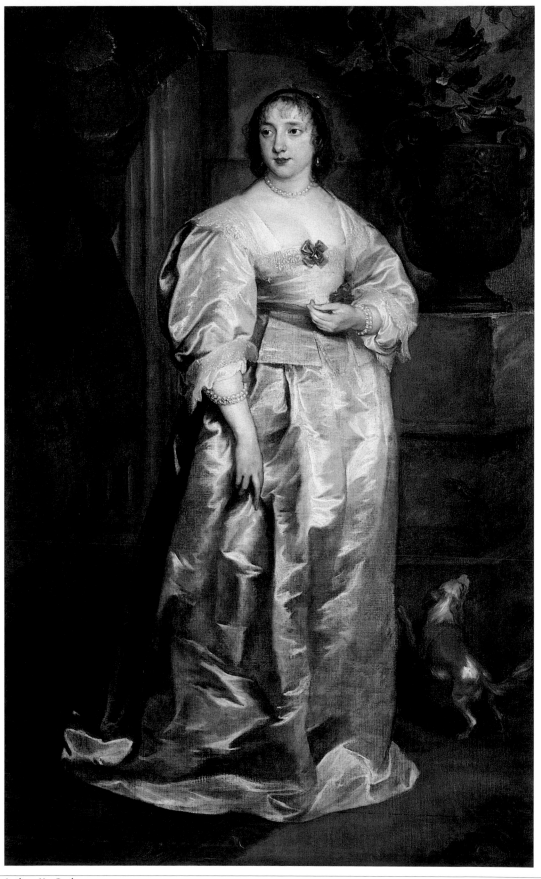

21 **Anthony Van Dyck**
1599–1641
**?A Lady of the Spencer Family**
c.1633–8
Oil on canvas
207.6 x 127.6

represented his work. A refined and aristocratic sense of formal reticence is conveyed here by the understated and easy grace of the subtly silver-toned brushwork. This is matched in all Van Dyck's work by the confident poses of the sitters and even by the light use of symbols – the dog and the lizard (both symbols of fidelity) in the Tate painting are gently rather than insistently part of the overall effect. The dense literary and programmatic quality of much earlier portraiture gives way to a form which has the immediacy and reality of Holbein, but with a new seductive painterly aesthetic. Van Dyck's art is associated with the baroque, and his brilliant colour effects, novel use of light and shade and animated composition is in sharp contrast to the often shadowless world preferred by Elizabeth and her contemporaries. The move to a more classical, timeless look, especially in the French-inspired fashions of the 1630s, was perfectly matched by Van Dyck, who effortlessly dramatised his often politically doomed patrons with their slightly haunted and melancholy looks.

Van Dyck's success was almost immediate – with his £200 annual salary, knighthood and appointment as 'principalle Paynter in ordinary to their Majesties', together with his busy, fashionable studio practice, he was probably the first superstar artist in Britain. He transcended the usual artisan status of the painter and was on equal footing with those he portrayed and the so-called Whitehall group who surrounded the king.

Portraiture, however refined, is a business. Described by the poet Edmund Waller as a 'shop of beauty', Van Dyck's studio was obviously large, staffed with Flemish assistants and full of props such as damask curtains, pillars, truncated columns, costumes and so on. Prints and other visual material would give clients a choice of poses, hands and other features suitable for all requirements. Van Dyck offered an international painting style for the Stuart ruling class. Interestingly, he not only painted the king and his supporters, but his parliamentary opponents too, often quite puritanical in their views, but who were equally keen to be 'fashioned' by the great man.

### Fruits of Knowledge

Our account has been dominated so far by portraiture, and this reflects the reality of the market for art in the period under discussion. Other genres were practised, however, including still life, which was a boom area in the Netherlands and therefore likely to have had an impact on nearby Britain. Different questions arise when considering such images. A mild pornography of food can be discerned, for instance, in Nathaniel Bacon's painting of a cookmaid (no.23), whose ample melon-invoking cleavage is contrasted with a variety of

2 David Des Granges
1611 or 13–?1675
**The Saltonstall Family**
c.1636–7
Oil on canvas
214 x 276.2

Sir Richard Saltonstall draws back a curtain to reveal his dead first wife and is shown with his eldest children, one being his son who, as a junior, still wears girl's clothing as was the tradition. The seated woman is his living second wife with their new child. Similar in theme to tomb sculpture of the period, the painting is a touching image of a family united beyond death. The artist, a miniaturist, works in a highly decorative provincial style, which forms a marked contrast with the courtly look of Van Dyck. Note the landscape imagery of the tapestry.

23 **Nathaniel Bacon**
  1585–1627
  **Cookmaid with Still Life
  of Vegetables and Fruit**
  c.1620–5
  Oil on canvas
  151 x 246.7

24 **Engraved frontispiece to
'A Treatise of Fruit-Trees ...
Togeather with the Spirituall
Use of an Orchard; or, Garden of
Fruit-Trees' by Ralph Austen**
  1653, 15.6 x 10
  Bodleian Library Antiq. E.e.1653.1

fruits to convey a traditional sense of sexual temptation, fertility and plenitude. Such subject matter with its loaded connotations has its origins in mid-sixteenth century paintings, in which religious scenes were domesticated by juxtaposing a biblical episode in the background, viewed through a door or window, with a foreground dominated by an arrangement of food on a table. These moralising pictures, constructed to prompt pious thoughts in the midst of daily life, became over time images of the here and now, and the residual religious meaning remained by implication only.

Nathaniel Bacon, who lived in East Anglia, was an amateur artist, one of the 'gentlemen' addressed by Prince Henry's tutor, the delightfully indecisive Henry Peacham in his *The Compleat Gentleman* of 1622. This popular book encouraged, among other accomplishments, what were seen as the civilising and ennobling skills of drawing and painting. The early seventeenth century saw a move by aristocratic and wealthy gentlemen towards an interest in the visual arts for aesthetic rather than merely social reasons. This is evident in the expansion of art collecting and a deepening interest in Continental, particularly Italian, modern art. These new virtuosi or connoisseurs were mainly connected to the court and became objects of intense suspicion and antipathy to their puritan critics. Peacham's writings on art, which grew from his involvement with the writers of Prince Henry's intellectual circle, preached a kind of amateur gentility that had a pronounced effect on British culture for many decades, even centuries. In part he was writing against men such as William Prynne, who attacked the whole of court culture during the Stuart period as a corrupt proto-Catholic waste of money. Although his particular concern was with drama and especially with the masque, as we have seen he turned his attention to the previously less visible activities of collecting and connoisseurship. The debate over images and idolatry that dominated much of the discourse about the visual arts in England since the 1530s found in Prynne a passionate and often overbearing contributor.

Although frequently absurd in his pronouncements, as for instance when he later accused the Earl of Arundel of keeping a nunnery in one of his houses in Greenwich, Prynne certainly spoke for many. Contrasting it unfavourably with that of James I, he attacked the court of Charles I for its obsession with painting and sculpture, which he called 'sinfull, idolatrous and abominable'. Thus when Peacham, quoting Pliny and other classical authorities, defended art by its utility for princes in warfare and civil life, he also brought to bear a religious argument, mindful of the criticism from those such as Prynne: 'And since it is only the imitation of the surface of nature, by it as in

a book of golden and rare-limned letters, the chief end of it, we read a continual lecture of the wisdom of the Almighty Creator by beholding even in the feather of a peacock a miracle, as Aristotle saith.'

Returning to Bacon's painting, then, probably painted in the 1620s, we can see it, with its contemporary Eve figure in front of a paradisial East Anglian landscape, as another potentially controversial artefact – for Prynne a lewd incitement to base pleasures, for Bacon and Peacham, perhaps, a celebration of God's creation. Bacon, who travelled frequently in the Low Countries, included among his interests agriculture and horticulture, and grew melons on his estate. The painting obviously reflects these activities, which in turn were the subject of intense theological speculation. Puritans, during the Civil War period in particular, held out the possibility of art, science and technology allowing man to recover his lost Edenic state. Ralph Austen, for instance, an enthusiast for religious and political reformation, published his *A Treatise of Fruit-Trees … Togeather with the Spirituall Use of an Orchard; or, Garden of Fruit-Trees* in 1653, with an engraved frontispiece proposing a marriage of 'profits' and 'pleasures' (no.24). Austen combined practical and experimental horticulture with spiritual meditation on trees and orchards and the fall of man. He stressed horticulture as the true ancient husbandry before Adam was 'put away from this worke to till the ground, a lower and inferior labour'. Adam was thus a gentleman amateur before committing original sin.

Nathaniel Bacon was a kinsman of Sir Francis Bacon, the author of the seminal *Advancement of Learning* and *Great Instauration*, which were important catalysts for the mainly puritan revolutions in science and technology, of which Austen's book is just one small piece of evidence. These ambitions, as we shall see, led to the founding of the Royal Society, and to a whole ideology of scientific knowledge and national expansion.

### Art in Exile

The uneasy political peace of the 1630s came to a violent end with the outbreak of civil war in England in 1642. Throughout that decade of the masque, Charles did not call Parliament once, thereby creating an angry opposition incensed, among other things, by his lavish expenditure on an elite culture. In the courtly art scene Van Dyck, who had died exhausted in 1641, was succeeded as chief painter by the Englishman William Dobson. Dobson was mainly based at the exiled court in Royalist Oxford and there painted some of the finest portraits of the age. Trained under the German painter and tapestry designer at the Royal tapestry works at Mortlake, Francis Cleyn (no.25), Dobson quickly, perhaps hastily, developed a Venetian style, probably

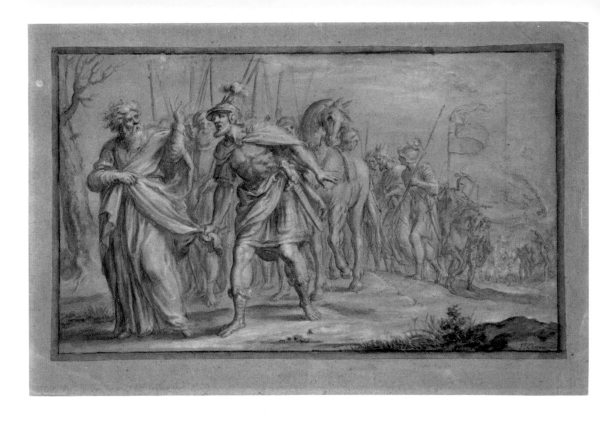

acquired by access to the large Royal Collection. His portrait of the courtier, diplomat, arts patron, MP and entrepreneur *Endymion Porter* (no.26) is one of his masterpieces. It was painted at the same time as the arch-iconoclast William Dowsing was devastating the medieval Catholic fabric of the churches in the parliamentary stronghold of East Anglia. Porter was a patron of Cavalier poets, such as the clergyman Robert Herrick and Sir John Suckling, as well as of major foreign painters such as Gentileschi. He had negotiated the purchase of the Duke of Mantua's remarkable collection for Charles in 1628, as well as drawing the king's notice to Van Dyck. His own impressive though small collection, like Charles's dispersed during the Commonwealth period in the 1650s, reminds us how important such property was to the status of the courtier.

Like many loyal Royalists Porter died in exile, considered by many to be one of parliament's most heinous enemies. His portrait by Dobson, though clearly indebted to Van Dyck and other European sources, is also very English in its complex symbolic composition. The prominent bust of Apollo, god of the arts, refers to Porter's reputation as a Maecenas, while the sculptural frieze shows the figures of Sculpture and Painting as well as that of Pallas Athene. The latter is not only a patron of the arts but also protector of states

at times of war – an apt emblem for the moment of the painting's execution. Dobson is dressed as a country squire, and his classical pose is derived from a lost portrait from Charles's collection of the Emperor Vespasian, by Titian. He is out hunting in a costume that is deliberately dated, as is the German wheel-lock rifle he is holding. The implication is of a conservative or traditional figure, unlike the parliamentary, often metropolitan types who were fighting him, or the efficiently modern soldiers of Cromwell's New Model Army, who were engaging Charles's troops across the country. It has been suggested that Porter's florid face shows a man who has turned to drink. As the stormy landscape may suggest, the intense self-fashioning in the portrait has an almost tragi-comic quality once we are aware of the dramatic circumstances Porter found himself in. It is a defiant manifesto of a class of men about to lose everything.

Dobson's own premature death in poverty, in a garret in the new artists' district of St Martin's Lane near Westminster, reminds us how fragile an artist's condition could be, tied as he was to the fate of others. Rejected earlier in his career as a Steward of the Painter-Stainers' Company, he certainly suffered from his political allegiances. At least, however, he didn't suffer the punishment meted out to his ideological opponent William Prynne who, perhaps fashioning himself on

25 **Francis Cleyn**
*c*.1582–1658
**Samuel's Reproach to Saul**
*c*.1630–5
Pencil, pen and ink and wash
on paper
24.5 x 39.6

**Francis Cleyn was probably trained in the Netherlands and may have travelled in Italy. He came to England in about 1624–5 and was employed by Charles I as a painter, a masque designer together with Inigo Jones and the principal designer to the new Mortlake tapestry factory for which this biblical image may have been designed.**

**William Dobson**
1611–1646
**Endymion Porter**
c.1642–5
Oil on canvas
149.9 x 127

Foxe's martyrs of the 1550s, in the 1630s had his ears cut off for offending the monarch's dignity (no.27).

### Interregnum

In spite of the bad omen of the notorious William Dowsing, who systematically trashed so much religious art in East Anglia in the 1640s, the interregnum of Oliver Cromwell's rather monarchical Republic (1649–1660) witnessed more arts activities than is often imagined. And it is worth noting that, in spite of the period's general reputation for dour puritanism, the diarist John Evelyn recorded in 1654 that 'the women beegan to paint themselve, formerly an ignominious thing, and used only by prostitutes'. The Westphalian portrait painter Peter Lely established himself as a major prospect for the future, and Thomas Flatman was among native painters who made a distinct contribution to the national culture. Cromwell himself, while cashing in on the value of Charles's collection by selling much of it off, also kept a fair proportion, presumably because he valued it for more than its financial worth. Famously quoted as asking Peter Lely to paint him 'pimples, warts and everything as you see me' – that is, unfancifully and not in the Van Dyck mode – Cromwell patronised the derivative painter Robert Walker who became his 'court' painter. Walker often imitated the hated Caroline predecessors in order to give the new regime some of the imperial splendour it required in an international context.

A rare example of history painting from 1654 gives some idea that the puritan republic was more than a matter of iconoclasm and banning mince pies. *Aeneas and his Family Fleeing Burning Troy* was painted by a young Kentish 'gentleman-painter', Henry Gibbs (no.28), and is presumably another instance of work by an amateur in the Peacham school of refined attainments. The narrative subject is taken from Virgil's *Aeneid*, and shows the epic's hero Aeneas fleeing his native city with his son Ascanius. He carries his father Anchises who is holding statues of the household gods, while his wife Creusa is detained by one of the invading Greek soldiers. Perhaps based on engravings of Flemish paintings from a century earlier, the theme seems to beg for historical over-interpretation. It is not known what Gibbs's political affiliations were, but it is tempting to see an arcane and highly personal reference to the effects of the civil wars a few years earlier from the point of view of a participant on the king's side. The familial tragedy and use of idols to represent the power of a whole culture are certainly highly suggestive of such meaning. There may be another explanation, of course, and we are left with another fragment from an age whose full artistic story will always remain the subject of intense speculation.

28 **Henry Gibbs**
1631–1713
**Aeneas and his Family Fleeing Burning Troy**
1654
Oil on canvas
155 × 159.8

27

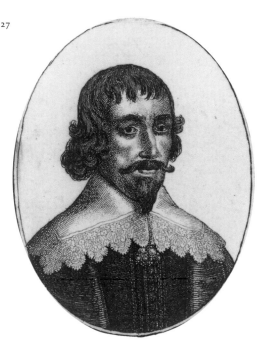

27 **Wenceslaus Hollar**
1607–1677
**William Prynne**
c.1645–50
Engraving
The Ashmolean Museum Oxford

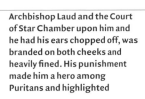

William Prynne's book 'Histrio-Mastix' of 1633 criticised court culture, from masques to art collecting, as immoral and wasteful. Its implicit attack on Charles I's queen, Henrietta Maria, brought the wrath of Archbishop Laud and the Court of Star Chamber upon him and he had his ears chopped off, was branded on both cheeks and heavily fined. His punishment made him a hero among Puritans and highlighted the cultural gap between court and non-court worlds.

Our account of art in Britain so far has stressed a number of interrelated factors – the self-fashioning central to early modern British culture; a dominant courtly and aristocratic context for painting; the impact of the Reformation and the ensuing religious debates about images and, as a corollary of this, the highly contested nature of the visual arts: art could be a matter of life and death. While these factors continued to shape the overall landscape in which art was made in this next phase, some began to diminish in importance and to give way to new ones.

History, even the carefully tended gardens of art history, is an untidy, incomplete and debatable business. Perceived 'watersheds' often turn out to be convenient fictions for historians who may attempt to neaten everything up in the interests of a particular narrative they wish to tell. In spite of this warning, however, there is a strong case for claiming that Britain after the restoration of the monarchy in 1660 becomes a place we begin to recognise more easily as 'modern', in a way I think it is far more difficult to see in the case of the pre-Civil War period. The progress, if such a Victorian term is allowed, of the visual arts embodies much of the rapid change that took place in all areas of life. The transition from the glamorous portraiture of Lely and the grand baroque decorative schemes of Verrio, Laguerre and Thornhill to the 'modern moral subjects', as he called them, of the latter's ambitious son-in-law William Hogarth, is startling and exhilarating. Strangely, this half-century or so at first glance seems less exciting in terms of most of the British art we are considering. But that shouldn't put us off.

The key to understanding the transformation lies in the growth of a modern commercial society and its extraordinary visible expression, Daniel Defoe's 'prodigious Thing', London. By 1700, with a population of over half a million and expanding exponentially, the capital of the new 'Island Kingdom' was the largest city in Europe, and on track to becoming the heart of an immense overseas trading and military empire. London was an unrivalled centre of banking (the Bank of England was founded in 1694), insurance broking and a wide range of other financial services. It was also the home of a new style of party politics (of the Whig and Tory parties) and of a successful constitutional monarchy following the Glorious Revolution of 1688 when William of Orange was invited to become King with the overthrow of the Catholic James II. A cabinet system of government, backed up by a professional civil service, were also newly refined parts of the body politic. The newly founded Royal Society (1662) was to have a profound effect on art, as we shall see shortly. Finally, following the Fire of London in 1666, the city was rebuilt with Wren's St Paul's Cathedral the centrepiece of a typically muddled and compromised rapid redevelopment. The fashionable new areas of terraces and squares built to the north and west of Westminster saw the expansion of residential and commercial quarters which became the West End we know today. Pall Mall was to become fashionable at the moment the seeds of the shopping mall were sown.

Within this new world lay the foundations for the growth in established forms of art such as portraiture and grand decorative schemes, and the burgeoning of new or previously unexploited ones – landscape, sporting scenes, still life, conversation pieces, narrative. Coupled with a host of phenomena – the rise of dealing, auctioneering, printmaking from paintings, small art schools and academies, the 'improvement' of young ladies through the practice of drawing, and new forms of widely read critical writing about art – we have the ingredients for a modern art world not so very different from the one we see today.

In the year 1680, over fifty thousand works of art flooded the London art market, with many more than that passing through the auction houses. Artists and all the associated trades followed the money and fashion westwards and settled in Covent Garden and, later, the Leicester Square area. They provided much of the spin and illusion that sustained the fragile edifice of new money and manners. We had lift-off.

### The Beauty Factory
Fantastick Fancies fondly move;
And in frail Joys believe:
Taking false Pleasure for true Love
… But Pain can ne're deceive
('The Mistress', lines 29–32, John Wilmot,
Earl of Rochester)

The court of Charles II is associated with a certain licentiousness and morbid frivolity, a sort of bitter decadence, embodied in the drama of Wycherley and Etherege, the erotic verse of the libertine Earl of Rochester and the glistening-eyed, pouting ladies depicted by the 'portrait factory' of Peter Lely. As we have seen, the German Lely had arrived in England at the start of the Civil War. He had moved on from apprenticeship in Haarlem in Holland to 'pursue the natural bent of his Genius in Landtschapes with small figures and Historical Compositions'. Finding the taste was for portraits he turned to this, and became the leading practitioner until his death in 1680, living in the prime residential area, the Piazza in Covent Garden, and acquiring a knighthood and a major collection of old master paintings. The sale of his collection after his death was the first spectacular, 'must-be-at' society auction. Although he died in debt, during his lifetime Lely was even able to lend cash to Charles II.

Lely was at the height of fashion in the 1660s and 1670s and organised an efficient studio to meet the enormous demand for his 'new-look' portraiture. Sittings were arranged between nine o'clock in the morning (or seven during a busy season) and four o'clock in the afternoon. A pose and costume were agreed – perhaps from an engraving and clothing in Lely's collection, a rapid chalk drawing offered to the client for initial approval and the head painted from life. Except for very grand clients, Lely had the backgrounds and draperies painted by assistants such as Robert Hooke. Other assistants were constantly making frequently requested copies. The industrial nature of the enterprise led to some accusations of underhand practice, one commentator complaining, 'I have known Sir Peter Leley change an originall, for a copy, especially to thos that don't understand pictors'.

A classic example of Lely's early Restoration portraiture, with Pope's 'sleepy eye, that spoke the melting soul', is *Two Ladies of the Lake Family* (no.29). With exaggerated top lighting, moist lips and eyes, shadow under their double chins and stormy landscape, it has all the highly dramatised quality which made Lely such a success. Dressed in the *déshabillé* style of the period, when a loose, timeless Roman look was desirable in portraits over a specifically contemporary one, the two ladies playing French-made guitars evoke the licentious clergyman-poet Robert Herrick's preference that:

> Be she showing in her dress
> Like a civil wilderness
> That the curious may detect
> Order in a sweet neglect
> ('Delight in Disorder', from *Hesperides*, 1648)

29 **Peter Lely**
1618–1680
**Two Ladies of the Lake Family**
*c*.1660
Oil on canvas
127 x 181

Such an undressed look was a way of conveying, among other more obvious things, social superiority at a time when the less elevated would have to wear full dress in the presence of their betters. The emphasis upon a certain 'generality' is also evident in the features of the sitters. Lely invented a facial type which made his clients look the same – something they seem to have been quite happy with. The fashioning of these selves seems to have more to do with fashion than with selves. With the growth of West End social outings and of theatre-going as the culture loosened and politics decentralised, looking the part to a large, moving audience was a pressing concern.

### Whigs in Wigs

There were many portraitists at work in London competing with Lely for custom – the Catholic painter John Michael Wright (no.31) and the Swede Michael Dahl, for example – and it is also during this period that the major cities elsewhere in Britain were able to support at least one, if fairly unglamorous, portrait painter. The artist in London who superseded Lely, and by all accounts undermined him in the last years of his life, was another German, Godfrey Kneller. Trained in Holland and Italy, he also settled in a lavish property in Covent Garden Piazza from where he ran his studio, charging £50 for a full-length portrait. He was able to

paint 'grand-style' or more intimately. His celebrated Kit-Kat series gave its name to a standard portrait size of 36 by 28 inches (91.5 x 71 cm). The series was commissioned by the publisher Jacob Tonson for a West End club patronised by eminent Whigs, including writers such as Congreve, Addison and Steele, and painters including Kneller himself. His portrait of John Smith (no.32), who made mezzotints of many of Godfrey Kneller's portraits, including the Kit-Kat series, shows two men who were mutually in debt for their success. Kneller's reputation was spread widely through the dissemination of such prints. This painting was a gift to Smith by Kneller, whose self-portrait mezzotint is held here by the engraver. Mezzotints were a Dutch invention brought to Britain in 1662, according to the diarist John Evelyn, by Prince Rupert, an amateur engraver. They produce a very subtle effect suitable for reproducing oil paintings.

Kneller understood the stresses and strains of his dynamic adopted culture, and that individual merit was now seen as acquired not inherited – one was a gentleman by virtue rather than by rank. The *Spectator*-reading freemason and man of affairs wanted to be 'civil with ease' and would turn to books of etiquette and expensive tailors to achieve the desired urbane effect. Defoe and many others of his class looked down with contempt at fifty per cent of the population living

**30 Henry Anderton**
c.1630–1665
**Mountain Landscape with Dancing Shepherd**
c.1650–60
Oil on canvas
45.7 x 59.7

This is the earliest landscape by a British painter in the Tate Collection. Henry Anderton was a portrait painter and contemporary of Peter Lely. He is thought to have studied in Rome and may have been influenced by

the northern European artists working there and by the French landscapist Claude Lorraine. The Arcadian setting with rustic figures was to become highly popular in Britain by the eighteenth century, informing

both painting styles and landscape gardening.

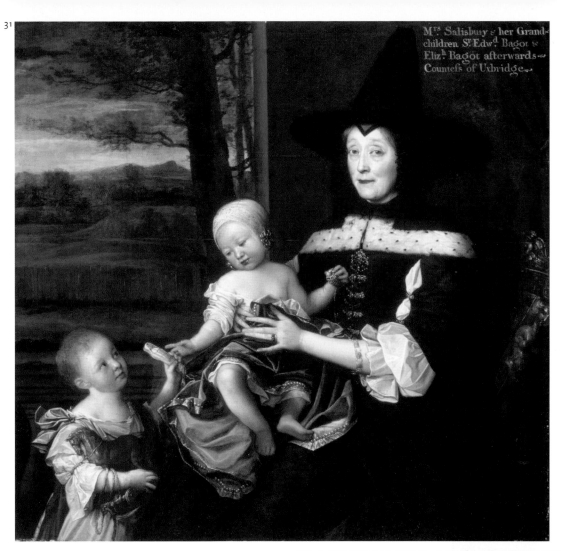

Mrs. Salisbury & her Grand-
children Sr. Edwd. Bagot &
Elizh. Bagot afterwards
Countefs of Uxbridge

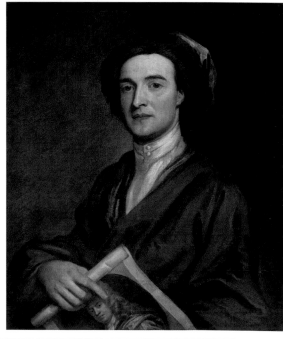

**32 Godfrey Kneller**
1646–1723
**John Smith the Engraver**
1696
Oil on canvas
74.9 x 62.2

**31 John Michael Wright**
1617–1694
**Portrait of Mrs Salesbury with her Grandchildren Edward and Elizabeth Bagot**
1675–6
Oil on canvas, 129.5 x 133.6

John Michael Wright was a Catholic painter and antiquarian who had lived in Rome before returning to England, where he was Lely's chief rival. His portraits are far less glamorous but more individual and probing. This is part of a series of works commissioned by Sir Walter Bagot of Staffordshire and is of his mother-in-law and his children. X-rays show many changes during painting, confirming Bagot as a demanding patron, who paid £140 for the series. Wright struggled to keep the young children amused with toys and other diversions while he painted.

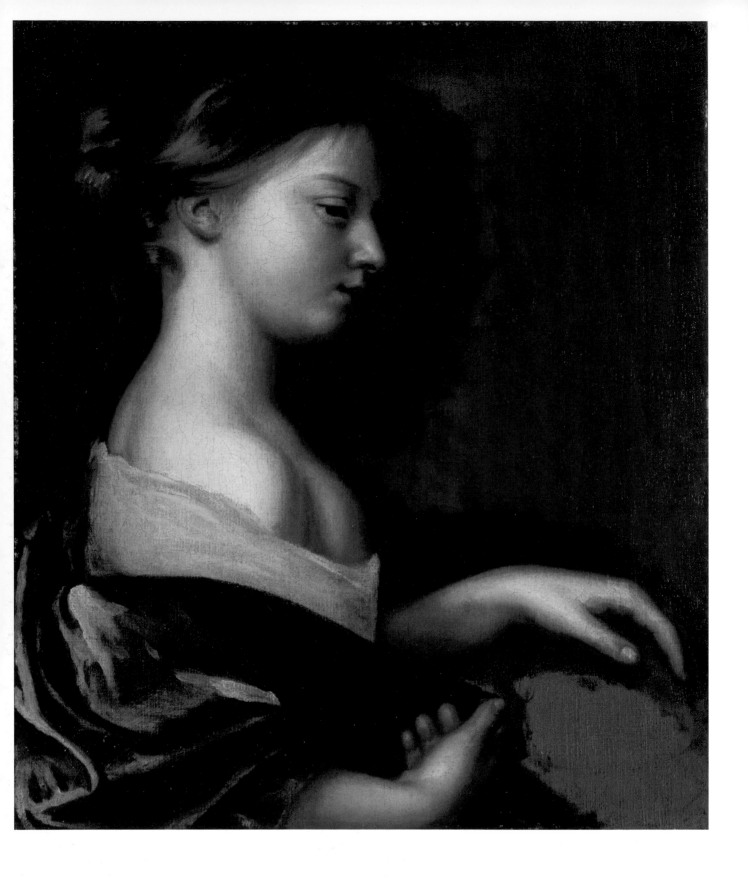

**33 Mary Beale**
1633–1699
**Portrait of a Young Girl**
c.1681
Oil on canvas
53.5 x 46

Mary Beale is the first of few women painters in our story and one who believed in the God-given equality of men and women. She was a friend of Peter Lely, lived in fashionable Pall Mall and painted many portraits of clergymen. The diary of her activities kept by her husband Charles, an alchemist and paint manufacturer who experimented with new colours, gives great insight into late-seventeenth-century art and society. Of particular interest is their close connection with the Royal Society. Probably painted 'up at once', i.e. at one session, on a coarse canvas, during a period of decline in major commissions when she turned to 'Study & Improvemt', this unfinished canvas may be of a godchild or studio assistant.

35 **Hubert François Gravelot**
1699–1773
**The Coffee-House**
c.1735
Pen and ink, watercolour
and pencil on paper
16.4 x 10.4

at subsistence levels, and upwards with irritation at a country landed class of a hundred and sixty 'quality' families and a few thousand baronets, knights and esquires. For the new urban man, self-fashioning included an ambition to attain such heights and to reform a powerful elite in the interests of national prosperity. Their usually Tory opponents – masters of satire such as Pope and Swift – mercilessly and a little impotently waged a war of words on the upstart culture. One commentator wrote in the 1730s : 'When all distinctions of Rank and Station are broke in upon, so that a Peer and a Mechanick ... indulge in the same diversions and luxuries ... shall not fair and fearless Satire oppose this outrage upon all reason and distinction.' We shall find more 'mechanicks' than peers as things progress.

### Art and Coffee

The Kit-Kat was among many groups which flourished in this extremely clubbable age. Whether it was Slaughter's Coffee House, frequented in particular by artists, Masonic Lodges or the Royal Society itself, London society was dominated by clubs and societies of usually politically like-minded professional men. By the turn of the eighteenth century, the prevalence of these groups indicates a move from a culture presided over by aristocratic interests to one determined by the

ambitions of the rising middle classes with their entrepreneurial zest and appetite for news and gossip. By the end of Queen Anne's reign in 1714 there were over two thousand coffee houses alone in London, reminiscent of today's fashion for American coffee outlets, though without the chain monopolies and carefully contrived mass lifestyle (no.35).

It was in this commercialised and dynamic context of individual ambition that the diverse market and specialised genres we associate with a modern art scene began to flourish. An early example of a low-life or picaresque subject, possibly intended as decoration for a coffee house or dining club, is Francis Le Piper's series of panel paintings illustrating Samuel Butler's influential satire on puritanism, the poem *Hudibras* (1663-73), which later appeared in an edition with eighteen engravings after Le Piper (no.34). We know little about the artist, who was a talented draughtsman with a strong tendency to caricature, and who was seen by the early historian of British art John Buckeridge in his *An Essay towards an English School of Painters* (1706) – an interesting title from our point of view – as an important figure in the development of the proposed 'school'. The oak moulding around the panels suggests they may have been installed in a setting such as a coffee house to be enjoyed by gentlemen socialising together. The preposterous Hudibras, a sort of Non-Conformist Don

34 **Francis Le Piper**
?1640–1695
**The Combat of Hudibras and Cerdon**
after 1678
Oil on wood
23.5 x 43.2

A scene from Part I, Canto III of Samuel Butler's 'Hudibras', an enormously popular satire on the epic style, in which the zealous puritan Hudibras fights a troupe of bear-baiters, a reference to contemporary debates on the sport. He lifts his pistol at one of them, Cerdon, while his squire Ralph, having difficulty mounting his horse, is attacked by another baiter. Hudibras's long ears and nasal voice were supposed traits of Puritans. Butler was connected to the Royal Society and a religious sceptic who believed 'all knowledge is but a right observation of Nature'.

**36 Edward Collier**
active 1662–1707
**Still Life with a Volume
of Wither's 'Emblemes'**
1696
Oil on canvas
83.8 x 107.9

37

Quixote, can be seen as a prototype of the characters Hogarth was to make widely popular in the 1730s.

Edward Collier's intriguing still life of 1696 (no.36) is representative of a genre of painting that gained in popularity at this time, although never to the degree it had in his native Holland. Nevertheless, Collier worked in both London and the Netherlands, adapting his work to the taste of each place. Here he includes, among the usual skull and other *vanitas* symbols of life's transient pleasures, a copy of the early seventeenth-century poet George Wither's *Emblemes*. It is open at the frontispiece, where we see a portrait of Wither and below it the poem:

What I WAS is passed by
What I AM away doth flie
What I SHALL BEE none do see
Yet, in that, my Beauties bee.

This reminds us of the literary and theological moralising we have seen in Elizabethan and Stuart painting. Now, however, the still life might include Acts of Parliament and other items reminiscent of the coffee shop and the gossiping age of Collier's peers.

### 'Close, Naked, Natural'

Francis Barlow was a member of the Royal Society which encouraged invention in all areas of science,

technology and art and was an intellectual driving force behind Britain's industrial and cultural growth. Barlow's reputation – he was referred to by Dr John Wilkins, the first chairman of the Royal Society, as the 'famous paynter of fowle Beasts and Birds' – meant that he was the only native painter invited to work on the redecoration of the Duke of Lauderdale's spectacular Ham House. His paintings of animals and birds (no.38) are the record of an intense observation of the natural world of the kind encouraged by the Royal Society with a view to discovering 'whether they may be of any advantage to mankind, as food or physic; and whether those or any other uses of them can be further improved'. We are reminded of the earlier work and ideas of Sir Nathaniel Bacon and his relation, Sir Francis, whose writings were the inspiration for the founding of the Royal Society. 'Fine' as they are intended to be, Barlow's paintings are equally concerned with the serious matter of mankind's dominion over nature. Following in visual matters the Royal Society's injunction on literary style to observe 'a close, naked, natural way of speaking, positive expressions, clear sense, a native easiness', Barlow's art reflected a desire to represent the visible world in a national 'plain style'. With such an approach he could thus enhance his fellow countrymen's understanding of the natural world, so important to the whole

**7 Robert Hooke** 1635–1703
**Large fold-out engraving of
a flea from 'Micrographia'**
London
1665
British Library, London

Robert Hooke was a scientific experimenter, showman, illustrator and assistant to Lely, and said he would have been a painter but for the nauseous effects of solvents on him. The illustrations for 'Micrographia',

made while Hooke was Curator of Experiments of the Royal Society, became a seventeenth-century 'coffee-table' book success not only with the King, for whom they were first drawn, but with a wide amateur

scientific audience. Microscopes were all the rage in the 1660s. Samuel Pepys records his delight looking at the images and his disappointment with his own 'interpreter's glass'. Hooke, a colleague of Christopher Wren

on various projects, designed the prototype air pump for Robert Boyle in the 1660s, which features in Joseph Wright's famous painting a century later (no.80).

economy. Continental baroque art was often dismissed at the time as pompous fantasy and a source of superstitious ignorance and backwardness. We shall see shortly, however, that there could be important exceptions to this attitude.

### Ancient Britain

Closely associated with Royal Society concerns were those of antiquarians such as the doctor and parson William Stukeley. His notes and drawings of ancient sites in Britain such as Stonehenge and Avebury show the origins of a scientific history and, at the same time, a fascination with national origins and ethnic identity that verged on the crackpot in its theories about Druids and other magical matters. The amateur culture of patriotic antiquarianism typified by Stukeley can also be found in the work of the York-based glass-painter Henry Gyles, whose house was the venue for meetings of local Royal Society virtuosi. As with Stukeley, his fascination with national monuments such as Stonehenge expresses a growing awareness of a powerful national history that predated the Romans and gave a genealogical credibility to the country's wider ambitions (no.39).

Cities such as York had strong local artistic and intellectual scenes, and one of Gyles's acquaintances there, the gentleman artist and virtuoso Francis Place, lays serious claim to being one of the pioneers of topographical landscape in Britain. Trained by the great engraver Wenceslaus Hollar in London in the 1660s, Place, whom the diarist and so-called 'father' of British art history George Vertue said had wealth enabling him to pass 'his time at ease', travelled widely in Britain and Europe. His drawings of animals, medical and scientific subjects, landscapes, grotesque heads and the like were published in the *Philosophical Transactions* of the Royal Society. He made prints of Barlow's drawings, began to practise as a potter and even seems to have been involved in the founding of the Bank of England. Above all he drew incessantly the landscape and antiquities of his native Yorkshire and the rest of the British Isles, providing a perfect visual equivalent for the descriptions of indefatigable travellers and observers of the time such as Daniel Defoe and Celia Fiennes (no.40). Like Stukeley and many others of this period, Place was the epitome of the leisured but energetic gentleman who mixed with a range of other men from a variety of backgrounds and interests and pursued a life dedicated to learning in its broadest sense.

At this stage, art, science and commerce were viewed as part of one knowledge, as empirical investigation into the natural and human worlds surveyed its objects regardless of the specialised

38 **Francis Barlow**
?1626–1704
**Hawks and Owls**
mid-1650s
Watercolour and pencil on paper
13.9 x 20

**39 Henry Gyles**
c.1640–1709
**Stonehenge**
c.1690
Chalk on paper
8.4 x 21.7

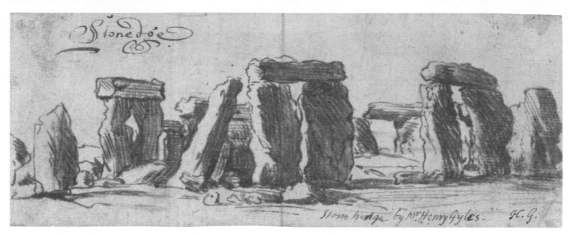

categorisation which later created compartmentalised disciplines. It is no coincidence that it was during the seventeenth century that the first collections and early museums were formed, and that they contained all kinds of objects, from paintings to skeletons, ancient relics to anatomical curiosities, with an almost surrealistic disregard for the kind of taxonomies we take for granted today.

The gardener, traveller and collector John Tradescant, whose famous collection known as the Ark in South Lambeth, just across the river from Tate Britain, formed the basis of the Ashmolean Museum in Oxford, was typical of the enthusiasm that led ultimately to the founding of great national collections of art and science. Their initial aim was nothing less than a complete scientific understanding of all things, and the creation of a nation and empire of enormous economic and intellectual power. Place, of course, accentuated the importance of the visual artist in this grand project, and would have fully concurred with the sentiments of his friend the York physician Martin Lister, whose translation of the Dutch entomologist Joannes Goedaert Place illustrated in 1682: 'Naturall History is much injured, through the little incouragement which is given to the Artist, whose noble performances can never be enough rewarded: being not only necessary, but the very beauty and life of this kind of learning.'

## Good Prospects

By 1700, landscape in oil does begin to challenge the preponderance of portraiture, although it is not for at least another half-century before it begins to establish its dominant position in our perception of British art. The seeds sown by men such as Place and Stukeley, with their scientific, antiquarian and nationalistic interests, were nurtured to great effect by the Flemish artist Jan Siberechts. The Painter-Stainers would note the pre-eminence on their turf of another foreigner, but as Kneller eventually became master of the Company, there is a sense that at one level such animosities were relaxing. Earlier, landscape had often appeared as a backdrop to portraits and other art forms, or on overmantels and above fireplaces, and usually bore some allegorical meaning. Siberechts took the topographical tradition of the country-house literature of poets such as Ben Jonson and Andrew Marvell that had been popular throughout the century, and gave it powerful visual impact. In his semi-bird's-eye views of great houses and their estates, such as that at Belsize in Middlesex (no.41), which is now covered by north London suburban housing, Siberechts presented large estates as the centre of an ordered and fertile world ruled by enlightened landowners. The distant view of London perfectly reflects the ideal relationship between town and country that prevailed

**40 Francis Place**
1647–1728
**Dinsdale, Durham**
c.1678
Pen and ink on paper
11.8 x 20.7

Francis Place, a friend of Royal Society-connected artists such as Francis Barlow and Henry Gyles, is a significant precursor of all the great English landscape painters. Influenced by the topographical artist

Wenceslaus Hollar, he worked with pen and ink on sketching trips to various parts of Britain including the Northeast. He was a contemporary of Daniel Defoe whose 'Tour Throuh the Whole Island of Great Britain' of

1724–6 proclaimed the delights of British topography: 'Where-ever we come, and which way soever we look, we see something new, something significant, something well worth the travellers stay.'

at the time, in spite of the tensions created by urban growth. In 1713 Alexander Pope wrote his landscape poem 'Windsor Forest' expressing this Augustan vision:

> Rich Industry sits smiling on the plains,
> And peace and plenty tells, a STUART reigns

This is the ideology of Rubens' Banqueting Hall and the divine right of kings, which had not disappeared with the new post-1688 political arrangements.

The map-like view, or 'prospect', was made popular for a wide audience by another major Flemish artist, Leonard Knyff, whose *Britannia Illustrata*, engraved by Johannes Kip, surveyed the grand estates of Britain and was published in 1707, the year of the Act of Union with Scotland. The idea of a place called Britain, rather than the separate nations of England, Scotland and Wales, was beginning to gain wider, if intermittent and controversial, credence.

### Gods on the Ceiling

The late seventeenth and early eighteenth centuries witnessed the great period of baroque decorative art in Britain. The enormous private buildings constructed or renovated by the aristocratic families at Chatsworth, Blenheim and elsewhere, illustrated by Knyff and others, along with major public institutions such as Christopher Wren's St Pauls' Cathedral and his pupil Nicholas Hawksmoor's Painted Hall at the Royal Naval College, Greenwich, were the settings for the great painting schemes of ambitious grandees, kings and politicians. Inevitably, many of these were executed by foreign painters such as the Frenchman Louis Laguerre and the Italians Giacomo Amiconi and Antonio Verrio. However, one English painter thrived in this area. James Thornhill, a patriotic Tory MP, Master of the Painter-Stainers' Company, freemason and founder of his own art academy after seceding from the one set up in 1711 by Kneller, had travelled extensively on the Continent. He assiduously studied the art and architecture of the great European cities and returned with a vast knowledge, determined to create a distinctly national school of art. This was a new and significant ambition.

Thornhill was a prolific artist, and for each decorative commission would make a series of rapid pencil and pen-and-ink drawings prior to executing oil sketches, from which he and his assistants would paint on ceilings, staircases and other surfaces. His oil sketch of *Thetis Accepting the Shield of Achilles from Vulcan* of c.1710 (no.42) formed part of his efforts towards a scheme at Hanbury Hall in Worcestershire for the lawyer Thomas Vernon. The subject, designed for a staircase wall, was from Book XVIII of Homer's *Iliad* and shows Achilles' mother, Thetis, persuading Vulcan

41 **Jan Siberechts**
1627–c.1700
**View of a House and its Estate in Belsize, Middlesex**
1696
Oil on canvas
107.9 x 139.7

to forge new arms for her son following the capture of his armour by Hector. This was a popular subject from a text that would have been very familiar to an educated gentleman at the time. Thornhill may well have seen the same subject painted by Tintoretto or Vasari while in Italy on his Grand Tour. His French rival and influence, Laguerre, had painted at Chatsworth in the 1690s where Thornhill had later worked.

A public commission such as the Painted Hall at Greenwich was an altogether grander affair (no.43). Containing three hundred figures and covering 36,000 square feet (3,350 sq. m), it took Thornhill and his large team a total of eleven years to complete. For his work the artist was paid nearly £7,000, which today would be in the order of half a million pounds. Started against the background of war against Louis XIV's France and intended as praise of the 'Liberty' guaranteed by the new constitutional monarchy, it was completed during a time of peace and just before the accession of the Hanoverian dynasty. Art, Truth, Wealth and Wisdom are among the abstract virtues lauded against the dangers of War, Tyranny and Chaos. Gods, goddesses, zodiac figures, contemporary men of eminence such as the Astronomer-Royal and Thornhill himself, as well as members of the royal family, are orchestrated into a

huge, still masque that sought to rival the great baroque decorations of Paris and Rome. There is a certain irony that a style identified so strongly with Catholic absolutism should be the vehicle for the sentiments and ideas of the proudly Protestant and parliamentary British state.

The painting, dominated by a Rubensian apotheosis of the monarchs William and Mary, allowed him to give full rein to his talents and experience, which included stage design for opera. This background was crucial, for it enabled Thornhill to bring together building, image and word in a truly dramatic ensemble, which to a sophisticated contemporary viewer would have functioned as a virtual stage setting of a history subject. Pose, expression, colour, tone and spatial structure formed a complex symbolic visual language which we struggle to read today.

Towards the end of his career others struggled too and Thornhill's masterpiece was the last great example of this trend in British art. Differently minded artists, architects, men of taste and patrons in the 1720s ushered in an utterly new kind of visual culture, the more restrained Palladian style promoted by Lord Burlington and his protégé the painter, architect and designer William Kent. Prosperous Britain was going to start to look different.

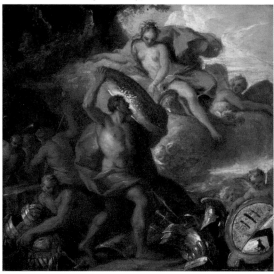

2 **James Thornhill**
1675 or 76–1734
**Thetis Accepting the Shield of Achilles from Vulcan**
c.1710
Oil on wood
48.9 x 49.8

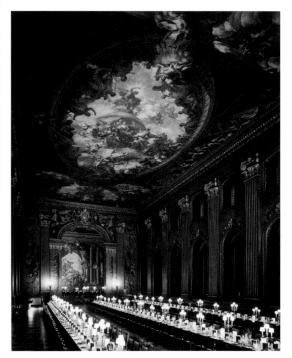

43 **James Thornhill**
1675 or 76–1734
**Ceiling of Painted Hall, The Old Royal Naval College, Greenwich**
1708–12

# Chronology
## 1477–1720

**1477**
William Caxton's first printed book
Eton Chapel Wall paintings begun.
Finished by 1487

**1483**
Accession of Richard III

**1485**
Battle of Bosworth. Accession
of Henry VII and start of Tudor Dynasty

**1508–12**
Michelangelo paints Sistine Chapel
ceiling, Rome

**1509**
Accession of Henry VIII

**1512–18**
Pietro Torrigiano tomb for Henry VII
and his queen, Westminster Abbey

**1517**
'Evil May Day' apprentice riots
in London includes Painter-
Stainers' members

**1526–8**
Hans Holbein's first stay in London

**1527**
Royal divorce crisis

**1530**
Fall of Thomas Wolsey. Succeeded as
Lord Chancellor by Thomas More

**1531**
Henry VIII named Protector
and Supreme Head of Church
in England

**1532**
Thomas More resigns.
Holbein returns to England

**1534**
Act of Supremacy confirms
Reformation

**1535**
Thomas More executed

**1536**
Dissolution of Monasteries begins
under Thomas Cromwell.
Anti-Reformation 'Pilgrimage
of Grace'.
Union of England and Wales.
Hans Holbein appointed Court Painter

**1538**
Destruction of religious shrines
including Beckett's at Canterbury

**1539**
Coverdale's *Great Bible*
in English published

**1540**
Execution of Thomas Cromwell

**1543**
Death of Hans Holbein

**1545**
John Bettes, *Unknown Man in a
Black Cap*, earliest painting in
Tate Collection.
Council of Trent begins Counter-
Reformation (concludes 1563)

**1547**
Accession of Edward VI with Lord
Somerset as Protector

**1549**
First Book of Common Prayer

**1550–3**
Height of first wave of iconoclasm
in England

**1550**
Giorgio Vasari *Lives of the Artists*
published in Florence

**1553**
Accession of Mary I who reintroduces
Catholicism

**1555**
Start of burning of heretics
('Protestant Martyrs'). Thomas
Cranmer burned 1556

**1558**
Accession of Elizabeth I

**1563**
First edition of John Foxe *Book
of Martyrs*.
Cecil's draft decree on royal images.
Accademia del Disegno,
Florence founded

**1574**
First Jesuits arrive in England

**1577–80**
Drake's circumnavigation of the globe

**1581**
Painter-Stainers' Company granted
royal charter

**1586**
William Camden *Britannia* published,
an influential antiquarian study
of Britain

**1588**
Defeat of Spanish Armada

**1593**
Accademia di S.Luca, Rome founded

**1600**
Approximate date of Nicholas Hilliard
*The Art of Limning* (pub. post-
humously 1912).
William Shakespeare writes *Hamlet*

**1601**
Earl of Essex's rebellion fails

**1603**
Accession of James I and beginning
of Stuart dynasty

**1605**
Gunpowder Plot.
Francis Bacon *Advancement
of Learning* published

**1606**
Henry Peacham *The Art of Drawing with
a Pen* published

**1611**
Authorised ('King James') version
of Bible published

**1618–22**
Inigo Jones builds Banqueting House,
Whitehall

**1620**
*Mayflower* Puritan ship sails to America

**1623**
First Folio of Shakespeare's plays

**1625**
Accession of Charles I

**1629**
Charles dissolves Parliament
until 1640.
Rubens begins work on paintings
for Banqueting House

**1632**
Van Dyck settles in London.
First coffee shop opens in London

**1640**
'Long Parliament' called

**1641**
Death of Anthony van Dyck

**1642–9**
Civil War.
Second wave of iconoclasm

**1648**
Académie Royale, Paris founded

**1649–60**
Execution of Charles I in 1649
is followed by a Republic under
Oliver Cromwell.
Second wave of iconoclasm in England

**1658**
William Sanderson *Graphice ... The Most
Excellent Art of Painting* published

**1660**
Restoration of monarchy and
accession of Charles II

**1662**
Restoration of Church of England.
Royal Society receives charter

**1666**
Great Fire of London; followed
by rebuilding and rapid expansion
of London

**1667**
John Milton *Paradise Lost* published

**1678**
John Bunyan *Pilgrim's Progress*

**1679–81**
Emergence of 'Whig' and 'Tory' parties

**1685**
Accession of Catholic James II.
William Aglionby *Painting Illustrated ...*
includes Vasari *Lives of the Artists*

**1687**
Newton *Principia Mathematica*
published

**1688**
'Glorious Revolution' and accession
of William III and Mary II

**1690**
John Locke *An Essay Concerning
Human Understanding*

**1694**
Bank of England founded

**1701–14**
War of Spanish Succession

**1702**
Accession of Anne following
settlement leading to
Hanoverian dynasty

**1707**
Union of England and Scotland

**1708–12**
Thornhill's paintings at Greenwich

**1711**
*Spectator* magazine first published.
Earl of Shaftesbury *Characteristics*
published

**1712**
Sir Godfrey Kneller's Academy,
London founded

**1714**
Accession of George I

**1715**
First Jacobite Rebellion defeated.
Jonathan Richardson *Essay on the
Theory of Painting* published

**1718**
Thornhill's Academy, London founded

# 1720–1760
# Rising Expectations

Modern consumer society begins in eighteenth-century Britain. Although at almost any point in history it seems that, like some eternal dough, the middle classes are rising, it is nevertheless true that from the late seventeenth century in England we can discern in the cultural sphere a decline in court power and patronage and the growth of a distinct bourgeois interest. Keen to improve their artistic and social standing through a polite lifestyle, people of the middle class spent increasing amounts of time and money on a variety of conspicuous products and activities – from the objects they acquired for their new homes; the new fashions they wore; the books they read and plays and concerts they attended; to the dancing, drawing and etiquette masters they employed; the tours of Britain and Europe they undertook and the exhibitions they visited. Addison and Steele's immensely popular periodical the

*Spectator*, the first lifestyle magazine, is an indication early in the eighteenth century of the arrival and interests of this expanding strata of consumers, who aspired to gentility and learning. In the case of the visual arts, the aristocratic art-lover and collector Horace Walpole complained that 'the rage to see … Exhibitions is so great, that sometimes one cannot pass through the streets where they are'. The class distinctions evident in such sentiments, expressed by those with an assumed cultural authority and understanding, are a recurring feature of eighteenth-century experience.

This rage for art exhibitions was fuelled by a buoyant art market, released from a previous technical prohibition on importing foreign works of art, and by a decline in the influence of a strictly Protestant view of the visual arts. Thousands of paintings, sculptures, prints and drawings, antiquities and antiques flooded

**Balthazar Nebot**
active 1730–1765
**Covent Garden Market**
1737
Oil on canvas
64.8 x 122.8

Possibly Spanish, Balthazar Nebot was one of a number of Covent Garden-based painters along with Joseph Van Aken. By the time of this painting, Covent Garden was being replaced as the fashionable quarter by

Leicester Fields, where Hogarth moved in 1733, Mayfair and further west. Dominated by the fruit, vegetable and flower market, it was now associated with seedy low life, pickpockets, prostitution and even murder.

The polite family in the foreground is approached by a beggar whose dog impolitely urinates against a post. Bare-knuckle fighting goes on in the right middle-distance. Nebot's clients vicariously enjoyed

these social contrasts and the morbid aspects of crime and punishment that Hogarth exploited in his works.

into the country, and even more items passed through dealers' hands and into the new auction houses. This rapid circulation of art as a commodity, previously limited to a small network of interests, altered the context in which contemporary art was produced and bought. Indeed, it is during the eighteenth century that the very notion of art as a near-autonomous category developed. The often bitterly contested specialist presentation and discussion of it in the public sphere with which we are familiar today – one thinks of the annual Turner Prize brouhaha – was established. During the eighteenth century, taste became a battle-ground of often politically-charged debate in the new periodicals and newspapers, as earlier aristocratic forms became displaced by, or merged with, more vulgar tendencies. A kind of moral sociology began to replace theology as the main vocabulary of discussion. Many people were now less bothered with whether something was French and possibly 'Catholic' in manner than whether it was fashionable and generally 'improving'. The ubiquitous 'conversation piece', an informal group portrait, is testimony to this fashion-able conviviality and marks the first great appearance in art of the gossiping classes (no.45). We shall see later, however, that not everyone followed this trend.

With all these changes, furthermore, came a transformation in the status of the native visual artist

and the growth of the idea of a national 'school' of British art – but not without a prolonged struggle. A hectic jostling for power between artists, collectors, connoisseurs, critics and other active participants gives the period a volatile quality quite unlike that which preceded it, for all the latter's debate and hostility. The question of who decided what was good and bad in art became almost as important as who decided matters of political and religious import – and as ever all three areas were interconnected.

## Enter the Pug Painter

The artist most associated with these changes is William Hogarth (1697–1764), the first Pop artist. Apprenticed to a silver engraver, Ellis Gamble, Hogarth grew up in the new London of hyperactivity and social upheaval. By the early 1720s he was producing satirical prints, many concerned with taste, and in 1728 painted his first major picture, *The Beggar's Opera*, of which a 1731 version is in the Tate Collection (no.46). The painting shows a scene from John Gay's *The Beggar's Opera*, which was first produced by John Rich at Lincoln's Inn Fields theatre in January 1728. Gay's work was an entirely new kind of satirical entertainment that was an immediate and wild success. The formula was simple – the Italian Opera with its arias and classical gods and goddesses was

---

45 **Joseph Van Aken**
c.1699–1749
**An English Family at Tea**
c.1720
Oil on canvas
99.4 x 116.2

The 'conversation piece' was a popular imported portrait format in Britain during the rococo period of c.1720–1750. The term refers to the polite conversation both depicted in and prompted by the painting.

Concerned with subtle distinctions of rank, fashion, behaviour and social interaction, conversation pieces are the visual evidence of the middle-class consumer culture described by Addison

and Steele in the 'Spectator'. Joseph Van Aken was a member of a dynasty of painters from Antwerp active in England, who later specialised in painting drapery for leading portraitists. His group is shown taking part

in an elaborate tea ceremony in a rather fanciful setting, dominated by a statue of Bacchus. The figures adopt poses as recommended in the many books on deportment popular at the time.

turned on its head by replacing these conventions with low-life characters from contemporary London. *The Beggar's Opera* was thus a subversive pastiche that brought popular culture into the normally sacrosanct world of high art, and created a hybrid form which challenged preconceptions about good and bad taste and about social class and criminality. The government was in fact so threatened by its impact that the proposed sequel, *Polly*, was banned and, indeed, the theatre gave way to the novel as the major narrative art form of the eighteenth century.

The plot concerns the progress of a highwayman, Captain Macheath, his relationship with two women, his betrayal and imprisonment and an unlikely last-gasp reprieve from execution. With its sixty songs and disjointed narrative, *The Beggar's Opera* was successful because, like a soap opera, it was about recognisable characters and settings and seemed to express a new sense of national confidence at the expense of imported styles. Gay wrote enthusiastically about the thrill of walking the streets of modern London. Real criminals such as the notorious housebreaker Jack Shepherd, politicians such as the Prime Minister Sir Robert Walpole and sexy Italian singers could all be identified in Gay's motley characters. The audience mainly knew about such goings-on through pamphlets and newspapers bought in shops or coffee houses. In particular they were fascinated by criminal activities at all levels of society – indeed the connections between 'high' and 'low' crime were the very essence of the new ballad opera. Instances of malpractice abounded: in 1720 sleazy politicians, mainly Whigs and City businessmen, manipulated the stock market at the expense of the public in the disastrous pyramid scheme known as the South Sea Bubble; in 1725 the Lord Chancellor was convicted of embezzling huge sums of money; and Jonathan Wild, the biggest underworld figure in London, was hanged a year after his corrupt practices as the bogus 'Thief-Taker General' led to the execution of Jack Shepherd, the popular criminal-hero.

Gay's comic opera and Hogarth's painting were knowing exploitations of this taste for sensational stories of crime, corruption and sexual intrigue. As Gay's friend the poet Alexander Pope put it in a footnote to his satire *The Dunciad*: 'It spread into all the great towns of England, was play'd in many places to the thirtieth and fortieth time ... it made its progress into Wales, Scotland and Ireland ... The fame of it was not confin'd to the author only: the ladies carried about with 'em the favourite songs of it in fans; the houses were furnish'd with it in screens.' It all seems familiar to us today, with our enormously increased media networks.

16 **William Hogarth**
1697–1764
**A Scene from 'The Beggar's Opera', VI**
1731
Oil on canvas
57.2 x 76.2

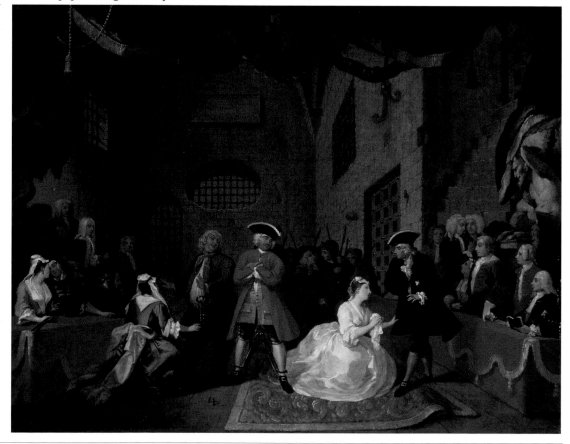

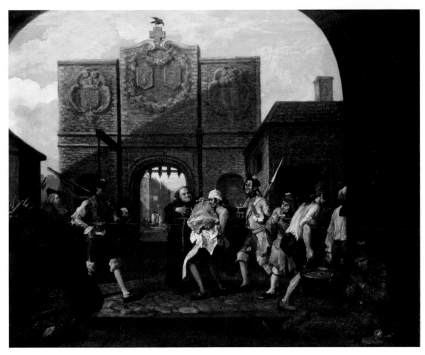

47 **William Hogarth**
1697–1764
**O the Roast Beef of Old England
('The Gate of Calais')**
1748
Oil on canvas
78.8 × 94.5

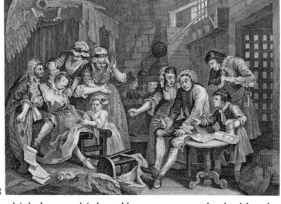

48

Hogarth shows the much discussed moment in Act III, when the anti-hero Macheath, standing in chains in Newgate prison, is flanked by two women who both believe they are married to him, Polly Peacham and Lucy Lockit. They plead with their fathers, respectively a lawyer and a gaoler, for his life. Hogarth introduces a cheeky real-life element into his picture by showing the actress Lavinia Fenton, who plays Polly, on the right, singing one of the most popular airs and looking towards her real-life lover the Duke of Bolton. He is shown seated in a box on the stage. Such titillating details added to the overall sense of outrage felt in certain quarters, particularly religious ones, which objected to what they saw as the opera's immorality.

Hogarth's art was itself concerned with the problem of moral behaviour in the modern urban world, while at the same time he sought to make a fortune from representing the sinful actions of his contemporaries. In line with similar themes in popular drama and the nascent novel, and following the earlier efforts of artists such as Le Piper, he created a highly successful format in his *Progresses*. These charted the rise and fall of young people in the dangerous labyrinth of London. *The Harlot's Progress* of 1732, *A Rake's Progress* of 1735 (no.48) and *Marriage à la Mode* of 1743, to take three famous examples, were complex visual narratives

which drew on high and low art sources, both old and new, to create a secular alternative to the waning moral influence of the Church of England. Like his friend the novelist and magistrate Henry Fielding, Hogarth, a philanthropist and freemason, saw the visual artist as a socially influential figure whose inventions could transform thought and behaviour in the melting pot of the modern city. This was a new and ambitious claim, both in its self-appointed aspect and in its means of achievement.

### Roast Beef and Frogs

Hogarth was a fierce patriot and believed his work superior to the often dubiously attributed old master foreign paintings on the growing art market, which were still popular with many collectors. He believed that he had created a distinctly modern and uniquely British art form for his times. His *O the Roast Beef of Old England* ('The Gate of Calais') of 1748 (no.47) underlines these attitudes. It shows a servant carrying a sirloin of British beef to a local inn in the French port. He is surrounded by figures indicative of the poverty, oppression and superstition of French society – a fat friar and ragged and skinny soldiers eating *soupe maigre*. Through the gate in the background locals go down on their knees before the host, while in the left foreground fat fisherwomen see an image of the friar

48 **William Hogarth**
1697–1764
**A Rake's Progress (plate 7)**
1735
Etching and engraving on paper
31.8 × 38.7

The second of Hogarth's 'modern moral subject' series, the paintings for this classic series of engravings were painted in 1733. Hogarth waited for the passing of the

Engravers' Copyright Act, which he had instigated, before publishing the prints at two guineas a set in 1735. Even then pirate copies had found their way onto the market. Tom

Rakewell is shown in this plate in the Fleet debtors' prison, having squandered his rich elderly wife's fortune. The final plate shows him in the Bedlam lunatic asylum where he

'miserably expires' – the site of the painter Richard Dadd's incarceration a century later.

in the flat fish in front of them. In the shadows on the right, on the run from the failed '45 Rebellion, an exiled Scottish Jacobite shivers with only stale bread and an onion, which together form a snail shape, supposed by the British to be, like frogs' legs, a regular part of the French diet. On the left, in front of the sentry box, Hogarth himself is shown, Hitchcock-like, in his own painting. It was supposedly painted after his return from a visit to Paris with friends during the Peace of Aix-la-Chapelle, one of the fairly rare moments during the artist's lifetime when Britain and France were not at war. Hogarth was loud in his condemnation of all things French during the trip, and the hand on his shoulder indicates the moment he was arrested on suspicion of spying.

The painting was made widely popular and highly influential in its message through a print published the following year and by a lively anti-French song based on it composed by a friend. This praised the 'raw' power of British beef and denigrated the sauce-drenched and paltry delicacies and insipid broths of French cuisine. The commercial, political, military and religious rivalry between the two countries, which had been rising since the late seventeenth century, dominated European politics until the defeat of Napoleon in 1815. It helped to forge a sense of national identity in Britain, particularly since the Act of Union with Scotland in 1707, and this identity found expression in art, fashion, food and all other aspects of the culture. Taste was heavily inflected by these territorial instincts. Hogarth saw himself as a John Bull in art, inventor of a hard-hitting moralising art based on direct observation of the social world.

A print such as Louis Philippe Boitard's *The Imports of Great Britain from France* of 1757 (no.50) provides an important wider context for understanding Hogarth's belligerent views. It shows French ships disembarking goods and fashionably dressed people at a quay in the City of London. Wines, cheeses, lace and perfume are among the luxury consumables destined for British shops and customers. Dedicated to the 'Society of Anti-Gallicans', Boitard's print highlights the intense fear among many Britons of being flooded with French goods and manners, and the effect this would have on the country. In particular it was believed that women would become sexually promiscuous and obsessed with shopping, and that men would become idle and effeminate. Hogarth's painting is a bullish statement about stemming this contaminating flow and is drawn from the murky depths of a sense of national being and destiny. Given Hogarth's own debt to French rococo art (largely through the new and large exiled French

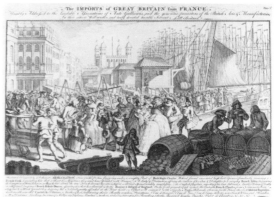

50 **Louis Philippe Boitard**
**The Imports of Great Britain**
**from France**
1757
Engraving
British Museum BM 3653

49 **Chinese export porcelain punch bowl, Canton, decorated with Hogarth's 'The Gate of Calais'**
c.1750–55
diameter 40.5
Victoria and Albert Museum

52 **William Hogarth**
1697–1764
**The Painter and his Pug**
1745
Oil on canvas
90 x 69.9

51

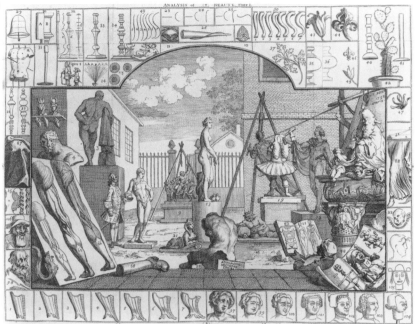

Huguenot population of London), his position has an ironic air about it. However, he was not alone in his fear of the 'frenchification' of Britain and the perversion of a true self-fashioning among his native contemporaries.

Hogarth's painting, like much popular imagery, found its way not only onto paper but also onto ceramics. The beautiful punch bowl decorated by Chinese artists in Canton was commissioned by a member of the East India Company in the early 1750s (no.49). He had presumably provided them with a print of Hogarth's painting from which to work. We are reminded how trade was now truly global and how relatively quickly cultural artefacts moved around and were transformed in new contexts during this period, as the British Empire grew. Extraordinarily the figures on the punch bowl have faintly Chinese features.

### Masonic Lines

Hogarth's self-portrait of 1745 (no.52) is typically forthright, even Cromwellian, in its depiction of a scar on the artist's forehead and of the mischievous pug dog. The painting highlights two aspects of his art: its literary basis, as signified by the volumes of three great British authors – Shakespeare, Milton and Swift – and its intellectual basis, invoked by the curved line on the palette. Hogarth, a founder-member in the mid-1730s of the re-formed St Martin's Lane Academy for training

and promoting artists, was also an art theorist. His *Analysis of Beauty* (1753), through a dense and sometimes eccentric prose style, put forward three important ideas: the need for the artist to work from nature rather than from academic models; and, anticipating the ideas of modernist art, the need to learn to memorise the fleeting images he registered in a fast-changing world, through the use of a special visual shorthand. He also emphasised the primacy of what he called 'The Line of Grace' (or Beauty). This 'serpentine' line, in two or three dimensions, correctly balanced between tautness and slackness, was found by Hogarth in all forms in the natural world, and identified by him as the basis of all aesthetic pleasure (no.51). It could be found in plant forms and chair legs and, in complex compositions, created a kind of visual dance for the eye which he claimed delighted in such movement. Hogarth likened the line to the development of a narrative, with its sub-plots and surprises, and to the kind of (probably French) dance forms performed by his aspiring audience. Certainly he was offering an art which, by a kind of aesthetic osmosis, was intended to improve the inner moral being as well as, perhaps in spite of, pleasing a fashionable taste for the rococo. Thus Hogarth makes virtually a moral case for the profound importance of his serpentine line, as well as giving it a mystical quality

51 **William Hogarth**
**'Analysis of Beauty' (plate 1),**
London
1753

The main image is set in the sculpture yard of Hogarth's friend Henry Cheere on Hyde Park Corner. The ideal classical sculptures are humorously contrasted with both ideal and

imperfect humans. Around the edge of the print are various versions of the serpentine line indicating its extremes and ideal mean.

probably informed by his masonic interests. Art had found a new level of significance in society and the artist a new role as moral guide and aesthetic arbiter.

**Art and Pleasure**

Hogarth, together with other British artists in the 1730s and 1740s, was involved in a number of projects that aimed at presenting contemporary art to a widening audience and, in some cases, allying that aim with an ethical or philanthropic one. Vauxhall Gardens (no.54), until its redevelopment by the entrepreneur Jonathan Tyers in the early 1730s, was a disreputable spot on the south bank of the Thames where drunkenness and prostitution were among the chief attractions. Under Tyers' proprietorship, the pleasure gardens were transformed into a venue fit for genteel customers, with its orchestras playing Handel, fine food served in supper boxes, a gigantic bandstand and sculptures set in a formally arranged landscape of groves and alleys. Along with theatres, concert halls, portrait painters' studios and picture galleries in the West End, suburban Vauxhall, usually reached by boat from Westminster until the building of Westminster Bridge in the 1750s, was part of a fashionable social and cultural itinerary (no.55).

Francis Hayman, a colleague of Hogarth at the St Martin's Lane Academy and a close associate of

Tyers, was one of the leading contemporary artists, working with a team of assistants, who provided a series of paintings for the Vauxhall supper boxes. The paintings, like stage scenery, would be let down in the evenings for viewing by the diners and other visitors, for whom visual pleasure was not limited to the purely aesthetic. As a contemporary wrote: 'what adds not a little to the pleasure of these pictures, they give an unexceptionable opportunity of gazing on any pleasing fair-one, without any other pretence than the credit of a fine taste for the piece behind her'. Hayman, Hogarth, Tyers and others fully understood the libidinal aspects of the new world of metropolitan pleasure they were so adroitly exploiting. But they also issued health warnings about an uncontrolled predilection for pleasure.

The general theme of the supper-box paintings at Vauxhall was of games and pastimes, drawing eclectically on Shakespeare, French rococo art and other sources. One of the surviving examples is Francis Hayman's *See-Saw* of c.1742 (no.53), which shows a group of figures in a fantasy setting with a ruined tower and rickety see-saw. The scene appears harmless enough until one realises that the sexual attention being given to the woman on the left has prompted a jealous reaction in the young man with clenched fist on the far right. Another woman looks up at the

53 **Francis Hayman**
1708–1776
**See-Saw**
c.1742
Oil on canvas
139 x 241.5

**54 Antonio Canaletto**
1697–1768
**Vauxhall Gardens;**
**The Grand Walk**
c.1751
Oil on canvas
50.8 x 76.8
Private collection

**55 Louis-François Roubiliac**
c.1705–1762
**George Frederick Handel**
1738
White marble
height 135.3
Victoria and Albert Museum

Portrait sculpture rivalled painting in the 1730s and 1740s. This large piece by the French sculptor Louis-François Roubiliac stood in the South Walk of Jonathan Tyers' Vauxhall Gardens, where Handel's music was performed. Tyers hoped the sculpture would enhance the polite respectability of his popular but crowded garden 'leisure centre'. One newspaper spoke of the statue invoking 'the harmony which has so often charm'd even the greatest Crouds into the profoundest Calm and most decent Behaviour'. As so often, there is an assumption of disorder among large crowds which art can contain.

precariously perched figure on the see-saw above her. We are watching, then, the moment just before excitement and pleasure collapse into chaos and violence – a theme worked over time and again in the moralising culture of early Hanoverian Britain, be it in Hogarth's *Progresses*, Addison's essays or Fielding's novels. 'New pleasures, new dangers' is the clear message in an increasingly hedonistic consumer society. Thus this early display of art in a public setting was also aimed, if ambiguously, at improving its audience's morals in a fashion that harks back to the religious wall paintings of earlier centuries.

## Art and Duty

The next step in widening the audience and establishing the artist's new role was to find a less commercial and more respectable setting for the display of the new British art. In the early eighteenth century, London was perhaps the only major city in Europe without an institution for looking after its many abandoned, unwanted or orphaned children. The ship-builder Captain Thomas Coram obtained a royal charter for his Foundling Hospital in 1739, and in 1740 was painted by Hogarth who became a governor of the new hospital the same year (no.56). As the new premises were being built to the north of Holborn, which was then on the edge of London,

Hogarth conceived a scheme with others to provide the new building with examples of contemporary British art. He enlisted figures such as Hayman, Joseph Highmore, the portraitist Thomas Hudson and the landscapist Richard Wilson to offer paintings, or their services as decorators, for the embellishment of the interior. The resulting grand portraits of governors, views of other London hospitals, biblical scenes with a distinctly Protestant 'improving' bias towards good works, became a major attraction for polite society who could mix social intercourse with charitable gesture.

An example of the kind of Protestant religious painting intended for Coram's institution is Joseph Highmore's large canvas *The Good Samaritan* of 1744 (no.57). Highmore, a polymath and high-ranking freemason, had recently made twelve paintings of scenes from Samuel Richardson's immensely popular epistolary novel *Pamela*, which told the story of a virtuous young lady who, through her goodness, overcomes the lascivious attentions of her guardian, Mr B., and eventually marries the reformed seducer (no.59). Highmore's paintings were made into a set of large prints for framing or for an album, and were intended for export to a French as well as a British audience. The first painting shows the sinister Mr B. finding Pamela at her writing desk. In the

56

57 **Joseph Highmore**
1692–1780
**The Good Samaritan**
1744
Oil on canvas
159.5 × 144.8

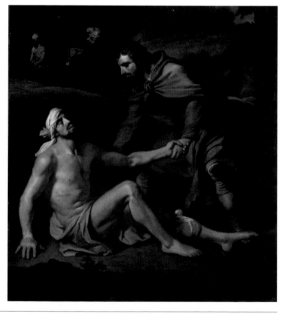

---

6 **The Governor's Room in the Foundling Hospital, Thomas Coram Foundation for Children, London**
1740s

Still open today in the rebuilt Coram Foundation in Bloomsbury, the interiors of the old Foundling Hospital display the works commissioned to decorate it in the 1740s. **This view shows Francis Hayman's**

'The Finding of Moses' of 1746 and Hogarth's 'Moses Brought Before the Pharaoh's Daughter' of 1745.

59 **Joseph Highmore**
1692–1780
**From 'Four Scenes from Samuel Richardson's "Pamela"'.**
**I: Mr B. Finds Pamela Writing**
1743–4
Oil on canvas
65.1 x 75.9

background, prominently displayed, is a painting of the Good Samaritan, probably referring to Pamela's mistress who had given her an education but then, ironically, entrusted her to her unworthy son.

The image of the Good Samaritan was very popular at the time and at the heart, so to speak, of the philanthropic movement in which Highmore and Hogarth were central figures. The scene in

Highmore's painting, from Luke 10, 30–37, shows the Samaritan with the man, who has been set upon by thieves, about to help him up and onto his horse. The classical features and noble bodily form of the victim, based on the famous Belvedere torso, is no doubt intended to contrast with the hunched figure of the long-nosed, thick-lipped figure of the turbanned assailant in the background.

58 **Arthur Devis**
1711–1787
**Breaking-Up Day at Dr Clayton's School at Salford**
c.1738
Oil on canvas
120.7 x 174.6

Arthur Devis painted both in London and in his native Lancashire, where his doll-like conversation pieces were popular with the new manufacturing and commercial middle classes. Dr John Clayton's recently founded grammar school was intended for the sons of wealthy high-church conservatives and in local competition with the free-thinking Manchester Grammar School. His school taught classics and, as the globe and telescope suggest, modern sciences. Clayton holds a scroll with a quotation from Horace exhorting pupils to 'drink in these words with a pure heart'. The potentially disruptive relaxed attitudes of all the boys set against a fantasy Peak District setting are counter-pointed by the earnest sense of discipline, piety and learning.

**50 Allan Ramsay**
1713–1784
**Thomas, 2nd Baron Mansel of Margam with his Blackwood Half-Brothers and Sister**
1742
Oil on canvas, 124.5 x 100.3

Allan Ramsay had a very successful career as a portraitist based in London and Edinburgh. This enigmatic and slightly mournful work, with its smooth Continental finish, shows the son by her first marriage of the recently deceased Anne Blackwood in the company of his three half-siblings. The relationship of the eldest son with his half-sister is particularly strange. He gives her a knowing stare while she holds his hand and the dead bird in it. Her thumb touches a wound on the bird as she almost seems to come of age before us, giving an impression of undergoing a silent rite of passage.

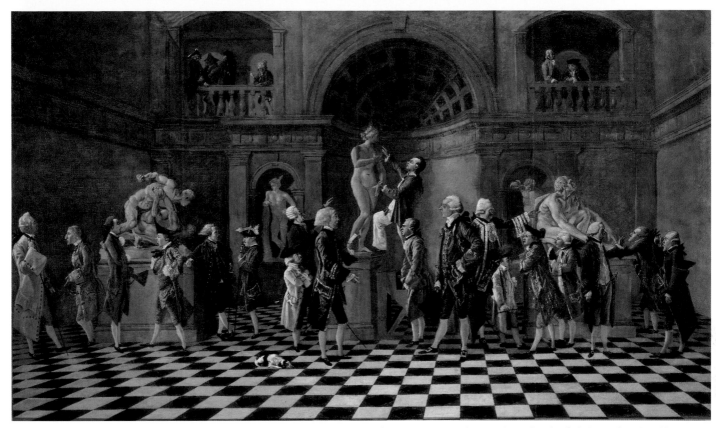

historian has recently pointed out, the world of Georgian portraiture was, in a buyer's market, a cut-throat one of tough commercial enterprise. For those who failed, there was a hard life of insecurity and poverty in a world where fashion and social hierarchy changed quickly and subtly. The portrait painter had to navigate this dangerous terrain with charm, skill and a ruthless eye for new opportunities. It was Reynolds's own view that in a capital city with eight hundred painters there was room only for eight of the highest standing. The rewards, often going to men from modest backgrounds such as Reynolds, George Romney and John Opie, could be enormous. For Reynolds, a fashionable villa in Richmond and an ornamented gilded coach driven by silver-laced and liveried coachmen were intended, as his pupil and biographer James Northcote wrote, 'to give a strong indication of his great success and by that means tend to increase it'. Polite conversation in a luxuriously decorated and furnished studio, which also acted as an informal salon for fashionable society, created an impression with often socially aspiring clients that they were in the company of a man of the highest distinction and culture. They hoped he would give them something of that distinction in their portraits, and Reynolds usually did not disappoint them.

Friends and sitters waiting to be painted would be present as Reynolds worked, and would gossip and even play music as they leafed through print albums looking for suitable poses and compositions. (The apostolic succession of great portrait painters meant that Reynolds would have acquired the print albums and parts of the collections of his legendary predecessors such as Van Dyck and Lely.) This sociability was a little risqué, and artists' studios with their narcissistic atmosphere carried with them the taint of sexual liaison and licentiousness. Recent investigation has started to reveal even less reputable links to prostitution. No doubt all of this actually added to the appeal of the portrait studio. After all, this was city life.

Reynolds employed four assistants, an expensive undertaking, from whom he supposedly kept his 'colour secrets' on papers in locked drawers. He experimented, often disastrously, with pigments and media during an age when there was an almost mystical search for ever more brilliant effects, in a constant bid by painters to literally outshine their rivals. Sir Walter Blackett's mordant lines express the disillusion felt after a short while by some of Reynolds's sitters:

Painting of old was surely well designed
To keep the features of the dead in mind.
But this great rascal has reversed the plan
And made his pictures die before the man.

---

**66 Thomas Patch**
1725–1782
**A Gathering of Dilettanti in a Sculpture Hall**
c.1760–61
Oil on canvas, 137.2 x 228.6
Collection of Sir Brinsley Ford

Thomas Patch specialised in Grand Tour caricatures. Here, he shows an imaginary hall in Florence filled with British 'dilettanti' such as Sir Horace Mann who points at the 'Venus de' Medici' from the left of the statue and Lord Cowper, second from the right, who admires the Arrotino sculpture. Patch shows himself at the centre where he 'canonises' the Venus. Most of the gentlemen plot and gossip and ignore the art. This was the sort of atmosphere in which much Hanoverian and Stuart political espionage took place in Rome.

Reynolds's materials and methods were transformed by his study of the old masters in Italy. He moved from a 'direct' style in the 1740s, acquired through his apprenticeship to Hudson, to one of subtle transparent glazes over a blue-black and white underpainting. To this basic structure was added white priming for the building up of heads, over which delicate carmine flesh tones were applied. His use of bitumen and waxes, although initially impressive in their effects, eventually led to the deterioration of many of his works.

Reynolds used long brushes and, as one lady sitter reported, 'continually walked backwards and forwards. His plan was to walk away several feet, then take a long look at me and the picture as we stood side by side, then rush up to the portrait and dash at it in a kind of fury.' The element of performance and even seduction was obviously a key part of Reynolds's working style.

Reynolds's academic theory as presented in his *Discourse* stressed the hierarchy of genres in art. History painting, depicting heroic or tragic moments drawn from classical, biblical or other literary sources, was at the apex of this hierarchy, with portraits, landscape, still life and others ranged in order below it. Yet, as was very obvious to his contemporaries, Reynolds barely practised what he preached. His portraiture, 'historicised' as it was, far outstripped his efforts at

grand historical painting. This led to accusations of hypocrisy by other artists resentful of his power and wealth as well as critical of his inconsistencies.

The Irish painter Nathaniel Hone's oil sketch for *The Conjuror* was for a finished work that was excluded from the 1775 Royal Academy exhibition on the grounds that it included what was claimed to be an ungallant nude figure of Reynolds's close friend the Swiss painter Angelica Kauffmann (no.64). The main purposes of the painting, however, were two-fold: to attack Reynolds's eclectic use of old master painting as plagiarism, hence his 'conjuring up' his art from a swirl of old master prints identifiable as the sources for his most celebrated works; and to point out his failure to support history painting in grand public spaces, the professed aim of his ideal academic artist as figured in the *Discourses*. This is alluded to by showing in the background St Paul's Cathedral, for which a scheme of new religious painting had recently been proposed and which Reynolds was accused of thwarting through cynical indifference.

### The History Men

History painting, although usually poor business, witnessed some outstanding experiments in the later eighteenth century. In fact attempts to develop a serious, intellectually demanding art was often allied

57 **Matthew William Peters**
1742–1814
**Lydia**
c.1777
Oil on canvas
64.2 x 77

One critic wrote of this painting that 'every man who has either his wife or daughter with him, must for decency's sake hurry them away'! Peters originally painted a version of this work for Lord Grosvenor, one of many aristocrats who liked sexually titillating pictures as well as hard-core pornographic prints. Matthew William Peters later took holy orders and no doubt regretted this earlier part of his life. 'Lydia' is a character in a play by John Dryden, offering a sort of literary fig-leaf for the image.

**68 James Barry**
1741–1806
'The Thames, or the Triumph of Navigation', from 'A Series of Etchings by James Barry, Esq. from his Original and Justly Celebrated Paintings, in the Great Room of the Society of Arts'
First published 1792
Etching and line-engraving on paper
42.1 x 50.5

**69 James Barry**
1741–1806
**King Lear Weeping Over the Dead Body of Cordelia**
1786–8
Oil on canvas
269.2 x 367

James Barry's scene from Shakespeare's tragedy set in ancient Britain shows the blind and bard-like Lear weeping over his daughter Cordelia's body and being comforted by Kent. Painted for John Boydell's Shakespeare Gallery scheme, it combines powerful human drama with a species of antiquarian and archaeological accuracy. Stonehenge, transported to the Dover white cliffs complete with Druids, is shown in the background, and the scene evokes a strong sense of national history, myth and destiny. Barry's neo-classical approach compresses the main action into a shallow theatrical 'frieze' of figures in the foreground. The tragic self-blinding of Lear was notoriously rewritten by Nahum Tate in 1681 to cause less offence to the audience and was the preferred version for most eighteenth-century audiences.

**70** **John Singleton Copley**
1738–1815
**The Death of Major Pierson,
6 January 1781**
1783
Oil on canvas, 251.5 x 365.8

'History' painting could be contemporary. John Singleton Copley, a Bostonian loyalist working in London, painted this scene from the conflict with France in Jersey during the American War of Independence.

Copley, deliberately invoking Christ's descent from the Cross, shows the hero, Pierson, just after being shot dead by the French, and avenged by his black servant. Members of Copley's family were used as models for

the fleeing women and children, whose safety is assured by the disciplined British redcoats repelling the enemy forces. Copley showed this work at a privately rented space in London where visitors were charged for

entry. An engraving for sale gave details of the main characters. George III reputedly studied it for three hours and it was later the Duke of Wellington's favourite battle painting.

78

71 **Henry Fuseli**
1741–1825
**Titania and Bottom**
c.1790
Oil on canvas
217.2 x 275.6

Another painting for Boydell's Shakespeare Gallery, this dream-like scene from 'A Midsummer Night's Dream' shows the drugged queen of the fairies, Titania, in a rapture over the ass-headed weaver Bottom.

Henry Fuseli was a polymathic Swiss artist who made his career in London, eventually becoming Professor of Painting at the Royal Academy. His fascination with science, the occult, physiognomy and the far reaches of psychological experience, made him one of the most original artists of his time. His entomological interests can be seen in the fantastical half-insect figures, while his fascination with sexuality and the grotesque can be discerned in the mixture of pouting young women and other foreground figures. A lapsed Protestant priest, Fuseli drew many pornographic images throughout his career.

72 **James Gillray**
**'Titanus Redivivus: – or The
Seven-Wise-Men consulting the
new Venetian Oracle', a scene
in the Academic Grove, No.1**
Etching and aquatint
Pub. 2 Nov. 1797 by H. Humphrey

54.9 × 42
British Museum
James Gillray (1757–1815) is
best known for his satirical
anti-French images during the
Napoleonic Wars. He also
attacked the art world and,

here, the Royal Academy's
humiliation by a confidence
trick about 'the Venetian
Secret'. This resulted from a
rush by some academicians to
gain access to the 'secrets' of
a Venetian painting manual.

Gillray shows seven of the
dupes – who include Joseph
Farington and John Opie – as
students at the Academy
drawing from a headless Apollo
Belvedere. Above them the
miniaturist Miss Provis, who

perpetrated the fraud, is shown
painting an absurd image of
Titian. Boydell is shown slinking
away to the bottom right with
the shade of Reynolds rising
from the floor on the left.

to commercial projects. The failure of such enterprises was more to do with contemporary demand, largely dominated by a taste for portraits, landscape and sporting art, or with the intrusions of war into the usually European-wide commercial arrangements, than with the inadequacies of the product.

A generation of painters devoted much of their effort to history and narrative painting – among the most important being James Barry, John Hamilton Mortimer and Gavin Hamilton. Their works were often vehicles for republican political views and for grand narratives of human history, moral virtue and the destiny of the nation. The most self-consciously heroic and uncompromising of these artists, the Irish painter James Barry, expressed such extreme views in his writings, in the opinion of his detractors, that he was, uniquely, expelled from the Academy during the war against revolutionary France. His enthusiasm for and conviction about his own beliefs led Barry to undertake, at his own expense, an ambitious series of six large paintings, called *The Progress of Human Knowledge* (no.68), for the Great Room of the Society for the Encouragement of Arts, Manufacture and Commerce, whose headquarters were in Adams's Adelphi development. This project, worked on between 1777 and 1783, coincided with the triumph over George III of the revolutionary forces in America,

whose aims Barry was in complete sympathy with. They were, in effect, a modern republican version of the royalist baroque schemes of Thornhill and his contemporaries that we have already looked at. The early paintings show progress during ancient civilisation with a focus on figures such as Orpheus, Herodotus and Socrates and on the republican glory of Periclean Athens. The later paintings are largely concerned with the triumph of commerce – a celebration of great British navigators who paved the way for the nation's world trade – and include *The Distribution of Premiums in the Royal Society of Arts*, which has an array of men and women. These include famous contemporaries such as Samuel Johnson and Elizabeth Montagu, but also peasants and inventors of winnowing machines and cranes, symbolising the triumph of a democratic technological society.

The forty-two foot (12.8-metre) *Elysium* shows a judgment day encompassing figures from Aristotle to Shaftesbury and, by contrast, a glutton, a king, a pope and other villains cast into hell. The paintings are ambiguous, as Barry shows artists not as he believed they should be, in charge of their destinies and leading society, but in the unstoppable historical movement of progress, merely one among many groups competing for resources and honour in a commercial society. The Society of Arts represented an integrated view of

73 Gavin Hamilton
1723–1798
Agrippina Landing at
Brindisium with the Ashes
of Germanicus
1765–72
Oil on canvas, 182.5 x 256

Gavin Hamilton was a Scottish painter, picture dealer and archaeologist who settled in Rome, where he conducted important excavations and was a close associate of the classical scholar J.J. Winckelmann. A fan of Poussin's paintings and of Homer's writings, he encouraged a taste for a severe Greek classical style and was responsible for initiating the famous excavations in Athens by Stuart and Revett which influenced the neo-classical style in art and architecture in the work of the Adam brothers, the sculptor John Flaxman and the ceramics of Josiah Wedgwood. This early example of classical history painting shows a subject from Tacitus's history of Rome. Germanicus, father of Caligula, supposedly died in Antioch of poison or magic. His widow is shown landing at Brindisi, carrying his ashes back to Rome in an urn.

knowledge in which art played a role alongside science, commerce and manufacturing, but it was the Royal Academy that uniquely represented the interests of artists, and ultimately helped to make art a unique and specialised category of activity. We live with the consequences of this development today.

As Britain established a sense of its identity and imperial destiny in the eighteenth century, so it found suitable images of itself in history and literature. A literate public versed in the works of Shakespeare, Milton and those other authors who formed a defined canon of English literature acquired a taste for the illustration of their works. There were, of course, many illustrated novels, plays and poems available for this growing audience. When the wealthy printseller Alderman John Boydell announced in 1786 his plan for a Shakespeare Gallery of paintings illustrating scenes from the Bard's work, he saw it both as a celebration of Britain's greatest author and a way of shaping a consciousness of national characteristics. It was also a shrewd commercial venture which would make its profits by selling throughout Europe engravings of paintings by all the major British academicians.

At its opening in new premises in Pall Mall in 1789, the new Gallery, which became a fashionable social venue as Vauxhall Gardens had been in the 1730s and 1740s, displayed works by eighteen artists including

Reynolds, Barry and Fuseli. Boydell's initial success was followed by further attempts to cash in on the public's new taste – Thomas Macklin's gallery, devoted to British poetry and to biblical scenes, Robert Bowyer's gallery with illustrations from David Hume's *History of England*, and Henry Fuseli's Milton Gallery. It was the war against France in the 1790s that finally scuppered these schemes. However, their long-term success was in promoting the idea of contemporary British art and putting it on a par with that of foreign competitors and even, in some cases, with the old masters. Furthermore, there was now an established and widely disseminated iconography of British history and literature that entered the wider 'national mind' and which continues to colour our perception of the past.

Boydell later wrote proudly of the Shakespeare Gallery, which had closed and been sold off in 1805, the year of the Battle of Trafalgar: 'every artist, partaking of the freedom of his country, and endowed with that originality of thinking, so peculiar to its natives, has chosen his own road, to what he conceived to be excellence, unshackled by the slavish imitation and uniformity that pervade all the foreign schools.' A consensus agreed that Shakespeare was 'various' in his genius, a British characteristic Hogarth would have applauded, and that the nation's

74 **George Romney**
1734–1802
**John Howard Visiting
a Lazaretto**
c.1791–2
Pen, ink and wash and pencil
on paper, 34.3 × 48.9

George Romney was a major portrait painter with ambitions to make history pictures his main output. As with most artists, this proved virtually impossible. This work is a sketch towards an image of the

famous prison reformer John Howard, who visited gaols and plague hospitals ('lazarettos') throughout Europe in the 1770s. His proposals for change, published by the radical bookseller Joseph Johnson in

1777, were part of a broader move towards liberal social policies.

art should be similarly so, in opposition to the authoritarian, rule-bound efforts of European, in particular French, art.

### Weird Light in Lambeth

One of Reynolds's fiercest critics was William Blake, the son of a Soho hosier, who described the topdog of British art as 'hired to depress art'. Blake reacted violently against the polite enlightenment culture which it seemed to him dominated British artistic life. Rejecting the rationalist and often atheist philosophies of history of men such as Edward Gibbon and David Hume, Blake saw all things *sub specie aeternitas* (under the aspect of eternity) – his self-created history of the world was theological, albeit in a fashion which went unrecognised by the established Anglican church. Blake is both a descendant of the great Puritan traditions in which William Prynne was such a melodramatic figure, and the exponent of a joyous vision of the human body and sexuality, which Prynne would no doubt have heartily disliked. Blakes's famous remark that the puritan and republican poet John Milton was 'of the Devil's party without knowing it' expresses well the contradictory sources of Blake's thought.

Blake was a Non-Conformist in his religious beliefs, and thus quite typical of the urban artisan class from which he came. We shall see a not dissimilar

background in the case of J.M.W. Turner, with rather different results. Blake believed in direct revelation by reading the Bible and by cultivating his visionary faculties. As a young man he was briefly a follower of the cult of the Swedish scientist, philosopher and theologian Emmanuel Swedenborg and, like many men of his era, throughout his life was fascinated by all things occult. For Blake, believing that all great artists had also to be Christians, the imagination was a divine gift and creativity a kind of worship. This belief, generally eccentric in the forms it took, makes Blake one of the first major Romantic artists, a term we shall return to.

Blake was apprenticed as a teenager to an engraver, James Basire, in Covent Garden, right by the Grand Lodge of the Freemasons, another cult which influenced him, and he was given the task of making drawings from medieval paintings and monuments in Westminster Abbey. This experience, a kind of accidental medieval spiritual and artistic training in the interests of a normal commercial venture for the Society of Antiquaries, was very important in his development. It introduced him to a world both of national antiquity, an interest we have seen growing inexorably among artists and writers since the seventeenth century, and also of deep religiosity, which focused his energies on a dissenting and monastic tradition.

75 **William Blake**
1757–1827
**Elohim Creating Adam**
1795/c.1805
Colour print finished in ink and watercolour on paper
43.1 × 53.6

William Blake was a dualist, which meant that the creator of the material world was for him a punishing, false god. This colour print shows the bearded Elohim (an Old Testament name for God) creating Adam from the green slime of matter. Adam writhes in pain, already crushed by the serpent of original sin, as the sun sets and the light of the world is extinguished.

In the 1780s, he attended drawing classes at the Academy and proved himself to be a talented draughtsman, making watercolour drawings of biblical and historical subjects in conformity with the requirements of academic strictures. However, he was not trained in oil painting and his later annotations to Reynolds's *Discourses* show his deep suspicion of the practice in its use of an overly material and deceitful medium, which he believed was inferior to the techniques of medieval art – illuminated manuscripts and frescoes being the spiritually elevated forms he had in mind above all. Blake also objected in principle to Reynolds's emphasis on generalising from nature, and instead insisted on the visionary depiction of what he termed 'minute particulars', believing eternity was visible in a grain of sand rather than in the abstractions of grand compositions. Such attitudes to particularity had a deep influence on the young Pre-Raphaelites half a century later. Finally, Blake saw Reynolds, as Hone and other radicals did, as the representative of a corrupt and exploitative ruling class who preached great art but practised flattery. Blake shared the view of his friends Fuseli and Barry, that with Reynolds and the Academy in charge there could be no great national school of art devoted to history painting in public places, which might inform the national renewal that the President of the Academy himself had advocated.

Blake's republicanism meant that he was closely connected to radical artists such as Barry and George Romney, and to controversial writers such as Tom Paine and Mary Wollstonecraft. In 1790 he left the West End and moved to Lambeth, then a rural suburb south of the Thames but close to the rapidly expanding metropolis, and lived and worked there in a house with his wife and assistant Catherine. It was in this new home and studio in Hercules Buildings, against the background of the wars with revolutionary France and the draconian measures taken against dissidents such as himself, that he produced most of his celebrated *Illuminated Books* (no.79).

These extraordinary works were produced in small editions using Blake's unique colour printing technique. This involved etching the words and images of his visionary illustrated poems on to the printing plate, and then working over the small runs of impressions with pen and ink and other media to create different effects for each plate. The richness of the forms and colours, and the intricate imaginative relations between words and images, make these among the most brilliant and unusual products of the time. In works such as *Songs of Innocence and Experience*, *The Book of Urizen*, *Europe*, *America*, *Jerusalem* and others, Blake created a mythical world of his own that was simultaneously a commentary on the political, social

11

6 Alexander Cozens
1717–1786
From 'A New Method of Assisting the Invention in Drawing Original Compositions of Landscape' (plate 11), 1785
Aquatint on paper, 24 x 31.6

Born in Russia and rumoured to be the illegitimate son of Peter the Great, Alexander Cozens settled in England in 1746. Working as a drawing master, he invented a technique in the 1750s for assisting the imagination in landscape composition. This consisted of creating 'blots' of ink randomly disposed on paper, which could then be turned into finished works. This typically Romantic approach, the basic principle of which was actually pioneered by Leonardo da Vinci, assumed the autonomy of the imagination and the power of subconscious processes.

77 **William Blake**
1757–1827
**Newton**
1795/c.1805
Colour print finished in ink
and watercolour on paper
46 x 60

and cultural forces of the contemporary world – all
seen, finally, within an eternal rather than a mundane
scheme of things. These are complex and demanding
works which nevertheless are utterly beautiful and full
of simple and moving images and concepts. Poet and
artist have probably never been so effectively united in
one individual.

The Tate collection of Blake's work is concentrated
on his unique works – that is works which, unlike the
published books, are framed individually. He thus
appears as a draughtsman and watercolourist rather
than as a writer-artist. The famous image *Newton*
(no.77), finished in ink and watercolour on paper, is
one of a remarkable series of large colour prints .
Technically these are of great interest as they derive from
Blake's revolutionary printing methods. It is thought
that, using a strange mixture of pigment and carpenter's
glue, he painted the design on a piece of millboard,
which was placed in his large press and from which he
took two or three impressions. These were then
individually finished with watercolour, pen and ink. The
effects of the process are visible in the 'minutely
particular' granulation of the botanical matter on the
rock and the overall stunning surface of rich colour and
deep translucency that is achieved. This is a high-order
of technical innovation, owing something to the ink-
blot aesthetic of Blake's contemporary Alexander

Cozens (no.76) but also looking forward to processes
developed in the twentieth century.

The overall theme and purpose of the series is not
entirely clear, but most deal with aspects of the fall of
man, whom Blake believed lived in a divided state. His
art sought a form of reintegration of the fragments
of the self's shattered being. Here we have a version of
self-fashioning of a very different order to what we
have seen so far – the artist, through God and the work
of the imagination, invents a new man for society, who
will emerge through an engagement with the art of the
divinely inspired genius. Blake had no doubt he was
working under grace, hence the many stories of his
ecstatic visions of angels and biblical and historical
figures that his supporters, and detractors, have left us.

Blake, much influenced by Gnostic heresy, believed
the material world and the body constituted a kind of
anti-existence, and that the imagination offered the
only escape from this dark and painful condition.
Thus his image of Isaac Newton, the great
seventeenth-century mathematician (as well as
alchemist and theological and occult speculator, as
Blake may have known) shows this almost deified
national hero as a semi-naked figure sitting on, even
melting into, a lichen-encrusted rock at the bottom
of the ocean. In Blake's mythology, water represents
materiality, and Newton, whose pose is derived from

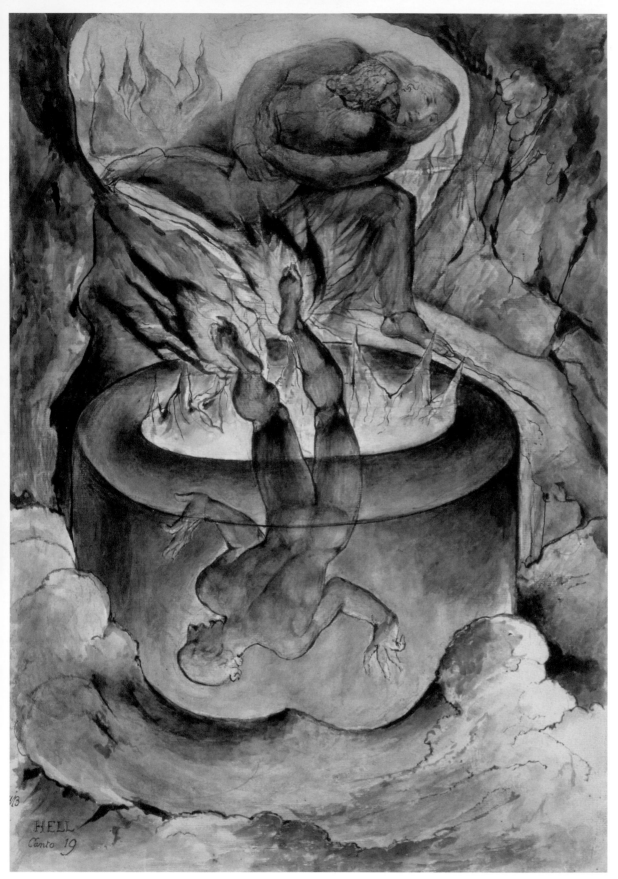

8 **William Blake**
1757–1827
**'The Simoniac Pope', from**
**'Dante's Divine Comedy'**
1824–7
Pen and ink and watercolour
on paper, 52.7 x 36.8

Blake completed over a hundred watercolours towards his proposed illustrated edition of a translation of Dante's 'Divine Comedy'. Most of these dwelt on episodes from the 'Inferno'. Here a simoniac (one who trades in the spiritual for pecuniary gain) pope, in this case Nicholas III, is plunged into a fiery vat head-first as the cicerone, or guide, Virgil hurries Dante past the scene.

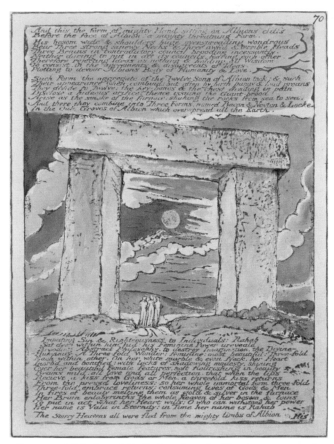

a figure on Michelangelo's Sistine Chapel ceiling in Rome, peers at the geometrical design he is inscribing, absorbed by his reasoning as if caught in a self-spun spider's web. Blake's purpose here is to give visual form to his critique of the myopic and repressive constrictions imposed by rationality and materialism on modern man. The Royal Society ethos we have seen informing much British art over the previous hundred years – although interestingly resisted for other motives by the 'satanic' Reynolds – was in the main anathema to Blake, and he viewed science and technology with great suspicion. Blake is one of the first counter-culture figures in British art, and his insights into the condition of humanity under capitalism and the ideology of progressive modernity still inspire radicals today.

Although he avoided persecution in the 1790s, Blake did face a sedition charge for which he was acquitted, after an altercation with a British soldier while working for the poet and editor William Hayley in Felpham, Sussex, in the early 1800s. This was the only occasion he lived outside London, and the only Grand Tour he ever took was strictly the one through the infinite cosmic landscape of his imagination. Although sometimes making good money from his own works – a few collectors would pay handsomely for his *Illuminated Books* – and from commercial work, Blake was indifferent to worldly success and lived in

modest conditions in London throughout his career. He was not an astute businessman and never effectively promoted his ambitions – his only one-man show, staged at his brother's house in Soho in 1809, was not only met with a bemused or hostile critical reaction but sold nothing. In order to sell his watercolours of biblical and Miltonic subjects and his visionary history subjects painted in a technique he called fresco, he was always dependent on the limited patronage of those such as the minor civil servant Thomas Butts. Not for Blake the extended network nurtured by Reynolds and more astutely fashionable painters.

His final years were dominated by three major projects – the vast national epic myth of his illuminated poem *Jerusalem* (no.79), his illustrations intended to accompany a translation of Dante's *Divine Comedy* (no.78) and his set of engravings of the Book of Job. In the 1820s, Blake lived off the Strand in some penury with his loyal wife, and gathered around him a group of young admirers such as John Linnell and Samuel Palmer, who kept his work and memory alive after his death and ensured that later generations would be able to know and respond to his life's work.

### Midlands Lunatics
Back to Planet Earth and rewind a few decades. Unlike Blake, many British artists saw science as a

79 **William Blake**
**Jerusalem,** 1804/*c.*1820
Relief-etched plate finished with watercolour, pen and ink
approx. 21.9 x 15.9
Yale Center for British Art.
Paul Mellon Collection

The huge 'trilithon' structure shown in this hand-coloured image is based on Stonehenge, perhaps drawn from William Stukeley's book of 1740 about the site. William Blake's image stresses the overpowering

forces of rationality and materialism that he associated with the Druids, supposedly the builders of Stonehenge. He relates the patriarchal tyranny of the Druids with the baleful influence of the British scientific

philosophers Sir Francis Bacon, John Locke and Sir Isaac Newton, who are shown here, so to speak, under the weight of their myopic learning, 'plotting to devour Albion's Body of Humanity and Love'.

heroic venture. The increasing stresses and strains of commercial rivalry and political disagreement that characterised the growth of art in Britain in the later eighteenth century have been seen so far primarily in the spheres of portraiture and history painting. The specialisation of artists in certain areas, a division of labour so to speak, gives the period its distinctive and dynamic quality. Literature and philosophy have been seen to form the intellectual foundations of the work discussed, disciplines at the heart of Reynolds's and the Academy's notions of art.

There were, however, other sources which reflect forces at work in British society that Reynolds and his supporters found problematic and even inimical to their conception of the highest art. Where the Academy sought a transcendent category of art, beyond the immediate interests and vulgar particularities of the present, others pursued those very impurities in order to make what they believed was a truly modern art for the nation. And many of them sought to do so beyond the metropolis.

Like most of his contemporaries, Joseph Wright (known as Wright of Derby) relied heavily upon portraiture to make a living, training under Reynolds's master, Thomas Hudson, in London in the 1750s. It was, however, a series of remarkably original, dramatically lit scenes of scientific and industrial

subjects exhibited at the Society of Artists between 1766 and 1773 that made his reputation. The mezzotints of his works, some published by Boydell, made him known throughout Europe. *An Experiment on a Bird in the Air Pump* of 1768 (no.80) shows a critical moment during a demonstration in a middle-class home somewhere in the Midlands. A rare white cockatoo, perhaps the pet of the horrified looking young girls, is about to be spared suffocation by a Dr Who-like itinerant demonstrator, whose hand is poised over the stopcock of the air pump, first designed by Robert Hooke in the 1650s. The dark room, illuminated only by a candle and moonlight – this may be a reference to a learned group of the time called the Lunar Society (commonly called the Lunaticks), who met at full moon each month – provides the setting for one of the most hauntingly unconventional conversation pieces in the history of art. The bird's imminent revival, immediately above a jar with the remains of a human skull, lends the painting a spiritual aspect with its reference to the Holy Spirit, in the traditional form of a white bird, and even to alchemical practices.

Wright was close to a scientific and intellectual circle, with strong freemasonry associations, centred on Lichfield in Staffordshire, and which had close connections to the Royal Society – a pattern in regional

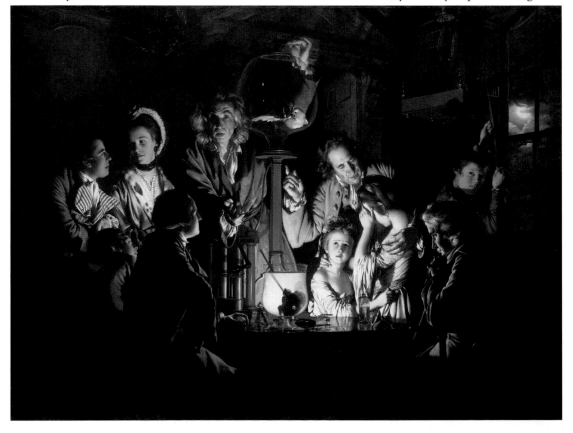

80 **Joseph Wright of Derby**
1734–1808
**An Experiment on a Bird in the Air Pump**
1768
182.9 × 243.9
The National Gallery, London

culture we have already noted in the previous century. This circle included local men of outstanding talent and influence, such as the pottery magnate Josiah Wedgwood, the cotton manufacturer Richard Arkwright, the physician, botanist and poet Erasmus Darwin and the writer, publisher and translator of the Genevan philosopher Jean-Jacques Rousseau, Sir Brooke Boothby. This was a world of enlightened gentlemen, where commerce, science, technology, art and education were seen as intimately linked to the progress of civilisation and to the power of the nation. We have already seen James Barry's association with such views through the RSA in this regard. Wright was painting the optimistic vision of this world at the height of its confidence. It was a culture, furthermore, of the fast-growing provincial cities of the Midlands and the North, which saw themselves as independent from London.

Wright, never a full member of the metropolitan Royal Academy, was typically experimental in his approach. He avidly studied the new mechanical inventions of his time at first hand and constructed miniature theatres using glass transparencies to create illusionistic landscapes. *An Iron Forge* of 1772 (no.81) is one of a series of paintings of night scenes in an early industrial setting, with glowing ingots and tilt-hammers powered by water wheels, which have the ambition of history painting. In a country where technological advance and industrial productivity were so important, Wright's transformation of his scenes by classical allusions and by subtle religious suggestions of the nativity provided a heroic mythology of contemporary fact. The central figure, masterfully looking at his well-dressed wife and children, while his employees forge the brilliantly glowing iron, is the epitome of the power of the virile new British workman. Wright replaces Thornhill's Vulcan with his own updated, muscular iron-master, following a tradition of visual modernisation started by Hogarth.

## Mr Stubbs the Horse Painter

In the case of George Stubbs, born in Liverpool and trained there and in York, we find another artist for whom the relationship between art and science could be tested within the conventional specialist genres of history, portrait, landscape and, in particular, the highly popular area of sporting art. The son of a currier and leatherseller, Stubbs dissected and drew from an early age, and while in York studied anatomy at the County Hospital. We can see Stubbs, in his early experience, as a brilliantly talented part of that regional culture we have already noted, where art and science were natural partners and probably more easily so being outside the fashion-conscious London art world.

82 **George Stubbs**
1724–1806
**The Anatomy of the Horse**
1766
Tate Archive, TAB.1x

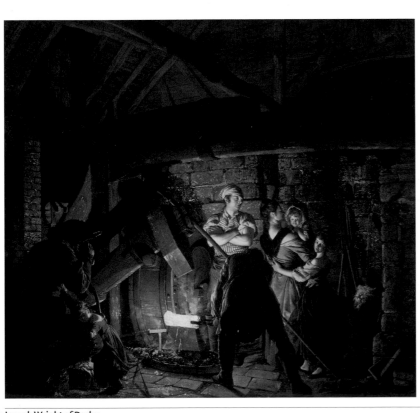

81 **Joseph Wright of Derby**
1734–1797
**An Iron Forge**
1772
Oil on canvas
121.3 x 132

His illustrations to John Burton's *Essay towards a Complete New System of Midwifery* (1751) were produced while painting portraits in Yorkshire, and involved teaching himself the art of etching. After a brief but important journey to Italy, Stubbs lived in the obscure village of Horkstow in Lincolnshire, probably under the protection of an established patron of his, where he spent sixteen months working on a major project, *The Anatomy of the Horse* (no.82).

Assisted by his common-law wife and working in constrained and gruesome conditions as he dissected and drew, Stubbs produced an astonishing series of drawings that were the first of the subject made in Europe for over a hundred and fifty years. Stubbs took his drawings to London in 1758, where he went to practise as a portrait and animal painter. Unable to find any engraver ready to take on the unusual task, Stubbs worked in the evenings to engrave the images himself and published the work in 1766. His reputation as the leading artist in his area was secured and earned him the praise of anatomists and artists across Europe. Stubbs always claimed that his purpose in undertaking the project had been in the interests of painting, and that his chief anatomical interest had been in bone, sinews, muscle and skin rather than internal organs. His intense study certainly helped to make him the most brilliant horse painter of his, or indeed any, age,

and to compensate for the tag of mere 'horse painter' that bedevilled such artists.

Stubbs, like Wright, was more closely connected to the Society of Artists than to the Academy, at least until 1775 when he transferred his allegiance. As a committee member of the Society, he invited the celebrated surgeons William and later John Hunter to dissect a human body in the presence of members.

Like most artists, Stubbs mixed with a wide range of contacts and patrons in order to pursue his career. He had a business relationship, for example, with Josiah Wedgwood in an experimental attempt to produce large enamel paintings on biscuit earthenware which, although ultimately unsuccessful in commercial terms, was typical of the many such enterprises artists undertook in this supremely entrepreneurial period.

His horse paintings were aimed at an often sophisticated aristocratic clientele who, although frequently derided by metropolitan critics as interested only in field sports, appreciated the artist's subtle use of classical composition and references as well as his smooth, precise realism. In his series of paintings and engravings on the theme of a lion attacking a horse, Stubbs even managed to make a kind of history painting out of an animal subject (no.83). Drawing on antique sculpture, which he probably saw in Rome, Stubbs charts, in four episodes, the lion's attack, from

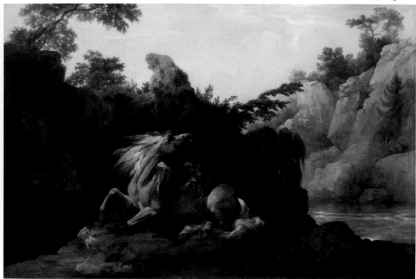

**83 George Stubbs**
1724–1806
**Horse Devoured by a Lion**
?exh. 1763
Oil on canvas
69.2 x 103.5

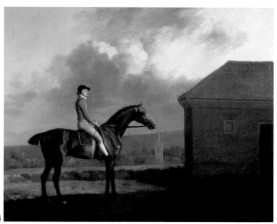

84

**84 George Stubbs**
1724–1806
**Otho, with John Larkin up**
1768
Oil on canvas
101.3 x 127

Stubbs catered for the huge market for sporting pictures. This painting shows a successful horse, owned by Lord Ossory, and a celebrated gentleman jockey of the time outside a rubbing-down house at Newmarket, the premier racing venue.

**85 Joseph Wright of Derby**
1734–1797
**Vesuvius in Eruption, with a View over the Islands in the Bay of Naples**
c.1776–80
Oil on canvas
122 x 176.4

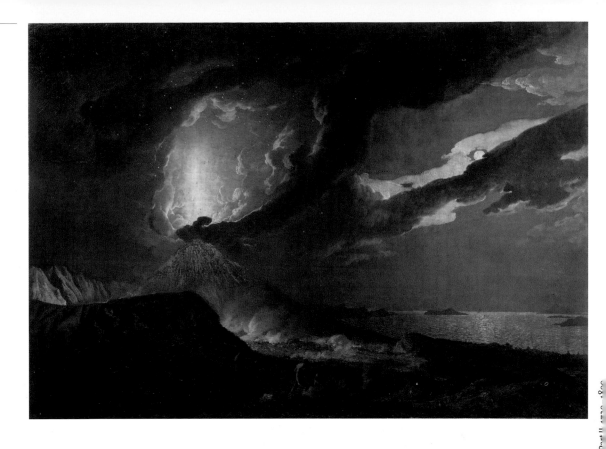

the horse's first fearful anticipation, to its collapse as the predator sinks his teeth into its flanks. Stubbs's fascination with the complex expressions of fear and ferocity in face and body in his wild animals has a powerfully anthropomorphic dimension. We see, albeit at an early stage and by analogy, a scientific understanding of man in relation to the animal kingdom that was to have profound intellectual and moral implications. The scalpel and the microscope were revealing nature in ways quite at odds with the idealisation of human bodies and minds at the heart of, say, Reynolds's world view. When Stubbs began work in 1795 on his *Comparative Anatomical Exposition of the Structure of the Human Body with that of a Tiger and a Common Fowl*, he was embarking on a project, uncompleted at death which, although not new in concept, uncannily anticipates the evolutionary ideas of Charles Darwin fifty years later.

### Volcanic Patriotism

Stubbs and Wright were also exponents of distinctly new forms of the genre that was beginning to seriously rival portraiture in terms of output and status – landscape. In Stubbs's case landscape was usually a background to his main subject, be it a horse, a wild animal or, in the case of his famous 1785 pair of images of human activity, *Haymakers* and *Reapers*.

The backgrounds to his *Lion and Horse* pictures and to some other subjects are of Cresswell Crags, a site on the Nottinghamshire–Derbyshire border. The caves within these limestone cliffs were excavated in the nineteenth century and found to contain the remains of prehistoric animals including horses and cave lions. It is quite possible that such remains were visible during Stubbs's visits in the 1760s and 1770s; certainly the area had a wild quality entirely suitable to the primeval natural world he was trying to evoke. It is likely, therefore, that the growing enthusiasm for British history, antiquarianism and archaeology informed Stubbs's choice of setting.

Wright was certainly interested in such matters, and was closely associated with geologists and local historians who focused their attention on the Peak District in Derbyshire and on sites which became popular with tourists, such as Matlock Tor. One such figure was John Whitehurst, a clockmaker, geologist and freemason, who wrote on Derbyshire, where he found evidence of volcanic activity at Matlock, and speculated on the subterranean fire below the landscape that had determined its transformations and present form. Such was the national pride in these prehistoric events that by the 1780s, even Switzerland was being described as the 'Derbyshire of Europe'! Wright's Grand Tour to Italy in 1773 took him beyond

Rome to Naples and to Mount Vesuvius whose eruption in AD 79 had destroyed Pompeii. Wright painted thirty views of the volcano over the years, catering to a broad market for images of this major tourist sight and focus of natural scientific investigation by men such as the English Ambassador at Naples, connoisseur and *volcaniste* Sir William Hamilton (no.85). 'When you see Whitehurst, tell him I wished for his company when on Mount Vesuvius, his thoughts would have centr'd in the bowels of the mountain, mine skimmed over the surface only ... there was a considerable eruption ... Tis the most wonderful site in nature', Wright wrote to his brother.

Wright was interested in the mysterious power of the volcano, the spectacular effects of eruption and the historical associations, such as the burial of the Roman writer Pliny the Elder, who was killed while exploring the volcano's rim. The interest in volcanoes highlights the peculiar mix of amateur science, classicism, connoisseurship and quasi-religious theorising typical of the enlightenment period. Sir William Hamilton, who gave his collection of lava specimens from the Vesuvius area to the newly founded British Museum in 1768 and wrote long letters to the Royal Society about his theories, related volcanoes both to the bodily humours and to a wider cosmology: 'I know of no subject that fills the mind with greater ideas than the volcanic history of the world ... the great system of dissolution and renovation which seems the Universal Law of Nature, by which a sparrow, a city, a region or a world, probably, have their beginning and end.' We are entering the Romantic imagination of Turner and Wordsworth in such sentiments, where a 'natural theology' seeks subtle, pantheistic correspondences between man's destiny and the natural world.

### The Man of Sentiment

Such meditation on the mysteries of nature, body and soul is embodied in Wright's portrait of *Sir Brooke Boothby*, the Derbyshire landowner and editor of Jean-Jacques Rousseau's *Premiere Dialogue* (no.86). Rousseau, whose radical political and educational theories had such an enormous impact on European thought and political history, had visited Britain in the 1760s, where he met Wright's circle. His stress on nature as the source of all freedom and virtue and his progressive attitudes towards child-rearing had a great influence on British radicals – Wright and others, for example, allowing their children freedoms of behaviour and expression frowned upon by more conventional families. The portrait of Boothby shows a plainly dressed but fashionable Rousseauist reclining in a wooded landscape, holding a volume of the master's work and, a little melancholy in expression – perhaps

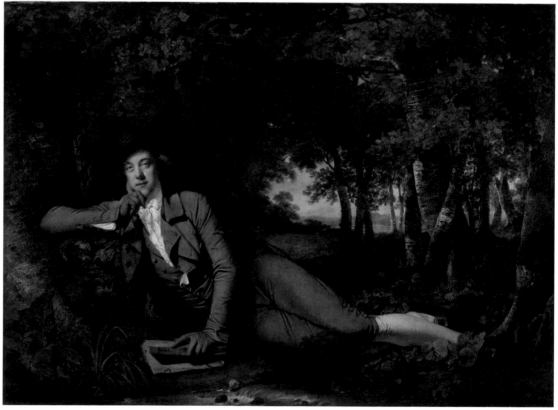

86 **Joseph Wright of Derby**
1734–1797
**Sir Brooke Boothby**
1781
Oil on canvas
148.6 x 207.6

alluding to early seventeenth-century miniatures and literature of the 'saturnine' personality – acting out the part of the modern man of sentiment. Henry Mackenzie's 1771 novel *The Man of Feeling* was the classic novel of sensibility of the period, whose hero 'lay himself down ... on the banks of a rivulet ... stretched on the ground, his head resting on his arm'. Significantly, Mackenzie's book was also an attack on the traditional aristocrat's proprietorial relation to the land.

### Roman Britain

Landscape in many different ways became identified as the typical national genre in painting by the end of the eighteenth century. We have seen the earlier topographical and classical forms of landscape that became established in Britain during the seventeenth century. In the main these were produced for aristocratic clients, who wanted an estate represented or an old master landscape by, or after, one of the great French landscapists, Claude Lorrain or Nicholas Poussin. The first major British painter of classical landscapes was the Welshman Richard Wilson. While he painted mainly for an elite of aristocrats, by the time of the 1814 British Institution exhibition of landscape painting he was being presented, together with Gainsborough, as one of the originators of a distinctly native landscape art for a broad audience.

Like most aspiring young artists, Wilson trained as a portrait painter in London, and through this work became well connected in titled circles. Taking advantage, as many did, of a period of peace in Europe in the 1750s, Wilson travelled to Italy at nearly the same time as Reynolds and, staying there over five years, made a series of fine drawings and related paintings of Italian landscape subjects. These were sold to Grand Tourist patrons such as the 2nd Earl of Dartmouth, who arrived in Rome in 1753.

Wilson was closely connected to the Roman artistic scene through figures we have already met, such as Thomas Jenkins, Horace Mann and Cardinal Albani. He also knew foreign artists such as the bohemian Anton Raffael Mengs and the French landscapist Claude Vernet, as well as fellow Britons Reynolds and the pioneering Scottish neo-classical history painter Gavin Hamilton. Mengs was a close friend and disciple of the German classical scholar J.J. Winckelmann, who transformed taste from the 1750s and 1760s by accentuating in his widely read books the achievement of the Greeks and stressing the classical ideal as 'noble simplicity and calm grandeur'. Such ideas can be connected to Rousseau's 'noble savage' and emphasis on a 'natural virtue', and thus to the new attitudes to landscape. Few artists, including Wilson whose imaginative domain was Roman rather than Greek,

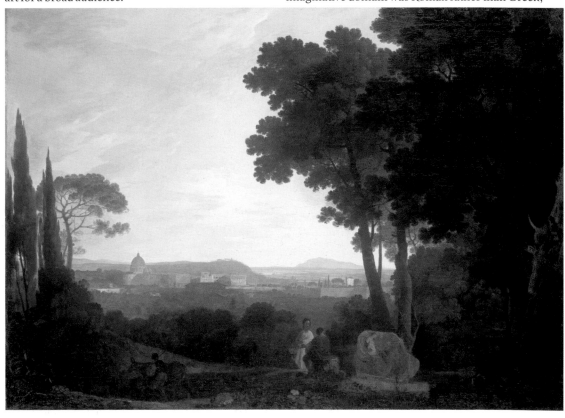

87 **Richard Wilson**
1713–1782
**Rome: St Peter's and the Vatican from the Janiculum**
c.1753
Oil on canvas
100.3 x 139.1

were unaffected by this zealous pursuit of the true ancient splendour.

Back in Britain, Wilson was intimately involved with the Society of Artists, and then with the Royal Academy as one of its founder members. During the 1760s he exhibited classical landscape paintings which, for at least a decade, before he declined into alcoholism and depression, dominated the market for such work. *Rome: St Peter's and the Vatican from the Janiculum* of *c.*1753 (no.87), painted for the Earl of Dartmouth in Rome, shows the Holy See from the popular tourist viewing spot of the hill in Trastevere, which was supposedly the site of a city founded by the god Janus. Looking north beyond the dome of St Peter's, through the calm evening light conveyed by delicate glazes of colour, are the hills Monte Mario and Monte Soracte, familiar sites in the Roman Campagna to the Earl and other tourists. Wilson's pupil William Hodges wrote of the 'classical turn of thinking in his works, and the broad, bold and manly execution of them; which added to the classical figures he introduced into his landscapes, gave them an air more agreeable to the taste of true connoisseurs and men of learning'. This 'manly' learnedness is evident in the classically garbed foreground figures and sculptural fragments, which deliberately create a poignant contrast with the contemporary scene of Rome in the middle distance. Such paintings are intended, through their carefully contrived composition of framing trees or buildings in the foreground, and gently receding planes leading the eye to a hazy distant prospect, to provoke certain trains of thought. These were in part poetic, by evoking the classical past in settings of natural Arcadian beauty, and in part moral, by prompting a meditation on the decline of empires and the transience of human endeavours. Thus a kind of visual time-travel, supported by reference to the writings of classical authors such as Virgil and Theocritus with their emphasis on the recovery of a lost golden age, also reminded the educated viewer of the melancholy truth of the present.

For British men in the 1750s and 1760s, such a meditative art had an urgent significance in a country struggling to grow as a commercial and military empire. While trade and productivity lay at the heart of this dramatic growth, the dangers of complacency, pride and luxury, which had ruined Rome, were always waiting to destroy the nation. Social disorder, immorality and decadence were frequently cited by contemporary writers as the likely negative consequences of Britain's rise to power. We have already seen a version of these kinds of fear in Boitard's print of the dangers of corrupting French imports. The guide books used by Grand Tour

88

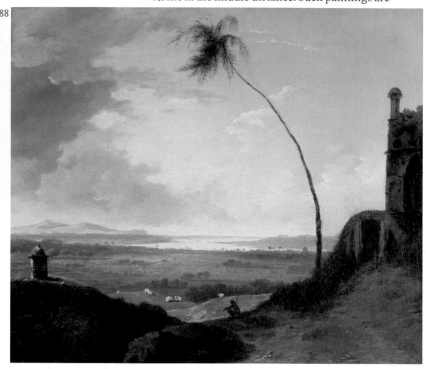

89 **Aerial view of Stourhead, Wiltshire**
*c.*1730–90

88 **William Hodges**
1744–1797
**Tomb and Distant View of Rajmahal Hills**
1782
Oil on canvas
62.2 × 72.4

Is it Italy? No, it's India, seen, like Richard Wilson's wild Wales (no.91), through classically picturesque spectacles. William Hodges, a pupil of Wilson, followed the course of empire by accompanying Captain Cook to the South Seas as a draughtsman, and as artist to Warren Hastings and the East India Company on the subcontinent. This view of a 'Hindoo' architectural detail, a subject Hodges became an expert in, with the River Ganges and the Rajmahal Hills inhabited by lawless tribesmen in the background, creates a tension between an 'alien' subject matter and European aesthetic expectations. In his 'Travels' and other works, Hodges wrote of the conceptual difficulties of painting such scenes.

travellers emphasised the moral lessons to be drawn from contemplating the relics of Rome's greatness, while British poets such as William Whitehead stressed the same message in august verse form:

> Beneath yon cypress shade's eternal green
> See prostrate Rome her wondrous story tell,
> Mark how she rode the world's imperial queen,
> And tremble at the prospect how she fell.
> ('Elegy III. To the Right Honourable George Simon Harcourt, Visc. Newnham', written at Rome, 1756)

Wilson painted a landscape art for those who favoured a social elite and the conservative values of a classical culture – a view at odds with the more radical propensities of Wright's Brooke Boothby, whose contemplation of nature led to a very different set of attitudes.

### 'A Most Agreeable Scene'
The classicism of Wilson's landscape painting was spectacularly mirrored by the landscape gardening of men such as the architect, designer, painter and arbiter of taste William Kent, who was scorned by Hogarth for his Palladian fashionability back in the 1720s. Kent at Stowe in Buckinghamshire during the 1730s, and Henry Hoare II at Stourhead in Wiltshire from the 1740s (no.89), turned Italian spectacle into British

reality. Hoare, who had travelled extensively in Italy, transformed his ancestral grounds under the influence of Claude and Poussin, and introduced temples, grottoes, bridges and other Italianate features into a radically reordered landscape. The quotations from Virgil, Ovid and the English Augustan poet Alexander Pope inscribed on these features suggest there may have been an ambitious allegory intended for those walking through the grounds, which was based on Virgil's *Aeneid*. The poem tells the story of Aeneas's travels and the founding of Rome, and was routinely interpreted as a prefiguration of the founding of ancient Britain by Brutus, another character in the epic. Thus, like Wilson's paintings, the artificial landscapes created mainly for pleasure by landowners also carried strong historical, literary and moral connotations for a warring nation, which saw itself as the new Rome and inheritor of the inevitable grand responsibilities that entailed.

### The Welsh Campagna
Wilson also applied classical forms to British views in his paintings, and could almost turn local landscapes into Italian scenes as if by some theatrical magic in the vein of Inigo Jones. However, as the dominance of patrician taste waned, or changed, and as fascination with Britain's past grew, Wilson developed altogether new forms of representation. *Llyn-y-Cau, Cader Idris*

90 **Johann Zoffany**
1733–1810
**Colonel Mordaunt's Cock Match**
c.1784–6
Oil on canvas
113.5 x 149.8

Racial tensions. The British imperial presence in Bengal is shown here in a painting commissioned by the Governor-General Warren Hastings from the German portrait and conversation-piece artist,

Johann Zoffany. Zoffany, popular with George III, spent much of the 1780s in India and shows here a cock match, frowned upon in England, at the court of Asaf-ud-daula of Oudh between the Nawab's bird and

that of the English mercenary Colonel Mordaunt. This work has a Hogarthian sense of barely contained chaos, ethnic difference and a delight in multiple incidents.

92 **Benjamin West**
1738–1820
**The Bard**
1778
Oil on oak
29.2 x 22.9

91

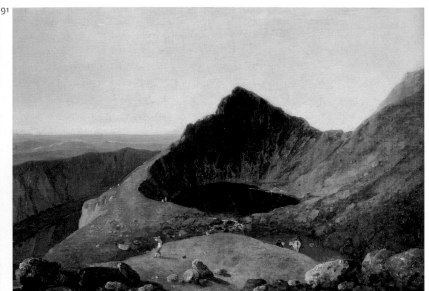

(no.91), reminding us of Wright's views of Vesuvius, brings together geology, ancient history and patriotism in a North Wales landscape, which looks ahead to the 'sublime' and 'romantic' landscape painting we shall examine later. Taking some liberties with the foreground and with the distances involved, Wilson shows a volcanic lake, behind which rears the precipice of Craig-y-Cau with the Bay of Cardigan shimmering in the distance. In the mid-foreground the figures depicted include an artist, perhaps Wilson, at work and a man looking towards the valley of the Dysynni through a telescope.

Although remote, often inaccessible and still unpopular with most tourists, Wales had become an object of intense historical, antiquarian and geological study. The scholarly initiators of this Celtic Revival in the mid-eighteenth century drew on ancient manuscripts and other sources to put Wales, as it were, back on the map. The vogue for new information, whether true or false, about ancient Britons and Druids, and a new understanding of a pre-Roman and Saxon past for Britain, led to a wave of writing and image-making.

We have already seen this interest in men such as Henry Gyles and William Stukeley. The poet Thomas Gray's work 'The Bard' (1757) describes how the last Bard (poet) to survive the persecution of the English King Edward I, in the late thirteenth century, curses the invading army before hurling himself from the top of Mount Snowdon. Gray's poem expressed a strong sense of British, rather than English, national identity in tune with the new nation's complex idea of its deepest character. The American-born Academician Benjamin West's *The Bard* of 1778 (no.92) is just one of many examples of the way the imagined heroes of Britain's Celtic past became mythically visualised – druidic long white hair and beard, flowing cloak, bare feet and harp being standard features for the doomed and isolated visionary. The identification of a lone seer with a wild landscape became a cliché of romantic painting and literature throughout Europe. This was a very different human presence to the one of the civilised gentleman in his well-tended grounds or even the reclining sentimental type in his shady literary grove.

### 'Make it Rough'

Theorising about art becomes more prevalent as the eighteenth century progresses, and begins to shape the wider audience's experience and expectations. German philosophers created the new area of 'aesthetics', a Latinate term coined by Alexander Baumgarten in 1750 to stress the importance of the senses in apprehending beauty, and analysed later at the highest level by the great Immanuel Kant. There

91 **Richard Wilson**
1713–1782
**Llyn-y-Cau, Cader Idris**
?exh. 1774
Oil on canvas
51.1 x 73

was also a strong tradition of such writing in Britain, from the Earl of Shaftesbury's *Characteristicks* (1711) onwards, and art became a means of talking about the other great philosophical questions, moral, political and spiritual. One of the first concepts to move from the seclusion of the studio and cognoscenti's drawing room into the public sphere was that of the 'picturesque', a term broadly applied to kinds of image, tourism, gardening and amateur draughtsmanship.

As tourism in Britain became more popular, so the demand for a certain kind of imagery grew. Guide books recommending particular itineraries, say through the Lake District, were accompanied by illustrations which pictured the landscape in ways evocative of old master artists. Polite society's new conversation pieces were landscapes, either real or depicted, offering endless opportunities for refined discussions of nature, morality and art. The really earnest seeker of the picturesque could purchase a darkened reflecting 'Claude Glass', as an aid to transforming actual scenes into pleasantly composed images. The typical notion of a 'beautiful' landscape was derived from the idealised classical compositions of Claude Lorraine, the key influence on Richard Wilson, while a more 'sublime' effect would draw on the wilder scenes of the Italian painter Salvator Rosa. So, in the first instance, picturesque referred to the conformity of the perception of a real landscape to a number of types of paintings. By the 1770s, however, the term becomes more specific and carries a set of pictorial and emotional associations.

The first writer to develop some of these connotations for a wide readership was the Revd William Gilpin, an amateur artist and writer. In the 1780s and 1790s he wrote a number of essays for a middle-class readership on picturesque landscape based on his observations in the Wye Valley and in South Wales. He defined the qualities of the picturesque as those of irregularity, variety, roughness and curious detail, comparing it favourably with the regularity, smoothness and generalisation of the academically beautiful – 'make it rough', he wrote, 'and you make it also picturesque'. Following some of the ideas we have found in Hogarth's *Analysis of Beauty*, Gilpin became such a fanatical exponent of his all-embracing idea that he soon became the butt of satirists, most famously in William Combe's long poem *Doctor Syntax's Tour in Search of the Picturesque. A Poem* (1812), illustrated by Thomas Rowlandson (no.93). It is significant that professional artists were so scathing about Gilpin's words and slightly clumsy images – the energetic churchman's encouragement to his readers to take up the fairly undemanding hobby of landscape sketching was to some degree a threat to their trade.

**93 Thomas Rowlandson**
1756–1827
**Plate 18 of 'Doctor Syntax's Tour in Search of the Picturesque. A Poem'**
1812

94

**94 George Morland**
1763–1804
**Outside the Ale-House Door**
1792
Oil on canvas
34.9 × 27.3

With such painters as Thomas Gainsborough and Francis Wheatley, George Morland created a popular genre of peasant scenes, typically of figures by cottages and ale-houses. The son of a painter and forger and notorious as a drinker, gambler and jailbird, Morland's scenes have provoked art historical debate about their political overtones at a time during the wars with revolutionary France when groups of lower-class characters took on a significance they did not normally carry. Morland was a pioneer of the moralising and picturesque Dutch-inspired genre scenes, which later brought such success to David Wilkie and William Mulready.

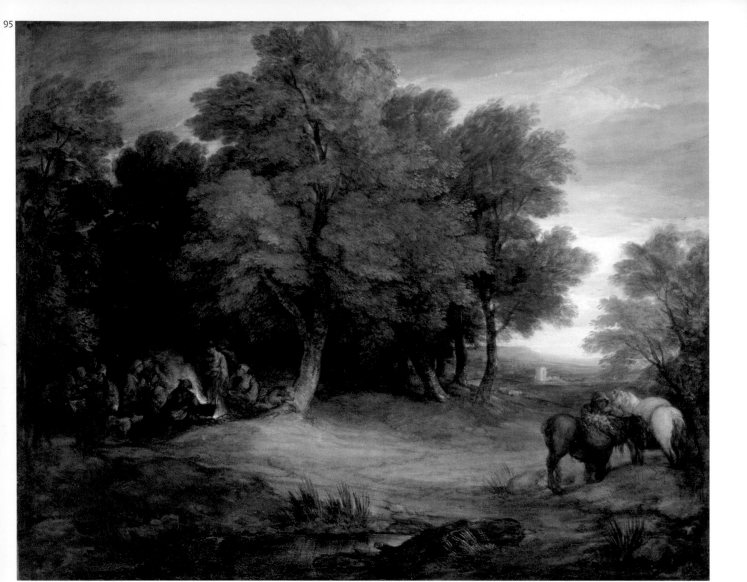

96 **Robert Ker Porter**
1777–1842
**An Ancient Castle**
*c.*1799–1800
Watercolour and pencil on paper
20.9 x 29.6

95 Thomas Gainsborough
1727–1788
**Gypsy Encampment, Sunset**
*c.*1778–80
Oil on canvas
120.6 x 150.5

Art historians have squabbled for at least two decades about the political meanings of eighteenth-century landscape paintings. At a time of calls for the nationalisation of land, how far were images, such as this one by Thomas Gainsborough, fantasies designed to reassure landowners and others with a vested interest in social stability? Gainsborough seems to identify here with his gypsies and peasants, as Augustus John was to do in the early twentieth century. Gainsborough's own interests, motivated by a distaste for his main source of income, portraiture, are with aesthetic questions of colour and atmosphere. A native of Suffolk, Gainsborough mainly worked from imagination, creating models of scenes with twigs, bits of glass and moss in his candle-lit London studio.

The 'amateur' tag also did not help the cause of professional landscape artists who, led by J.M.W. Turner and others at the start of the nineteenth century, sought parity with history and portrait painters. Peacham's courtly gentlemen amateurs, who partly fashioned themselves through drawing, had transmogrified over two centuries into a large army of often female enthusiasts, wandering the countryside in search of improving views and prospects. In Jane Austen's *Northanger Abbey* and *Sense and Sensibility*, this search of course extended to prospective spouses, allowing the novelist to make ironic comments about the different natures of men and women – rational and capricious, utilitarian and emotional and so on.

In the art criticism of William Hazlitt and the feminist writings of Mary Wollstonecraft in the late eighteenth century, we have the beginnings of a simultaneous critique of the oppression of women through such polite education, and of the vulgar consumerism it was associated with. The debates are as heated as those about religious images a few hundred years previously.

The professional artist most often popularly recognised as the genius of the picturesque was the short-lived watercolourist Thomas Girtin, son of a London brushmaker, of whom it has been claimed that Turner said that had he lived, 'I should have starved'. Whatever the truth or exact meaning of this now famous statement, Girtin was certainly a very great talent. The comment in the highly popular *Repository of Arts* published by the printseller, publisher and artist materials manufacturer Rudolf Ackermann, conveys the high esteem in which he was held: 'In the works of too many artists we perceive only the labour of the hand, but in Girtin the hand was obviously directed by a superior mental power and capacity.' He was seen as quintessentially English in his manner, was technically daring and possessed an intuitive grasp of a landscape's essential features. The convergence of his brief career with the wars against France no doubt accentuated the critical tendency to find in his work signs of a national genius.

Girtin and Turner both worked in the 1790s for the physician, amateur artist and connoisseur Dr Thomas Monro at his house in the newly fashionable Adelphi Terrace in the West End, built by the Adams brothers. Girtin, Turner and other young artists were employed in the evenings to copy works by predecessors such as J.R. Cozens and Thomas Hearne – Girtin, for example, doing outlines and Turner filling them in with watercolour washes, the two artists working at a shared candle-lit desk. Girtin made various tours of Britain and his ambition, shared with Turner, Edward Dayes and others at the

97 **Thomas Girtin**
1775–1802
**The White House at Chelsea**
1800
Watercolour on paper
29.8 x 51.4

On a biscuit coloured paper, Thomas Girtin, who died of tuberculosis or asthma at the age of twenty-seven, creates a tranquil Thames scene at sunset. It is dominated by a bright house on the Chelsea shore picked out by leaving the paper virtually bare. Influenced by Rembrandt and made while he was undertaking schemes of panoramic views of London and Paris, this was the kind of watercolour that became synonymous with a distinctly English school of landscape. Girtin, even above J.M.W. Turner, was seen as its natural, and tragic, leader.

time to elevate the status of landscape art led him and his friends to form a sketching club in 1799 called The Brothers. This group anticipated the Pre-Raphaelite Brotherhood in its quasi-masonic ethos of fraternity, and aimed to establish a 'school of Historic land-scape'. They soon became the Sketching Society which followed the pattern of each member hosting a meeting, setting a 'poetical subject' to be drawn and providing food and drink for colleagues. Robert Ker Porter was the host, and possibly the founder, of the first meeting of the Society at his studio off Leicester Square in 1799. His *An Ancient Castle* (no.96), painted in monochrome washes, is typical of a new Romantic tendency in landscape art to paint 'poetical subjects', in response to Joshua Reynolds' call, in his 4th *Discourse*, for a national school of landscape painting in an elevated style. Whatever the reservations artists had about the Academy's first President, his word counted.

## Panoramavision

Between the baroque opera and ceilings and cinema came the 'panorama'. Girtin was among many other artists, including Philip James De Loutherbourg, who contributed to the rage for panoramas, which lasted from the time the Irish artist Robert Baker displayed his 'interesting and novel' 360-degree view of Edinburgh on a huge cylinder, in the middle of which the paying spectator stood, until the middle of the nineteenth century. Girtin's panorama of London, the *Eidometropolis*, painted in 1797–8 and finally shown at Vauxhall Gardens in 1802, was 6 by 36 yards (5.48 by 32.91 m), and was a relatively sophisticated example of this new entertainment, which was dominated by sea battles and storms. Music and other sound-effects accompanied the landscape images, which demanded elaborate structures to house them and to accommodate the crowds of visitors.

98 Robert Mitchell
fl.1782–1810
**Section of the Rotunda, Leicester Square, in which is exhibited the 'Panorama'** 1801
Coloured aquatint, 28.5 x 44.5
The National Film Archive London

This shows the world's first panorama rotunda, designed by the Scottish architect Robert Mitchell. This could show two panoramas at once and in the Upper Circle can be seen Henry Aston Barker's famous 2,700 square-foot (251 sq.-m) 'London from the Roof of the Albion Mills', the drawings for which were executed in 1790–1791. The finished panorama was painted in oil on canvas and first shown at Leicester Square in 1795.

In spite of the war with France, Barker's panorama visited Paris.

# Chronology
## 1720–1800

**1720**
'South Sea Bubble' financial crash.
John Vanderbank's Academy,
London founded

**1726**
Swift *Gulliver's Travels* published

**1727**
Accession of George II

**1728**
Gay's *Beggar's Opera* first performed

**1733**
Society of Dilettanti founded to
encourage connoisseurship and
art collecting

**1735**
St Martin's Lane Academy, London,
founded by Hogarth and others.
Engraver's ('Hogarth's') Copyright Act

**1738**
Beginnings of Methodism

**1740–8**
War of Spanish Succession

**1741**
Samuel Richardson *Pamela*
published

**1744**
Samuel Baker's first auction of books –
firm later becomes Sotheby's

**1745**
Second Jacobite Rebellion. Failure
results in end of Stuart hopes

**1749**
Henry Fielding *Tom Jones* published

**1753**
William Hogarth *The Analysis
of Beauty* published

**1754**
Society of Arts founded

**1754–62**
David Hume *History of England*
published

**1756–63**
Seven Years' War between Britain and
France – first 'world war'

**1757**
Edmund Burke *Philosophical Enquiry*
published on ideas of sublime
and beautiful.
British Museum founded

**1760**
Accession of George III.
First Society of Artists exhibition
in London

**1762**
Stuart and Revett *Antiquities of Athens*
published

**1763–71**
Horace Walpole *Anecdotes
of Painting* published

**1764**
William Hogarth dies

**1766**
George Stubbs *Anatomy of
the Horse* published.
James Christie's first sale of art works

**1767**
Laurence Sterne *Tristram Shandy*
published.

**1768**
Royal Academy founded.
First volumes of *Encyclopedia
Britannica* published.
Adam brothers begin work on
the Adelphi

**1770**
Captain Cook arrives at Botany Bay

**1771**
Richard Arkwright's first spinning mill.
George Vertue *Anecdotes of Painting in
England* published

**1776**
Edward Gibbon *Decline and Fall of
the Roman Empire* published.
Adam Smith *Wealth of
Nations* published

**1776–81**
American War of Independence

**1777**
John Howard *State of Prisons* published

**1780**
Anti-Catholic Gordon Riots in London

**1784**
Ordnance Survey of England
established

**1785**
*The Times* newspaper founded

**1786**
Boydell's Shakespeare
Gallery founded

**1789**
French Revolution starts.
William Blake *Songs of Innocence*

**1790**
Edmund Burke *Reflections on the
Revolution in France* published

**1791**
Thomas Paine *Rights of Man* published

**1792**
Mary Wollstonecraft *Vindication of
Rights of Women* published.
Joshua Reynolds dies

**1793–1815**
War with France

**1794**
Uvedale Price *Essay on
the Picturesque* published

**1795**
Ecole des Beaux-Arts, Paris founded

**1796**
Vaccination against smallpox
introduced

**1798**
Irish Rebellion.
William Wordsworth and
Samuel Taylor Coleridge *Lyrical
Ballads* published.
Joshua Reynolds *Discourses* published

Whether I look merely at home, or, stretching my eye farther, contemplate the boundless prospect of conquest and possession – achieved by British perseverance and British valour – I clasp my hands, and turning my eyes to the broad expanse above my head, exclaim, 'thank heaven, I am a Briton'.
(Mr Gregsbury in *Nicholas Nickleby*, 1839, by Charles Dickens)

Between 1790 and 1830, over 130 million people lived under British imperial rule. By the end of the nineteenth century, the figure was far higher. Britain, already self-conscious as a 'warrior nation', also became the most powerful industrial and commercial power in the world. Paradoxically, as many historians point out, the 'warrior nation' became, in the first half of the nineteenth, one of the most 'inhibited, polite, orderly, tender-minded, prudish and hypocritical'

countries in the world. Hogarth's world was disappearing fast.

These facts must have some bearing on the development of the nation's visual culture even if it is difficult to untangle the connecting threads – whether on Turner's obsession with the rise and fall of empires, Constable's often nostalgic rural vision, Landseer's images of 'wild' nature and sentimental pets, Ward's brooding native landscape protected by well-bred beasts, the increase in 'oriental' subject matter, Cruikshank's fear of social implosion or the state's increasing concern with the economic and ideological significance of the fine arts. The question of this newly imperial nation's contradictory tendencies will not be laboured here, just indicated as a feature of British life which grows in significance and remains a potent national heritage today. Mr Gregsbury's proud but faintly comical words still resonate.

**9 Philip James De Loutherbourg**
1740–1812
**The Battle of the Nile**
1800
Oil on canvas
152.4 × 214

Born in Strasbourg, Philip James De Loutherbourg is yet another foreign-born 'British' artist. He worked for the actor David Garrick on stage sets in the early 1770s and in the 1780s was celebrated for his

'Eidophusikon' in Lisle Street, an early panorama with music and cunning landscape effects. A devotee, like William Blake, of Swedenborg's theology, he was also a freemason, faith healer and an experimenter in the

occult aspects of light and oil paint. His esoteric interests led a crowd to attack his house in Hammersmith in 1789. De Loutherbourg's theatrical skills made him a brilliant painter of battle scenes and here the

extraordinary explosion of colours signifies the crucial destruction of the French flagship by Nelson's fleet at ten o'clock one dramatic evening in 1798.

100 **after Joseph Mallord
William Turner**
1775–1851
**Birmingham
Engraved by James Storer**
1771–1853
Published 1795
Engraving on paper

The Itinerant.

BIRMINGHAM.

### The Odd Couple

Our view of British art in the first half of the nineteenth century is dominated by the work of two landscape painters who have both made major contributions not only to art history but also to the wider national culture – in the case of John Constable in his creation of an imagery that has helped to define a sense of the typical English landscape and, in the case of J.M.W. Turner, a type of the native genius. Throughout the last century and a half, they have both been used in the interests of defining aspects of the national identity, while nevertheless retaining their pre-eminence as English painters of international status.

Constable and Turner loom large in the Tate Britain displays. Famous as a pair of opposites in temperament and talents, their parallel careers are evoked by the almost comical image of the two men's rivalry on Varnishing Days at the Royal Academy. These were occasions, formally established in 1809, when artists could work on their canvases in situ just prior to the preview of the Academy's annual exhibition – still the only show in town in the early nineteenth century, in spite of strong competition from venues such as the British Institution. Legend tells of the stout and top-hatted cockney Turner increasing the brightness of his colours to almost absurd effect, while the usually reserved and reclusive

Constable would add red and other touches to outwit his duelling partner.

This was, after all, the era of the Romantic musical virtuoso and grand actor, with the requirement of major artists that they perform their lives and art publicly. Artists were now public personalities, and the creation of personal identity and the pursuit of self-promotion was part of a successful career. Inevitably no artist could control such matters, which may be just as well in many respects, and this complicates our view – whereas in earlier periods we tend to suffer from a lack of information, we are now faced with not only much more data about artists but with much more unreliable data and mythmaking.

Examining the two men's art alongside one another will allow us to see a variety of aspects of their individual characteristics, while pointing up some wider questions about art in Britain during the Napoleonic wars and in the period during which Britain came to be regarded as the most powerful nation in the world. The industrial growth that was such an important component of this power was something which fascinated Turner, who not only painted his obsession with the sun – apparently described by him as 'God', perhaps a teasing intimation of his uncertain religious beliefs or unbeliefs – but with the destinies of human and

mechanical energy throughout history. As a devoted follower of Richard Wilson, Turner was much admired for his classical landscapes, with their literary allusions and morally uplifting sentiments. But he also saw contemporary life as part of the dynamic of history from an early stage in his career.

As a young man he made his living primarily from topographical watercolours of sites across the country, which served as the basis for engravings in the popular guide books and picturesque literature of the time. This was usually dominated by views with some clearly historical associations, but Turner's prospects of the nation included new towns such as Birmingham, which would have been understood as fast-growing manufacturing centres of the sort we might associate with Joseph Wright (no.100). Turner enjoyed the contrast of old housing and medieval churches with the smoking chimney stacks of factories, and would undoubtedly have felt a degree of patriotic pride in making images of the modern country he was growing up in. While before, the great contrast in historical landscape art had been between Rome and Carthage, now it was between London and Paris, Manchester and Lyon. Turner's classical landscapes are full of earnest warnings about the dangers of power, luxury and imperial decadence, and the same sense of history's inexorable processes informs his contemporary views

of industrial Britain. His pessimism about the inevitability of decline, expressed in his ongoing poem 'Fallacies of Hope', quotations from which were used by the artist to inform the reading of his paintings, makes his complex vision clear in its main thrust (no.101).

Constable was equally interested in the world around him – indeed, unlike the classically minded history artist Turner, he only painted contemporary scenes. His attitude towards that scene, however, is entirely different. Constable's chief aim was to capture a particular version of the rural setting of lowland southern England, in which he had grown up as the son of a prosperous East Anglian agricultural businessman. *Flatford Mill* (no.102), which shows the view up a navigable river on his father's land, is a masterpiece not only of painting but of the observation of an actual working landscape. While it evokes a timeless idyll at one level, at another it powerfully attracts our interest in the activities, vessels and machinery – and even the geology, botany and meteorology – of a particular place at a particular time one day in Suffolk in 1816. Constable worked on this piece outdoors, and his concern with realism can be gauged by his apparently tracing the outline of the scene with ink on a piece of glass held up to the view before him on an easel.

The mill and river were part of Constable's sense of himself, and the signature in the foreground is painted

01 **Joseph Mallord William Turner**
1775–1851
**Snow Storm: Hannibal and his
Army Crossing the Alps**
exh. 1812
Oil on canvas
146 × 237.5

The verses from J.M.W. Turner's on-going 'Fallacies of Hope' poem, using a theme from the poet James Thomson's 'Seasons' (1726–30), refer to Hannibal, whose tiny figure mounted on an elephant can be seen under the vast, sublime arching storm over the Alps. He is warned by the breeze to beware of 'Capua's joys', meaning the debilitating pleasures of Italy. Inspired by a storm seen in Yorkshire, Turner used Livy's 'History of Rome', perhaps also to comment on Napoleon's disastrous collapse in Russia that year. Turner, who hung the work low at the Academy, uses a swirling vortex composition to draw the spectator into the drama.

102 **John Constable**
1776–1837
**Flatford Mill ('Scene on
a Navigable River')**
1816–17
Oil on canvas
101.6 x 127

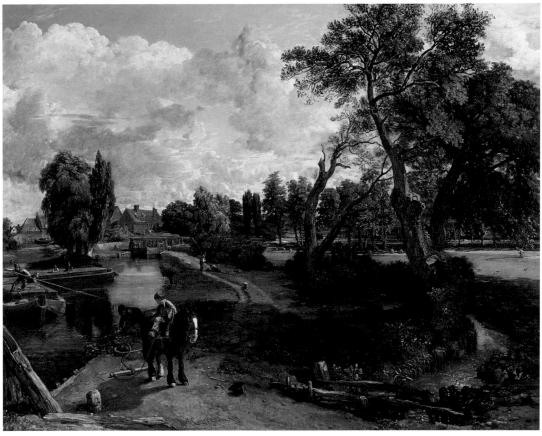

as if it were inscribed in the earth with a stick by a young boy. It is in part a proprietorial gesture, but also a nostalgic one. and much of Constable's art is concerned with a disappearing landscape remembered from boyhood. Constable was Conservative politically (Turner was probably more liberal and Whiggish) and also a devout Anglican. His idea of who he was and what Britain was is informed by his identification with a certain social hierarchy sustained by the theology of the Book of Common Prayer and a deep attachment to the values and rhythms of the country rather than the town. His love of English poets such as Thomas Gray and James Thomson contrasts interestingly with Turner who, while he much admired these writers, was more eclectic and wide-ranging in his reading.

Unlike the untravelled landlubber Constable, who never left England and didn't greatly enjoy his one trip to the Lake District, Turner was maritime as well as mountaineering in his instincts, and restlessly travelled across the British Isles and to Europe, sketching and taking notes towards finished works. *The Shipwreck*, exhibited at his own gallery in 1805 (no.103), is typical of the way in which Turner combined a dramatic sea subject with competition with the old masters and the ambition to make a contemporary form of history painting for a broad audience. Clearly intended to rival the great Dutch

painters of the seventeenth century, this large canvas was a huge success. It is obviously a bravura piece of painting with its brilliant evocation of a lowering sky, overwhelming waves and agitated foam which threaten the survivors of the shipwreck.

More than that however would have struck Turner's contemporaries. In the year of Nelson's victory at Trafalgar, the inhabitants of an island nation fighting for her survival would have been thrilled by an image which dramatised so brilliantly the power and sublimity of the sea and man's impotence in the face of such vast natural forces. Furthermore, for a country which suffered annually about five thousand deaths at sea, and which was fed on often sensational stories and crude reportage of sea disasters, this was history painting for the present moment. It has been suggested that this painting may have been intended to refer to a recent shipwreck of a vessel captained by the brother of the great landscape poet William Wordsworth. The narrative of this event was well known, with its brave captain probably committing various errors of judgment as the drama unfolded, the reactions of the crew ranging from cowardly selfishness to the highest valour and, not least, stories of vast treasures lost when the ship sank.

Such disasters provoked intense speculation and gossip as well as providing enormous opportunities

**03 Joseph Mallord William Turner**
1775–1851
**The Shipwreck**
exh. 1805
Oil on canvas
170.5 x 241.6

104

*Dreadful Shipwreck of the FRANCIS MARY,*

**04 James Catnach**
1792–1841
**Dreadful Shipwreck of
the Francis Mary**
1826
Woodcut, 19 x 34
St Bride's Printing Library, London

A reminder of the popular art of the time, seen by many more than went to the Royal Academy or were able to afford expensive prints. This is a news broadside, or 'catchpenny' print, which carried a lettered key to explain the details. Up to a quarter of a million copies of such images could be distributed. James Catnach came to live in the printers' area of Seven Dials in London's Covent Garden from Northumberland in 1812. At his retirement in 1838 he was, like Turner, a wealthy man.

for the publishers of cheap prints and manufacturers of mugs, tea-towels and a host of other memorabilia. We are inevitably reminded of the popularity of disaster movies today such as *Titanic*.

Constable had little positive interest in such subject matter, at least for his own practice, and was probably scornful to some degree of Turner's instinct for a sure-fire popular image (*The Shipwreck* was widely distributed as a print). He was particularly disdainful of the urban masses who were attracted to such themes and his hostility, tempered by a kind of weary humour, can be discerned in one of his rare paintings of the sea, *Chain Pier, Brighton*, painted in 1826-7 (no.105).

Concerned that such beach scenes were becoming hackneyed, Constable nevertheless seems to have resolved not only to paint a major visual statement with the sky, as ever in his work 'the chief organ of sentiment', and the rich details of the foreground figures at work and at rest, but also to subtly convey, by a kind of grandeur of muted contrast, his melancholy about the world of modern leisure. The work was developed from drawings made of the new chain pier in 1824. He wrote to his friend the Revd John Fisher that 'Brighton is the receptacle of the fashion and off-scouring of London. The magnificence of the sea, and its (to use your own beautifull expression) everlasting voice, is drowned in the din & lost in the tumult of stage coaches – gigs – 'flys' &c. – and the beach is only Piccadilly ... by the seaside. Ladies dressed & *undressed* – gentlemen in morning gowns & slippers on, or without them altogether about *knee deep* in the breakers – footmen – children – nursery maids, dogs, boys, fishermen – *preventive service men* (with hangers and pistols), rotten fish & those hideous amphibious animals the old bathing women, whose language both in oaths & voice resembles men – all are mixed up together in endless & indecent confusion.'

Constable's magnificent windswept panorama shows fishermen at work in the foreground with signs of the growing holiday resort in the middle-ground and background – the bathing huts and a few bathers braving the cold and, rising ominously behind them, the new Marine Parade. Constable shows an old economic order giving way to a new one under the sign of an immense and surely theologically suggestive cloudy sky, which lets through a subdued but powerful light.

Turner showed a greater relish for modernity and, perhaps being a child of the inner city himself, seems to have found the rise of a mass society less alarming than the countryman Constable. In his later years in particular Turner painted some major statements about nature and modern progress, which create a very different sense of contemporary reality from those of his great rival. Painted five years after Constable's

**105 John Constable**
1776–1837
**Chain Pier, Brighton**
1826–7
Oil on canvas
127 x 182.9

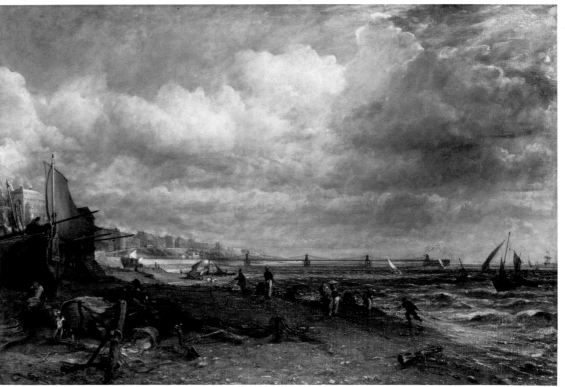

**106 Joseph Mallord William Turner**
1775–1851
**Snow Storm – Steam-Boat off
a Harbour's Mouth Making
Signals in Shallow Water,
and Going by the Lead**
exh. 1842
Oil on canvas
91.4 x 121.9

death, *Snow-Storm – Steam-Boat off a Harbour's Mouth Making Signals in Shallow Water, and Going by the Lead* of 1842 (no.106), with its typically lengthy title, is in some respects a manifesto of his vision. The subtitle to the painting goes on to claim that the 'Author was in this Storm on the Night the Ariel left Harwich'. Perhaps apocryphally, Turner also claimed he had been lashed to the mast in order the better to experience the storm.

Probably with a characteristic play on words, Turner gives a view from the eye of the storm. Christ- or Odysseus-like, Turner the heroic Romantic artist suffers the full intensity of nature's fury and paints his experience to maximise the spectator's sense of being at the heart of a vortex of swirling energy. Thus the humanly produced flame and smoke emitted from the funnel of the distressed steamer are sucked away from their source by a far greater power. The allusion in the title 'going by the lead' refers to the necessity during poor visibility of ships finding their way by using a lead weight hung overboard with a rope which, with the use of a map charting the depths of the water, allowed for a crude system of navigation. This no doubt appealed to Turner's imagination of the mind, going 'blind', struggling by its own efforts through a harrowing storm. This is a remarkable visualisation not only of a seastorm but of a whole way of seeing man's place in the wider scheme of universal forces. Turner pits his

creative organising skills against nature, as Constable did, but his position is more risky and the pessimism more exhilarating. Few critics saw the virtue of this at the time, and one accused Turner of painting with 'soap suds'.

While Turner was a bachelor with a housekeeper who bore him two children, Constable was a married man whose tubercular wife gave birth to seven children. This fecundity did her health no good, and in spite of convalescence in healthy spots such as the southwest coast and the family home in Hampstead on the northern edge of London, she died exhausted in 1828. It seems very likely that the devastation Constable felt at this loss is conveyed in his drawings and paintings of the ruined Hadleigh Castle on the mouth of the Thames in Essex (no.108). The large oil sketch for the finished painting has a dramatically viscous surface of dragged paint with stringy white highlighting, which is in contrast to the smoother finish used in the exhibited version.

Constable worked laboriously in developing his major works and seems to have suffered greatly as he approached a final exhibitable piece. The spontaneity and emotional gestures in paint which are a hallmark of his oil sketches are usually far less evident in the final works. Like Turner, Constable was searching for an authenticity of expression through uncharted

**107 John Constable**
1776–1837
**Cloud Study**
1822
Oil on paper laid on board
47.6 x 57.5

One of a hundred or so pure cloud studies using oil paint on paper made by John Constable in Hampstead in 1821–22. It is inscribed on the back: '27 augt 11, o clock Noon looking eastward large silvery (clouds?)

wind Gentle at S West'. Meteorological records for 1822 suggest this was a bank of towering cumulus clouds about to produce rain during a stormy day. Knowledgeable through his father's business with

windmills and the ideal conditions for their working, Constable was fascinated by the contemporary meteorological writings of Luke Howard and Thomas Forster. His theological and psychological convictions

give his sky studies a profound sense of a supernatural breeze.

technical realms, which often provoked severe criticism from other painters, collectors and the host of art reviewers.

Hadleigh Castle was of course a fine example of the picturesque historical ruin, popular as a subject with an audience fascinated by the medieval national past. In that sense, with its lonely shepherd and dog in the foreground, it evokes a certain familiar genre. The ruined tower, whose dark hollow interior is revealed by a vertical gash in the wall facing us, has a kind of personality to it that seems to go beyond that of the architectural anthropomorphism typical of the period. Constable wrote to friends after Maria's death that he was much obsessed with gloomy subjects and desolate places. Even the engraving of *Glebe Farm*, which has become famous among the icons of his imagery of homely Suffolk, included a ruin, 'for, *not* to have a symbol in the book of myself ... would be missing the opportunity'. So he places himself, as it were, in the foreground, under a turbulent sky, looking over a bleak estuary early in the morning, as if to convey the full weight of a deep depression. But there is a strong sense of something beyond individual pain. Where Turner painted himself, so to speak, as part of a modern machine struggling against fate, Constable depicted himself as part of the land, awaiting his own death with a kind of stoical fortitude. It is known that he greatly admired a poem by Wordsworth, 'Elegiac Stanzas – Suggested by a Picture of Peele Castle, in a Storm' (1807), based on a painting of a ruined castle by Sir George Beaumont, which ends, 'Not without hope we suffer and we mourn'. Constable's deep religious faith, tested by his study of nature in the book as well as the field, remained intact in an age fast losing its religious certainties.

The dynamic and notoriously experimental Turner was himself a supreme artist of the national picturesque. One subject to which he returned throughout his career was the great castle at Norham on the River Tweed on the English–Scottish borders (no.109). Turner had reproduced a version of the subject in his *Liber Studiorum* (1816), a treatise on the types of landscape art, and used this as the starting point for one of his most memorable late works. The thinly worked oil painting – which could not have been easily displayed publicly when it was painted in the mid-1840s due to its unfinished appearance – is radically depleted of naturalistic detail except for enough visual clues to establish the setting. The much-diluted pigment runs down the canvas as Turner plays a serious and sophisticated game with representation – here in the interest of his all-consuming passion for capturing evanescent light effects, atmospherics of place and complex reflections. The castle and

108 **John Constable**
1776–1837
**Sketch for 'Hadleigh Castle'**
c.1828–9
Oil on canvas
122.6 x 167.3

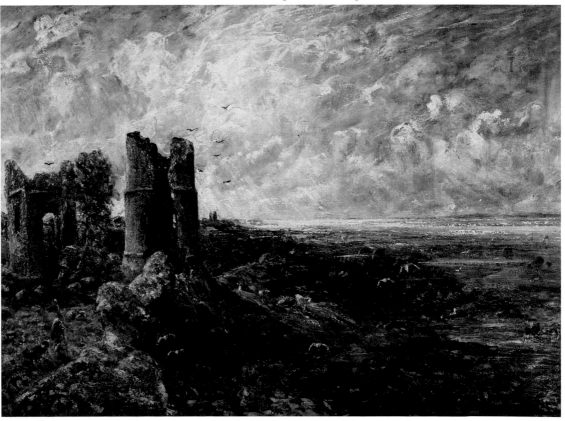

surrounding landscape seem to dissolve into the sunlight and water, and the effect on the viewer is an almost mystical subversion of tangible experience.

Turner had a personal metaphysical theory of light, which was in his imagination a sign both of the unfathomable power of the sun and of the threat of total extinction by the great star that scientists and bishops alike believed would one day expire. Turner's fear of going blind, evident in a number of the subjects he painted, was as much an existential dread as a phobia about physical injury. Like Constable and many artists at the time, he was a keen reader of books on light and optics, and in his last years heavily annotated the *Colour Theory* by the great German poet and natural philosopher Goethe, which had been translated into English by a future President of the Royal Academy and Director of the new National Gallery, the painter Charles Eastlake. Goethe, with a conviction which would have delighted Blake, rejected the optical theories of Newton based on physics, and instead proposed a subjective analysis of the spectrum divided into 'positive' colours – red, yellow and green – and 'negative' ones – blues, blue-greens and purples. These, Goethe believed, corresponded to states of mind – positive ones such as happiness and warmth and negative ones such as restlessness and anxiety. Turner dwelt on these concepts over many years and

found novel, unexpected and, for his critics, often unwelcome means to reinvent them in pictorial terms. Unlike Constable he does not appear to have had firm religious convictions, and can almost be compared to the German philosopher Arthur Schopenhauer in his deep yet fragile pessimism. As if reflecting a frenetic race to outwit time and to forget the darkness towards which he was headed, Turner's avalanche of work produced over a career of more than fifty years has been hailed as a precursor of both Impressionist and abstract art – a distinction, particularly with respect to abstraction, which he might have viewed with some considerable misgiving. He was rarely abstract in his impulse, but rather was a spiritually charged visionary of empirical experience. A man of fruitful contradictions, he was in many senses a descendant of Joseph Wright as much as of Claude Lorrain, the painter he is most often associated with, and next to whose works he expressed in his will the wish for his own canvases to be seen in the National Gallery.

### The Also-Rans

It has been the subsequent misfortune of many talented contemporaries of Turner and Constable to have been viewed as also-rans, who merely make up the numbers prior to the arrival of the young Pre-Raphaelite painters at mid-century. Artists such as

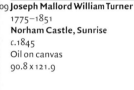

**109 Joseph Mallord William Turner**
1775–1851
**Norham Castle, Sunrise**
c.1845
Oil on canvas
90.8 x 121.9

Crome, Wilkie, Mulready, Etty, Landseer, Dyce and Martin are not such remarkable figures, it is true, but they produced high-quality work in their fields, which testify to a period of great activity and change in British art. The line often taken, no doubt in order to neaten up history once again and to set up the Pre-Raphaelites as *dei ex machina* after a *longueur*, is that these artists are dull in both execution and concept and represent a kind of banalisation of British art in the wake of a declining Romanticism.

A cursory look at the major events in British history and art during the post-Waterloo period from 1815 up to the Great Exhibition of 1851, the year of Turner's death, reveals enormous change during a period of imperial expansion and peace in Europe. The highlights include the arrival of the railways and the penny post, the invention of photography, the introduction of gas lighting in London, the emancipation of Roman Catholics after nearly three centuries of suppression and the beginnings of the Oxford Movement, the passing of the first Reform Bill and the rise of Chartism, the publication of Marx's and Engels' critiques of capitalism, the abolition of slavery and the epoch-making discoveries of the second law of thermo-dynamics and of natural selection. We have entered a period of acceleration across the board of human activity and Britain plays a central role in all areas.

In the visual arts there are a number of key developments, with the opening of the National Gallery in 1824 and the founding of the first national art schools in the 1830s being the most important. (Technical developments considered elsewhere are significant too – the production of many new pigments, for instance, giving artists a whole range of possible new effects and, in the longer term, the revolution in representation instituted by photography.) Both reveal the state taking an often reluctant but important role in shaping policy, which was to have major consequences for the growth of the fine arts in the nation. It is important to remember that Britain's political supremacy after 1815 was a source of anxiety for many leading figures, who feared complacency would set in and that Britain would soon find herself in decline. We have seen this theme in art and literary and political theory earlier – Turner's art is obsessed with it – but the intensification of the involvement of government makes the debate more critical and heated. Against a background of a growing utilitarianism in economic and political thinking, in a nation fast turning into an urban society, governments invested in culture in order to achieve certain ends. Where the Stuarts had seen the arts as an instrument of power in terms of diplomacy and popular spectacle, the new democracy had far more wide-ranging and tricky ambitions.

110 **George Robert Lewis**
1782–1871
**Clearing a Site in Paddington for Development**
?c.1815–23
Pencil and watercolour on paper
26.7 x 49.5

The turn of the nineteenth century saw the acceleration of the expansion of London as it became the first 'World City'. The village of Paddington, through which the new Regent's Canal ran, is shown as a site of the westward development of the metropolis, rural life giving way to the urban as part of a trend many viewed with great concern.

Edwin Landseer was a child prodigy, a favourite painter of Queen Victoria and the inventor of an anthropomorphic animal world that could be both sentimental and extremely violent. Sir Walter Scott was the hugely successful writer of the romantic 'Waverley' novels, whose house at Abbotsford in Scotland Landseer first visited in 1824. Landseer depicts Maida, Scott's ageing deerhound, lying on a rug, and a younger dog sitting behind. He captures the archaic atmosphere of the novelist's home, with ancient armour, hunting horn, falcons, boar spears and a deerskin rug with horns, and where only animals can seem both contemporary and not out of place.

The National Gallery was not only founded in order to compete with France at the level of national pride and to house works formerly privately owned for all to see, it was also part of a strategy to help the economy retain its momentum. The logic was something like this: the great European nation-states survived through commerce, trade and industry. These flourished in a competitive and international market. It was therefore necessary to have a number of functions in place in the sphere of culture – an aesthetically educated and sophisticated class of artisans and manufacturers able to produce attractive and well-designed goods which would sell at home and abroad. Part of this could be achieved by making available to these classes works of art, the awareness and study of which underpinned such taste.

Hogarth, Barry and Reynolds would have found nothing unusual here. In order to capitalise on the design talent available the new National Gallery and similar institutions founded in the large regional and industrial cities would be supported by a network of new art and design schools. Following the founding of the Royal College of Art in 1837 as a founding part of the great Albertopolis project in South Kensington – which included what became the Victoria and Albert Museum with its mission to provide an aesthetic education for the subsequent generations of industrial

magnates, designers and artisans – other art schools mushroomed across the country. A primary artistic aim was also to establish finally a truly national school of British art, with its own character, history and sense of destiny. We have the beginnings of 'Brit Art' and the origins of the Turner Prize.

A further expected side effect of these policies was to be more broadly social and moral. The new initiatives, generated through a series of select parliamentary committees in the 1830s and 1840s, presided over by figures such as Prince Albert and Henry Cole, the first great art world committee man and administrator of the Great Exhibition in 1851, aimed at reform of public behaviour and morals especially among the working classes. While visiting exhibitions and reading new magazines such as the *Art Journal* were part of middle-class life it was hoped that the potentially fractious and disobedient urban masses would forsake what were believed to be their preferred pastimes of drinking, casual sex and seditious violence, and turn to a more piously genteel existence. The local gallery and art class would replace the pub, manners would improve and Britain would retain its slightly surprising ascendancy in the world through inspired product design and informed consumerism. Looking at art was good for you, whether it was the old masters or a maiolica plate. The inner person was

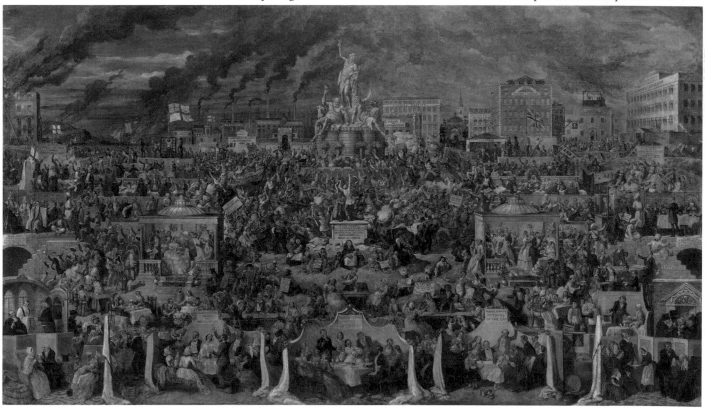

112 **George Cruikshank**
1792–1878
**The Worship of Bacchus**
1860–2
Oil on canvas
236 × 406

A panoramic view of the effects of alcohol on British society. Clergymen, doctors, railway drivers – all of society has succumbed to the curse of drink. George Cruikshank was a political caricaturist in the tradition of James Gillray, who had satirised the private life of the Prince Regent early in his career. A reformed drinker who had already made a popular Hogarthian series on the evils of alcohol, Cruikshank was involved in many temperance schemes to improve the habits of the working classes, including a drive to promote tea-drinking and provide alternatives to the pub. This work toured the country as part of a nationwide campaign. The scene is dominated by the god Bacchus, whom we have already encountered in the company of Joseph Van Aken's respectable bourgeois tea-drinkers in the 1730s (no.45).

**13 John Crome**
1768–1821
**The Poringland Oak**
c.1818–20
Oil on canvas
125.1 x 100.3

improved and society civilised by such experiences. That was the theory.

### 'Give up Norwich'

While such policies had enormously complex effects throughout art practice and indeed throughout the wider society, they seemed in the first instance to have come from London. We have seen, albeit fleetingly, that the new regional cities of the Midlands and the North had their own cultures of art and learning, with often radical intellectual and aesthetic outlooks and an independent turn of mind which deeply influenced British art. They were also often more politically radical and religiously non-conformist than their London counterparts with their connections to court, government and the City.

A good instance of a provincial art scene is that which came to be called the School of Norwich. The quickly modernising capital of East Anglia, made prosperous by its textile industry, had by the early nineteenth century its own art society to match the other scientific and philosophical ones, exhibitions, businessmen collectors and native artists able to earn a fair part of their living locally through the new wealth of their patrons. Although the artists' livelihoods depended upon teaching young ladies drawing, acting as dealers and restoring and copying old master works,

there was an economic base within which a career could be pursued that was not present fifty years earlier. As never before, artistic activity and its visible support in such settings was seen as a sign of local vitality and a mark of prestige.

The dominant figure in Norwich painting was John Crome, admired by Constable and Turner, and an early pioneer of *plein air* painting – that is, making watercolour drawings and, in some cases, even finished oil paintings, out of doors. Responding to the taste for local topographical scenes with all their personal and historical associations, and to the identification of the East Anglian aesthetic 'turn' with the great Dutch landscape painters of the seventeenth century, Crome invented an iconography of the local landscape that helped to form a sense of regional identity. This ran from the city itself to popular spots such as Mousehold Heath, to the Norwich River and Yarmouth beach along the coast. The latter scenes can be compared with Constable's Brighton scenes already discussed.

In the case of *The Poringland Oak* of c.1818–20 (no.113), we have a work that evokes the local vision of Constable with the more classical idylls of Turner, and yet which has a very specifically local significance with interesting allusions to a sense of the national. Crome, like most of his fellow Norwich painters, was neither parochial nor indifferent to the London and indeed

114 **John Sell Cotman**
1782–1842
**Norwich Market-Place**
c.1809
Watercolour on paper
40.6 x 64.8

The elegant shops on Gentleman's Walk paved with Scotch granite, on the left, and the busy Norwich market stalls give an impression of a thriving city in a buoyant nation at war. Cotman, a master of water-colour wash drawing, creates a modern vibrancy suggestive of intense activity and energy. Viewed from the north east, this scene is reminiscent of the views of Covent Garden popular nearly a century earlier.

European art scene. He travelled to France and sold his work through the London system. This awareness is evident in Crome's picturesque yet mysterious oak. Indebted to a range of sources, including Hobbema and Ruysdael, Crome concentrates his attention on the intricacies of branches and leaves, through which a light shines onto a group of young boys bathing in a pool. The oak tree of course has a particular resonance in Britain as the national tree and, during the Napoleonic Wars that had ended a few years before this work was painted, it had acquired a powerful connotation of safety, strength and historical endurance. Many oaks throughout the country had locally inspired names like the Poringland, and some were associated with myths and historical events and attained a kind of personality. If the over-interpretation is allowed, the boys can be seen as safe under its vast presence and shade as if in the company of some wise elder.

Crome, like Constable, was a naturalist whose botanical interests were deeply inflected by theological beliefs. He owned the complete works of William Paley, whose *Natural Theology and Evidences of Christianity* presented the natural world as proof of the Creator's existence, and had a major impact on artists and writers including Coleridge and John Ruskin. Before the age of Darwin, artists such as Crome could believe with little difficulty that art and science were both practices united in their revelation of the truth of God's power and providential activity in nature. It is during these early years of the nineteenth century that we find a distinctly British sense of the native naturalist artist observing the light and colour of his surroundings, and thereby confirming both a national genius for such activity and its conformity to the will of the creator.

Unlike their French counterparts who were academically inclined to worship abstract rules and precise drawing, so it was claimed, British artists had a natural aptitude for colour and the capturing of impressions out of doors that embodied an independnce of mind and imaginative freedom. Hogarth might well have approved of such general sentiments, if slightly bored by the subject matter. As a Londoner he might also have concurred with the exhortation of the great watercolourist John Sell Cotman to his son Joseph: 'If you wish to be an artist you *must* leave Norwich ... Give up Norwich and all its little associations.' Such advice was not, and is not, new and has shaped the course of British art.

### 'Definitively Sublime'

Hogarth probably would have found more to his taste the huge canvas painted by James Ward of *Gordale Scar* of ?1812–14 (no.115). Ward, a combative Londoner, was the most successful animal painter of his time, and with this painting he rose to the challenge of depicting what the artist and collector Sir George Beaumont believed to be a subject which defied the artist's grasp.

The setting is a massive range of limestone cliffs near Skipton in the northern Pennines, which the enthusiastic tourist in search of the truly sublime landscape would need a day's walk from Settle to reach. It had already been identified in 1769 by the poet Thomas Gray as a place of unique 'horror': 'I stayed there (not without shuddering) a quarter of an hour, and thought my trouble richly paid, for the impression will last for life.' Ward was commissioned by Lord Ribblesdale to paint this most dramatic part of his vast estate and spent three years working on the subject. Exaggerating the true scale of the Scar in the interest of overwhelming panoramic impact, Ward also took liberties with the fauna, relocating Ribblesdale's prize herd of cattle and the other animals from the shelter of Gisburn Park some miles away.

Given the dangerous time during which Ward painted his *magnum opus*, it seems legitimate to interpret the scene with its fierce white bull as in some sense a response to the wars with France. Edmund Burke, the theorist of the sublime, had in fact designated the bull as a 'definitively sublime' creature, and the strength and virility of the particular historic breed Ward depicts protecting his herd can be seen as a symbol of national defiance. Here is the true John Bull in his primeval condition. The towering scene with its rolling clouds and dark chasm similarly evokes a powerful sense of the ancient national landscape which is being defended during wartime.

The 'sublime' was a category, along with the 'picturesque' and the 'beautiful', which dominated the discussion of landscape art from the 1750s until well into the nineteenth century. It was a term coined in its modern usage by the philosopher and politician Edmund Burke in his influential *A Philosophical Enquiry into the Origin of our Ideas of the Sublime and Beautiful*, published in 1757. Burke, a friend of fellow Irishman James Barry, proposed the sublime as both a natural and an aesthetic experience – a sense of being overawed by vast, dark and threatening natural forces which could be felt in the face of a real storm or mountain or before the representation of such an object. The typical qualities of the sublime were obscurity, infinity, vastness and the sense of godlike and unimaginable power – 'whatever is in any sort terrible or is conversant about terrible objects or operates in a manner analogous to terror is a source of the sublime'. Obviously in the case of art one could have the illusion of this religious, sexual or simply vertiginous thrill without suffering the possible consequences for real.

115 **James Ward**
1769–1859
**Gordale Scar (A View of Gordale, in the Manor of East Malham in Craven, Yorkshire, the Property of Lord Ribblesdale)**
?1812–14, exh. 1815
Oil on canvas
332.7 x 421.6

116

116 **Samuel Palmer**
1805–1881
**Coming from Evening Church**
1830
Mixed media on gesso on paper
30.2 x 20

Size doesn't matter. Son of a London Baptist bookseller, Samuel Palmer was a childhood visionary and devotee of William Blake whom he met in 1824 through his 'good angel', the painter John Linnell. He deeply admired Blake's tiny woodcut illustrations to Virgil's 'Eclogues' (1821), which he described as 'corners of Paradise'. Palmer was the leading figure among a group of artists, The Ancients, who sought a spiritual vision of social calm and order in the 'Valley of Vision' around the village of Shoreham in Kent in the 1820s. This work in tempera shows a procession of villagers in an almost fairy landscape under a huge impasted moon. The figures, Gothic church, cottages and arching trees seem to merge into one pantheistic landscape of a transcendent order. Gold powder, amber glaze and varnish add to the rich effect.

In contrast with the received idea of art as a controlled and distanced experience of nature, Burke's concept opened up a whole new area for the artist, which allowed for a more emotionally charged art. Turner's snowstorms, whether alpine and historical or of his own time and place, were deliberate exercises in evoking such experiences. As we have seen, Turner was perhaps the most zealous of all in experiencing sublimity at first hand in order to paint it for his sensation-seeking viewers.

### The Tradesman's Entrance

The middle classes continued to rise, of course, in numbers at any rate if not in esteem. They had traditionally sought to emulate aristocratic taste but as we have seen earlier in the eighteenth century, before Reynolds established a more severely chic attitude among his contemporaries, they also looked for an art which expressed something of the world they had made and lived in. Into the complex and politicised art scene we have just briefly sketched, came a number of great early Victorian collectors, such as Robert Vernon and John Sheepshanks. They gave their collections to the new national museums and were, like Henry Tate later, tradesmen with distinctly bourgeois tastes and varying needs to promote themselves in society. They preferred cabinet-size paintings of mainly British and recent 'genre' (everyday life) and literary subjects, as well as landscapes, which had become identified by now with the national school. Buying their works through the expanded range of exhibiting venues and dealers in contemporary art, they aimed to represent a committed faith in the quality of living British artists and, like the sculptor Sir Francis Chantrey, hoped their bequests would further the cause of encouragement. Inevitably they became embroiled with the growing art bureaucracy in their patriotic and proudly individual efforts to donate works to the nation. This meant, in the case of Vernon and Sheepshanks, that they became rivals and split what would have been a huge nucleus for a much-vaunted Gallery of British Art (eventually the Tate Gallery) between the National Gallery and the Victoria and Albert Museum.

### Suffer the Little Children

A classic example of the art bought by a collector such as Robert Vernon is William Mulready's *The Last In* of 1834–5 (no.118). Vernon bought the work, painted in light colours over a white ground on a mahogany panel, after seeing it at the Royal Academy summer show in 1835. Mulready, an Irish-born painter who became highly successful in London through genre images such as this that dwelt on popular domestic themes, often focused on childhood and the role of adults in bringing

---

17 **David Wilkie**
1785–1841
**The Peep-o'-Day Boys' Cabin, in the West of Ireland**
1835–6
exh. 1836
Oil on canvas, 125.7 x 175.3

Part of the Vernon Gift, this work by J.M.W. Turner's close friend David Wilkie has a remarkable fluidity in its treatment of a subject that caused some controversy. The Irish rural poor were seen as both primitive and insurgent, inclined to drink and violence. The Peep-o'-Day Boys were an outlawed sect and Wilkie shows one of them just returned from a night raid. The painting was compared by a critic with a painting by William Collins of an English cottage family about to go to church on a Sunday morning: 'Agitation, treason, murder, crowd the one; quiet, peace, content, – yea, even in poverty, – encompass the other.'

children to maturity. The Scottish artist David Wilkie, and before him Hogarth and Dutch painters of the seventeenth century such as Jan Steen, were the main models for his art. *The Last In*, lightly humorous as it is, neatly encapsulates contemporary concerns with the education of the poor.

The 1830s were marked by various official reports into the setting up of a national education system, and the then current debates about pedagogy are certainly referred to by Mulready in his depiction of an ancient teacher in an old-fashioned country school. It is exactly the sort of carefully crafted and gently moralising picture which many saw as the epitome of a publicly responsible art aimed at a broad audience. See this, so the argument ran, and you quietly learn lessons for life. A more subtle innuendo for the informed was Mulready's use of colour and figures loosely derived from Raphael's School of Athens in the Vatican in Rome.

The old schoolmaster employs a well-worn educational approach to his tardy pupil involving the ploy of public humiliation. He sarcastically bows as the boy, standing at a heavily locked door, enters a room full of already cowed children while, behind the miscreant, apprehensive partners in crime wonder whether to brave the reception they will also get. The girls are more obedient and silent while the boys are fidgety and animated. A birch reminds all the children

what the ultimate punishment might be. The little agonies of early experience are contrasted with the almost dreamlike landscape viewed through the window, as if to visualise the transition from a sort of flawed innocence to the pain of experience and knowledge. The dominant figure in many respects is the schoolmaster, whose authority is ambiguously presented, as befits the main agent in a dilemma which is unlikely ever to be resolved. Vernon and his peers could easily relate to what would have been seen as a moral conversation piece for modern times.

### London Babylon

When in 1828 the German critic G.F. Waagen saw one of the huge, as he called them, 'historiated' compositions of the Northumberland-born painter John Martin, he said that they 'unite in a high degree, the three qualities which the English require, above all, in a work of art, – effect, a fanciful invention, inclining to melancholy, and topographic historical truth'. This rather perspicacious generalisation does capture the appeal that Martin's work held for his audience in the 1820s and 1830s, not only in Britain but in America, France and elsewhere in Europe. Martin, a quarrelsome outsider who had more or less trained himself, and who also became a superb soft steel engraver by which means his works became widely

118 **William Mulready**
1786–1863
**The Last In**
1834–5
exh. 1835
Oil on mahogany
62.2 x 76.2

known, had a unique apocalyptic imagination that eventually inspired early epic cinema sets.

Working at the height of his powers during the time of the great popularity of panoramas, which we have already seen, Martin had a sense of the grand Miltonic gesture that played well to his London audiences. Reflecting the contemporary fear and fascination with cataclysmic natural, political and supernatural events, his complex, archaeologically informed scenes drawn from biblical and ancient history can be seen as the first major religious art for a Protestant audience in Britain.

His late triptych, of *The Great Day of His Wrath* (1852), *The Plains of Heaven* (1853) and *The Last Judgement* (1853) was his extravagant visionary swansong, based on the Book of Revelation. In *The Last Judgement* (no.119), we are shown the heavenly congregation of Christ and Angels presiding in brilliant eschatological whiteness over the end of human history. Below, eternity can be seen; to the left, the saved, including many great figures from the national past; to the right are the damned, among whom can be seen the whore of Babylon, Catholic priests and the unfortunate passengers of the new London-Paris express, who plunge into a gaping chasm at the heart of the painting along with the hosts of Gog and Magog.

Martin's art can be linked to the great baroque decoration of the seventeenth century, to Wright's spectacular volcano images and to Turner's large academic 'machines', as such history paintings were called. They are also related to a Regency and early Victorian taste for urban fantasy, such as the drawings of the architectural draughtsman, Joseph Gandy, and of Turner, and social anxieties about the consequences of industrialisation and urbanisation. As with Turner, Martin's historic subject matter is often a thin veil for the theatricalisation of acute contemporary concerns about the onset of pandemonium.

Martin was not untypical of his time in also producing schemes for, among other things, the improvement of London's water supply, sewers and transport system, publishing pamphlets to get them seriously considered by the government. His imagination ran far beyond the canvas and embraced a Napoleonic vision of the transformation of society, reminiscent of James Barry. We have entered an age when artists' ambitions are not just creatively at odds with that of the mainstream, but when such a stance becomes an unspoken rule for many. The canvas now offered a blueprint for change.

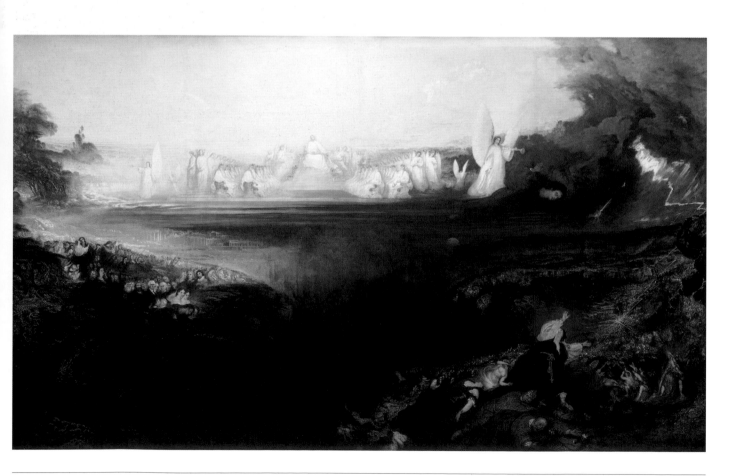

119 **John Martin**
1789–1854
**The Last Judgement**
1853
Oil on canvas
196.8 x 325.8

120 **Richard Dadd**
1817–1886
**The Fairy Feller's Master-Stroke**
1855–64
Oil on canvas
54 × 39.4

Richard Dadd, a painter and friend of Frith, murdered his father in 1843 and was sent to Bethlem Hospital, the setting of the demise of Hogarth's Rake a century earlier. This fairy painting, executed piecemeal in obsessively minute detail with tiny touches of paint, shows a Fairy Feller about to split a large chestnut with his axe in preparation for the construction of Queen Mab's coach. The central patriarchal figure, echoing Blake's figure of Urizen, may be based on the Pope, whom Dadd had seen in Rome and wished to murder. The other figures include Shakespeare's Oberon and Titania and other fantastic creatures reminiscent of Henry Fuseli's painting from 'A Midsummer Night's Dream'.

The debates about the fine arts in Britain – about training, the canon, public taste, manufacture and design, public commissions, subject matter and so on – almost demanded the noisy intervention of some ambitious and talented young artists with an aesthetic and intellectual programme of their own. This happened in 1848 – the year of the Communist Manifesto, revolutions in France and elsewhere in Europe, an uprising in Ireland and Chartist agitation in Britain. Characteristic of all these upheavals was the rise of the 'avant-garde' – a military term which became applied in the early nineteenth century to political groups outside the mainstream. By the middle of the century, the term was being applied to groups of artists and intellectuals, often going under the title of an 'ism', with the assumption that they held views and engaged in practice ahead of the taste of the majority. This inevitably meant that such groups would be likely to cause some shock to the general public on account of some or many aspects of their work. That this had happened before was obvious; the difference was in the relationship artists felt towards what we now call 'straight' society. This was one of an opposition, now clearly formulated, to contemporary values – be they aesthetic, political, sexual or religious. In addition to such high-minded positions many artists, adrift in the changing seas of a market economy, saw self-organisation as a matter of survival.

'Isms' in the cultural field refer to the idea of a movement, and by that is generally meant some nearly natural force within society, some more or less formulated system of concepts, which have their own momentum. In science 'isms' are often indicative of some unusual biological process. It is no coincidence that the Pre-Raphaelites who formed themselves as a group in 1848, and whom we shall consider below, were close in a number of their political sympathies to another 'ism' grouping, the Christian Socialists, founded by Charles Kingsley and F.D. Maurice in 1849.

### Oxfordism

Perhaps the key background factors to understanding the initially controversial impact of the Pre-Raphaelites when they arrived on the scene in 1849 and 1850 are religious ones. The Oxford Movement, note the active term again, represented from 1833, in the wake of Catholic emancipation in 1829, a return to a high church theology and liturgy in Britain, and a rejection of the latitudinarianism (broad church philosophy) and worldliness of the Church of England throughout the Georgian period. The Anglican John Newman, who converted to Roman Catholicism in 1851, was the inspirational figure for the Tractarians, as the members of the Oxford Movement were called, who sought to reintroduce ritual and who insisted on the reality of the Incarnation and Eucharist. This meant for the quickly growing and influential Tractarians the need for new Gothic-style churches in the cities, a return to incense, bells, sacred music, elaborate vestments, furniture, high altars and a range of other visual forms including medieval-style wall paintings. Newman, John Keble and their followers furthermore saw their tendency as a return to a distinctly English form of worship, which would appeal to the ever-troublesome urban masses. The controversies about the Oxford Movement were intense – there were even 'No Popery' riots in 1850 at a church in Pimlico, near the site of Tate Britain, because of the vicar's ritualistic mass. We are back with the heated religious feelings of the sixteenth and seventeenth centuries, and their deep connections to the sense of national identity and security.

### Ave Maria

In this context it is not difficult to see why a group of young, recently graduated art students, displaying works at the Royal Academy with a strongly Catholic religious imagery and adding to their signatures the mysterious monogram 'PRB' for Pre-Raphaelite Brotherhood, should have caused a stir. Their main spokesman was an Anglo-Italian painter and poet, Dante Gabriel Rossetti, who shared a studio with a fellow Brother, William Holman Hunt. Rossetti's *The Girlhood of Mary Virgin* (no.122) could hardly have been more provocative to conventional religious opinion and aesthetic taste, and was certainly a 'manifesto' painting. The Eton Chapel Virgin was beginning her resurrection.

Painting the work at his family home in what is now Hallam Street in London's West End, in 1848–9,

**122 Dante Gabriel Rossetti**
1828–1882
**The Girlhood of Mary Virgin**
1848–9
Oil on canvas
83.2 x 65.4

**121 John Ruskin**
1819–1900
**The North-West Angle of the Façade of St Mark's, Venice**
c.1851
Watercolour and drawing on paper, 94 x 61

John Ruskin's many journeys to Venice reinforced his love of the city's Gothic architecture, about which he wrote in his hugely influential 'The Stones of Venice' (1851–3). Ruskin believed that the Gothic was a divinely ordained style rooted in the observation of nature and the proper architecture for an ideal society. His many details of St Mark's façade were a visual meditation on this truth. He also saw drawing as the basis of all artistic knowledge, and his ideas in this respect were part of the curriculum at many art schools during the Victorian period. His essay, 'The Nature of Gothic', was the classic statement of his beliefs.

Rossetti, who struggled with his technical inexperience at this stage in spite of tuition from Ford Madox Brown, used his sister Christina, who was to become a major poet, and his mother as models for the figures. He worked from real antiquarian books and with an artificial vine as props, and painted very slowly with thin oil paints on a white ground, which gave the picture a bright and translucent quality. This technique, although not new (we have seen Mulready using it in the 1830s), became the PRB hallmark and was evidence of a reaction against standard academic technical procedures.

Rossetti, who helped to rediscover William Blake, shared his great predecessor's dislike of Reynolds, dubbing the first President of the Royal Academy 'Sir Sloshua'. Rossetti wrote to his godfather the geologist Charles Lyell that 'the subject is the education of the Blessed Virgin, one which has been treated at various times by Murillo and other painters, – but, as I cannot but think, in a very inadequate manner, since they have invariably represented her as reading from a book ... an occupation obviously incompatible with these (those?) times ... I have represented the future Mother of Our Lord as occupied in embroidering a lily, – always under the direction of St. Anne ... At a large window (or rather aperture) in the background, her father, St Joachim, is seen pruning a vine.' Much of the Pre-Raphaelite credo can be gathered from this statement, in particular the high seriousness of the subject matter and the search for factual accuracy. The Pre-Raphaelites insisted on a notion of truth to nature, which involved both a precise naturalism and a commitment to historical exactitude. Blake would certainly have approved in principle of this concern for 'minute particulars' and the medieval piety of purpose.

The religious symbolism is almost claustro-phobically intense and embodies the fashion for reinventing the Catholic sacraments for a modern audience. (Remember, as an insight into Rossetti's aims, that this work was to be seen at the Free Exhibition in Hyde Park, where he bought space, not in a church.) Rossetti and his family attended Christ Church Albany Street, which had been founded by the Tractarian E.B. Pusey, and whose vicar had revived ritual, decoration and choral music for his working-class congregation in Cumberland Market. The church was connected with an Anglican Sisterhood nearby, which undertook social and educational work among the local poor. Young girls were taught embroidery as a holy employment suitable for virgins and the products of these activities were the altar frontals and other decorations for the local church. Rossetti, who at this stage in his career was enthusiastic about such improving schemes, said to a fellow Pre-Raphaelite

in 1852 that his painting 'was a symbol of female excellence. The Virgin being taken as its highest type.' We have seen a number of images so far which had an overt educational meaning, from Hogarth to Mulready, but this one conveys a newly zealous attitude.

Rossetti wrote two sonnets to explain the symbolism of the painting, one of which adorns the deliberately archaic frame. The books represent the three theological virtues – hope, faith and charity and their associated colours blue, green and white – and three of the four Cardinal virtues, with Fortitude appropriately lying at the bottom and the lily, symbol of innocence, on the top as a model for the patient, rather gloomy Virgin's work. The dove outside, of course, represents the Annunciation that will occur; the lamp is piety; the rose is the Madonna's flower; the vine the coming birth of Christ; the tri-point robe refers to the one worn by the Lord during the Passion and to the Trinity. The ancient organ refers to the contemporary revival of Catholic church music. The whole work focuses therefore on the inevitability of the pre-elect girl's holy impregnation and reward.

Rossetti was in fact far less interested in the archaeological and strictly naturalistic detail of his works than his fellow PRBs. Following Blake and some of the literary 'Immortals' he listed at the time who included Dante, Shakespeare, Keats and Browning, Rossetti held a spiritual view of art in which the devout artist found truth in his heart's desire rather than in conventional themes, on the one hand, or naturalism on the other. This is an important point as it returns us to the question of idolatry as opposed to pious devotion, which has been a recurrent question throughout the narrative of this book. Heading the list of Immortals, indeed, was none less than Jesus Christ. In the first issue of the Pre-Raphaelite magazine The Germ, edited in 1850 by Rossetti's brother William Michael, Dante Gabriel published a story, Hand and Soul, about a medieval painter Chiaro dell'Arma who grows dissatisfied with his staple output of madonnas. His chief concern is that he has confused beauty with faith: 'From that moment Chiaro set a watch on his soul, and put his hand to no other works but only to such as had for their end the presentment of some moral greatness that should impress the beholder: and, in doing this, he did not choose for his medium the action and passion of human life, but cold symbolism and abstract impersonation.'

## Primitive Instincts
The Pre-Raphaelites had not invented a taste for art before Raphael, but had rather responded to one. Since the late eighteenth century art collectors and, for example, the German medievalist Nazarene

**123 Ford Madox Brown**
1821–1893
**The Last of England**
1864–6
Watercolour on paper
35.6 × 33

Ford Madox Brown influenced the Pre-Raphaelites through his contact with the medievalising art of the German Nazarene painters in Rome. He went on to paint modern themes, such as this picture of emigrants to Australia, a replica of an oil painting of 1855, inspired by the sculptor Thomas Woolner's departure for the New World in 1852, along with a record 369,000 other emigrants that year. It shows a brooding man, with Brown's features, disappointed in his hopes for success in England, accompanied on a boat taking them to a steamer by his wife who holds his hand and that of a baby hidden by her shawl. The white cliffs of Dover under Ruskin's 'storm cloud of the nineteenth century' suggest the dream of a declining nation.

(medievalist) painters in Rome, such as Friedrich Overbeck, had increasingly shown an interest in Italian and Flemish medieval art, and not just as the curiosity it seemed to be to most of Reynolds's generation. These works, then referred to as Primitive, which we now take to be masterpieces, found their way into the new National Gallery in the 1830s and 1840s and were analysed art-historically and technically by a number of artists and scholars such as Charles Eastlake, William Dyce and Ford Madox Brown. There was a growing appreciation of both the aesthetic and moral virtues of a less sophisticated art with its linearity, symbolism, strong colour and luminosity and perspectival awkwardnesses. What is particularly significant with the latter characteristic especially, is how the perceived naivety of the flat composition was taken to be a sign of Blakean sincerity and integrity and of a deeper vision than scientifically accurate spatial construction.

Primitivism had become a term of approval for many, and in Lord Lindsay's *History of Christian Art* (1847), the author encouraged young artists to follow the early Italian artists such as Giotto and Fra Angelico, who embodied 'a holy purity, an innocent naivete, a child-like grace and simplicity, a freshness and fearlessness, an utter freedom from affectation.' Some of this rhetoric, with its strong theological overtones, had been applied to Greek art during the neo-classical period sixty or seventy years earlier, but it now had the full force of a broad ideological and moral conviction. This was to be an art of national and artistic renewal, a theme we have seen a number of times already over the previous century or so. The Arundel Society, founded by John Ruskin and Henry Cole in 1849, took its mission to promote this forgotten art very seriously, 'so that the greater familiarity with the severer and purer styles of earlier art would divert the public taste from works that were meretricious and puerile, and elevate the tone of our National School of Painting and Sculpture'. Artists needed no greater encouragement than the symbolically powerful victory of the Catholic artist, designer and promoter of the Gothic style A.W.N. Pugin, in the competition to redecorate the new Palace of Westminster in 1835.

British visual culture was now firmly associated at the heart of power with the Gothic, and with all its political, social and moral overtones. We have also arrived firmly in the strange world of Victorian nostalgia – strange because the love of the pre-modern national past, from country churches and surrounding medieval chivalry in sexual relations to morris dancing and often bogus ceremony, was the overwhelming taste of such a dynamically fluid and modernising society. Joseph Paxton's remarkable glass Crystal Palace, with its cathedral space rapidly built with the

24 **Henry Wallis**
1830–1916
**Chatterton**
1856
Oil on canvas
62.2 x 93.3

The early death of talent, of the Keats sort, was always a good theme for painters. Henry Chatterton, who had faked medieval stories and poems under a pseudonym in the 1760s, committed suicide with poison in a London garret at the age of eighteen. Henry Wallis shows him after death, torn-up manuscripts on the floor, a pale figure lit by a dawn sky breaking over the City seen through the window. His life and dreams are symbolised by the candle smoke that wafts towards the light. The model for Chatterton was the writer George Meredith, with whose wife Wallis later eloped.

latest prefabricated materials for the Great Exhibition in 1851, is one of the most vivid realisations of this contradictory culture. One 'luminous detail', to quote a phrase of the American poet Ezra Pound, was that conservationists insisted on the retention of a line of ancient trees around which the huge structure had to be built.

### Christ in Oxford Street

My dear children, I am very anxious that you should know something about the History of Jesus Christ. (Charles Dickens, *The Life of Our Lord*, 1849)

Millais' *Christ in the House of His Parents* of 1849–50 (no.125), familiarly known as *The Carpenter's Shop*, was the most notorious PRB painting when it was exhibited at the Academy in 1850. Charles Dickens, who had written a story of Jesus's life for his children while Millais was painting his episode, ensured this notoriety by writing a damning review, in which he described the infant Jesus as a 'hideous, wry-necked, blubbering red-haired boy in a nightgown, who appears to have received a poke playing in an adjacent gutter', and the kneeling Mary as 'so horrible in her ugliness ... she would stand out from the rest of a company as a monster in the vilest cabaret in France or in the lowest gin-shop in England'.

Millais was no doubt offended by this, as it was his mother who had posed for the Virgin. It seems ironic that a socially concerned novelist like Dickens was so antipathetic to an image of Christ that showed him in such a light. Not only was the painting seen to ignore normal aesthetic standards, but it was viewed as blasphemous too. Holy subjects required idealisation, not the glaring realism of the daguerrotype. Ironically, one of the artist's primary pictorial sources was a *Holy Family* by the distinctly Reynolds-approved 'Post'-Raphaelite Italian painter Annibale Carracci. This showed the family in the carpenter's shop, and reflected the artist's Counter-Reformation stress on everyday life. Carracci had founded with his brothers the intellectually secretive Accademia degli Incamminati, the Academy of Progressives, with a programme similar to that of the Pre-Raphaelite Brotherhood.

Millais' obsessional dedication to photograph-ically precise detail involved working long hours in a real carpenter's shop on Oxford Street and carefully studying the muscular formation of a carpenter's arms to get Joseph just right. It didn't help either, as far as many were concerned, that this highly Marian depiction, echoing a similar tendency in Rossetti's *Girlhood* (no.122), was obviously imbued with so much Catholic liturgical symbolism. The dove was the holy

125 **John Everett Millais**
1829–1896
**Christ in the House
of His Parents
('The Carpenter's Shop')**
1849–50
Oil on canvas, 86.4 x 139.7

126 **William Holman Hunt**
1827–1910
**The Awakening Conscience**
1853
Oil on canvas
76.2 × 55.9

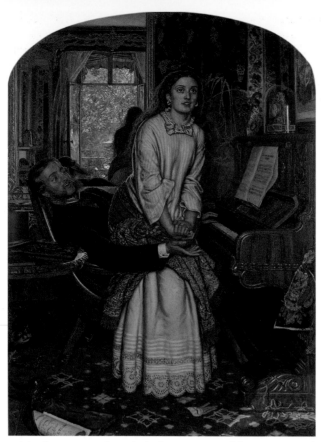

spirit; the carpenter's tools the instruments of the Passion; the table, the altar; the infant Jesus's accidentally wounded palm and drop of blood on his foot a prefiguration of the crucifixion – there is hardly a square inch of the meticulously worked canvas which doesn't offer up at least one symbolic meaning. Even the spatial arrangement of the shop invokes a church plan indicating the controversial High Anglican separation of the clergy and laity. Outside, beyond the fence representing the altar rail, are the shepherd's flock – not only the congregation watching the mysteries of the Holy Communion but, as it were, the Academy crowds seeing themselves as in a mirror. Religious, artistic and moral questions involved everyone, but the artists and writers were among the new high priests.

Millais' ploy was to bury such meanings in the dense naturalism of what was to be read as a historically accurate depiction of an ordinary Jewish workshop of the first century AD. The transfiguration of this real scene into a timeless sacramental moment in which past, present and future are conjoined in a transcendental moment, became a key feature of Pre-Raphaelite works and much subsequent Victorian painting. Such works did not have to be historical or biblical, however. Revelation could occur in the most sordid contemporary circumstances.

### 'Fatal Newness'

By the time William Holman Hunt displayed The Awakening Conscience (no.126) at the Academy in 1854, the Pre-Raphaelites had become major and mainly accepted figures in the art scene and had gained the support of the influential critic and promoter of Turner, John Ruskin. The work was shocking to many viewers, however. It is a resolutely contemporary-issue painting inspired by Dickens's novel David Copperfield, and drawing on the artist's research in the prostitute quarters of London. The scene represents a kept woman, modelled by Hunt's working class girlfriend Annie Miller, sitting on the lap of her lover, who has her installed in a maison de convenance in St John's Wood, north London. His cruelly casual playing of a few notes from a song of lost innocence, Thomas Moore's 'Oft in the Stilly Night', has brought about a sudden epiphany in the girl, described by one writer as in 'a provocative state of undress'. Behind her this moment of grace is conveyed through a mirror reflection of the scene she sees before her – the sunlit world of nature, emblematic of divinity, truth, beauty and her own childhood innocence.

As with The Carpenter's Shop, the viewer, standing in the light, is implicitly drawn into participation in the drama. The light is also shown in the girl's eyes, and in 1854 would have been understood as The Light of the

World, Jesus, the subject of Hunt's counterpart canvas at the Academy that year. The room is packed with symbols reinforcing the meaning – the cat playing with the bird (will the latter escape?); the picture above the piano of *The Woman Taken in Adultery*; the unravelled embroidery (she hasn't followed the virtuous path recommended by the Albany Street sisterhood); the book on the side table (a recent one on the history of writing that refers to the education of such girls – Hunt was teaching Annie to read at the time); and the vine-patterned wallpaper indicating an untended natural world. This is the urgent, fallen world of Mary Magdalene rather than the assured one of salvation of the Virgin Mary.

We have spoken of the high moral purpose of art in the early and mid-Victorian period and how taste, as ever, was a highly contested concept, with ramifications that went far beyond pictorial preferences. When John Ruskin wrote of this painting, he stressed above all what he saw as the 'fatal newness' of the interior. It wasn't just the squalid ethical relationship which was so disturbing: 'Nothing is more notable than the way in which even the most trivial objects force themselves upon the attention of a mind which has been fevered by violent and distressful excitement … There is not a single object in all that room – common, modern, vulgar (in the vulgar sense,

as it may be), but it becomes tragical if rightly read.' Here is the 'cash nexus' society analysed by Marx, where human relationships are sustained by oppressive monetary arrangements and where exploitative fashion means 'all that is solid melts into air', in Marx's words. 'Homo Economicus' prevails in a world of cheap and shoddy mechanically produced objects designed to titillate the lowest taste and to maximise the capitalist's profits – a criticism actually levelled at much of the content of the Crystal Palace.

Of course Hunt and the maverick Tory, Ruskin, were Christian reformers rather than atheistical socialists, and salvation could not be achieved simply by a reorganisation of the means of production. The Working Men's College founded by F.D. Maurice in the same year as Hunt's painting was exhibited gave away free copies of Ruskin's pamphlet, *The Nature of Gothic*, precisely in order to encourage a holy admiration of the true principles of design: 'the whole technical power of painting depends on the recovery of what may be called the innocence of the eye … of a sort of childish perception … as a blind man would see if suddenly gifted with sight'. This is the very experience of Hunt's fallen woman. Art was to be the royal road to salvation for the individual and the nation, and it is small wonder that Hunt said at the time that he felt 'really frightened every time I sit down to paint a flower'.

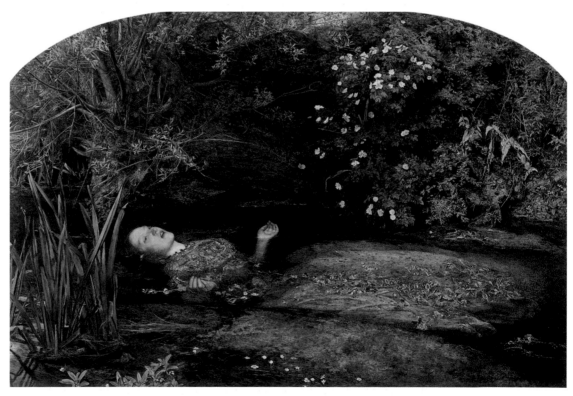

127 **John Everett Millais**
1829–1896
**Ophelia**
1851–2
Oil on canvas
76.2 x 111.8

This famous image from Shakespeare's play 'Hamlet' was a huge success when shown in Paris in 1855. The brilliance of the jewel-like colour, the startling image itself and the naturalistic precision has made

this, part of Sir Henry Tate's collection, one of the icons of nineteenth-century art. The model for the drowned heroine was Rossetti's future wife, Lizzie Siddal, who posed in a bath of water and became

rather ill as a result. The stream and vegetation were painted from studies made over a period of six months in Ewell, Surrey. All the many flowers, as in Shakespeare's play, have symbolic meaning – the poppy

for death, the daisies innocence and the pansies thought or love in vain. This is a natural world full of prophetic and supernatural meaning mainly lost today.

### 'Terrible Muses'

The Scottish polymath William Dyce, in his knowledge of the Primitives and the German Nazarenes, was influential on the Pre-Raphaelites, in whom he encouraged Ruskin to take an interest, as well as on the political progress of art practice and public cultural policy in Britain. He was a versatile painter of portraits and religious subjects, and a major contributor to what were intended to be exemplary historical mural decorations at Charles Barry and Augustus Pugin's new Palace of Westminster. A devout High Churchman who had also written a prize-winning paper on electromagnetism, he painted one of the most brilliant and haunting landscapes of the nineteenth century.

The white chalk cliffs at Pegwell Bay near Ramsgate in Kent were both emblematic of England and popular with amateur geologists, being rich in fossils. Dyce takes this familiar setting and unsettles or defamiliarises it – a classic strategy of much modern art – in *Pegwell Bay, Kent – A Recollection of October 5th 1858* of ?1858–60 (no.129). He stayed at Pegwell Bay in the autumn of 1858, and is probably the figure on the far right carrying artists' equipment and looking upwards into the fading light. The eerily isolated figures in the foreground are his wife, two sisters-in-law and one of his sons. Two of the women are collecting seashells and fossils while the tide is out, and the mother and son look out of the picture to our left, again drawing the spectator into the moment of representation. A critic wrote in 1902 of the painting that it was 'as if man had come to the ugly end of the world and felt bound to tell'.

The title is, uniquely for the time, specific about the exact date on which these ambiguous events took place. The fifth of October 1858 was the day on which Dyce saw a new comet, first spotted by the astronomer G.B. Donati on the second of June. The recollection is therefore both of a moment in his private life and of a cosmological event which fascinated, and disturbed, Dyce's audience. Religious doubt was now a subject which could be discussed and represented: Tennyson had written of the 'terrible muses', astronomy and geology, and Matthew Arnold's poem 'Dover Beach' had described the 'grating roar of pebbles' and nature's 'eternal note of sadness'. Science, in particular evolutionary theory, seemed to be revealing a vast universe whose creator was at the least inscrutable and, if some such as the German philosopher Friedrich Nietzsche were to be believed, dead. The absent god had left man high and dry on what might be a 'terminal beach'. Blake's legendary 'Albion', whose etymology was often supposed to include a Roman image of the white cliffs on its southern shoreline, was threatened not just by foreign invaders but by the spectre of

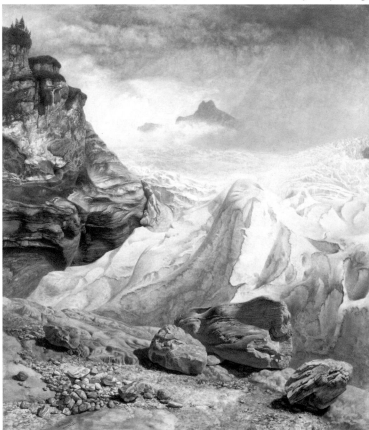

28 **John Brett**
1831–1902
**Glacier of Rosenlaui**
1856
Oil on canvas
44.5 × 41.9

John Brett was deeply influenced by Ruskin, and here we can see his master's geological fixation on stones as 'mountains in miniature', as Ruskin called them. Brett travelled to Switzerland to paint the glacier at Rosenlaui, celebrated for 'the transparent azure of its icebergs', as one travel writer described it. Brett emphasises with hallucinatory accuracy the boulders of granite and gneiss (the latter shown with characteristic layers of lines in the foreground in their remote and unreal setting).

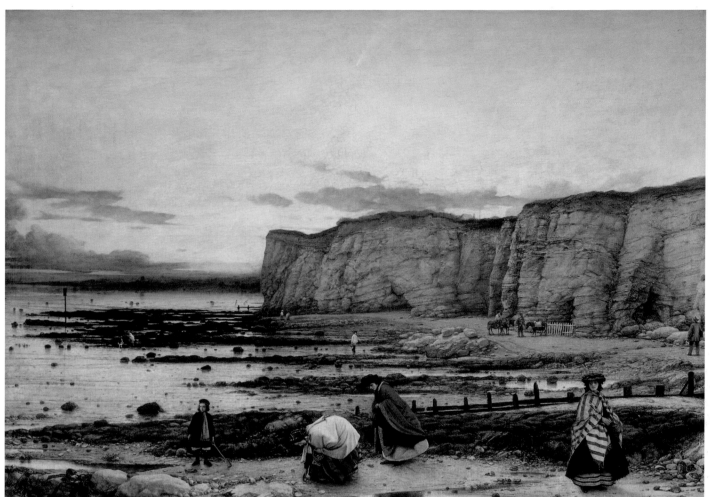

129 **William Dyce**
1806–1864
**Pegwell Bay, Kent –
A Recollection of October
5th 1858**
?1858–60
Oil on canvas
63.5 × 88.9

130 **George Gilbert Scott**
1811–1878
**Albert Memorial, Hyde Park**
c.1872–6

The last profound expression of imperial confidence? Prince Albert, an associate of Dyce, was a driving force behind the decoration of the new Palace of Westminster in the 1840s and the Great Exhibition of 1851. The latter, housed in Paxton's glass building in Hyde Park, he wanted to be 'a living picture of the point of development at which the whole of mankind has arrived'. Albert's death in 1861, aged forty-two, was a shock not just to Queen Victoria but to the whole nation. Scott's memorial signals the Victorian obsession with death. Architecture, sculpture and mosaics are brought together in a Gothic mega-artwork – friezes of artists, writers, scientists, sculptures symbolising the four continents, the arts, industry, commerce, science and religion, all point up like a Victorian spaceship to the heavens beyond. Inside sits the huge gold presence of Albert.

31 **Henry Alexander Bowler**
1824–1903
**The Doubt: 'Can These Dry
Bones Live?'**
exh. 1855
Oil on canvas
61 x 50.8

134

meaninglessness. The eighteenth-century fascination with volcanoes seemed to confirm man's role in a divine natural order and to support a proud attitude to national identity. Here, such confidence could be undermined by a sublime subject which had no need of vast, dark chasms and supernatural intervention.

### In Memoriam

Such a scene can equally be interpreted as a grand, if terrifying, hymn to God's wondrous creation, the touchstone of Ruskin's whole aesthetic philosophy. Nature, under the earnest Victorian microscope, drawn, painted, photographed, dissected, catalogued, archived and put into museums, was a multivalent concept and could offer proof for many human interpretations of its origins and destiny. Empiricism could easily lead to an agnostic doubt but, as we have seen in the early years of the Royal Society, was no necessary impediment to faith.

Henry Bowler's *The Doubt: 'Can These Dry Bones Live?'* (no.131), painted as an illustration to Tennyson's long poem *In Memoriam* (1850), was exhibited at the Academy in 1855, by which time its Pre-Raphaelite detail and finish were quite acceptable to the majority of visitors. The optimism of Bowler's image was also in its favour, as was its origin in a famous Old Testament text: 'The hand of the Lord was upon me, and carried me out in the spirit of the Lord, and set me down in the midst of the valley which was full of bones. And caused me to pass by them round about: and behold, there were very many in the open valley: and, lo, they were very dry. And he said unto me, Son of man, can these dry bones live? And I answered, O Lord God, thou knowest.'

This passage from the Book of Ezekiel precedes a mighty affirmation of the Resurrection, one which most of Bowler's spectators would have instantly anticipated. Another woman in need of spiritual conviction, the bonneted figure looking over the gravestone in a classically, or perhaps one might say, a Gothically, natural English churchyard setting, contemplates the skull and bones beneath her gaze. A fatally modern woman, she lacks the innocent belief of the grave's occupant, John Faithfull, who lies under the engraved words, 'I am the Resurrection and the Life', the opening line of the Anglican Burial Service and one that had recently much exercised biblical commentators. Under the horse-chestnut tree on the right another, double, confirmation in the word '*Resurgam*' (Resurrection) and a germinating chestnut, provides the clue right beside her. Bowler paints like a true follower of Hunt and Millais, bringing together literary and natural symbolism so that the viewer initially experiences the woman's condition, but is then reassured by signs which equate a certain comfortable natural order with a higher, divine one. Doubt is fine, as Tennyson for instance believed, as long as it does not become a rationalist conviction.

### The Crowd

With some few religious exceptions, artists were not yet seeking to paint the future – that, as it were, was yet to come. Artists had been and still were painting history and now, in the 1850s, they were indubitably painting a version of the present. 'The painting of the age', as it was described by the artist, was William Powell Frith's *The Derby Day* of 1856–8 (no.132). This provoked such interest that it required a barrier guarded by a policeman to keep at bay the crowds, who included the Queen and John Ruskin, and who were eager to read its detailed panoramic narrative of Victorian society at leisure. The large horizontal canvas, commissioned by the wealthy chemist Jacob Bell for £1,500, presented the urban crowd Hogarth had catered for at Vauxhall and against which Constable had reacted to so antipathetically thirty years earlier at Brighton. Nightmarishly for the landscape painter, had he been alive to witness the change which first took place the year after his death, this London crowd now had the railways to transport them all over the country. They could now indulge in what a fellow artist described as a 'saturnalia' which brought 'to surface all that is most characteristic of London life … We are surrounded by evils.' Derby Day itself was seen as 'the greatest holiday in the world', an opportunity for people to observe and stare at one another and almost like an annual Last Judgment rehearsal. The racing itself was of secondary interest.

Frith's popularity was immense, and his earlier panorama of a crowd on Ramsgate Sands exhibited in 1854 had been purchased by Queen Victoria for one thousand guineas. A fastidious artist in both his technical approach and his accounting procedures, Frith made extensive use of the new technology of photography as he worked on his canvas of the Epsom race crowd. He was an admirer of Hogarth, later painting moral 'progresses' but at this stage thought his great precursor an unsuitable model for contemporary art. However, there is a strong satirical drive behind the image in its presentation of about a hundred different social and ethnic stereotypes. The painting was like a living ethnological museum or Madame Tussaud's, and anticipated the interests of artists associated with the Mass Observation movement in the 1930s which we shall see later.

Frith, who made extensive drawings on location, commissioned the photographer Robert Howlett to 'photograph for him from the roof of a cab as many

32 **William Powell Frith**
1819–1909
**The Derby Day**
1856–8
Oil on canvas
101.6 x 223.5

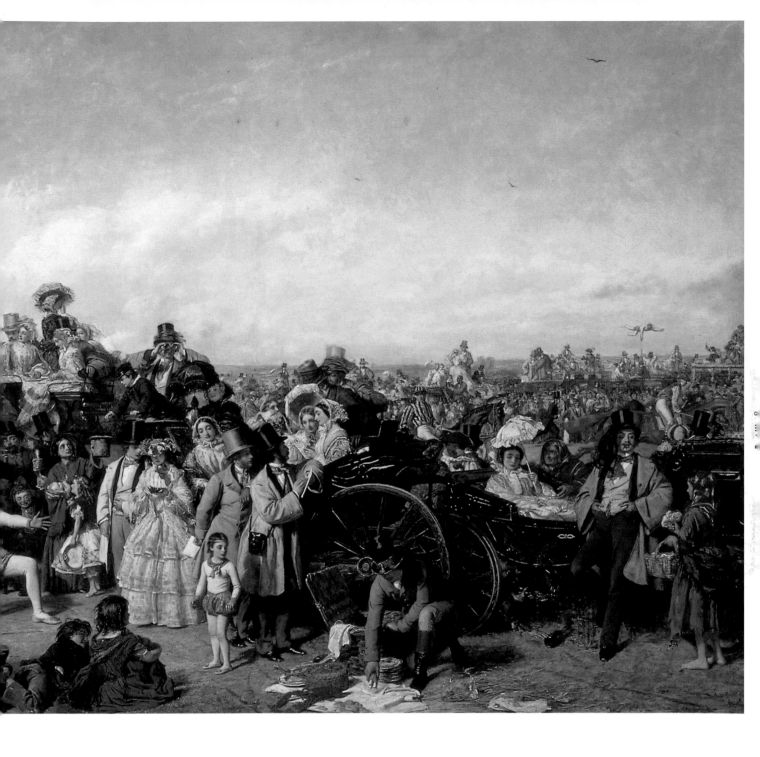

queer groups of figures as he could', underlining his role as an investigative anthropologist of contemporary life. Combining these field studies with drawings made in the studio of posed models, both friends and authentic types, Frith created a seething yet strangely static tripartite narrative that had to be read, as part of a novel might be. The three stories are minor moral tales: on the left, activity outside the Reform Club's ironically exclusive tent attracts 'thimble riggers' to cheat a city gent in his top hat. Standing nearby, a young besmocked countryman is restrained by his wiser girlfriend from losing his cash the same way. Just to the right, in deliberate contrast, a young city clerk, already fleeced by the tricksters, stares disconsolately out towards us having had his gold watch stolen by the shifty looking Scot behind him. In the middle, a socially mixed crowd of urchins and bourgeoisie watch an acrobat and his son, the latter distracted by the elaborate picnic complete with whole lobster, being laid out by a manservant. On the right, finally, reminiscent of Holman Hunt's kept woman but prior to any spiritual reprieve is a glum-looking courtesan in a carriage ignoring a Hogarthian gypsy hag reminding her no doubt of her eventual fate. This fate is determined by the louche dandy who is distracted by the jailbait of a flowergirl. This sordid group is contrasted with the healthy and upright young

officer-types and quietly elegant middle-class women to the left.

Frith took enormous care not only with costume and a technically precise finish but also with the physiognomy of his characters. Throughout the nineteenth century, it was a widely held pseudo-scientific belief that character could be read in people's facial features, and that ethnic types conformed at a basic level to certain traits of personality. The thimble riggers are recognisably criminal and/or Celtic types – that is, they are Scottish or Irish with all the prejudiced connotations such ethnicity entailed for a largely English audience. Near them are a Jewish swindler and a 'murdererous type'. There are gypsies, German tourists, Ethiopian serenaders, aquiline 'superior' types, garroters, wife-beaters and solid Anglo-Saxon policemen and squires.

The young 'out and outer', as Dickens described the type, who has had his watch stolen and who catches our attention in the left foreground, was the object of much interest among social naturalists in the mid-nineteenth century. He seems both alert and impressionable, his face a subtle mirror of evanescent emotions. He represents what was seen as a shallow, weak-jawed and puny city youth, employed as a shopboy or clerk and inclined to dress in cheap clothes of clashing colours – the clothing Ruskin had

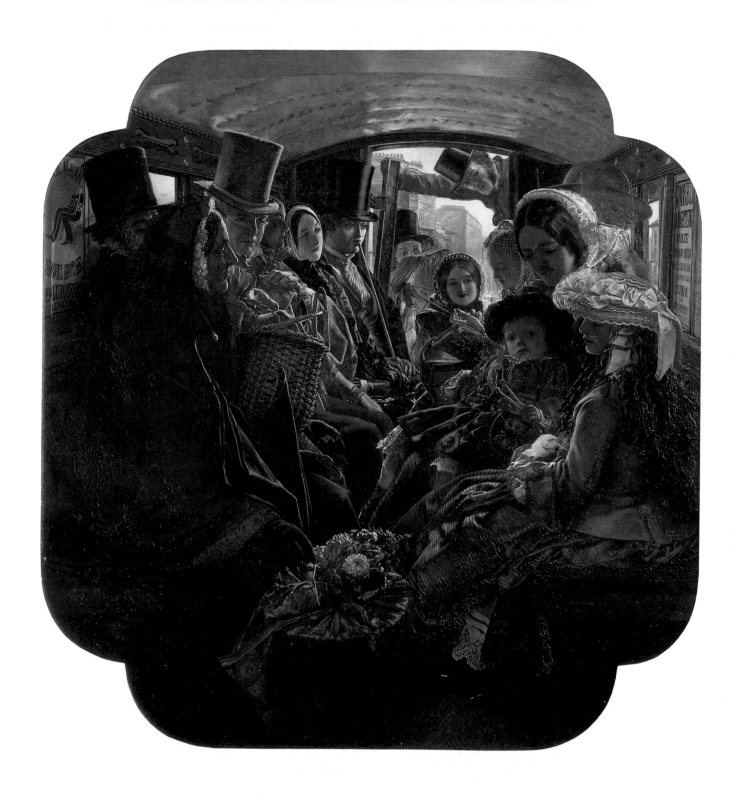

**134 William Maw Egley**
1826–1916
**Omnibus Life in London**
1859
Oil on canvas
44.8 x 41.9

Described by a critic as 'a droll interior', William Maw Egley's meticulously detailed scene inside a horse-drawn omnibus in Westbourne Grove near his home in West London, was painted to convey the intricate interactions of classes, generations and types. The main and slightly ambiguous emphasis seems to be on the beautiful young woman in fashionable clothing in the foreground. Another young woman, perhaps upstaged, waits to enter the crowded bus.

identified in *The Awakening Conscience* as of a 'fatal newness'. He was, so to speak, produced by a fast-moving commercial world and therefore deeply significant to social reformers. Charles Kingsley explained his habitat and behaviour thus: 'The perpetual stream of human faces, the innumerable objects of interest in every shop window, are enough to excite the mind to action, which is increased by the simple fact of speaking to fifty different human beings in the same day instead of five. Now in the city-bred youth this excited state is chronic, permanent. It is denoted plainly enough by the difference between the countryman's face and that of the townsman. The former in its best type ... composed, silent, self-contained, often stately, often listless; the latter mobile, eager, observant, often brilliant, often self-conscious.'

It was the French poet and art critic Charles Baudelaire, who like many of his fellow countrymen was fascinated both by British society and by paintings such as Frith's, and who was brilliantly to transform this city-type into a new kind of artist and intellectual – the detached and dandified *flâneur*, or idler, who wandered the streets of Paris, in the crowd but not quite of it. A true self-fashioner transcending his time, rather than a fashion victim with no centre of gravity, the *flâneur* registered impressions but then ordered

them – into art or poetry. In Britain, the big moral and political questions posed by the Victorian understanding of the interaction of social conditions and physical and psychological character led to many, often alarming, contradictory answers. Types came and went – by the 1880s the cigar-smoking city lad was remembered as a now extinct species – but the fear was always of the dangers of cross-breeding and national degeneracy consequent upon the squalor and confusion of the growth of cities. Many critics such as Ruskin, indeed, saw paintings such as Frith's encouraging rather than deterring a dangerous fascination with sensational low-life among the mainly middle-class crowds at exhibitions.

### Symbols of Decline

Art had always proposed ideal physical and moral types – this was one of its primary academic functions. Even Blake would agree in principle with Reynolds that the artist should be a finer type of human, optimistically creating an ideal world while representing the dangers to its achievement. By the 1870s, however, a new tendency created a new attitude and art – now the artist might him- or herself be a degenerate type and depict a world radically at odds with the uplifting vision that Ruskin, Matthew Arnold and others had proposed. Darkness, irrationality and pessimism had arrived to

5 **Samuel Butler**
1835–1902
**Blind Man Reading the Bible Near Greenwich**
1892
Photograph
St John's College, Cambridge

The novelist, philosopher, sheep-farmer and artist Samuel Butler wandered, 'flâneur'-like, through the poor districts of London, in search of subjects for his camera to 'snap-shoot'. He was drawn to the disabled and outcast, the antithesis of the classical perfection of the sculptures and other high art he had been trained in. Averse also to the melodramatics of Pre-Raphaelitism and to the 'sultry reticence' of Rossetti, whom he considered 'wrapped up in self-deceit', Butler wanted a thoroughly modern and disenchanted look at contemporary life. His blind man reads a Braille Bible, ironically surrounded by the ubiquitous advertisements of urban life that offer texts of a different order of 'vision'. This is very sophisticated image-making during the early years of photography.

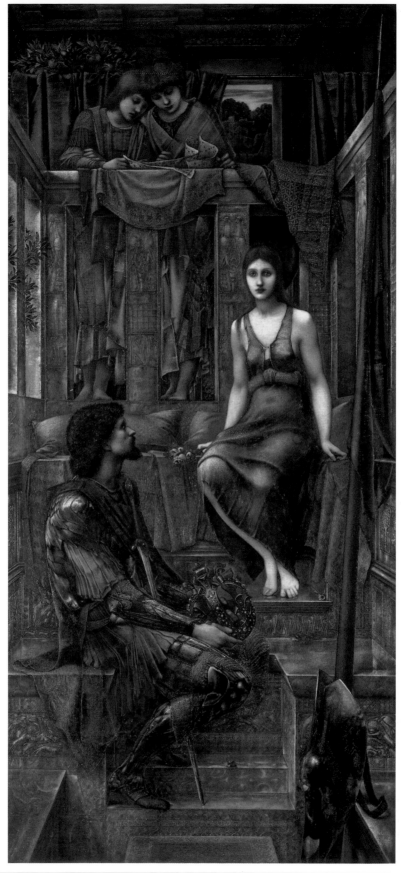

**136 Edward Coley Burne-Jones**
1833–1898
**King Cophetua and
the Beggar Maid**
1884
Oil on canvas
293.4 × 135.9

Edward Burne-Jones was heading for a career in the church, but turned to art under the influence of fellow Oxford undergraduate William Morris. An apprentice to Rossetti and disciple of Ruskin, for whom he later acted as a bemused witness at the Whistler trial in 1878, Burne-Jones worked on the Pre-Raphaelite murals at the Oxford Union in 1861. Following a period spent illustrating books and designing stained glass and tapestries with Morris, he burst onto the scene as a painter at the Grosvenor Gallery in 1877. This scene, from the eponymous poem by Tennyson about love overcoming the class divide, has a richly encrusted surface, showing a debt to Italian painters such as Crivelli, Mantegna and Botticelli. Burne-Jones hovered between a dream-like Symbolism and a commitment to socialist ideals.

spoil the progress to Utopia originally outlined by Francis Bacon in the early seventeenth century. We are moving into the world of Baudelaire's spleen and ennui, the boredom and 'exhilarated despair' of which, as we shall see later, the twentieth-century Francis Bacon was to become the principal iconographer. There was a kind of moral panic about these developments reminiscent of the Frenchification scare of the mid-eighteenth century. Britain it was feared was about to be overwhelmed by effeminate, immoral dandies, and the French would avenge Waterloo by an insidious invasion through taste and corruption.

Symbolism is a term almost as difficult of definition as Romanticism. It is used to describe art and literature mainly, however, and is thus more focused than its predecessor which, like modernism, is used to refer to the whole of a historical period from music to politics. While Symbolism can evoke a wide sphere of activities it is rooted in a notion of aesthetics. We have seen symbolism with a small 's' in a number of works throughout this book, from Hilliard's *Phoenix Portrait* of Elizabeth (no.6) to the Pre-Raphaelite's use of medieval religious symbols. What is different about Symbolism with a capital 'S' is that the fairly exact match of a visual form to a particular meaning – i.e. blue is for heaven, the rose is for the Virgin – is evaporated or made to resonate so that a vaguer evocation is achieved. Colour, which can now dominate a painting regardless of naturalistic rules of representation, is used to generate a mood which has no dictionary definition but may vibrate like a musical chord. An object, whether religiously conventional or everyday, takes on a sinister or dreamlike quality which provokes an irrational response.

It is as if all languages – verbal, visual or whatever – have had their grammatical structures loosened as the world seems to modulate in a possibly alarming way in defiance of a rational or scientific code. Interpretation – or hermeneutics as theologians and philosophers call it – is made highly problematic, and for those alarmed by the concurrent re-emergence of the phenomena of spiritualism and working-class politics, the European – and British – mind seemed to be in need of urgent attention. This attention might be repressive, but it is no surprise that Sigmund Freud's discovery of psychoanalysis and the interpretation of dreams and neurotic symptoms also developed during the period of Symbolism. Nor that his initial focus on women and hysterical illness relates so closely to the Symbolist obsession with women and their psycho-sexual experience (viewed mainly from men's points of view, it should be added).

At the heart of this change in British art was Dante Gabriel Rossetti, the exotically named son of an Italian political exile and Dante scholar, who nurtured an image of romantic bohemianism and of a matching secrecy around his practice as poet and painter. Significantly he never exhibited at the Academy, unlike his confrère Millais, who went on to become President of that institution. Given the highly devout and chaste images of the Virgin that initially made him famous, it is a little odd to see how these women of Rossetti's 'imaginary', to quote the psychoanalyst Jacques Lacan, became deeply sensualised and dangerous to know in the 1860s. The madness of Ophelia that Millais painted in 1851–2 from studies of Rossetti's model and lover, the artist Elizabeth Siddal, became the fatal attraction of an almost new breed of female. Rossetti, the inveterate womaniser and drug addict, was both grief-stricken and guilty when the frail and melancholy Siddal, whom he had married, died in 1862 of what has usually been taken to be a deliberate overdose of laudanum.

### Séance in the Studio

Rossetti's pictorial response to his loss was the seminal painting *Beata Beatrix*, upon which he worked for at least six years (no.137). It shows the 'Blessed Beatrice' of Dante's *Vita Nuova* (The New Life), translated by Rossetti between 1845 and 1864, in which the poet records his unrequited love and mourning for the young Beatrice Portinari. Beatrice, seated on a balcony overlooking Florence, is dressed in grey and green, colours indicative of hope and sorrow and love and life, and is shown in an indeterminate condition. She seems between this world and the next, eyes closed in reverie as a pink, haloed dove drops an opium poppy – source of laudanum, agent of sleep and symbol of death – into her hands, which rest on her lap as if waiting for the wafer at the Eucharist. The dove, a symbol of the Holy Ghost as well as a nickname for Lizzie, comes as a messenger of love and death. As Rossetti wrote in 1871 to the wife of the purchaser of the picture, Mrs Cowper-Temple: 'It is not at all intended to represent Death ... but to render it under the resemblance of a trance, in which Beatrice ... is suddenly rapt from Earth to Heaven.' This is partly a reference to the familiar analogy between death and orgasm, and Beatrice's tilted head, parted lips and intensely expectant expression can be read as sexual ecstasy. She is in the throes of an experience depicted in images of female saints by many Catholic Counter-Reformation painters.

Behind Beatrice's glowing hair is the city shrouded in a London-style sulphurous fog and two prominent if hazy figures – on the left the angelic figure of Love, who holds a heart surrounded by flame (we are reminded of the portrait of William Style of Langley,

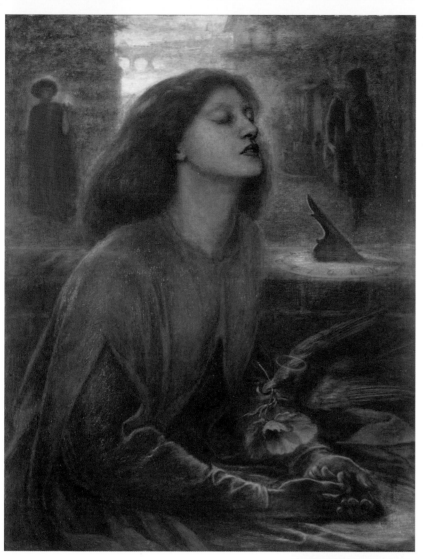

137 **Dante Gabriel Rossetti**
1828–1882
**Beata Beatrix**
c.1864–70
Oil on canvas
86.4 x 66

138

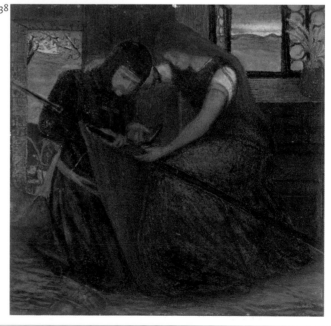

138 **Elizabeth Eleanor Siddal**
1829–1862
**Lady Affixing Pennant
to a Knight's Spear**
c.1856
Watercolour on paper
13.7 x 13.7

Elizabeth Siddal – she actually
spelt her name 'Sidall' – began
painting in 1852 and by 1855 was
being supported by Ruskin and
in an affair with Rossetti, whom
she later married. She and
Rossetti painted watercolour

scenes of medieval chivalry,
often in creative partnership,
and often with strong sexual
overtones, as seems to be the
case here.

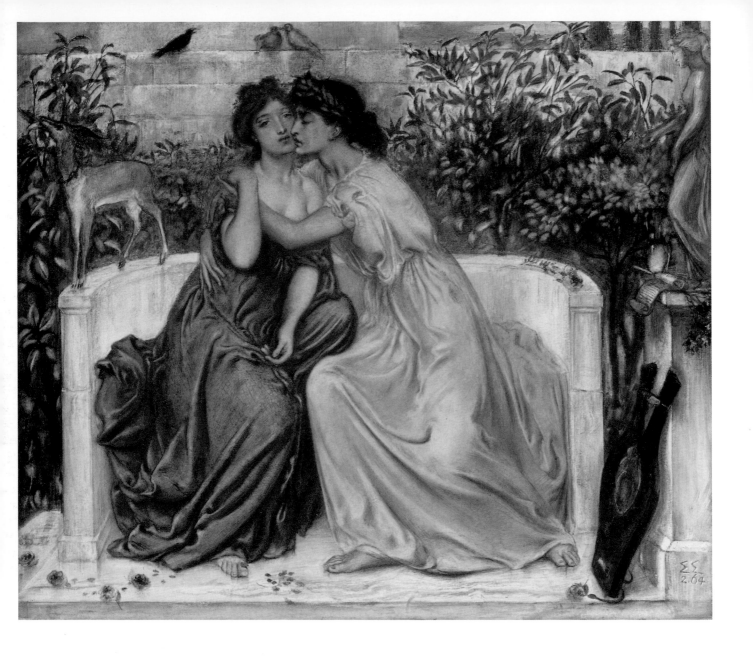

**139 Simeon Solomon**
1840–1905
**Sappho and Erinna in
a Garden at Mytilene**
1864
Watercolour on paper
33 x 38.1

The Tate's earliest lesbian image, painted by a homosexual disciple of Rossetti who was shunned by his earlier friends after conviction for gross indecency in 1873. Simeon Solomon exulted in his bohemian lifestyle, refusing financial assistance from wealthy Jewish relatives, and his art was ambiguous, provocative and decadent. Like his friend, the poet Algernon Swinburne, Solomon was fascinated by the life and work of Sappho, the pagan woman poet of ancient Greece, who was part of a community devoted to Aphrodite, the goddess of love. This image shows the rather masculine Sappho embracing her fellow poet Erinna in a garden on the Greek island of Lesbos.

no.15), the latter flickering to suggest Beatrice's fading life; on the right is Dante, watching until the last moment as Beatrice is taken to Purgatory to await Judgment. (Rossetti would of course have been concerned that Lizzie, as a probable suicide, might face the sort of punishment in Hell so graphically described by Dante in his *Divine Comedy*.) The sundial shows the time to be nine o'clock, the hour of Beatrice's death, and reminds us of the significance of the number nine for Dante – he met his beloved when she was nine years old and she died on 9 June 1290. Nine is the symbol of perfection, being three times three, the number of the Holy Trinity. It was also, unfortunately, the number of circles in Dante's Hell.

These are the symbols, but what about the misty vagueness? It is as if Rossetti was seeking to move from the one-to-one symbolism of his earlier works both through a profound ambiguity in the conjunctions of meaning and in the technique he develops. In his early poem 'The Blessed Damozel', he describes the woman's longing for her earthly lover's death so that they might be reunited. In the painting, he appears to be searching for a visual means to make this yearning physically feasible. He described Beatrice as seeing 'through her shut lids ... conscious of a new world'. The material world is thus dematerialised so that the spiritual world seems to be visible through it. We are reminded of the symbolically dissipating colours and buildings of that other great inhabitant of Chelsea, Turner, and are in the world of Victorian spiritualism as well as that of Rossetti's imagination.

The artist was among many at the time fascinated by the evidence of life after death offered by seances and other occult practices, and in direct opposition to crude Victorian scientism. The founding of the Society for Psychical Research, and even of a Spiritualists National Union, in the 1880s, was a recognition of the widespread interest in these matters, as well as revealing a typical concern to find scientific evidence for its validity. The 1880s was a decade of deep political tensions fuelled by economic downturn, and was the period when artists such as William Morris became committed socialists. With socialism and spiritualism intimately connected, especially among the working classes, it comes as no surprise that artists should show varying degrees of interest in both. This connectedness has a long history and evidence for it can be found in the life and art of Blake.

In the year of its inauguration, one of the founders of the Society for Psychical Research, the classical scholar F.W.H. Myers, published an influential essay called *The Religion of Beauty*, which interpreted Rossetti's art as a Platonic exercise in the revelation of ideal forms through the iconic representation of material beauty. He also saw Rossetti as a protofeminist in his new cult that was devoted to modern woman. Rossetti, a devotee of one of Blake's mentors, Swedenborg, who had written of the relationship between earthly lovers as a reflection of a heavenly union, needed no scientific proof of the afterlife, however, and apparently was greatly soothed by a successful encounter with Lizzie's spirit. He had a powerful sense of the union of body and soul in love, and in his scheme of things death played the central and culminating role in this transfiguration.

'There must be, somewhere, primordial figures whose bodies are nothing but their image. If one could see them one would discover the link between matter and thought', wrote the French novelist Gustave Flaubert in his *The Temptation of Saint Antony*. The ambivalently saintly and fleshly Rossetti certainly aspired to this discovery. Two macabre details hint at how important *Beata Beatrix* was to Rossetti – he began the painting during Lizzie's lifetime, but then abandoned it. In 1869, while still working on the canvas and in a guiltily suicidal frame of mind, he had her (apparently well-preserved) body exhumed so that he could retrieve a manuscript volume of his own poems entwined in her golden hair. Where many Victorian painters made images about past, present and future, memory and premonition, in Rossetti there was a new level of autobiographical involvement which blurred the lines between now and then, here and there, self and other in an unprecedented fathoming of the psychological. Symbolism, often identified with French and Belgian culture in the 1880s, has some of its deepest and, it was claimed at the time by detractors, most poisoned roots in Rossetti's art and in the response to it of other British painters and writers in the 1860s and 1870s.

### Chelsea Blue and White

Visitors to London do not find, as they do in Paris, men waiting about the principal streets, offering themselves as guides to Bohemia. The fun is in the life itself, and not to be had less cheaply than by living it. (Arthur Ransome, *Bohemia in London*, 1907)

The fast-disappearing riverside village of Thomas More's Chelsea was now the low-rent heart of Bohemia, taking over from the West End and its seedier northern surroundings as the favourite haunt of many artists and writers. Chelsea represented the western limit to the drift from the centre of fashionable artists' quarters, which had been taking place since the seventeenth century. Rossetti's house there on Cheyne Walk was the lodging place of many passing talents such as his brother William Michael, the second

generation Pre-Raphaelite painter Frederick Sandys and the controversial 'degenerate' poet Algernon Swinburne. This was the 'in place' for sex, drugs and spiritualism with Rossetti, the first pop-star artist, the high priest and spiritual forebear to Mick Jagger's character Turner in the 1970 film *Performance*. Bohemianism, associated in Britain with the travelling gypsies we have glimpsed in William Powell Frith's *Derby Day* and whom we shall encounter again in the life of Augustus John, meant a rejection of bourgeois norms of behaviour, an embracing of a kind of decadent Rousseauism which might have shocked Sir Brooke Boothby, and a love of the simple or, alternatively, low life. Slumming it moved from necessity to lifestyle. Paris had become the capital of bohemianism in the wake of the upheavals of the two political revolutions of 1830 and 1848.

We have mentioned the notion of the avant-garde as a product of the same background, and bohemianism was largely the 'lifestyle' dimension of the culture of avant-gardism. The book that later popularised the bohemian life of Paris for a wide and voyeuristic British audience was Henri Murger's *Scènes de la vie de Bohème*, much discussed among intellectuals and artists after its publication in France in 1849. As we have seen, however, the trappings and substance of artistic radicalism were not so easy to differentiate.

The artist's sexual life was now at the centre of his creativity and art, sex and politics were identified in ways we have become very familiar with.

We think of the bohemian artist's studio as full of voluptuous or consumptive models, depending on taste, an unmade bed (so popular today!) and a lot of bric-à-brac. Among Rossetti's bric-à-brac was oriental blue-and-white Chinese ware and this has a significance beyond that of the usual medley of exotic objects, which found their way often incongruously into paintings. There is an element of trend-setting of course, and artists' studios had contained many such items over the centuries, but there is also something more interesting going on. The range of visual references in art had usually been quite limited, and in the 1850s we have seen attempts at strict archaeological and historical accuracy. Now, however, there was a more global spread, with times and places mixed apparently at random as the fruits of empire returned to the 'heart of darkness'. Artists could include middle-eastern costumes in medieval European settings and use Japanese pictorial devices in depictions of contemporary London. There was a kind of restless multi-culturalism at work which for many commentators was symptomatic of a decadence. The Chinese punch bowl with Hogarth's *The Gate of Calais* (no.49) was the hybrid product of imperial trade, but

141 **Aesthetes and Swells** contrasted, 'Punch', LXXV 21 September 1878

40 **Elizabeth Butler (Lady Butler)**
1846–1933
**The Remnants of an Army**
1879
Oil on canvas
132.1 x 233.7

Jingoism was big business in late Victorian England, as the nation celebrated a succession of military campaigns in exotic settings such as Afghanistan and Africa. A Catholic convert married to an Irish soldier whom she followed from campaign to campaign, Lady Butler was the most popular military artist of her time, considered by Ruskin to be the first Pre-Raphaelite war artist. This work shows an army surgeon arriving at the walls of Jellalabad, the sole survivor of a disastrous retreat from Kabul in Afghanistan. The imperial hero was the antithesis of that immoral outrage, the degenerate bohemian (no.141).

**142 Harry Bates**
1850–1899
**Pandora**
exh. 1891
Marble, ivory and bronze
94 x 50.8 x 73.7

This is a fine example of what was known as the 'New Sculpture', which included the work of Alfred Gilbert, the sculptor of 'Eros' in Piccadilly Circus. Harry Bates's image of the first woman, Pandora, is of the classical equivalent of Eve, brought to earth by Hermes, and beautiful but reckless. In spite of being forbidden to do so, she opens a box with all the ills of the world in it, leaving only Hope. Here Bates shows the moment of temptation and choice, a prime theme in traditional history art. What was new about the style was the mix of smooth marble, sensuality and the real ivory and bronze casket. Referring in the sculpture to the male artist's role, Bates plays on the fact that Pandora was a divine creation from clay and on a parallel with the Pygmalion story, which was so popular during the period.

was made by a Chinese craftsman. As there was concern sometimes verging on panic about the mixing of classes and races in society, so the aesthetically officious saw in these new tendencies in art a dilution and contamination of the tradition. In its most extreme form this anxiety became associated with the fear of 'degeneration' – the weakening through miscegenation of the national identity and the eventual collapse of society. Frith had dealt with such fears and by the turn of the century the avant-garde were identified as one of the main channels through which the poison entered the country's system. Bohemian London, so close to the poor and alien in fact as well as spirit, was radioactive.

## That Pot of Paint

The pugnacious American painter James Abbott McNeill Whistler, who had arrived in London from Paris in 1862 a fully-confirmed bohemian out to *épater les bourgeois*, shared with his new friend Rossetti a passion for, among other non-European *objets d'art*, oriental ceramics and Japanese prints by artists such as Hiroshige. He was quite happy to transform his art with alien matter. Witness to the origins of Impressionism in France through acquaintance with some of the main movers there, Whistler created a unique form of cityscape, the *Nocturne*, which itself became as much a cult as Rossetti's brooding sirens. Like Rossetti, he was also a talented writer and was able to promote and defend his art in lectures and essays which became a byword for rapier wit and poetic description. One of his chief principles, shared with colleagues in Paris and London alike, was that art was neither about natural description nor moral improvement. Even its spiritual dimension in Whistler's case was distinctly agnostic and, like writers from his American compatriot Edgar Allen Poe before him to the aesthete Walter Pater later, he believed that all art 'aspires to the condition of music' and had no need to make society better nor required a good society to be produced. Such views were one thing for his contemporaries, their realisation in radically unorthodox painting was quite another.

*Nocturne: Blue and Gold – Old Battersea Bridge* of c.1872–5 (no.144) is a masterpiece of the simultaneously modern and mournfully nostalgic imagery Whistler created. It shows the old wooden bridge that connected Chelsea to the south bank of the Thames at Battersea, looking towards the tower of Chelsea Old Church to the left and the new Albert Bridge with its lights to the right. The bridge itself is exaggerated in height and a few figures walk over it, while in the foreground an eerie boatman manoeuvres his way along the Styx-like Thames. In the sky fireworks explode, prompting Oscar Wilde to quip later when it

was shown at the Grosvenor Gallery that the work was 'worth looking at for about as long as one looks at a real rocket, that is, for somewhat less than a quarter of a minute'.

The Thames was a complex symbol of London's wealth and power as the heart of empire, of the umbilical link of its source in rural middle England and the oceans to which it leads, of the course of the nation's destiny and of individual human fate – the sewage-ridden site of suicides and beachcombing as well as of pleasure trips and state ceremonies. Whistler, ignoring the building of the Embankment, which commenced as he was painting his series of *Nocturnes*, paints a twilit world of the river from a memory of its fading past while evoking London as a modern Venice. His nostalgia is similar to that of Constable but applied to an urban idyll which, as we have indicated, also conveys an almost funereal quality. This genre of London by Night was popular among artists and poets at the time, and by the turn of the century tourists were taking nocturnal guided trips round the city.

He would have himself rowed into the Thames by his boatmen the Greaves brothers, one of whom, Walter, he taught to paint, and would sketch and meditate on his scene into the early morning before returning to his studio. Mixing his paints with a runny mixture of copal, turpentine and linseed oil, he would brush and pour the 'soup', kept in little pots, in layers onto an absorbent, rough-grained canvas, primed a dark rusty red, and often laid on the floor or a table. The paint was applied in such a way, frequently rubbed down, that this priming would show through the thin glazes, in the form, for instance, of the main structure of the bridge. The effect of bursting fireworks would be achieved by delicately flicking paint at the surface.

In a letter to the French painter Henri Fantin-Latour, Whistler wrote: 'It seems to me that colour ought to be, as it were, embroidered on the canvas, that is to say, the same colour ought to appear in the picture continually here and there, in the same way that a thread appears in an embroidery ... in this way the whole will form an harmony. Look how well the Japanese understood this. They never look for contrasts, on the contrary, they're after repetition.' This reveals the source of much of Whistler's innovation. Japanese art had begun to enter the European market after centuries, thanks to the lifting of trade barriers with the west in 1853. The International Exhibition in London in 1862 gave Britons an early view of Japanese art in the section organised by the great and tireless lover of Japan, Sir Rutherford Alcock, which, many claimed, looked very impressive next to Gothic and classical forms nearby.

Specialist dealers such as Murray Marks catered for discerning connoisseurs and by 1875, the department

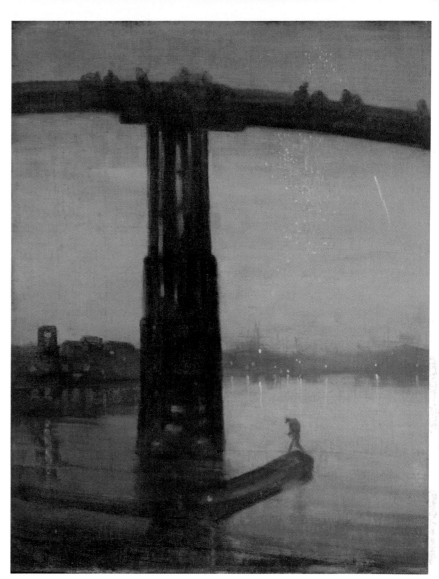

144 **James Abbott McNeill Whistler**
1834–1903
**Nocturne: Blue and Gold –
Old Battersea Bridge**
c.1872–5
Oil on canvas
68.3 x 51.2

143 **Walter Crane**
1845–1915
**From 'One, Two, Buckle
My Shoe'**
London, 1869
The Hornby Library, Liverpool
City Libraries

The craze for all things Japanese became widespread in Britain in the 1860s and 1870s. This children's illustration by Walter Crane, with its Japanese flat colour and strong line, shows a middle-class home with its prominent Japanese screen, and the mother sitting in an 'Anglo-Japanese' chair, holding a Japanese fan. Such accessories were seen as aesthetically improving.

store Liberty's had opened in the West End and was selling oriental-style furnishings, objects and fabrics. Avant-garde taste was therefore quickly available to a growing suburban consumership. Whistler was simply one of many artists and collectors who became fascinated not simply by the fashionable 'difference' of the art and its ethnographic interest, but by the exceptionally unexpected nature of its rules of representation and aesthetics. Flat colour, unusual and aperspectival viewpoints, asymmetrical compositions, abbreviated forms signifying figures and other details, unusual harmonies of colour – all of these were disruptive of the canons of Western art, and rendered the sharply detailed moralising story intended to improve its viewers quite untenable in many respects.

Familiar as it is, Ruskin's angry critical reaction to Whistler's art, and prices, at the new Grosvenor Gallery founded by the amateur artist Sir Coutts Lindsay in 1877, and the libel action brought to court by Whistler on account of it the following year, are a turning point in the history of art in Britain. Ruskin's letter to *The Times* was intended to carry the full weight of a critical reputation, which was both beyond reproach for admirers and a source of intense irritation to detractors: 'For Mr Whistler's own sake, no less than for the protection of the purchaser, Sir Coutts Lindsay

ought not to have admitted works into the gallery in which the ill-educated conceit of the artist so nearly approached the aspect of wilful imposture. I have seen, and heard, much of Cockney impudence before now; but never expected to hear a coxcomb ask two hundred guineas for flinging a pot of paint in the public's face.' At one level this ironically replays old controversies about 'lack of finish' and technical incompetence, which Turner, whose late work is often compared with that of Whistler, had been embroiled in, and the continuing warfare between artists and critics that began in the eighteenth century. But there was much more to it than this, and the debate was every bit as significant as the one over religious images two or three centuries before.

The trial was a financial disaster for Whistler, from which he barely recovered, and a humiliation for Ruskin who lost it and was ordered to pay a farthing's damages to the painter. The press had a field day reporting the trial and Gilbert and Sullivan immortalised the dispute between 'aesthetes' and 'philistines' in their comic opera *Patience*, which coined the immortal phrase of 'greenery-yallery' to describe the new art and mores of the Grosvenor Gallery artists. The French play *La Cigale* by Meilhac and Halevy had already appeared in an English translation in the West End in 1877 as *The Grasshopper*. It included an 'artist of the future', 'Pygmalion Flippit', who claims Whistler to be his

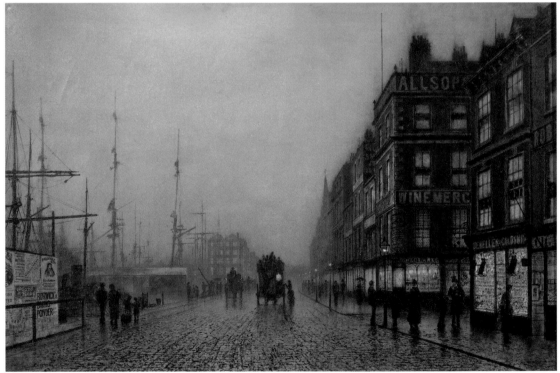

**45 Atkinson Grimshaw**
1836–1893
**Liverpool Quay by Moonlight**
1887
Oil on canvas
61 x 91.4

Atkinson Grimshaw was born in Leeds and was a railway clerk turned self-taught painter. At first influenced by Ruskinian principles and by Pre-Raphaelitism in his detailed landscape scenes, he turned towards a more atmospheric painting of moonlit night scenes in northern dockland cities such as Newcastle and Liverpool. Influenced by Whistler, who admired him, he captured natural and artificial lighting effects in rain and fog conditions, often adding a slightly melancholy or mysterious note through an omnibus or other vehicle receding into the distance.

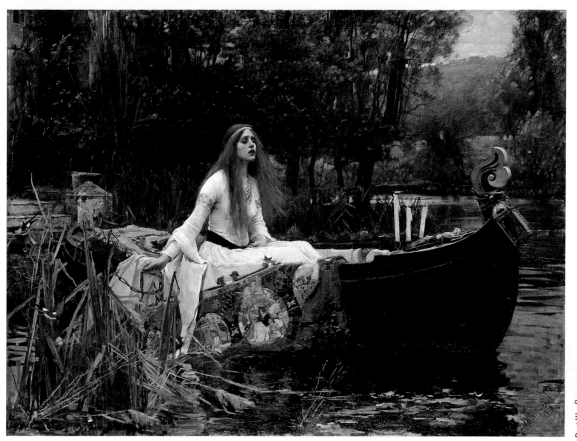

'great master' and who paints a 'Dual Harmony', which could be hung either way up, perhaps the first such joke at the expense of modern art.

There are many contradictory aspects to the trial – for instance Ruskin himself had said many years before, in his *Stones of Venice*, that 'we are to remember, in the first place, that the arrangements of colours and tones is in art analogous to the composition of music and entirely independent of the representation of facts'. He also called as a witness Edward Burne-Jones, a distinctly Grosvenor Gallery artist and creator of imaginary worlds, who equivocated in his evidence on the question of finish. What was at stake, though, was the fundamental value of art and its role in society. For Ruskin the artist, like a divinely inspired natural scientist, attended to the beauty of nature's intricacy in order to praise God and thereby to elevate human experience. Furthermore the most serious art had a wider purpose to educate morally, as great literature did. Whistler on the other hand saw beauty as independent of naturalistic description and, like music, arrived at through formal harmonies and a grand indefiniteness.

Equally he belittled the narrative and moral function of art. The trial judge asked him on a number of occasions to explain what was meant by some of his apparently random brushstroke 'signifiers', and he always dismissed these questions as irrelevant. In his essay 'Red Rag', published the year of the trial, he had already said of one of his *Nocturnes*, 'I care nothing of the past, present or future of the black figure placed there because the black was wanted at that spot. All that I know is that my combination of grey and gold is the basis of the picture.'

Whistler had a profound impact on artists, architects and designers and on a whole generation concerned with the wider culture – his Peacock Room, designed for the Blue and White china of the collector Frederick Leyland, extended the principle established in his carefully wrought painted frames; the architect E.W. Godwin made major alterations to Whistler's White House at Chelsea, and a generation of young disciples such as Mortimer Menpes and Walter Sickert carried the cause into the next century.

As a result of the disputes over Symbolism and what came to be known as Aestheticism, art, objects, representation, meaning and morality had been shaken from their previously intimate links, and the gaps which appeared around these terms were to provide exciting openings, as well as cul-de-sacs, for future artists. The legal system had acknowledged the limits of its jurisdiction over aesthetic matters, a bitter blow for many and a warning of deeper dangers at work in society. It was in the wake of these urgent

146 **John William Waterhouse**
1849–1917
**The Lady of Shalott**
1888
Oil on canvas
153 x 200

Possibly over the years the most popular painting in the Tate Collection, here is a tragic female cursed by love, from the eponymous Tennyson Arthurian poem. The Lady of Shalott is only allowed to view the world in a mirror but disobeys this rule when passion makes her look directly at the handsome Sir Lancelot. The mirror breaks and she ends her life floating down the river to Camelot singing her last song and staring with 'glassy countenance' at a crucifix. A little ironically, Waterhouse paints the mythical background in a style close to that of the Impressionist-influenced realists of the 1880s.

debates that the founding of the Tate Gallery took place a few years later.

## The Men Who Fell to Earth

The city was the natural origin and setting for the refined and unworldly Symbolist and Aesthetic art we have been considering. London, with its extremes of wealth and poverty, its rich tapestry of urban types and lifestyles, embodied the contradictions of Victorian society in a way plain for all to see.

There was a world beyond the city, however, whatever population movements towards it might suggest and Ruskin, for one, was far happier with a younger generation of artists who, while adopting techniques derived from French Impressionism, did so with both a concern for finish and with socially and morally significant subject matter. The concern with social conditions which grew again in the 1880s, following a period under Gladstone, and then Disraeli, of laissez-faire prosperity and its downside in the 1860s and 1870s, is reflected in the writings of men such as Ruskin, Thomas Hardy and William Morris, and in paintings by artists such as George Clausen and Frederick Walker (no.147). In particular there was a preoccupation among painters with the plight of the rural poor, picking up on the French Realist art of Gustave Courbet and Jean-François Millet in France,

which had appeared in the 1850s and that of their followers, and of writers such as Emile Zola with his novel *La Terre* (Earth) of 1887.

The mysterious pastoral vision of Samuel Palmer and the Ancients in the 1820s and 1830s and the fecund harvest scenes so popular in the 1840s and 1850s were replaced by something with a far harsher outlook. Since at least the writing of William Cobbett in the 1830s, there was a strong sense that the countryside was becoming a wasteland. Where Hogarth's contemporaries could rightly boast of the well-fed John Bull farm labourer with his roast beef and barrel of beer, now political satirists parodied 'The Roast Beef of Old England' with bitter references to the 'disgrace … of those that have ruled Old England'. The causes of economic decline in the fields are complex, involving the effect of new machinery and the intricacies, injustices and inefficiencies of land ownership and agrarian improvement. The agricultural writer James Thorold Rogers wrote of the revolution on the land in 1884, the year Clausen completed his *Winter Work*: 'The agricultural labourer was then further mulcted by enclosure, and the extinction of those immemorial rights of pasture and fuel which he had so long enjoyed. The poor law professed to find him work, but was so administered that the reduction in his wages to a bare subsistence became an easy process and an

147 Frederick Walker
1840–1875
**The Vagrants**
1868
Oil on canvas
83.2 x 126.4

Inspired by gypsies on Clapham Common, the short-lived wood engraver and illustrator Frederick Walker at first offered this subject to a magazine, but then made an oil painting of it. Although a fine example of the social realist style that began to flourish in the 1860s, it also has a Symbolist atmosphere with its leading figure, the almost Rossettian woman on the left, looking perhaps with anger at the toiling boy adding wood to the fire, a melancholy image of futile effort.

148 **George Frederic Watts**
1817–1904
**Mammon**
1884–5
Oil on canvas
182.9 x 106

Part of the grand aesthetic Holland Park Circle, with Frederic, Lord Leighton, Albert Moore and others, G.F. Watts was a heroic forebear and torchbearer of Symbolism. By 1880 he was much concerned with the evils of capitalism and materialism. Mammon (Aramaic for 'riches') is shown as a Blakean figure of grotesque ugliness and power, crushing youth and beauty beneath his feet as he sits dressed in gold, clutching money bags on a skull-decorated throne. The rich Venetian colour is deployed to create a satanic image of this pope of blind greed, a King Midas who knows the price of everything and the value of nothing. Watts wanted to cast a huge sculpture of Mammon to be installed in Hyde Park for public worship.

150 **George Clausen**
1852–1944
**Woman in a Mangold Field**
early 1880s
Photograph
Royal Photographic Society, Bath

economical expedient.' Such views had led to the founding of a union for farmworkers in the 1870s and a more organised form of resistance to exploitation than earlier uprisings and Luddite attacks on machinery had achieved.

Clausen, influenced by the French painter Jules Bastien-Lepage and his highly methodical realist technique, made images of labour, whether dignified or not, which was a theme of not much interest to the brazenly idle aesthetes of the city such as Wilde and Whistler. He settled at Childwick Green outside St Albans in Hertfordshire in 1882, and for two years lived and worked there, sketching, taking photographs (no.150) and painting the labourers and their bleak landscape. There was a degree of identification as well as sympathy with his subjects: 'We went there because it was cheaper to live, and there were better opportunities of working. One saw people doing simple things under good conditions of lighting; and there was always landscape. And nothing was made easy for you: you had to dig out what you wanted.' He seems to have followed the writer Richard Jefferies in the latter's conviction expressed in 1874 that 'in the life of the English agricultural labourer there is absolutely no poetry, no colour'. By way of respite Clausen made two trips to France, one to Paris, capital of the art world and the other, significantly, to Brittany.

Brittany had become a fashionable place to work and live among artists since Gauguin had stayed there, and increasingly artists not only wished to paint such primitive and remote places but to transfer their lives to them. Hertfordshire was a little less romantic and picturesque of course. *Winter Work* (no.149) shows workers topping and tailing mangolds for sheep fodder and is painted in a gloomy range of colours appropriate to the season and setting with coarse-textured paint, onto a roughly woven canvas. The high horizon line accentuates the muddy oppression of the work, and the three adult figures are shown trapped in the grinding repetition guaranteed to make prosperous town viewers uncomfortable and guilty. The addition of a young girl poignantly holding a hoop, symbol of the freedom and pleasure she will barely experience, was probably made by Clausen in an attempt to add a sentimentally more appealing image. It didn't sell when first shown and Clausen himself soon concluded that this degree of hard realism wasn't good for his retirement prospects. His later images of agricultural labour are more idealising and ennobling.

Bastien-Lepage had caused a controversy when he exhibited in London in 1880, and artists from the Pre-Raphaelite and Symbolist stables saw his art as dour and earthbound, as of course it was intended to be. The aesthetic writer George Moore writing of Clausen

49 **George Clausen**
1852–1944
**Winter Work**
1883–4
Oil on canvas
77.5 × 92.1

and his mentor in 1893 criticised them for having seen 'nothing but the sordid and the mean … The common workaday world … can be only depicted by a series of ellipses through a mystery of light and shade.' Moore's own mentor, Whistler, would have agreed with this view of a fallen art unredeemed by imagination. But it depends on what you mean by 'imagination'.

### The French Connection

In spite of decades of political and military hostility, the interactions between British and French art had been strong since the early eighteenth century with the arrival in Britain of rococo fashion and of Huguenot skills in art and design. In the nineteenth century, despite a common opinion to the contrary, the traffic was not all one-way from Paris. Constable made a bigger impact in Paris in his lifetime than in London, Turner was viewed with awe by many Impressionists and the Pre-Raphaelite, Victorian narrative painters and Symbolists had all been highly influential on French art. The great Symbolist poet, Stéphane Mallarmé, had written effusively about Whistler, for instance.

When French Impressionism travelled across the Channel, radical as it was visually, it was in part a repayment, so to speak, of a French admiration for the tradition of English *plein air* watercolour painting of the turn of the century.

Along with Whistler it was another American who had previously worked in Paris who helped to introduce the new way of painting to Britain. The Olympian New Englander John Singer Sargent, a character straight out of Henry James, a writer whom he knew well, was associated with an expatriate group of high-society American artists, writers and businessmen in England in the last two decades of the nineteenth century. He had made a reputation as a daring portrait painter in Paris and had been in the city for the entire period of Impressionism's heyday. In fact during this time he was a dedicated follower of the tonal painter Carolus-Duran and of Manet rather than of the more classically Impressionist Claude Monet of whom he was a friend. When he arrived in England from Paris he set about experimenting with the possibilities of Impressionism, while simultaneously becoming unofficial court portraitist to the plutocratic elite of late Victorian and Edwardian Britain. The former practice was more a labour of love while the latter was conducted as a business, charging huge fees and establishing the basis of a reputation that by the turn of the century was quite awesome. As a character says in a Saki short story in 1904, 'to die before being painted by Sargent is to go to heaven prematurely'.

151 **Frederic, Lord Leighton**
1830–1896
**And the Sea Gave Up the Dead Which Were in It**
exh. 1892
Oil on canvas
228.6 x 228.6

An enormous tondo, or circular painting, by the grandest artist of the late Victorian period. The scene is from the Book of Revelation and shows the resurrection of the bodies of the dead. It was intended for a scheme to decorate St Paul's Cathedral that came to nothing and was completed for Sir Henry Tate when Leighton heard of his plans to found the Tate Gallery. A tribute to Michelangelo, the painting was considered by the artist to be his finest effort and the one he wished to be remembered by. Leighton had painted many images concerned with the theme of death, this one showing his interest in the myth of Persephone who annually returns to the world, and with the physiological facts of states of life and death. The Dean and Chapter of St Paul's were disturbed by its ambiguous mixture of idealism and realism.

**52 John Singer Sargent**
1856–1925
**Carnation, Lily, Lily, Rose**
1885–6
Oil on canvas
174 x 153.7

156

## Child's Play

'When I use a word,' Humpty Dumpty said, in a rather scornful tone, 'it means just what I choose it to mean – neither more nor less.'
(Lewis Carroll, *Through the Looking Glass*, 1871)

George Clausen's forsaken little girl was possibly introduced into the cold Hertfordshire field to make the painting more attractive to a buyer. The Victorians are notorious for both their sentimentality and their strictness towards children, and the second half of the nineteenth century is notable for the complex debates and attitudes towards childhood, innocence and the role of adults. Ruskin's eventually insane love for the anorexic Rose la Touche whom he first met when she was ten is a particularly tragic case in point. Again, the questions of education and instruction become prominent. From the earnest Christian tales inspired by John Bunyan's *Pilgrim's Progress*, and sometimes Hogarth's *Progresses*, to the topsy-turvy agnosticism encouraged by Lewis Carroll's *Alice* stories in the 1860s and 1870s, we see a shift that mirrors the transition from Ruskin's outlook to that of the aesthetes and Symbolists.

Carroll explicitly denied any meaning to his bizarre, dream-like narrative and said that it was up to the reader to decide. Author and authority, as they had been in Laurence Sterne's *Tristram Shandy* in the eighteenth century, were undermined by a Rousseauesque denial of conventional civilised values and received knowledge. By the 1890s children such as the young Virginia Stephen (later Woolf) were able to laugh at biblical stories under the gaze of indulgent and sceptical parents who no longer believed that titles such as Maria Louisa Charlesworth's *Ministering Children*, published in 1854 when the Pre-Raphaelites still held pious views, were of much value.

Childhood has always been a controversial topic, of course. It is associated with innocence and original sin, with the garden of paradise and the descent into hell. It has been used to create morbid fictions of death as well as of eternal joy and we live in an age fixated on child-abuse and other distressing features. All these contradictions pervade Victorian images of children. For conservatives the world was a moral picture book, where each action and object held a particular lesson; for progressives this fabric of meaning meant claustrophobic fear and suffocation and needed to be ripped apart. The garden becomes a refuge from the adult world, where play and true spiritual growth are possible, if often only in a melancholy way that Brooke Boothby might have understood. Innocence was back. Whether it was Kenneth Grahame's *Wind in the Willows* and *The Golden*

Age, J.M. Barrie's *Peter Pan*, with its later memorialisation in Kensington Gardens, E. Nesbit's *The Treasure Seekers*, Kipling's stories, the festooned children's illustrations of Ruskin's protégée Kate Greenaway, or Frances Hodgson Burnett's *The Secret Garden*, we see a vast genre of adult literature about children which speaks volumes about the period.

John Singer Sargent came to Britain in 1884, eventually settling in Tite Street, Chelsea, near Whistler and other artists, and where he rightly thought many found his painting 'beastly French'. He spent the early autumn months of 1885 and 1886 at the Cotswolds home of an American doctor and amateur artist, Frank Millet in Broadway, Worcestershire, in the company of a group of Anglo-American artists and writers. It was here that he painted the work he has become best known for in Britain, *Carnation, Lily, Lily, Rose* (no.152).

Inspired by a nocturnal scene he had witnessed in August in Berkshire of 'two little girls in a garden at twilight lighting paper lanterns among the flowers from rose-tree to rose-tree', at Broadway he used the children of his friend the illustrator Frederick Barnard, Polly and Dolly, dressed in white dresses made for the occasion. Far from working *alla prima* as Monet might have done, Sargent laboriously made preparatory sketches, brought the right kind of natural and artificial flowers into the garden and played around with the composition and with the shape of the canvas. Eventually he settled on a square format and worked as light allowed for a short period each evening, frequently scraping it down in the morning. He analysed the artificial and natural light effects of the oriental-style lanterns and fading sunlight on the girl's faces and dresses, at one point complaining to his friend the novelist Robert Louis Stevenson that 'my garden is now a morass, my rose trees black weeds with flowers tied on from a friend's hat'.

After eventually finishing it, Sargent exhibited what he had described to some acquaintances as 'Darnation, Silly, Silly, Pose' at the Royal Academy in 1887. It was a major popular and critical success and was immediately bought for the nation by the Chantrey Bequest, thus passing influentially into the public realm.

The title of the painting was taken from a popular song of the time in which the question 'Have you seen my Flora pass this way?' is answered by the response, 'Carnation, Lily, Lily, Rose', whose apparent nonsense probably encodes the secret love messages to be found in books such as Kate Greenaway's *Language of Flowers* (1884). Robert Louis Stevenson's illustrated book *A Child's Garden of Verses* was published in 1885, as his friend Sargent was at work on his painting, in which the child in the poems plays in an ordinary English garden. It ends with the lines:

As from the house your mother sees
You playing round the garden trees,
So may you see, if you will look
Through the windows of this book,
Another child, far, far away,
And in another garden, play.

Stevenson, as Sargent surely, was aware of the extent to which his dream of childhood was based on memory as well as observation, and we are entering that *fin-de-siècle* world dominated by literary memories of childhood, which found its expression most memorably in Marcel Proust's epic novel *A la Recherche du Temps Perdu* and, in a very different mode, in Freud's analysis of his patients' neurotic symptoms as caused by repressed memories. (Proust, tellingly, was a great admirer of Ruskin, the Pre-Raphaelites and British Symbolism.)

'Play' is a key term. New educational theories stressed the importance of play in the formation of children's minds and characters, and rejected the classification and repetition that had previously been the foundation of learning. The ideas of Friedrich Froebel had become popular in the 1850s when the first kindergartens were established in Britain, stressing the 'organic' growth of children under the auspices of adults acting as sympathetic and intelligent 'gardeners'.

The discovery of nature by the child was seen as analogous to the rediscovery of Eden, and this theme can be found in art and literature right through to the 1920s from seeds planted by Froebel's book, *System of Infant Gardens*, translated into English in 1855. This later inspired a book on children's gardens by Gertrude Jekyll, the doyenne of modernist Edwardian gardeners. Froebel accentuated the child's learning through the senses and the close connection between the physical and psychical and these ideas fed into widely read books such as the child psychologist James Sully's *Sensation and Intuition* (1874), which anticipates the stream of consciousness ideas of William James and their later impact on artists and writers such as Virginia Woolf, Roger Fry and the New England-educated T.S. Eliot. The opening of the latter's 'Burnt Norton', from *Four Quartets*, with its late summer setting in a mysterious Cotswold manor, was inspired by the beginning of *Alice in Wonderland* where 'Alice hears the footsteps of the White Rabbit and cannot get through the door into the rose-garden':

Footfalls echo in the memory
Down the passsage we did not take
Towards the door we never opened
Into the rose-garden.

**153 Helen Beatrix Potter**
1866–1943
**'The Finished Coat', from 'Illustrations for "The Tailor of Gloucester"'**, c.1902
Pen and ink and watercolour on paper, 11.1 x 9.2

Beatrix Potter is probably better known to most than the majority of artists in this book. As an artist and naturalist, her children's stories about anthropomorphic animals have been translated worldwide and her characters are on cards, cushions, cups and a myriad other items in many homes. 'The Tailor of Gloucester' was Potter's personal favourite among her works, the second of her books, and tells of an old tailor commissioned to make an elaborate waistcoat, who is helped in his task by the mice in his shop. There is none of Edwin Landseer's cruelty here.

**154 Aubrey Beardsley**
1872–1898
**The Fat Woman**
1894
Pen and ink and ink wash
on paper
17.8 x 16.2

Aubrey Beardsley was the visual arts' 'enfant terrible' of 1890s decadence, and a major contributor to the most shocking journal of the decade, 'The Yellow Book'. This image, possibly a caricature of Whistler's wife, is almost certainly set in the Café Royal in Regent Street, a favourite artists' haunt with its actresses and ladies of the night. Beardsley used pen and ink to revolutionary effect, drawing on Japanese prints and French artists such as Manet and Degas to create an aesthetically energised world of moral decline and spiritual exhaustion, picking up on Turnerian themes and anticipating the sense of 'exhilarated despair' of Francis Bacon.

This is the comfortable but haunted world visualised in Sargent's *magnum opus*, with its free-form symbolism open to myriad interpretations.

### Capturing Effects

In an age of intense competition and of proliferating artists' groups, clubs and societies, Sargent was a founding member of the New English Art Club in 1886, along with artists such as George Clausen, Walter Sickert and Philip Wilson Steer. Founded to offer regular annual exhibiting opportunities for painters sympathetic to new developments in Paris and tired of the Royal Academy's conservatism, the NEAC was the main platform for British Impressionism. Such groupings expressed a mix of idealised fraternising à la PRB, aesthetic preference and economic opportunism. One writer introducing the catalogue to the Royal Institution of Water-Colour Painters' exhibition in 1909 explained how the exhibitions of such groups offered the artist a chance 'to make a bid for the favour of the public – commercially of great value – and to give his opportunity to the professional critic – a matter of notoriety or the reverse – but it also enables him to seek the appreciation of his brother-artists, the intrinsic value of which, only an artist can realise'.

Impressionism was controversial not so much on account of its subject matter, which was usually conventional or concerned with unproblematic pleasure, as of its technical means. The dabs and dashes of pure paint applied to a bare or white canvas, most often out of doors, was an affront to expectations of craftsman-like finish and attention to the detail of nature. This was an aesthetic in tune with new ideas of the natural quality of child's play and of spontaneous creativity, and seemed to be at odds with the adult rigour of academic draughtsmanship and painting. The human senses were stressed and the fleeting experiences they offered, rather than the transcendent and idealised forms of old master art. However much Sargent might struggle to achieve his effects, they were viewed with suspicion by many. His approach was often conciliatory, however, and a painting such as *Carnation, Lily, Lily, Rose* represents a middle way, hovering between extremes.

Steer's paintings between 1887, when he visited Paris, and 1894 when he changed course, seemed more radical and were even described by one critic as 'evil'. Although many of these canvases were worked on over a number of years, and sketches, memories and reworkings in his Chelsea studio were part of his usual practice, they have a luminosity of colour and brilliance of broken brushwork which make them outstanding. In certain cases he did work straight onto the canvas outside and leave his initial effort alone, although even

---

**155 Roderic O'Conor**
1860–1940
**Yellow Landscape**
1892
Oil on canvas
67.6 x 91.8

Roderic O'Conor was an Irish painter of ancient noble descent who worked mainly in France, particularly at the artists' colony at Pont-Aven in Brittany where he met Gauguin. Van Gogh was also a major influence on him and this work, with its thick stripes of unmixed paint apparently squeezed onto the canvas, represents some sort of extreme of technique at this time. Shadows, for instance, are made from ribbons of red and green and O'Conor spoke of the importance of creating a direct and powerful expression of feeling almost 'to the point of hallucination'.

**156 John Singer Sargent**
1856–1925
**Ena and Betty, Daughters of Asher and Mrs Wertheimer**
1901
Oil on canvas
185.4 x 130.8

The Reynolds of his age, John Singer Sargent is probably best known for his glamorous society portraits of the nouveaux-riches and aristocracy of the late Victorian and Edwardian period. This double portrait is of the daughters of the art dealer Asher Wertheimer in his magnificent house in Connaught Place in the West End. They are surrounded by the trappings of wealth – old master paintings, a Louis XV commode and so on. Clearly we are looking at a painting of confident outsiders, Jewish women whose image the critic D.S. MacColl described as possessing 'a vitality hardly matched since Rubens, the race, the social type, the person'.

in these cases there is a considered, often Japanese and semi-abstract, approach to the composition. His powerful contrasts of complementary colours such as red and green and blue and yellow, while conforming to well-established nineteenth century colour theory, have some of the visual and emotional intensity of a Signac or Van Gogh.

In terms of the themes of childhood and creativity we have touched on, Steer's paintings of this period are direct and joyful in manner, with light and colour playing an orchestrated poetic role in defining a particular and passing mood. As in the case of Sargent, the symbolism, mirroring the colour, is loose, with its typical repertoire of beaches, high skies, running and strangely hieratic and anonymous children and bridges, boats and other signs of transition and change. Steer painted many of his most successful works on holidays spent in Walberswick and Southwold on the Suffolk coast (no.157).

These fishing villages, like those of St Ives and Newlyn in Cornwall, were popular among artists in Britain emulating the Brittany locations and homes of their French counterparts in search of a perceived child-like, primitive and pre-modern simplicity. They quickly became fashionable retreats and eventually venues for arts festivals for middle-class visitors looking for healthy air and anxious to avoid the vulgar horrors of more popular seaside resorts. Such discerning visitors might also be the patrons of artists like Steer who had helped to create the mythology of innocent and creative leisure centred on remote (i.e. not too near a railway station with all its Frith-like possibilities) and unspoilt places such as Walberswick. Art had become in part an escape, and pictures, as one artist had written in 1871, 'loopholes of escape for the soul, leading it to other scenes and spheres, as it were … where the fancy for a moment may revel, refreshed and delighted. Pictures are consolers of loneliness … a relief to the mind … windows to the imprisoned thought; they are books; they are histories and sermons … and make up for the want of many other enjoyments to those whose life is mostly passed amidst the smoke and din, the hustle and noise, of an over-crowded city.' Not quite what Ruskin and Morris had had in mind, but nonetheless probably an accurate description of the way things were for most artists and their clientele.

157 **Philip Wilson Steer**
1860–1942
**Girls Running,**
**Walberswick Pier**
1888–94
Oil on canvas
62.9 x 92.7

# Chronology
## 1800–1900

**1800**
Act of Union with Ireland

**1801**
First Census.
Population of UK 10.4 million
(USA 5.3 million)

**1802**
William Paley *Natural Theology*
published

**1803–12**
Elgin Marbles transferred
to British Museum

**1804**
Horticultural Society founded

**1805**
Battle of Trafalgar.
British Institution for the Development
of the Fine Arts founded

**1807**
Abolition of slave trade

**1808**
Edward Edwards *Anecdotes of Painters ...
who have resided ... in England* published

**1811**
Regency begins.
Luddite disturbances against
new machinery.
John Nash begins
Regent Street, London

**1814**
George Stephenson builds first
steam locomotive.
Walter Scott *Waverley* published

**1815**
Defeat of Napoleon at Battle
of Waterloo.
Controversial Corn Laws passed

**1816**
'Bread or Blood' riots in East Anglia.
Jane Austen *Emma* published

**1819**
Peterloo massacre by militia of
political reform demonstrators
in Manchester.
First iron steamship launched

**1820**
Accession of George IV.
French painter Théodore Géricault's
*Raft of the Medusa* shown in London

**1824**
John Constable's *Haywain* shown and
highly regarded at Paris Salon.
National Gallery, London founded.
RSPCA founded

**1825**
Stockton and Darlington
railway opens.
Trade unions legalised

**1828**
J.T. Smith *Nollekens and his Times*
published

**1829**
Catholic Emancipation.
Metropolitan Police founded

**1830–3**
Charles Lyell *Principles of Geology*
published

**1831**
'Swing' agricultural riots

**1832**
Great Reform Bill enlarges franchise

**1833**
Oxford Movement founded

**1834**
Slavery abolished in British Empire

**1836**
Charles Dickens *Sketches by Boz*
with illustrations by George
Cruikshank published

**1837**
Accession of Queen Victoria.
Death of John Constable.
School of Design (later Royal
College of Art) founded

**1838**
Public Record Office opens

**1839**
W.H. Fox Talbot publishes
a photographic negative.
Chartist riots in Britain

**1840–52**
Charles Barry and A.W.N. Pugin,
Houses of Parliament

**1841**
*Punch* magazine first published

**1843**
John Ruskin *Modern Painters*
first volume published as defence
of Turner

**1844–6**
Famines in Ireland.
'Railway Mania'

**1845**
Friedrich Engels *Condition of the
Working Classes in England* published

**1848**
Revolutions in France and elsewhere
in Europe.
Karl Marx and Friedrich Engels
*Communist Manifesto* published.
Founding of Pre-Raphaelite
Brotherhood

**1850**
Alfred Tennyson *In Memoriam*
published

**1851**
*Great Exhibition*, London.
Death of J.M.W. Turner

**1852**
Victoria and Albert Museum opens

**1854**
Working Men's College,
London founded

**1855**
Gustave Courbet's 'Le Réalisme'
pavilion at Universal Exhibition, Paris

**1857–65**
Transatlantic cable laid

**1857**
National Portrait Gallery,
London opens

**1859**
Charles Darwin *Origin of Species*
published

**1861**
UK population 23.1 million
(USA 32 million).
Death of Prince Albert

**1863**
First underground railway in London.
Edouard Manet's *Déjeuner sur l'herbe*
exhibited at Salon des Refusés, Paris

**1865**
Lewis Carroll *Alice's Adventures
in Wonderland* published

**1866**
Medieval historical study established
by William Stubbs at Oxford.
Richard and Samuel Redgrave
*A Century of British Painters* published

**1867**
Reform Act further widens franchise

**1869**
Matthew Arnold *Culture
and Anarchy* published

**1870**
Elementary Education Act

**1871**
George Eliot *Middlemarch* published.
Slade School of Fine Art, London opens

**1874**
First *Impressionist Exhibition*, Paris

**1877**
Grosvenor Gallery, London opens.
Society for the Preservation of Ancient
Buildings founded

**1878**
First electric street lighting in London.
Ruskin/Whistler trial

**1879**
First telephone exchange in London.
Public granted unlimited access to
British Museum

**1881**
Population of London is 3.3 million
(Paris 2.2 million and
New York 1.2 million)

**1882**
Society for Psychical Research founded

**1885**
Walter Pater *Marius the Epicurean*
published

**1886**
Robert Louis Stevenson *Dr Jekyll and
Mr Hyde* published.
New English Art Club, London founded

**1887**
Bloody Sunday socialist
demonstration in Trafalgar Square

**1888**
Arts and Crafts Exhibition Society,
London founded

**1890**
William Booth *In Darkest England,
and the Way Out* published

**1891**
Oscar Wilde *The Picture of Dorian
Gray* published

**1894**
*Yellow Book* first published with Aubrey
Beardsley as art editor.
Rudyard Kipling
*The Jungle Book* published

**1895**
National Trust founded
Marconi invents wireless telegraphy.
H.G. Wells *The Time Machine* published

**1895**
Lumière brothers invent
cinematograph

**1896**
First cinema opens in London

**1897**
Tate Gallery opens

**1899**
Magnetic recording of sound invented.
Start of Boer War

We are not only 'the last men of an epoch' … we are more than that, or we are that in a different way to what is most often asserted. *We are the first men of a future that has not materialised.* We belong to a 'great age' that has not 'come off'. We moved too quickly for the world. We set too sharp a pace. And, more and more exhausted by War, Slump and Revolution, the world has *fallen back.*
(Wyndham Lewis, *Blasting and Bombardiering*, 1937)

By 1900, Britain was arguably still the greatest power in the world, and this coloured artists' perceptions of the direction in which things were moving. The slow rise of what Wyndham Lewis called the 'drastic winds' of the modern movement in Britain from the late nineteenth century had a certain dynamic about it, which on the one hand seems to be centrifugal – the image of the 'vortex' was a common one in the early twentieth century, and referred to the power of London as well as to a sense of a concentration of power in visual culture – and yet on the other it carried a centripetal 'virus' within it. The vague but real expectation of some unification of art, architecture and design was linked to an equally vague sense of the historical inevitability of a new society, one in which artists and intellectuals would play a crucial role. By the outbreak of the Second World War, many of those involved looked back on the pre-1914 period as a paradise of optimism and freedom, and bemoaned the apparent loss of initiative and the fragmentation of their dreams consequent upon the disaster of the Great War. Yeats's line, 'The centre cannot hold', seemed to have been prophetic. As the world changed and factions became entrenched, art appeared to be losing its privileged position as the vanguard of the good, the true and the beautiful.

### Lady Killers

The hustle and din of the overcrowded city was the experience of most of the population, who might expect a few overcrowded days at the seaside and a Bank Holiday at the human zoo of the Derby. The artist who invented a suitably train-smoked visual approach to the blighted underworld of squalid bedsits and raucous music halls was Walter Sickert, a follower of the French artist Degas and of Whistler. Sickert was renowned for his mordant wit, expressed in essays of

a brilliant prose style, and for his resolutely bohemian mode of life. At the turn of the century he moved the centre of gravity of art in London back to the middle of town and away from Chelsea, which was now becoming popular with wealthy young married couples and therefore no longer a suitable location for Bohemia. Camden Town, initially intended in the Regency period as a service area to the inhabitants of Nash's luxurious Regent's Park development, was working class, with a large Irish population, which had been transformed by the arrival of the railways in the 1840s. Euston, King's Cross and St Pancras stations and their main lines had cut through the housing and created a low-rent but fairly central district that had much appeal for young radical artists, many of whom were students at the Slade School of Art just to the south in Bloomsbury. Camden Town was the name not just of the area, nor even only a collective term for the artists who lived or worked there, but it also evokes a moment in the culture of art and its visual expression.

Sickert, following what the painter William Rothenstein called his 'genius for discovering the dreariest house and most forbidding rooms in which to work', settled in Mornington Crescent in a house whose garden backed onto the railway, and established a loose colony of artists. The rooms, gardens, pubs and music halls of their surroundings became the location for a George Gissing-like low-life muse. Sickert's unique combination of dandyish dress and manners, Impressionist techniques and dour realist subject matter, were a beacon of radical alternatives to rebel graduate artists in search of an artistic cause. This was the ethos of Baudelaire's *flâneur* who finds, almost like a saint, beauty in the unpromising reality of the modern city. Oscar Wilde's line about all of us being in the gutter but some of us looking at the stars might have been a motto for Sickert's followers such as Spencer Gore, who tempted the master back to London from France in 1904. With Sickert's dry theatrical sense of subject matter and his protégés' commitment to Post-Impressionist form and colour, the stage was set for a distinctive development in British art, which Sickert proselytized as of a 'modern character'.

The Camden Town group was officially launched in 1911 after various art world manoeuvrings, and became

**158 Spencer Gore**
1878–1914
**Rule Britannia**
1910
Oil on canvas
76.2 x 63.5

Spencer Gore was President of the Camden Town group, lived in Mornington Crescent and, like his mentor Sickert, painted many scenes of the local music halls. He developed a radically simplified formal vocabulary influenced by Cézanne, with a bright palette which, together, give his work a light and yet structured feel. 'Rule Britannia' was sung at the end of the evening at music halls and Gore celebrates the raucous working-class patriotism it expressed.

THE RISE
of the
FILM.

Professor Sir Hubert von
Herkomer's Cinematographic Endeavours at Bushey

Taking a Film of "The Old Woodcarver" in Professor Sir Hubert von Herkomer's New Cinema Theatre at Bushey
These illustrations have been specially drawn for "The Sphere" by Clement Flower

160 **The Camden Town Murder, cover illustration for 'The Illustrated Police Budget'**
12 October 1907
British Library Newspaper Library at Colindale

DISCOVERY OF THE CAMDEN TOWN HORROR!

the publicity-minded successor to the New English Art Club as the leading radical group in London. The holy grail was now the elusive target of modernity, in art and life. Sickert wrote in an art journal in 1910: 'The more our art is serious, the more will it tend to avoid the drawing room and stick to the kitchen. The plastic arts are gross arts, dealing joyously with gross material facts.' Not really the climate in which Sargent or even Whistler would enjoy working and certainly anathema to Ruskin, who believed that in the smoke of industry such as that filling the lungs of Camden Town he could smell 'dead men's souls'.

Much of the subject matter now seems unremarkable, with its frumpy women in shady rooms and silent, brutal men, lurid cheap wallpapers and crumbling terraces, the stock repertoire of social realism throughout the twentieth century. But it was pioneering stuff. It needed to be 'spun', of course, and the artists looked to popular culture for its ethos and means of transmission to a wider public. The Sickert clique enjoyed the popular press, and the popular press enjoyed sensational and seedy events. Crime and violence, rape and murder in the city were the new sublime for many. The sublime had always had death as its secret heart, but the divinity of romantic death had become the raw, untransfigured corpse in the white and tiled morgue.

In September 1907 a tabloid sensation occurred when the streetwalker Emily ('Phyllis') Dimmock had her throat slit from ear to ear in a sordid room she shared with a railway cook in Camden Town. The trial and acquittal of a young 'shabby genteel' glassware designer with a penchant for prostitutes dominated the press in the last months of 1907, and was a celebrated case for years. For many young painters this was a story that was easy to identify with at many levels – the otherworldly Rossettian femme fatale and the obsessed artist-lover transmogrified behind sooty lace curtains into almost Hogarthian parody.

During 1908 and 1909, Sickert made a whole series of drawings, prints and paintings to which he gave the collective title *The Camden Town Murder*. Following Manet's work of the 1860s, he staged a mute and ambiguous pair of figures – a nude woman and a clothed man – accentuating the *contre-jour* or unflattering lighting and the haunted space of sad rented accommodation in an extraordinary rough and densely worked surface of subtle touches of paint. *La Hollandaise* is typical of this kind of 'iron bedstead' work, painted a year before the murder but in keeping with Sickert's later use of the theme (no.161). Many commentators remarked on the violence of slashing strokes with which the paint is applied, and the 'mess' of marks that make up the face. It has even provided

'It is certainly a sign of wonderful progress in the past and of promise for the future when an artist of Professor Sir Hubert Herkomer's standing takes such an interest in cinematography', wrote 'The Sphere'. Public

cinema arrived in London in 1896, the year before the Tate Gallery opened. It soon became a huge attraction, posing similar questions for art as photography had earlier. The German-born Herkomer (1849–1914) had been

a pioneer of social realism in Britain. Interested in the chronophotography of Eadweard Muybridge in the 1880s, he built film facilities at Lululand, his home in Hertfordshire, and began to make

historical and fairytale films that he wrote, directed and starred in. Anticipating cinema's impact on society and concerned about its effects on the young mind, he believed in strong censorship.

161 **Walter Richard Sickert**
1860–1942
**La Hollandaise**
c.1906
Oil on canvas
51.1 x 40.6

evidence for some investigators that Sickert was involved as an observer in the Jack the Ripper murders in the East End in 1888. The sense of sexual menace in the painting is as unmistakable as the avant-garde *facture*, or surface, of the pigment.

The murder and trial and their reporting fed a popular modern fascination with true-life crime, sex, death, fallen women and the underclass. The literature of the detective story was already well-established, and artists such as Sickert's mentor Degas had referred to art itself as a kind of sophisticated crime, an analogy Sickert himself used. There was some sort of fatal match between the artist, with his cold gaze and sexual freedom, and this kind of subject matter, which Sickert realised had great potential. Later, he would supposedly dress as the Ripper and go into a kind of reverie while working, as if acting out some unspeakable event in an age seen by many as uniquely productive of such horrors.

What is of particular interest and indicative of the discussions about art at the time is Sickert's relationship to the subject matter. On the one hand he disclaimed any significance for titles, regarding them as mere conveniences. This view was supported by those, such as the painter and critic Roger Fry, keen to make art a formal affair with no literary connotations to contaminate it. On the other hand, Sickert was in many ways a Victorian in his concern with stories and looked for a synchronicity of technique and meaning: 'Is it not possible that this antithesis is meaningless, and that the two things are one, and that an idea does not exist apart from its exact expression? ... The real subject of a picture ... and all the world of pathos, poetry, of sentiment that it succeeds in conveying, is conveyed by means of the plastic facts expressed.'

This is one of the key questions of the dispute between Ruskin and Whistler, and the problematic posed by Symbolist painting in the late nineteenth century, still powerfully conducive to art and its debates. Eccentrically against the tide, Sickert looked to the reinvention of the art of Hogarth and Mulready, and provocatively named Charles Keene, the commercial illustrator, as the greatest artist of the previous century. Sickert, perhaps seeing the modern artist himself as a kind of prostitute, was playing to a wider audience as well as guying his artistic peers. He saw the success of 'problem paintings', pictures posing moral dilemmas, at the Academy as proof of the tastes of the non-elite viewers with whom he wanted to reconnect. In fact it was at about the time of the Camden Town Murder that these subjects, for a few decades the source of endless speculation and letter-writing in the newspapers, were declining in popularity. There was a kind of nostalgia to Sickert's interest in an age when art and illustration were becoming polarised, and the structures of Victorian society were changing rapidly towards one where a form of alienated and mediated indifference characterised much in human relationships.

Most of Emily Dimmock's neighbours probably knew her through the often crude images in such publications as *The Illustrated Police Budget* (no.160), rather than in person. While some artists saw such change as an urgent wake-up call to reinvent the world, starting on the canvas, Sickert maintained a sardonic and inscrutable stance. His more conservative and older colleagues, Ruskinians or aesthetes, were revolted by the suggestion, at least, of prurient subject matter and by the modern style of the painting, one referring to 'Slum Art', and some cutting off further relations with him. It was very much to his ironic taste that, like the art controversies of the time, the Camden Town Murder remained unsolved.

**The Two Johns**

The artist could of course avoid the decaying city and its corrosive, sick culture altogether. Escapees included the painters Augustus and Gwen John, who were an unlikely brother and sister. They represent quite different strands of art and attitudes, which are worth considering in the wake of our examination of the Camden Town scene. Both were self-fashioners of a high order who staked all on a reinvention of themselves.

Augustus John was a heroic bohemian mentor for many students at the Slade, where he taught at the turn of the century, and his reputation for a wandering and womanising, romanising or gypsy life soon overtook any interest in his abilities as a painter. Where Clausen and others went to the remote countryside or fishing port to paint local traditional life, John, who painted family and friends rather than actual gypsies, actually threw himself body and soul into a primitive way of life in emulation of Gauguin's Tahitian escapade. An avid reader of Walt Whitman's poetry and of George Borrow's mid-nineteenth-century books celebrating the romance of gypsy culture in rural Britain, John took the bohemian lifestyle fairly literarily as well as literally with his caravan, language and brooding, hirsute look.

A Welshman by birth, he was addicted to a fairly common contemporary taste for the Celtic Twilight – the romance of Celtic culture – and the pursuit of a healthy and simple outdoors existence. The shades of Rousseau and Brooke Boothby hover nearby once again, in a world where the Ramblers' Association and an early 'road–movie' ethos among city motorists meant such part-time indulgences could only be surpassed by a very serious identification indeed.

In 1905, as the sophisticated *flâneur* Sickert was installing himself in a railtrack setting just north of

**162 Harold Gilman**
1876–1919
**Mrs Mounter at the
Breakfast Table**
exh. 1917
Oil on canvas
61 x 40.6

Harold Gilman, like Gore a graduate of the Slade School of Art, was also a central figure in the Camden Town group. The impact of the first 'Post-Impressionist Exhibition' in 1910 was intense, and he became a disciple of Van Gogh's art in particular. This carefully structured image of his landlady in Maple Street in London, whom he painted frequently, almost makes her an icon of the teapot.

164 **Augustus John and family with caravan**
*c.*1909
Photograph
Private collection

63 **Augustus John**
1878–1961
**Washing Day**
*c.*1915
Oil on wood
406 x 302

165 **Gwen John**
1876–1939
**Dorelia in a Black Dress**
c.1903–4
Oil on canvas
73 × 48.9

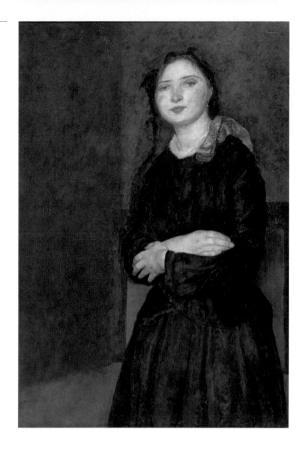

Euston, John the ingenuous gentleman artist of the road parked his newly acquired caravan on Dartmoor. With him were his pregnant wife, Ida, and his mistress Dorelia, who had just given birth to his midsummer night's son Pyramus, one of his many children.

While the women cooked, washed and tended the children, John matched his rediscovery of the childhood of man in the country with a free Impressionist technique which, in its sketchy brilliance, deliberately evoked a tramp's aesthetic. In part, then, his life and art were of a kind with the naive tendency and search for a child-like integrity we have seen in Sargent and Steer. John took the anthropologist role adopted in different ways, for instance, by Frith and Sickert, and made himself the masquerading subject rather than object of research. In search of an authentic community beyond the city's rootless chaos his art became a true *Autobiography of a Super-Tramp*, to invoke the title of W.H. Davies's 1908 bestseller. With John, the non-committal anarchist, art, sex and politics come together in a painted illusion of the heart's desire, and with the emphasis on the first two activities.

Like her brother, Gwen John was a student at the Slade where her teachers included Philip Wilson Steer, but unlike Augustus, she invented a very different Bohemia for herself. The Slade was a liberal, fee-paying art school dominated by female students, which allowed its middle-class young women as well as men to draw from the life model. Like the Royal College in the 1950s and 1960s and Goldsmith's in the 1990s, it produced a generation of artists, mainly male, who became the leading figures of their time in modern art. Gwen John was nearly alone among her female contemporaries in forging an art and life that ensured her an enduring reputation, and achieved this in spite of the limitations imposed on women's careers and self-perceptions. She was one of the New Women of the turn of the century who came to public notice most dramatically through the Suffragette movement, and who found Lizzie Siddal, Ida John and Dorelia, for different reasons, unattractive role models. They certainly didn't want to be models or muses, or elegant lady shoppers and wives of powerful men of the kind Sargent drew most of his considerable income from.

Although dishevelled hair and loose clothing and morals were part of the New Woman's tomboyish persona, Gwen, who shared with her brother a love of acting out fantasies, had a sophisticated personal script. She left London and moved to Paris where she studied at Whistler's *académie*, which had close links with the Slade. There she developed a tonal style of painting, using glazes of colour to match the subtlety of self-analysis and re-creation in her self-portraits and images of other women. Her portrait of her brother's

173

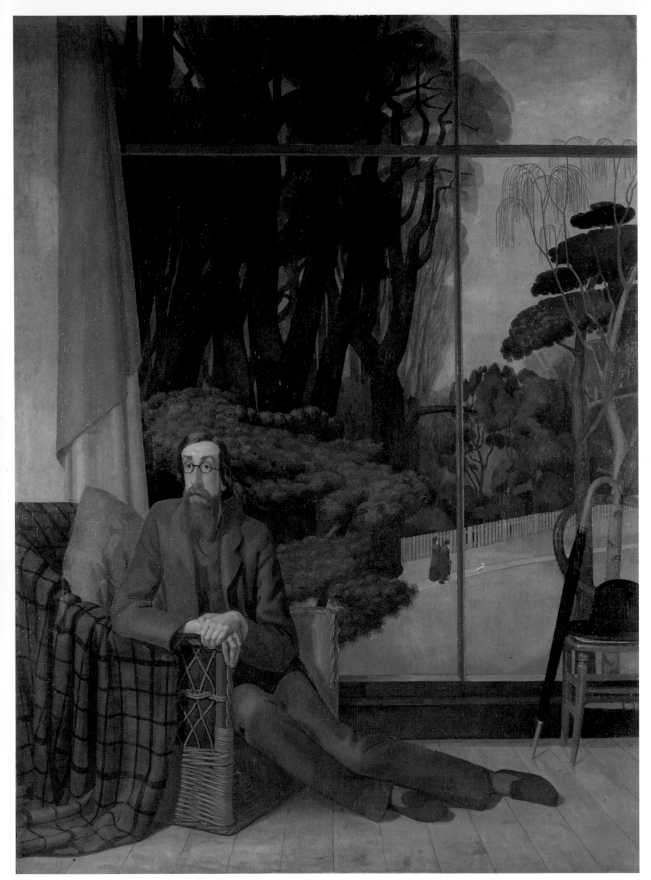

**66 Henry Lamb**
1883–1960
**Lytton Strachey**
1914
Oil on canvas
244.5 × 178.4

Henry Lamb drew and painted the Bloomsbury icon Lytton Strachey on a number of occasions from 1908. This grand portrait shows the awkwardly languid writer sitting in front of the view over the Vale of Health on Hampstead Heath from the artist's studio. Strachey was attracted to the good-looking Lamb, who seems to have struggled with their friendship at times while also teasing him. Painted on the eve of war and finished just as Lamb volunteered for medical duties, Lamb's 'Grandissimo', as the two men referred to the work, has a solid, slightly caricatural air about it.

mistress Dorelia McNeil, painted in 1903 in Toulouse on a walking holiday in France, before her companion became a full-time part of Augustus's roadshow, shows this woman as a man would have been unlikely to paint her (no.165). Rather than a sultry gypsy descendant of Rossetti's 'stunners', Dorelia, through the lens of Gwen's eye, is confidently independent. Gwen herself, who in spite of a projected self-image of introversion within a 'room of one's own', as Virginia Woolf put it, was an artist's model, a keen if ironic follower of fashion who haunted the department stores of Paris, and was quite confident enough to have an affair with the celebrated sculptor Auguste Rodin and to survive the experience. She also painted and drew a series of female nudes that are stark and uncompromising in their refusal of the male-orientated standard types of the time. The figures, often skinny and erotically *déshabillées*, are placed in poses unlike anything previously considered appropriate to the female nude. These images draw on a contemporary fashionable interest in Goya's paintings, the widespread fascination with bohemian and gypsy lifestyles associated with her brother and a new taste for a slim, almost boyish female form.

Gwen John's conversion to Catholicism in about 1912 was not unusual at the time; it confirmed her spiritual direction rather than represented a withdrawal from the world. In 1914 her notebook recorded: 'Last night the thought came to me to take courage and decide to acquire these virtues – to become a saint.' Strangely reminiscent of the Pre-Raphaelite cult of the Virgin, yet applied to herself, we find in these words an image of the modern woman artist, the New Woman who, despite her brother's trajectory through life and his caravan of women, was self-collected and self-made. 'We don't go to heaven in families now', she wrote, '– but one by one.'

### Significant Forms

By today's standards, none of the art we have been looking at seems remotely controversial, and the idea that Steer's paintings, for example, might be construed as in any way 'evil' is hard to imagine. We are now perfectly at ease with this turn-of-the-century art both in technical and thematic terms. It is mainly domestic in scale and always representational. At the time, however, the stakes seemed to be much higher and there were powers at work wanting to up them even further.

The Bloomsbury group, like the Camden Town group, but far more so, was about a whole attitude rather than a place to live and work. This very loose circle of artists, writers and intellectuals were connected by background (variously middle-class), education (Cambridge University), politics (usually liberal and socialist) and attitudes (modernist in most things and exponents of sexual freedom). They were highly influential in many areas of culture throughout the first half of the twentieth century: Roger Fry as critic and arts impresario, Virginia Woolf as novelist and feminist, Maynard Keynes as economic and political theorist, and the Hogarth Press as house publishers to Bloomsbury, bringing among other things Sigmund Freud's ideas to a wide public. They shared a common philosophical background heavily indebted to the ideas of the Cambridge don G.E. Moore, which was disseminated through the elite Apostles group. This stressed the over-riding importance of what has been called emotivism, where private emotional relationships and aesthetic experience were the pinnacles of ethical achievement.

Keynes later recalled that when he and other undergraduates read Moore's *Principia Ethica* in 1903, it was like 'a new heaven on a new earth'. Moore claimed 'good' as a simple indefinable property of personal affections and enjoyment of art, and that a right action was the one which produced the most good. Art and friendship, rather than religion or class politics for instance, were therefore the childlike as opposed to childish goals to be most strenuously pursued. The streets of Bloomsbury, located south of smoky Euston and encompassing London University and the British Museum and by now an artists' quarter, were therefore where, as one wit put it, a circle of friends lived in squares and loved in triangles. Lytton Strachey's *Eminent Victorians* joyously and languorously blew away the heavy pretensions of the previous century and opened up a new heaven for experimental play in art and life. Conversely, critics of Bloomsbury, from Wyndham Lewis through to Marxist analysts, have pointed to its closed-shop snobbery, interbreeding and aesthetic conservatism. The debate will continue.

Virginia Woolf famously claimed that the world changed beyond recognition in 1910. One of the pieces of evidence she adduced for this comment was the Manet and the Post-Impressionists exhibition, now often referred to as the *First Post-Impressionist Exhibition*, held that year at the Grafton Galleries and dubbed an 'Art Quake' by the critic Desmond McCarthy. The painter, critic and editor of the prestigious *Burlington Magazine*, Roger Fry, was the organiser, working through a high-society committee of like-minded art liberals. He brought to London, from a host of influential advanced private dealers and collectors in Paris – including Gertrude Stein and the entrepreneur of Cubism Daniel Kahnweiler – the work of Manet, Gauguin and Van Gogh, among other almost exclusively French artists. The response from many

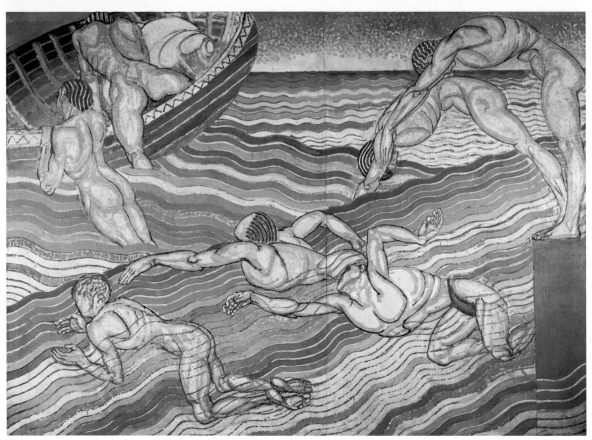

of the 25,000 who visited the show was predictably outraged and Francophobic, and Fry was seen as yet another harbinger of anarchy and national ruin by, among others, the usual academicians accusing the art of being 'evil'. Fry was pushing at an open door as far as a younger generation was concerned, however, and the sales from the show must have heartened the directors of the gallery. After all, by 1910, Manet had been dead for nearly thirty years, and Cézanne and many of the other big names had long since ceased to upset most of their French audience and were prime and highly priced targets for elite collectors. Picasso, Derain and Rouault were the most visually radical painters, and there was no trace of the recent and truly revolutionary tendency of Cubism.

The public was, moreover, becoming accustomed to art outrages in a way, as we have intimated, not unconnected with their interest in sex and murder. Fry was a shrewd spin doctor with a conviction about his aims that was impressive, and he began to replace Sickert among young artists and writers as the fashionable figure in the art scene. Spencer Gore, for instance, had his practice transformed by a sustained encounter with some of the pictures in the show. He was not alone among those who entered the Grafton and were struck in the crucial first room by Fry's cunning hanging of his stalking horse, the more

familiar Manet in works such as Bar at the Folies Bergère, alongside his secret agenda, Cézanne's geometrically challenging still-life and landscape images. Cézanne, claimed Fry, was 'the great genius of the whole movement'. Many were persuaded.

What lay behind the term 'Post-Impressionism', coined by Fry for his exhibition? It is, of course, a convenient phrase to describe a range of art practice in France and elsewhere between about 1880 and 1910. Some characteristics seem to be held in common, if a little leeway is permitted. Compared with Impressionist art, whether the dabbed bright colour of Monet and Steer or the more tonal effects of Degas and Whistler, there was a formal stress on line, structure and pattern. The art had a kind of iconic impact by which a sense of reality was evoked. Fry and his supporter the critic Clive Bell used the term 'Significant Form' to describe the new monumentality at which they were driving. Representation was not the aim, nor narrative, nor even 'atmosphere'. This was a bracing new world of aesthetic form, a sort of democratised classicism, which Fry believed played on some deeper, purer set of feelings than most recent art could achieve.

In a sense there was a parallel with Pre-Raphaelitism but Fry, as part of his strategy to carve out a clear critical position, waged a war of words on illustration and moralising as much as Whistler had done in the 1870s.

167 **Duncan Grant**
1885–1978
**Bathing**
1911
Oil on canvas
228.6 x 306.1

Duncan Grant was one of the major Bloomsbury artists and worked in a number of styles from Impressionist to abstract. This large work was part of a group commission based on the theme 'London on Holiday'

organised by Roger Fry for the dining room at Borough Polytechnic in South London. Influenced by early Christian mosaics in Sicily and by Michelangelo, the seven figures are all drawn from one model

who is shown in stages of movement from right to left. The highly stylised figures were thought by one critic to be a 'nightmare' unsuitable for working-class students.

Equally, his disdain for what he saw as 'slick' art was every bit as ferocious as Blake's attack on the 'immorality' of Reynolds's trickery with oil paint. Sargent, who perhaps unsurprisingly, had refused to sponsor the 1910 exhibition, was singled out for particularly harsh treatment and his reputation suffered for many years as a result. Fry later called him as 'genuine as a man ... as he was striking and undistinguished as an illustrator and non-existent as an artist'. Ouch.

'Significant Form' stressed genuine, unified emotion and had much to do with the theories of child education we have already discussed, as well as what has been called the 'emotivism' of G.E. Moore. In Cézanne, Fry found an art that demanded response before interpretation: 'We learn to read the prophetic message, and, for the sake of economy, to neglect all else. Children have not yet learned it fully, and so they look at things with some passion. Even the grown-up man keeps something of his unbiological, disinterested vision with regard to a few things.' This deeper, 'disinterested' and yet, as Fry saw it, physiological response, was connected with a desire for freedom from convention in all areas of life. At the turn of the century this was often viewed with suspicion as politically and sexually dangerous talk. The often reported outbursts of nervous laughter that greeted

the powerful colour of Van Gogh, Gauguin's naked women and Cézanne's strange apples at the Grafton Galleries can be, and were, interpreted as an expression of sexual tension rising to the surface. Everyone sensed this, but only those who had read Freud or the French philosopher Bergson had an account of it. The new language of art criticism was about experiencing strong emotion from form and colour and avoiding the delusions of life, whether it be from looking at the detail of a William Powell Frith panorama or the moral of a work of social realism. 'Art', wrote Clive Bell with an interesting twist in his influential book Art (1914) 'is above morals, or rather all art is moral because works of art are immediate means to good.'

For Fry and Bell, the qualities of great art are timeless and can be found across time and space; there was no steady Victorian progress but simply the authentic and the inauthentic: 'What quality is shared by all objects that provoke our aesthetic emotions? What quality is common to Sta Sophia and the windows at Chartres, Mexican sculpture, a Persian bowl, Chinese carpets, Giotto's frescoes at Padua, and the masterpieces of Poussin, Piero della Francesca, and Cézanne? Only one answer seems possible – significant form. In each, lines and colours combined in a particular way, certain forms and relations of forms, stir our aesthetic emotions.' A circular argument perhaps, but

168 **Roger Fry at work in the Omega Workshops**
c.1913
Anthony D'Offay Gallery, London

The Omega Workshops opened to the public in Fitzroy Square in 1913, under the direction of Roger Fry. They produced furniture, textiles and wallpapers designed by young artists working in a broadly Post-Impressionist style. Craftsmen were employed to make many of the objects, which were always sold anonymously. The Workshops pioneered abstract design and had a wide range of customers, from passing members of the general public to members of high artistic society. Abandoned as a business in 1919, they were nevertheless highly influential and the style remains popular today. Charleston Farmhouse near Lewes in Sussex is open to the public and gives a good idea of the Omega look.

persuasive for many who felt encouraged to find the magic quality in anything, whether it be a madonna or, as Fry famously pointed out, a coal scuttle. In particular it was liberating for a post-Victorian generation embarrassed by the legacy of Empire and racial stereotyping, as it meant the 'primitive' art of Africa could be valued as highly as Western art. Children, negroes, perhaps D.H. Lawrence's heroic working classes, even the insane, previously lumped together as uncivilised and therefore incapable of making or appreciating art, were being pushed towards a place at high table now that aesthetics was innate and basic.

Fry's fear was that for all the exciting change in art, the British public was unable to rise to the aesthetic, political and sexual challenge, out of touch with the rhythmic and unconscious wellsprings of its aesthetic humanity. He turned his attention to embarking on yet another transformation of taste, through design as well as art. The Omega Workshops (no.168), which employed young artists sympathetic to the new aesthetic to design and manufacture everyday objects such as candlesticks and fabrics, was the organisation by which he hoped to inaugurate this change. Charleston Farmhouse in Sussex is the surviving testimony to this enterprise, with its faintly amateurish but attractively cosy rooms of pastel colours, and Post-Impressionist furniture.

## Abstract Emotion

In 1912, Fry organised another Post-Impressionist exhibition at the Grafton Galleries. This time there were British and Russian as well as French sections, selected by Bloomsbury *aficionados* and advertised with a stark black-and-white poster. It was far more challenging to conventional taste than its predecessor and was visited by at least 50,000 people. Cézanne and his followers, Matisse and Picasso and the Cubists were the main figures in Fry's reworking of the modern canon. Matisse's astonishingly bold use of flat colour in works such as *The Red Studio* (which the Tate might have bought in the 1940s, when it was on the market in London) had, said Fry, 'a purity and force which has scarcely ever been equalled in European art'. Matisse became, in Bloomsbury circles, the *ne plus ultra*, the ultimate example, of the avant-garde artist.

The British group, selected by Clive Bell, included the Bloomsbury faction, Vanessa Bell, Duncan Grant and Fry himself, as well as Henry Lamb, Stanley Spencer and Wyndham Lewis. Augustus John declined the invitation to exhibit. Vanessa Bell's *Studland Beach*, painted in 1912 but not shown at the exhibition, represents the Bloomsbury position at perhaps its most convincing (no.169). Its theme relates to a genre of beach scenes, which had become popular since the early nineteenth century, the moment of explosion in

169 **Vanessa Bell**
1879–1961
**Studland Beach**
c.1912
Oil on canvas
76.2 x 101.6

seaside resorts we have seen Constable fulminate against. Sea, air and water, it was generally assumed, were good for the health, and dispelled melancholy and the sicknesses of city dwellers. Like Walberswick and St Ives, Studland in Dorset was a fairly remote, definitely pre-industrial and barely inhabited spot frequented by cultivated middle-class visitors such as Bell's family, who would have found Weymouth or Bournemouth a little vulgar. The beach there was long and empty and conducive to a relaxed meditation on everything from evolution and the nature of personal identity, to politics and sexual pleasure. Perhaps above all, the beach was a civilised space for families and for children's play, the breeze, sand, horizon and sea providing a natural setting for a rejuvenated life. Such simple but refined experience was not so easily found at Brighton.

Bell seeks to evoke a particular version of the beach theme in simplified, 'significant' hieratic forms, the figures turned away from us, and with Matissian stretches of non-naturalistic colour seemingly scrubbed onto the canvas. Like the oddly sepulchral changing-tent indeed, the painting has some of the quality of canvas about it, suggestive of the overall aesthetic emotion at such a site. It has also been convincingly suggested that the work, with its strange dreamlike evocation of a repeating memory, resonates

with the presence of the artist's mother Julia, described by Henry James as 'beautiful, pale, tragic', who died suddenly in 1895 and whose death seemed to precipitate a series of other deaths and family tragedies over the following decade. The significance of this possibility is that the form's 'significance' may not be simply a formal one of colours and lines in a 'certain arrangement' that verges on pure abstraction. Personal relationships, memory and art are drawn together in this account in a distilled and moving way, and disappear and reappear in the pulsating, oceanic deep blue. Few works of art of any power are reducible to theory, and most rebound on our emotional lives with all their confusion of half-told stories and half-sensed meanings.

### Conspiracy Theories

Another exhibition in 1912, also the year of a major retrospective of Whistler's art at the Tate and the *Post-Impressionist Exhibition*, provoked an entirely different reaction. This was the exhibition of Italian Futurist painters at the Sackville Gallery around the corner from the Grafton and, strangely, next door to Whistler's old tailor. Futurism was an idea before it was a practice, the *Manifesto* written by the poet and impresario Filippo Marinetti appearing on the front page of *Le Figaro* in Paris, before a group existed,

170 **David Bomberg**
1890–1957
**In the Hold**
c.1913–4
Oil on canvas
196.2 × 231.1

David Bomberg was a Jewish artist from the East End of London associated with, but not a member of, the Vorticist group. Trained at the Slade, he developed a brightly coloured geometrical art that appears to be abstract but is in fact based on drawings from real scenes and objects. This kaleidoscopic grid hides figures lifting a child from the hold of a ship in the docks near to where Bomberg lived. It is possible this shows an illegal immigrant being unloaded from a ship in the wake of laws restricting entry to Britain, following massive immigration in the 1880s and 1890s from Russia, the home of Bomberg's parents.

already a legend in his own mind. Futurism was the most polemical and internationally-minded 'ism' to have yet appeared, and aimed at a revolution in Italian art and culture by a radical embrace of modernity – speed, machinery, crowds and violence were to be its subject matter. Marinetti soon gathered around him a group of painters and sculptors, who quickly responded to the innovations of Cubism and created a brashly multi-coloured and formally aggressive style. The rhetoric of the stream of manifestos and related heavily publicised and riotous events organised across Europe emphasised 'lines of force', 'simultaneity' and 'dynamism'. The spectator was not encouraged to stand back from the artwork and have a disinterested experience, but rather to throw him- or herself into the heart of the fragmented pictorial action. Art became a political tool for a social revolution, through which Marinetti hoped Italy would become a modernised leading European power. Like many, he was tired of the compromise of a liberal consensus.

For a number of young artists in London, this was a welcome alternative to the quiet domesticity and contemplative ethos of much contemporary art in Britain. The Vorticist group was formed in 1913 following a public row between its founder, the painter, writer and polemicist Wyndham Lewis, a former protégé of Augustus John at the Slade, and

Roger Fry. The Rebel Art Centre was established with its headquarters in Great Ormond Street. Lewis and his associates published the first issue of its proto-punk journal *Blast* in the summer of 1914, which used striking typography and launched an assault not just on tired Victorian culture but on what was seen as the effeminate reaction to it by Lytton Strachey and the Bloomsbury rivals (no.173). While sympathetic to the broad principle of 'significant form', the Vorticists and their allies were after a more masculine look and took a different view about subject matter. While distancing themselves from what they saw as the emotional fuss of the Italians and their sexualisation of machinery, the Vorticists also saw an opportunity to develop a distinctly British modernism that responded to the complexities of contemporary life. Like the Italians, and in contradistinction to the cooler, if rather French, cosmopolitanism of the Bloomsbury group, Lewis and his group were combatively nationalistic, claiming Britain as the origin of the industrial revolution and, with its tradition of satire and exploration, the ideal setting for an upsurge of artistic energy. London was the vortex into which this energy was drawn and from which a new art would emerge.

Vorticism looked hard and angular and though, like some experimentation by Bell and Grant at the same time, it played with pure abstract form, was ambitious

171 Jacob Epstein
1880–1959
**Doves**
1914–15
Greek marble
64.8 x 78.7 x 34.3

The New Yorker Jacob Epstein arrived in London from Paris in 1905 and settled in Britain. His early career was marked by controversy over large projects, such as the sculptures for the British Medical Association's

new building of 1907–8, which were seen as obscene. Epstein, like Bomberg a Jew, was also associated with but not a member of the Vorticist group. This streamlined carving in Greek marble of two copulating

doves is influenced by the work of Modigliani and other Parisian avant-gardists and mechanises its natural image. The overt sexuality of the sculpture was typical of Epstein's work which looked for primitive and

procreative themes as a source for a new and challenging semi-abstract art.

172 **Wyndham Lewis**
1882–1957
**The Crowd**
?exh. 1915
Oil and pencil on canvas
200.7 × 153.7

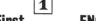

173 **Page 11 from first issue of 'Blast'**
July 1914

Following Italian Futurist tactics, 'Blast' used news-stand typography to make its point about waking up Victorian Britain. This page attacks the British climate for making the national character 'mild', while other pages 'blasted' British humour, sport, snobbish aestheticism and francophilia. There were also pages 'blessing' British maritime prowess and satire as well as the hairdresser who 'attacks Mother Nature for a small fee'.

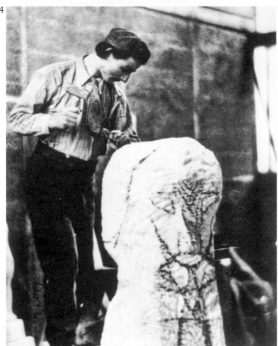

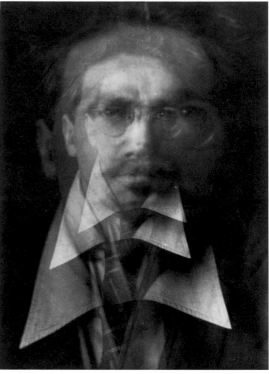

to create icons of the present – the sharp edges, flat heraldic colour and sense of movement of the city were transformed into streamlined formal visual equivalents. This condensed, almost emblematic art was intended to present the 'essence' of its subject. Lewis's *The Crowd*, painted just after the outbreak of war in 1914–15, is the sole surviving large Vorticist canvas of the period and demonstrates a set of attitudes unlike that to be found in any previous art in Britain (no.172). As with William Powell Frith, its subject is the crowd, 'that fat mass you browse on', as Lewis described it, and in that sense it is indicative of the modern intellectual's fascination with the modern masses, and of the disdain expressed in Lloyd George's cruelly succinct line about the working class's 'morbid footballism'. But Lewis has no interest in physiognomy or even any sort of individual detail. Rather, he creates a vast diagrammatic map of some sort of political action, presumably in Paris, given the *tricolore* visible, with joined-up stick-like figures caught in a moment of revolutionary and probably Syndicalist attack. The largest and robotic figures in the foreground seem to control this anonymous phalanx who are manoeuvred through a cityscape of Byzantine-coloured skyscrapers. Lewis was probably inspired in his choice of subject by the reactionary sociologist Gustave Le Bon, whose writings on the psychology of

the crowd in the age of democracy were widely read – his fans included Freud and Hitler.

Le Bon saw the reality of modern politics as the manipulation of voters through education and the media in the interests of a sinister elite. He believed the collective unconscious mind was more powerful than most individuals could resist, and that democratic politics was a conspiracy against freedom. His conservative views and interest in Hindu caste society meant that he took a poor view of the average human whom, he believed, required discipline and strong leadership. Lewis, whose own political views veered alarmingly between anarchism, liberalism and fascism throughout his career, seems to be posing a grand question: are you aware of the secret forces which control your actions, mind and destiny?

This is a kind of moral contemporary art history that Hogarth or Barry might have been interested in. It is inhuman compared with Bell's notion of art, but may have a force in the interests of human freedom that Bloomsbury painting did not aspire to. It was certainly uncompromising at all levels, testifying to the influence of Friedrich Nietzsche. The Aliens had landed.

### The Merry-Go-Round of War
With hindsight, it has been possible to see the extremely lively and pugnacious atmosphere in

---

**74 Walter Benington** d.1936
**Henri Gaudier-Brzeska carving Hieratic Head of Ezra Pound**
1914
Photograph
Tate Archive

The French sculptor Henri Gaudier-Brzeska was a member of the Vorticist group, and was killed on the Western Front in 1915. This photograph shows him at work on a huge phallic and totemic head of Ezra Pound

intended to represent the poet as a source of shamanic male creative power. It was carved, from a piece of marble bought by Pound, in a water-logged railway arch near Putney Bridge.

The American Ezra Pound posed for a number of iconic images during his career, including a series of 'Vortograph' portraits by his fellow countryman Alvin Langdon Coburn (no.175). Coburn used a system of

mirrors to break up the image and deconstruct Pound's fashionable self.

the small world of art in the Edwardian period as anticipating the war which 'broke out' (Wyndham Lewis's ironic phrase) in August 1914. Workers' militancy, the Irish Home Rule crisis, the German invasion scare in the press and in popular novels, and the unsettling question of women's suffrage, all during a period of Liberal government, were later viewed by participants as a set of signs which subsequently could be read as harbingers of a cataclysm. Cultural historians have recently pointed out some of the strange and even prophetic ways in which art, war and politics converged at the time – from Marinetti's premonition of fascism to the science-fiction fantasies of the time that prefigured modern warfare. The tank, for instance, appears in an H.G. Wells short story many years before its appearance on the Western Front in 1917, when it prompted the same sort of nervous laughter that greeted the Post-Impressionist Exhibition.

The deep connections between artists' thinking and occultism is evident in the way that the concept of 'sexual magic' of the 'Great Beast', the magician Aleister Crowley, influenced his disciple Colonel J.F.C. Fuller's tactics for the new tank from 1916, themselves adopted later by the Nazis when they developed the Blitzkrieg strategy. Vorticist compositions have much in common with the abstracted diagrams of this weird new military discipline. Ideas move in

mysterious ways, and the artistic imagination is often central to their origin and dissemination. Solomon J. Solomon, one of the significant figures of the Symbolist movement in the 1880s, was drafted in by the War Office to work on camouflage, and the Vorticist Edward Wadsworth developed 'dazzle' painting for ships with the naval expert and marine painter Norman Wilkinson (no.176). Many artists were true to type – Bloomsburyites were principled pacifists, Vorticists rushed to join up, Sargent was an official war artist travelling around in chauffeur-driven splendour, and Augustus John dreamily assumed that there was no fighting on Sundays. Sickert worked from newspaper images and Lady Butler, whose sons enlisted promptly, at the age of sixty-seven worked towards a major Waterloo Centenary exhibition at the Leicester Galleries in 1915.

Artists were up against high levels of jingoistic feeling and propaganda needs, and many found it difficult to work as avant-gardists in a *derrière-garde* position, to maintain their patriotism and to ignore the horrifying realities of the war as it fought its way into a muddy and bloody stalemate. Christopher Nevinson, who before the war was vilified by Lewis and others for signing up to Marinetti's Futurist movement, entered the war a visual radical and came out of it a chastened realist – of a sort. In 1915, while on leave from the Royal

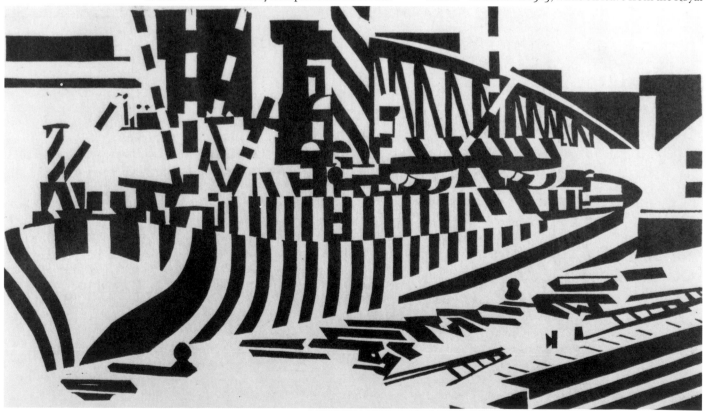

176 **Edward Wadsworth** 1889–1949
**Dazzle Camouflaged Ship in Dry Dock**, 1918
Woodcut, from 'Modern Woodcutters Book', no.4
13.3 x 20.9
The Imperial War Museum

**The idea behind the marine painter Norman Wilkinson's bright, abstract, even fantastic 'dazzle' painting for ships was to confuse submarine crews by breaking up the form of the ships with geometrical**

**patterning. The Vorticist artist Edward Wadsworth worked on the designs at the newly formed 'Dazzle Section' of the Royal Navy at the Royal Academy, and also supervised painting at dockyards. Neither the link**

**of Wilkinson's ideas to modern art nor the effectiveness of his designs is entirely clear.**

178 **Mark Gertler**
1891–1939
**Merry-Go-Round**
1916
Oil on canvas
189.2 x 142.2

177 **Christopher Richard**
**Wynne Nevinson**
1889–1946
**La Mitrailleuse**
1915
Oil on canvas
61 x 50.8

Army Medical Corps and, somewhat surreally, during his honeymoon in Ramsgate, he painted *La Mitrailleuse*, a kind of French machine-gun (no.177), which shows his art in transition under the acute pressure of events. French soldiers man one of the most destructive weapons of the war, one yelling orders, one already dead and two tensely facing the action, the whole group crushed into mechanised shapes under a sky dominated by barbed wire. The men have, so to speak, become part of the machine, and while with Futurism this was a kind of liberation into progress, here it is a Dantesque descent into blind, dehumanising ferocity. It should be remembered that most official war art was far more heroic, pious and conventional, and that painters such as Nevinson, Lewis and Bomberg were on the fringes of mainstream taste. They suffered the same kind of resistance as Turner had a century earlier: when asked by the navy to paint a canvas celebrating the Battle of Trafalgar, he produced a canvas that was deemed too anti-war in sentiment. Nevinson fell seriously ill while painting his nuptial canvases, during which time hundreds of thousands continued to enlist.

Another painter who was suffering from nervous exhaustion for different but war-related reasons was the painter Mark Gertler, pacifist friend of D.H. Lawrence and closely if ambivalently connected with the 'Bloomsberries'. Better known for his images of life in the Jewish quarter of Whitechapel in the East End, which by now had its own powerful avant-garde culture, he produced a major war canvas based on his observations of the fairground on Hampstead Heath, which was a truly disturbing revision of the popular imagery of leisure and childhood. Gertler had recently moved to the middle-class enclave of Hampstead from his 'native' East End, in an attempt to avoid the constraints of class altogether. A modernist moral variation on the theme of Francis Hayman's *See-Saw*, *Merry-Go-Round* shows doll-like military and female figures, reduced to the forms of their painted wooden steeds hurtling round on a carousel as if on a war machine (no.178). Open-mouthed, they are frozen in expressions which seem more redolent of horror than of joy. The whirling carousel, too, seems to be at a paradoxical standstill and is set against a deep, dark space eerily lit by stylised comets. This is a social machine of blind and deadly desire, which has careered into a metaphysical space where history is revealed as a futile race towards destruction. Humans, perhaps all too willingly, as in Lewis's *The Crowd*, are absorbed into a structure of sinister power that reduces them to functions of its inhuman momentum. Frith's individualised *Derby Day* revellers are now cloned ciphers for whom the artist has a kind of fascinated contempt. Lytton Strachey was shocked when he saw the work and said that he admired it but that, 'as for liking it, one might as well think of liking a machine-gun'. D.H. Lawrence, with whom Gertler stayed in a remote cottage in Cornwall for a period during the war, was similarly upset by the brilliance and despair of the work. Pointedly remarking that it 'would take a Jew to paint this picture', he also warned Gertler about the dangers of showing it at a time when such imagery might be seen as 'hun'-like in its 'alien' appearance.

There was certainly an equation among many in Britain at this time between modernism and Jewishness, and art reviewers of the period would refer to Cubist-looking art as 'cabbalistic'. Lawrence went on to say, alluding to the work's 'vortical' aspect, that by 1916 the formerly buoyant creative spirit of London had 'collapsed; the city, in some way, perished ... from being a heart of the world, and became a vortex of broken passions, lusts, hopes, fears and horrors'. Gertler's canvas was transformed into a sculptural frieze in Lawrence's novel *Women in Love*, where the characters are shown in 'an orgy of enjoyment ... a frenzy of chaotic motion'. For Gertler, *Merry-Go-Round* proved to be a brief and intense diversion from his real and more traditional instincts as a painter.

### The Waste Land

What are the roots that clutch, what branches grow
Out of this stony rubbish? Son of man,
You cannot say, or guess, for you know only
A heap of broken images.
(T.S. Eliot, *The Waste Land*, 1922)

France had been devastated by the First World War, most of which occurred on her soil. Russia and Germany experienced revolutions as a result of the war, and Germany faced the corrosive effects of hyperinflation in the wake of her humiliating defeat and the terms of the Versailles Treaty in 1919. Meanwhile Britain maintained a face of resilience, in spite of being severely crippled by the loss of three-quarters of a million men, many more wounded, and economic and political turmoil. The conditions in Germany, Russia and France, in different ways, and alongside a reaction in favour of classical values, or *rappel à l'ordre* (return to order), produced an avant-garde culture of some strength and pre-war vitality. Dada, Surrealism and Constructivism were all to leave a lasting mark on the future of modernism. In Britain, with a few exceptions, no such rejuvenation ever quite happened, and the twenties in art seem like an uncertain and even timid lull before the new energies of the 1930s. There was certainly none of the satiric anger in art there might have been if a latter-day Hogarth had been around to match the bitter etchings

**79 Stanley Spencer**
1891–1959
**The Resurrection, Cookham**
1924–7
Oil on canvas
274.3 x 548.6

and paintings of George Grosz in Weimar Germany. That mainly went into some of the literature of the immediate post-war years, only surfacing briefly and ironically in art in the war veteran Wyndham Lewis's work of the early 1920s. As the philosopher and art historian Michael Podro has written, however, the 'conditions out of which paintings emerge become interwoven in their content, which is not ... limited to the subject represented'.

The war haunts British culture in many ways throughout the inter-war period, at the end of which it reappeared like a very sick and predictable joke. In spite of the ubiquitous war monuments and national pride in victory, most agreed with Viscount Esher who wrote to a friend in 1919: 'You must get your perspective right. There is no chance of the future resembling the past. That is the first point. England and the Empire can never again be the England and Empire that you knew.' The mythology of the war as a biblical catastrophe pushed the high hopes of the Edwardian period into a distant fantasy, where it remained as a kind of lost paradise for survivors. For many the spiritualist revival of the 1920s was a way not only of communing with lost friends, sons and husbands but with a dream of a lost Britain.

The immediate pre-war period had produced a generation of talented young artists at the Slade School of Art, many of whom fought in the war, responded to it as war artists and continued their careers upon demobilisation. These included Stanley Spencer, William Roberts and Paul Nash.

### 'Angels in Jumpers'

Stanley Spencer had followed a unique path in creating a kind of modern vernacular art based on his experiences in his home village of Cookham which is on the Thames in Berkshire. His vision was Blake-like in its apparent naivety and unconventional and domesticated Christianity, and art historically stands, albeit eccentrically, in a tradition of Pre-Raphaelite and Symbolist imagery. *The Resurrection, Cookham* of 1924–7 presents the grand finale of Christian faith taking place in Spencer's local churchyard, the image inspired by his reading of John Donne's poetry, and Donne's description of such a site as 'the holy suburb of Heaven' (no.179). Unlike John Martin before him, Spencer was unclear about his ideas concerning a physical resurrection after a last judgment, but meant to convey in his huge canvas a celebration of a renewal of life on earth through the revelation of sexual love. Spencer told someone that the painting depicted a precise moment – 2.45 p.m. on a Tuesday in May. The moment was presumably orgasmic in a Rossettian way, and he and his fiancée, the painter Hilda Carline, figure

prominently in the painting in a number of episodes.

The painting combines past and present and transfigures fragmented literal reality into one of spiritual unity. In the centre, God the Father stands under a rosy porch and leans over a Hilda-like Virgin mother cradling three infants. To the right are various friends and ancient sages, such as Moses, who represent various intellectual and spiritual states of mind including contemplation, understanding and believing. On the left, by way of contrast in a way that would be unthinkable today, and shows how far the Empire and its legacy was then part of everyday consciousness, are Africans representing the senses. The Tate Gallery director Charles Aitken commented at the time on the 'white races ... occupied with things intellectual, the black races satisfied with simple tactile shapes'. (They are, perhaps, like children, handling 'significant form', that universally appreciated essence of all beauty?) Two of the black figures are engaged in a distinctly non-disinterested tactile activity! Although Spencer's original subtitle confirms this patronising theme it is actually possible to imagine him accepting the presence of black immigrants in Cookham should they have arrived.

Below the Africans, Hilda lies sleeping in a nest of ivy and is waiting to be woken with a kiss by Stanley, who stands naked nearby looking to the right. Hilda also appears on the far left smelling a sunflower with Spencer watching, and in the distance she climbs over a stile to board the pleasure-steam launch taking the resurrected to heaven. Spencer had always marvelled at the magic of the river at Cookham with its passing tourists and its crowded regattas, and we are reminded of the boats which took Hogarth's contemporaries to Vauxhall Gardens across the Thames from Westminster. Spencer appears again as an emblem of a signature on a book-like folding pair of tombs in the bottom right-hand corner. His friend Henry Slesser, in his judge's wig and robes in the centre foreground, emerges from a cornucopia of flowers – as in Pre-Raphaelite painting they all have particular symbolic meanings such as poppies for death, ivy for life everlasting and white roses for pure love. Sargent's image of the children's garden of innocent love springs to mind.

Spencer had fought in Macedonia and was shattered by his experience at the Front. His pre-war paradise of Cookham childhood and student life in Hampstead had been destroyed and he searched for redemption through his art. *The Resurrection* was a summation of his private life and public aspirations for renewal in Britain. His friend Henry Slesser was a Christian Socialist and Labour minister who in the year of the painting's completion spoke of the twenties as a decade in which a bewildered public witnessed a parade of 'isms' and of

'anarchy in ideal and practice ... theosophy, Christian Science, patriotism, pacifism, magic, spiritualism, psycho-complexities and auto-suggestions ... Against these ephemeral doctrines we offer the old yet ever-living dogma of the Catholic Faith as a balm and corrective to our present discontents.' Spencer's canvas was an idiosyncratic and possibly blasphemous and materialistic contribution to that promise, through an inspired egotism in which the self expands to redescribe the world on its own terms. Wyndham Lewis's description of his figures as 'angels in jumpers' neatly captures Spencer's homespun vision.

### Hollywood Comes to Town

Spencer incorporated a degree of modernist and even Cubist distortion into his painting and always looked to 'primitive' sources, be they early Italian or from further afield. In the case of William Roberts, we have an artist who remained urban in his interests and who spent much of his career in Primrose Hill, near Sickert's Camden Town. Roberts had experimented with abstraction as a member of the Vorticist group before the war, but after it turned to a populist style with definite ambitions to reach an audience, even a community, beyond the sealed world of the modernist elite. Continuing the tradition of representing popular entertainment established by Sickert, Roberts turned

his attention to the interior of a small cinema in Warren Street near Euston, one of the four thousand or more such venues in the country by then (no.180). Recognising that film was becoming the dominant visual form of the twentieth century, Roberts looks at its cultural effect in a semi-comic scene of audience and image reminiscent of familiar scenes of crowds at Victorian Royal Academy exhibitions. Cinemas often had grand names such as 'Academy' or 'Palace', which amused or irritated those involved in 'high' culture. Roberts's tight basement space contrasts its rich colours with the black-and-white silent screen, and the apparently Western violent action with the variety of responses among the working-class audience – from the indifference of a necking couple to the straining necks of those on the right gripped by the flickering image. Compared with William Powell Frith these are caricatures; compared with Lewis they are fairly autonomous individuals.

Disregarding highbrow figures such as the self-exiled Whistler, Sargent and Henry James, for example, this image is also the first to show the increasing impact of American culture in Britain. In 1920 the native cinema, badly affected by the war, was already considered to be an inferior product to that of the United States with its star system, daring themes, better scripts, more glamorous actors and vast

180 **William Roberts**
1895–1980
**The Cinema**
1920
Oil on canvas
91.4 x 76.2

181 **Edward Burra**
1905–1976
**Harlem**

1934
Brush and ink and gouache
on paper
79.4 × 57.1

financial backing. The British industry couldn't compete and in the year of Roberts's painting, only 144 out of 878 films available on the national circuit weren't American. Such a profound change in mass entertainment must have struck an artist such as Roberts forcibly, as before the war not only was the music hall a local and lucrative affair but the fledgling British cinema was also booming. This kind of colonialism was hard to interpret as well as to resist and the bogeyman of insidious French influence was being replaced by that of an American one.

### Harlem, Sussex

An artist who embraced the transatlantic flow with great and camp vigour was Edward Burra who graduated from the Royal College of Art in the 1920s. Fascinated by the darker aspects of low life, he frequented brothels and sailors' bars and took with him on these outings the fruits of a very wide reading and equally broad and eclectic set of visual referents – photography, George Grosz, Dada collage and Daliesque Surrealism, Goya and El Greco, Beardsley, Wyndham Lewis and, with great relish, cinema: 'Mae West remains my favorite since seeing Belle of the 90s which I enjoyed more than anything Ive seen for a long time my favorite scene is when she stands in diamonte covered reinforced concrete with a variety of parrots feathers ammerican beauty roses & bats wings at the back and ends up waving an electric ice pudding in a cup as the statue of Liberty.' Like the Hollywood-loving Surrealists in Paris who wandered from cinema to cinema looking for unique, surreal moments, Burra made film a source of constant inspiration.

Although, like Spencer at Cookham, he was firmly based in the sleepy Sussex village of Springfield, Burra frequently travelled in Europe and North and South America in search of subjects and sexual excitement. He lived in Harlem in New York during 1933, and on his return to the rural retreat of his studio used sketches, photographs and his memory to paint his experiences. He easily identified with black culture and was enthused by the Harlem Renaissance in jazz, literature and art, which made the district an avant-garde heartland far more invigorating than anything in London. Like his friend the 'negrophile' (as she would then have been termed) society hostess and arts patron Nancy Cunard, who published a large volume of essays and photographs in 1934 simply called *Negro*, he was involved in the cultural politics of race and ethno-graphy and sought the true 'heart of darkness' and what was then called 'negritude'. (Wyndham Lewis's ridicule of the naiveties of this tendency in his book *Paleface* (1929), won him few friends at the time.)

182 **Eric Gill**
1882–1940
**Inscription 'Ex Divina Pulchritudine'**
1926
Hoptonwood stone
30.6 x 45.7 x 3.8

Eric Gill, a Catholic convert, was a sculptor and pioneering typographer whose Perpetua and Gill Sans-Serif are classic typefaces. In the broad Arts and Crafts tradition and founder of an artists' community in Sussex, Gill wrote extensively on the spiritual function of art. Carved while Stanley Spencer was painting his unorthodox 'Resurrection' and Rex Whistler his Tate murals, in the year of the General Strike, this piece pays homage to the ideas of St Thomas Aquinas. The great medieval theologian's words translated mean 'The beauty of God is the cause of the being of all that is'. Gill's own earthy religiosity included incest and bestiality in his sexual life.

83 **Paul Nash**
1889–1946
**Landscape at Iden**
1929
Oil on canvas
69.8 x 90.8

Unlike Spencer's black figures resurrected in the English countryside, Burra's cool black and hispanic dudes hanging out on the sidewalk, in part derived from the popular caricatures of Miguel Covarrubias, are smart in dress and mind and fully part of the modern city with its cars and elevated railways, adverts, lazy sexuality and dodgy deals (no.181). It may all have been a touch patronising though, a picturesque view of things about which the artist probably had only an enthusiastic or touristic understanding. Carl van Vechten's popular 1926 novel, *Nigger Heaven*, had challenged the stereotypes but also ushered in an industry of white negrophilia. This was, and is still, difficult terrain for any representation.

### Metaphysical Garden

Such cultural cruising, racial and sexual adventuring and eclectic fantasy were one response in the 'roaring' twenties to a sense of T.S. Eliot's lost paradise, the 'Waste Land' and its symptoms of decay and mournful dissociation. Another and diametrically opposed one was that of Burra's close friend, the older Slade-educated Paul Nash, who had painted some of the most powerful images of the destruction of the landscape during the war.

In 1929, the year of the Wall Street crash, Nash painted *Landscape at Iden* (no.183). This shows a deep interest in Surrealism and in particular the 'Pittura Metafisica' of Giorgio de Chirico with its occult geometries, obscurely significant objects and haunted spaces. Nash shows a springtime view over the South Downs near Rye in Sussex where he was living, close to Burra's home. The foreground is dominated by a trug (basket) containing logs, an upright staff, a wattle fence, a windscreen and a truncated pyramid of logs. Behind that a fence around which a snake is coiled on the left separates the front stage-like area from a geometrically ordered orchard. The distant blue late-afternoon sky has almost sculptured white clouds floating across it. The image, rooted in the Symbolist tradition, is a kind of opening into a world of emblematic revelation.

The painting is deeply literary, with references to the Bible, the intricate prose of the seventeenth-century doctor Sir Thomas Browne, Nash's friend, the keeper of oriental art at the British Museum Laurence Binyon, and John Milton. Iden, echoing Eden with its tree and snake, is also Old English for 'place of the yew tree' and there is in this a reference to the graveyard. There is also a reference to the French Realist Millet's painting *The Angelus*, with its fork and basket of the praying peasants as they say the Ave Maria at dusk to celebrate the Incarnation at the moment of the Annunciation. In Milton's *Paradise Lost*, Eve experiences an angelic salutation and is nominated the 'mother of mankind'.

**184 Eric Ravilious**
1903–1942
**The Vale of the White Horse**
c.1939
Pencil and watercolour on paper
45.1 x 32.4

Age beyond age on British Land,
Aeons on aeons gone,
Was peace and war in
western hills
And the White Horse looked on.
(G.K. Chesterton, 'Ballad of the
White Horse', 1911)

Eric Ravilious was the visual poet of chalkland. Like Rex Whistler, he was a designer, illustrator and a war artist, before he was killed on a flight over Iceland. He trained at the Royal College of Art, where he came under the influence of Paul Nash. He was fascinated, like Nash, by the mysterious ancient landscape carvings on downland and made paintings of many of them during 1939 just before the outbreak of war.

This famous Bronze Age horse at Uffington, Berkshire, is shown with its semi-abstract scoured form following the gentle shape of prehistoric land under a rainy sky.

The 'fruitful womb' after the fall brings only death, however, represented by Nash in the pyre-like pile of logs, a familiar literary image of the dead of the Great War, and behind which grow the fragile progeny of the future, the orchard of Binyon's memorial poetry of the 1920s. This is subtle poetic image-making, evoking the war graves of northern France and a sense of the spirits of the British past and an uncertain future.

Referring to Millet and twelfth-century Chinese painting, Binyon had written in his *Painting in the Far East* (1913): 'The great subjects of all art and poetry are commonplaces. Life, Love, Death: these come to all of us, but to each one with a special revelation. It is by the new and original treatment … matter that is fundamentally familiar, that great art comes into being.' Nash found a mysterious way through his multiple sources to create a work which is a mystical elegy to the dead – a sort of highbrow spiritualism even – and a visual counterpart to Binyon's most famous lines: 'At the going down of the sun and in the morning/We will remember them.' The late twenties was the moment when most who experienced it finally felt able to remember the war in prose and paint – be it Siegfried Sassoon's *Memoirs of a Fox-hunting Man* or Spencer's Sandham Memorial Chapel at Burghclere. Nash described himself later as always a 'war artist without a war'.

## 'Going Modern and Being British'

In the early 1930s Nash and Burra were major figures in the group called Unit One, the first serious attempt to create an organised modernist movement embracing art, design and architecture in Britain since before the war. The name Unit One carried semi-corporate overtones as well as suggesting a Bauhaus-inspired purism. Setting out (another) agenda for national renewal through aesthetic transformation, Unit One had some of the characteristics of the second wave of Futurism under the aegis of Mussolini's new fascist regime. Indeed, McKnight-Kauffer, the graphic designer associated with the group, designed book jackets for Oswald Mosley, leader of the party of 'national reconstruction', the British Union of Fascists.

Unit One was not exclusively abstract in orientation, embracing Surrealist tendencies in Burra, John Armstrong and Tristram Hillier, and while abstraction dominated it was usually of the suggestive biomorphic variety, or rooted in landscape or figuration. The two young architects and designers involved, Wells Coates, a founder-member of the Modern Architecture Research Group, and Colin Lucas, were evidence of a faith derived from Le Corbusier in the architect as technologist. Wells Coates's early work in the late 1920s included designs for a small modern silk

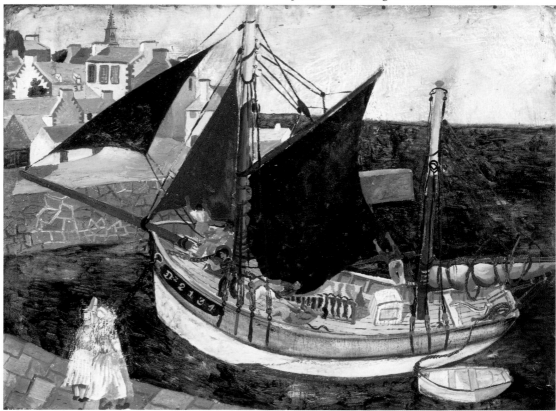

185 **Christopher Wood**
1901–1930
**Boat in Harbour, Brittany**
1929
Oil on board
79.4 x 108.6

The mainly self-taught Christopher Wood had seen Alfred Wallis's work with Ben Nicholson while on a trip to St Ives in 1928. Already a successful painter and stage designer based in Paris, he was motivated by this important visual encounter to move to Brittany in 1929, where he painted this picture of a boat in the small harbour at Treboul. It embodies a sophisticated naivety that many artists sought in the 1920s. A friend of Picasso, Diaghilev and Cocteau, Wood cut a romantic figure in Paris, a dissolute homosexual addicted to opium who was perhaps the leading British painter of his generation. Described recently as a 'fatal Englishman' by the novelist Sebastian Faulks, Wood committed suicide at Salisbury railway station in 1930.

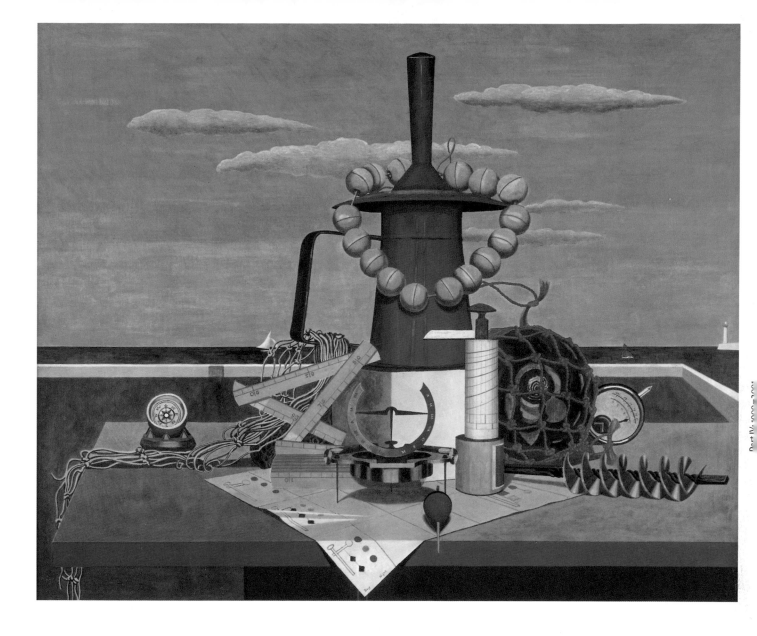

186 **Edward Wadsworth**
1889–1949
**Regalia**
1928
Egg tempera with oil on gessoed
canvas laid on board
76.3 x 91.7

Edward Wadsworth, a Vorticist
colleague of Wyndham Lewis,
was a member of Unit One and
painted both Surrealist and
abstract works. This painting in
tempera is a still life of ancient
and modern nautical objects set

outside with the sea behind.
'Regalia' perhaps refers to the
regalia of freemasonry, and the
objects certainly have a masonic
aspect. Wadsworth was
influenced by the strange, often
masonic, still-life painting of the

Italian Giorgio de Chirico, as well
as being interested in the 1920s
Parisian Purist art of Fernand
Léger and Amedée Ozenfant,
with its emphasis on the modern
machine-made object.

manufacturers in St Ives, run by the father of a future pioneer of post-war abstraction, Patrick Heron.

The Cresta chain of shops that grew from that enterprise were highly adventurous in their typography and abstraction and use of plywood, stainless steel and glass for shopfitting. Both men favoured open-plan interiors and ready-made parts for housing construction, and Wells Coates's Lawn Road flats in avant-garde Hampstead were designs for flexible modern living based on minimum requirements and unadorned white surfaces. The critic and promoter of Unit One Herbert Read described the prophet of concrete Lucas as seeking 'an architecture that is at once logical and visionary', thus neatly summarising the modernist position. British Arts and Crafts ideology via a European detour, this saw the artist, architect, designer and craftsman working in harmony to reshape the whole order of things. The public authority building schemes and private dwellings for the fashionably wealthy that are representative of the Unit One approach in the 1930s, and which survive today, testify to its imperfect hold on the popular mind. It is in cinemas and bypass factories that the modernist vision perhaps found its most widespread expression, and in the commercial design of bakelite radios and kitchen accessories for the mock-Tudor housing of the suburban ribbon-developments which post-war

British governments encouraged the population to move to. This comfortable consumer world was mainly a southern phenomenon, and ignored the harsh realities of the declining industrial north and East End poverty. Stanley Baldwin's mild but popular interpretation of England as a land of 'kindly hearted folk', mocked by the poet Stephen Spender in the phrase 'the world my sofa', wasn't quite the outcome Nash and his associates had in mind.

### Hampstead White on White

Unit One barely hid the split within its ranks as its Mayor Gallery exhibition of 1934 toured the country with a manifesto proclaiming a new marriage between art and industry that would have warmed Prince Albert's heart. The attempt to take a distinctly Continental modernism to cities such as Liverpool, Derby and Swansea was Ruskinian in the generosity of its gesture. The Dean of Liverpool Cathedral was sympathetic in a sermon and asked his congregation to note how the 'rhythm' of the new art was 'already passing into the everyday activity', while a Belfast newspaper proclaimed 'That's not the Unit; that's the Limit!' Many recognised a 'Soviet-like flavour' and didn't like the taste. Paul Nash, with his landscape, surrealist and literary inclinations might have been one of those who at least felt nervous about a full-blooded

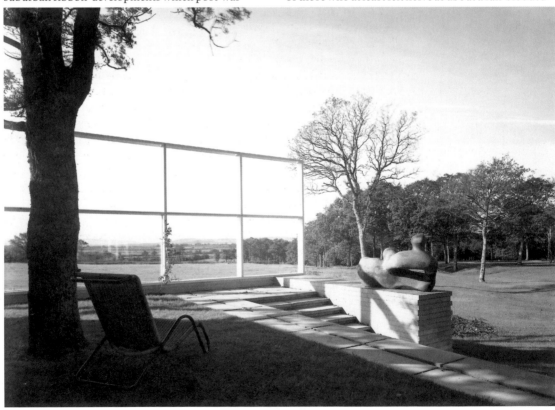

187 **Henry Moore**
1898–1986
**Recumbent Figure** (1938) in front of Serge Chermayeff building

Commissioned to adorn the terrace of his modernist house Bentley Woods at Halland, Sussex, by the architect Serge Chermayeff, Henry Moore's sculpture, with what he called its omniscient 'far seeing gaze',

is an icon of 1930s modernism of the kind satirised by the cartoonist David Low in his 'Modern Rake's Progress' of 1934. Moore developed the form for this Tate sculpture from an ancient Mexican sculpture and

his passion for Picasso's art. Carved from three laminated pieces of an Oxfordshire stone quarried near Banbury, its female forms are intended to echo those of the downlands against which it was to be seen,

mediating between the severe geometry of the house and the ancient landscape. Both architect and sculptor were included in the publication 'Circle' in 1937.

commitment to the streamlined rational brave new world others were zealously pursuing.

One such artist was Ben Nicholson, who had become leader of the previously Bloomsbury-orientated Seven and Five Society, which by 1935 passed a ruling that only non-representational works would be eligible in its exhibitions. He and his wife, the sculptor Barbara Hepworth, were rising stars, and had an aptitude for art-world politics that gave them great influence. Nash was ill in 1934 and by the following year his loose alliance of surrealist and abstract artists had collapsed. The initiatives that followed Unit One such as the *Abstract and Concrete* exhibition in 1936 and the magazines *Axis* and *Circle*, while never crudely limiting their horizons, presented a broad alliance of non-figurative art in the context of radical political and architectural change. The technocratic materialism of post-war welfare state culture has its immediate roots in the ideology of the artists and intellectuals of such formations who became known as 'the visible college' – from the scientific writing of J.D. Bernal to the ever-present apologetics of the 'new' of Herbert Read.

Nicholson arrived at his famous white abstractions of the mid-thirties by a route through landscape painting and Cubist experimentation. He and Barbara Hepworth were to be the founders of a new group of artists based in St Ives at the outbreak of war and, in spite of his Hampstead connections, Nicholson was too immersed in the landscape and its meanings ever to play a extremist role such as that of the great Dutch artist Piet Mondrian, who so influenced the theories of British abstractionists. However, 1935 *(white relief)* (no.188) represented to contemporaries some sort of extreme at the time it was exhibited. Whether or not such far reaches were a good or bad thing depended on opinion and these were far from united. As we shall see, Surrealists and Marxists tended to think not.

Nicholson's relief was carved from an old table-top found in a junkshop in North London, a curious tribute to the Camden Town ethos perhaps, yet serving as the ground for a hygienic white, symbolic of a smoke-free egalitarian future. Nicholson drew one circle by hand, the other with a compass and played their shapes off against the rectangles in two- and three-dimensional terms, creating what he described as 'an interplay of forces'. This was an art of high aestheticism and surgical formal rigour. It also drew its strength from a Freudian interest in the secret language of the unconscious. Nicholson spoke of the 'exciting tension' between such forces. 'You can take a rectangular surface and cut a circle deeper than, but without touching, the lower plane. One is immediately conscious that the circle has pierced the lower plane without having touched it ... and creates space. The

188 **Ben Nicholson**
1894–1982
**1935 (white relief)**
1935
Painted wood
101.6 x 166.4

awareness of this is felt unconsciously and it is useless to approach it intellectually.'

Nicholson reveals here his links not only to Bloomsbury 'significant form' thinking but also to the writings of his friend, the art writer Adrian Stokes. Stokes had written books on Quattrocento Italian art and on the sculpture of Agostino Duccio at the Tempio Malatestiano in Rimini. Deeply informed by psychoanalysis, which was such a powerful influence in Britain in the 1920s and 1930s, Stokes drew a distinction between carving and modelling in sculpture and elevated these technical terms to ones of psychological import. While 'modelling' took soft material and made of it what it would, 'carving' had to delicately discover the possibilities of a hard, resistant material. It represented an ethically mature and sympathetic approach as against the wilful egotism of modelling.

Nicholson's search for the 'exciting tensions' in his table-top was thus an act of controlled rediscovery and psychic reparation of damage caused to the mother in infancy. Stokes and Nicholson, fascinated by the materials of art and their scientific and emotional properties, were companion travellers to Italy where they reinvented the tradition of Ruskinian 'truth to materials' in a new mode of appreciation. For Nicholson 'truth to materials' was an article of faith, and he saw abstraction as a journey towards a religious sense of the 'infinite'. It is significant that he was an adherent of Christian Science, which proposed a reality beyond matter.

## Creative Tensions

When we turn to the sculpture of Barbara Hepworth, we find similar ideas working through a related but different visual vocabulary. Her sculpture was characterised by a love of carving in both stone and wood, and she brought to her practice a selfconsciously feminine set of attributes. By the time she made *Pelagos* in 1946, she had reached a maturity in her work that was to launch her into a successful career of international acclaim (no.190). This was in spite of bringing up a large young family and running a small nursery school. She became as imaginatively involved in the history and the pagan landscape of her adopted home of West Penwith, as Daphne du Maurier was with nearby central Cornwall in her brooding romantic novel *Rebecca*. This expressed the tensions and conflicts of modern British female experience in the dark 'other' of a Celtic 'inscape'. A different note was being struck in the male-dominated world of abstraction.

Partly inspired by the Russian constructivist sculptor Naum Gabo, who was living in St Ives, *Pelagos* is carved from a piece of dark elm wood into a double spiral, painted in its interior plane with a matt pale blue

**89 Alfred Wallis**
1855–1942
**Schooner under the Moon**
?c.1935–6
Ship oil paint on board
laid on wood
29.2 x 29.2

Alfred Wallis was a retired seaman living in St Ives who took up painting to relieve his loneliness after the death of his wife. He mainly painted from memory, and used household or ship paint applied to whatever surface he could find to hand. His simplicity of materials and style, and his unpretentious honesty of expression were seen as the marks of a true childlike primitivism by modernists such as Ben Nicholson. This work, painted on board, with its diamond format and compressed composition and flattening of space, can be seen as a major influence on Nicholson's own approach to abstraction.

and given the aspect of a primitive musical instrument by the use of taut lines of string. Extraordinarily, it is a landscape sculpture evoking a hill or wave, echoing similar moves by Nicholson in his work. It is drawn from her response to the view from her studio on Carbis Bay looking out across the Atlantic. *Pelagos* is Greek for sea, and the sense of myth is crucial to understanding the complex resonances of this anthropomorphic, womb-like polished shell, with its protective and expansive arms embracing the sea and the spectator's projected feelings. Rather than the existential drama of D.H. Lawrence and the metaphysical pessimism of Gertler during their stay in Cornwall during the First World War, Hepworth finds a full and nurturing redemption in the sculpted form of her Jungian 'oceanic' experience: 'I became the object. I was the figure in the landscape and every sculpture contained to a greater or lesser extent the ever changing forms and contours, embodying my own response to a given position in that landscape … I used colour and strings in many of the carvings of this time. The colour in the concavities plunged me into the depth of water, caves or shadows deeper than the carved concavities themselves. The strings were the tensions I felt between myself and the sea, the wind or the hills.' The language used is that of the analyst's couch and concerns sexual tension and aesthetic control. The art object is proposed as the abstracted integration of inner and outer, in tune with the writings of Stokes and his mentor the psychoanalyst Melanie Klein, and of the schizophrenic psyche of modern man and woman. Pylon lines and violin strings, mother and modern ovoid style are harmonised.

## Exquisite Corpses

'Or some such balls.' Paul Nash's words about the rhetoric surrounding Nicholson's breakaway towards a slightly impure abstraction recall the bitter in-fighting among the avant-gardists that is a consistent feature throughout the history of modern art. Nash was more comfortable with the possibilities offered by Surrealism than with the Bauhaus. The appeal of Surrealism to an English audience has always been very strong. Literary allusions, dream narratives and strangely transfigured human and natural forms were gratefully seized upon by those who found the chilly world of the abstract artists too 'antiseptic … narrow and severe', as the critic Hugh Gordon Porteous called it at the time, making much of it scatologically as a 'lavatory artform' in which, he claimed, 'objects are forbidden to have associations'. As we have seen, this is in fact at odds with Nicholson's view of his art, even in the white geometry of his rather tellingly named 'reliefs'.

190 **Barbara Hepworth**
1903–1975
**Pelagos**
1946
Part painted wood and strings
36.8 x 38.7 x 33

The Surrealist manifesto of 1924, published in Paris by the group's leader, the poet André Breton, was in the first instance a literarily inclined statement. Given the literary and francophile bias of the liberal educated classes, it is not surprising to find it entering the British arts scene fairly early on. We have already seen Nash and Wadsworth responding in the late twenties, easily dovetailing their Symbolist heritage with the newly radicalised French theories heavily based on Freud's ideas. These proclaimed the primacy of the subconscious mind over reason and the writer's and artist's moral and even political duty to discover novel techniques to uncover it. Seances, trances, dreams, games of chance and childish wordplay were some of the 'automatic', that is largely uncontrolled, means that were developed to realise a revolution in everyday life. From the artist's new processes, the hypnotic spectacle of conventional reality would be shattered and human sexuality and freedom released. A little uneasily such ideas were identified with the aims of Marxist revolution and dialectical materialism, and the Surrealists were mostly loyal fellow travellers with the Soviet regime in Russia.

The *International Surrealist Exhibition* at the New Burlington Galleries in 1936 (no.191) drew record crowds in a year when simplistic political attachments to left or right were becoming hard to sustain.

A revolution in the mind seemed a safer bet. When Herbert Read, who edited the volume *Surrealism* to accompany the exhibition, said that this time artists were not crying wolf and that critics should 'not judge this movement kindly. It is not just another amusing stunt. It is defiant – the desperate art of men too profoundly convinced of the rottenness of our civilisation', he was roundly ridiculed by hardened leftists such as the political satirist James Boswell, who collaged the quote onto a Grosz-like cartoon of fat wealthy types entering the exhibition.

But in truth, the avant-garde, never an item in Stanley Baldwin's or Ramsay MacDonald's election manifestos, depended upon the support of the wealthy for its continued existence. Some of these moneyed supporters and collectors were also artists, such as Roland Penrose. His *The Last Voyage of Captain Cook* was exhibited at the 1936 *International Surrealist Exhibition* which, with its high-profile publicity and eyecatching stunts, such as Salvador Dali's appearance in a diver's suit, became a fashionable venue and meeting place. Based on the surrealist objects of Dali and other artists that conformed to Breton's classic example (from the French poet Lautréamont) of a surreal image as 'the chance meeting on a dissecting table of a sewing machine and an umbrella', Penrose's sculpture excavates a series of linked ideas (no.192). The game

191 **International Surrealist Exhibition**
London, 1936

The 'International Surrealist Exhibition' of 1936 in London was a society and media event. This photograph shows, among other luminaries, in the back row, the painter Salvador Dalí, the poet Paul Eluard and the critic Herbert Read, while Eileen Agar sits wearing a hat in the centre of the front row. Works by Joan Miró, Jean Arp and André Masson can be seen in the background.

of visual consequences that children play to create grotesque human or animal figures was called Exquisite Corpse by the Surrealists, recognising the acute pleasure of the unexpected revelation of discordant parts and the murderous impulses which such games release. In the oedipally aggressive *The Last Voyage of Captain Cook*, the globe is formed from metal made to order for Penrose by a bicycle repairman. Placed within the globe, the plaster cast of a classical female nude, most exquisite of corpses, is of the sort used by art students and was bought by Penrose in Paris. It is a found object of the kind much utilised by Surrealists, and is painted with stripes to evoke the geological strata of the earth's interior, which the artist said was 'cut into' by man. The saw handle, minus blade, refers to this act. The title was chosen, the artist said, to sound typically 'surrealist', but presumably evokes a loss of male potency, the heroic explorer overwhelmed by the deep powers of mother earth whom he has invaded. We see a link with the themes of Nicholson and Hepworth, but a deliberate avoidance of the aestheticism and cult of natural materials that they espoused and a more overtly didactic or polemical edge to the work.

## Citizens and Subjects

The homosexual art historian Anthony Blunt, Keeper of the Queen's Pictures and spy for Soviet Russia, was in many ways the epitome of the contradictions within the educated progressive elite of the interwar years. Deeply opposed to capitalism and middle-class hypocrisies (except their own); impatient for change in society and culture and yet awkwardly disconnected from the masses who could bring about the end of the class system and its iniquities; this 'dominant class', to use the prevalent Marxist terminology, was frequently caught out by its own misjudgments. Blunt's apparently well-meaning treason was the most spectacular case. Cambridge-educated, he was a scholar of Renaissance art and baroque architecture and in the thirties, as an art critic and discreetly left-wing commentator, he supported the social realist artists of the time who were most closely identifiable with the aims of communist art theory. His dismissal of the inappropriate distortions of Picasso's *Guernica* was indicative of his rejection of what he called the 'limited coterie of aesthetes'. As with the Auden Generation of writers, the perceived benefits of communism among artists often overrode anxieties about its artistic direction as well as its political methods. Stalin's draconian attitude towards modernism and artistic freedom was not very encouraging, but Franco and Hitler seemed far worse. As Auden wrote in his 'Letter to William Coldstream' (a realist painter, supported by Blunt, in the middle-of-the-road Euston Road Group)

192 **Roland Penrose**
1900–1984
**The Last Voyage of Captain Cook**
1936; refurbished 1967
Painted wood, plaster and steel
69.2 x 66 x 82.5

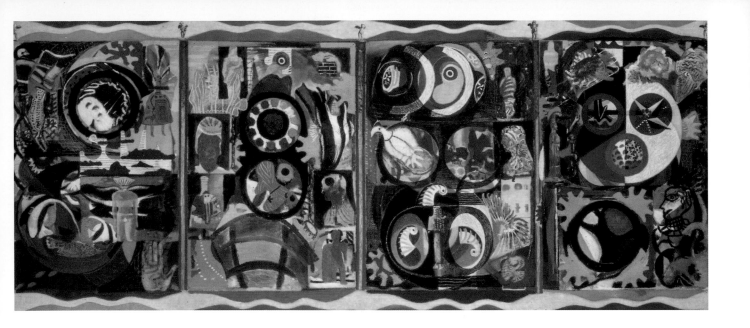

in 1937: 'We'd scrapped Significant Form and voted for Subject.'

The Artists International Association (AIA), founded in 1933 by dedicated communists such as the legendary Soho activist Misha Black, was a group dedicated to fighting fascism and, in the interests of maintaining a broad front, was so catholic in its membership that it included abstract, surrealist and social realist artists as well as older painters such as Augustus John and Laura Knight.

The founding group included satirical graphic artists such as James Boswell and James Fitton, who revived an interest in Hogarth for ends he might have abhorred. The imagery of the exhibitions was frankly propagandist in the Bolshevik agitprop tradition. The cellular approach to political change was adopted and international links maintained. Ambulances and aid for the Republican cause in Spain were organised in 1937 and leaflets, posters, banners and other material produced for marches, demonstrations and strikes. Workers' educational activities were held, and reading groups for raising consciousness ploughed through Marx's texts. Bourgeois formalism and surrealist antics were no substitute for rigorous class analysis and effective political intervention.

The analysis of society was taken to extremes by the Mass Observation Group. Founded in 1937 by the anthropologist Tom Harrisson, the artist-film-maker-Renaissance-man Humphrey Jennings and the poet Charles Madge, its purpose was to observe and record the life and opinions of working-class Britons. It achieved these aims by sending volunteer 'mass observers' into northern cities such as Bolton, where Harrisson was initially based, where they would watch and eavesdrop in pubs and other settings. Formal interviews and diary-keeping would also elicit accounts of behaviour among the inhabitants of 'Worktown' throughout the day. This approach was rather Fabian in its southern hauteur towards its northern subjects, but perfectly summarises the intense conviction of purpose and fascination with the objects of study of the middle-class observers.

William Coldstream, who had expressed a wish to reconnect art with a wider audience, was invited with his friend Graham Bell by Harrisson to paint in Bolton in April 1938, which they did from the roof of the local art gallery. Coldstream, who was involved with Auden in the documentary film movement in the 1930s through the GPO Film Unit, painted various works, photographs of which were presented to working-class viewers for comment alongside modernist works. Unsurprisingly his works were preferred to most others, hardly a class-based taste at the time. Adverse comment, though, was made about the absence of

---

**93 Eileen Agar**
1899–1991
**The Autobiography
of an Embryo**
1933–4
Oil on board
91.4 × 213

Eileen Agar was a major if independent figure within British Surrealism. This seven-foot (2.13-m) panel is divided into four main sections and further sub-divided into overlapping rectangles and circles. Agar saw female creativity as a kind of 'womb magic' and although she never had children clearly intends this early work to celebrate a woman's fertility through a kaleidoscope of human, animal and other biological forms – plants, birds, primitive figures, microscopic and telescopic images, burgeoning abstract shapes – which seem to coalesce into a continuous evolution of inner and outer worlds. This 'foetal autobiography' suggests a whole new dimension to self-fashioning.

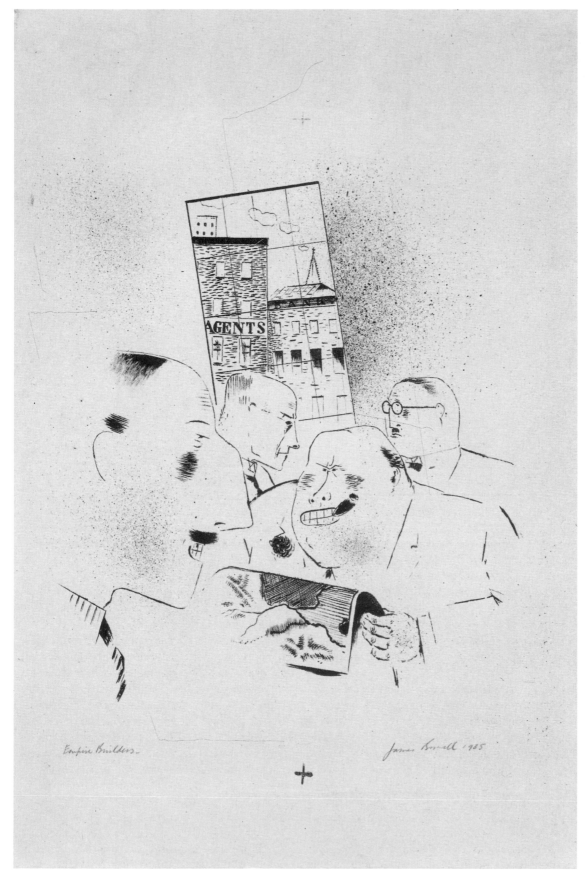

Empire Builders·                                    James Boswell 1935

**194 James Boswell**
1906–1971
**Empire Builders**
1935
Lithograph on paper
25.1 x 21.9

The New Zealander James Boswell was trained at the Royal College of Art, and joined the Communist Party in 1932. He was not alone. He was art editor for the new magazine 'Left Review' and provided many of its political cartoons, strongly influenced by the German artist George Grosz. This image of the 'Capitalist Class' shows balding, mustachioed and small-eyed businessmen driven by profit and wrapping up their exploitation of world labour. Boswell was a central figure in the anti-fascist Artists' International Association, organising banner-making and poster production.

196 **William Coldstream**
1908–1987
**On the Map**
1937
Oil on canvas
50.8 x 50.8

95 **Meredith Frampton**
1894–1984
**Portrait of a Young Woman**
1935
Oil on canvas
205.7 x 107.9

A different kind of social realism. The gentleman-painter Meredith Frampton exhibited portraits at the Royal Academy, where he studied until 1945, when poor eyesight stopped him painting. He worked in a neo-marmoreal classical style reminiscent of the French painter Ingres, but with a distinctly inter-war and modern feel. His still figures, painted with a meticulous technique, have a surrealist quality. This subject was painted as a respite from commissioned work and is typical of the artist's painting, with its emphasis on structure and clarity and the symbolic use of carefully chosen objects to evoke character. Perhaps such work can be, unwittingly, as politically radical as anything produced by the AIA.

figures in the paintings and the obsession with factory chimneys.

Coldstream's *On the Map* of 1937 (no.196) contradicts this impression while indicating clearly the Cézanne-inspired realist style he used for his Bolton pictures the following year. It shows Coldstream's fellow painter and Mass Observation colleague, Graham Bell, standing alongside a mutual acquaintance, the seated Igor Anrep, in a field in Suffolk. Although rural rather than industrial, the image of map-reading was very *au-courant*, inspired by the painter's friend W.H. Auden's obsession with maps, travel and landscape. The artist's role, in the Royal Society tradition, is seen as rationally locating the human figure within personal and geographical space. Mistakenly entitled *Off the Map* when lent to Winston Churchill, there is also a sense of the fragility of the human condition and the persistence of feeling lost and threatened, even in a world of presumed infinite progress. Turner would have understood such imagery.

The restlessly radical Harrisson grew bored with professional artists and moved on to encourage 'worker artists' such as the Northumbrian pit-men of Ashington Colliery and pavement artists in an exhibition called Unprofessional Painting in 1938. Alfred Wallis and the French naive painter André Bauchant were included for good measure. The whole AIA and Mass Observation enterprise, both of which were so much concerned with discourses of taste and the politics of culture, had a major if delayed impact on the early manifestations of Pop art in Britain in the 1950s.

197 **Humphrey Jennings**
1907–1950
**Still from film 'Spare Time'**
1939
British Film Institute

'Between work and sleep comes the time we call our own. What do we do with it?', asked Humphrey Jennings. Jennings was a leading figure in British Surrealism and the Mass Observation movement as a painter, writer and film-maker. His film 'Spare Time' was shot in various locations in the north of England and in Wales, and suggests an impoverished if resilient culture at the 'end of Wigan Pier' where toil or unemployment cast a long shadow over human leisure. As Britain approached the social and cultural welfare state, such ideas and images would have considerable impact. Young boys reading American comics were to be a source of Frith-like concern among the cultured elite.

**198 Wyndham Lewis**
1882–1957
**The Surrender of Barcelona**
1934–7
Oil on canvas
83.8 x 59.7

Wyndham Lewis painted between bouts of writing throughout the inter-war period. He developed a semi-Cubist figurative style and a complex range of historical and philosophical imagery closely connected to his fictional and theoretical writing. This work deals with the siege of Barcelona during the reign of Ferdinand and Isabella in the fifteenth century and is probably derived from a reading of the American Romantic historian William Prescott. It also refers to the Spanish Civil War about which Lewis, broadly speaking a Franco sympathiser, wrote a novel, 'The Revenge for Love', in 1937.

'Any news of the invasion, sir?' asked a village 'headman', when the 'Fryd' was called out in 1940 to oppose the armoured might of Germany with a few obsolete rifles. 'Not yet,' I replied. 'Well, I suppose it will come along in due course,' he added, as if it were a matter of ripening plums.
(T.C. Lethbridge, *Merlin's Island: Essays on Britain in the Dark Ages*, 1948)

You can divide the twentieth century at a number of mid-points. Choosing 1940 is to suggest the Battle of Britain and the Blitz were a beginning as well as an end – an ambiguous explosion into fragments which left so much up in the air. From the landscaped family groups of Henry Moore's post-war humanism to the bomb blasts at the end of Cornelia Parker's Postmodern garden, artists have responded to a porous culture where genetically modified plums don't have to ripen

in the old ways Constable would have understood, nor is the island kingdom at the heart of a world empire. While the empire shrank, or imploded, so the world grew into an imperfect global village, where journeys don't always end where they began and where 'now' is 'the contemporary'. T.S. Eliot's famous words in the *Four Quartets* in 1944 have, whether they know it or not, haunted artists ever since with their ambiguous and elegaic tone: 'History is now and England.'

### New Romantics

Artists could not prevent a Second World War, and for some of them it meant a depressing repeat of the war that was meant to end all wars. Some artists and writers such as Auden and Lewis left the country for North America, while others became involved in new official war artist schemes. Paul Nash's painting flourished in such circumstances and his *Totes Meer (Dead Sea)* of

199 **John Piper**
1903–1992
**Seaton Delaval**
1941
Oil on canvas laid on wood
71.1 x 88.3

John Piper worked on the 'Recording Britain' project during the war, when the national heritage was under threat from bombing. Seaton Delaval, a huge ruined baroque building by John Vanbrugh in Northumberland, offered him 'a splendid sense of drama' with 'its ochre and flame-licked red ... very much of our times'. This image of the north face of its gutted central block was painted on a heavily scored white ground to match the building's brooding massiveness. Piper, and his friend the poet John Betjeman, saw such buildings as 'vast old warhorses', emblematic of the nation's heroic history and present fight for survival. Here was an architectural equivalent of Gordale Scar.

201 **Paul Nash**
1889–1946
**Totes Meer (Dead Sea)**
1940–1
Oil on canvas
101.6 x 152.4

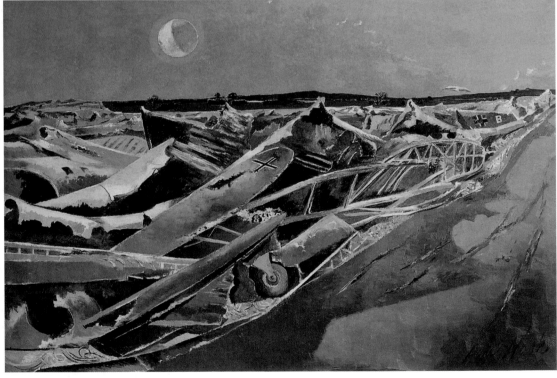

200 **David Jones**
1895–1974
**Aphrodite in Aulis**
1940–1
Pencil, pen and ink and
watercolour on paper
62.9 x 49.8

David Jones was a Catholic convert who fought in the First World War about which experience he wrote his long Eliotesque poetry and prose piece 'In Parentheses' in 1937. A disciple of Eric Gill, he learned wood engraving and was also connected with Ben Nicholson's Seven and Five Society. He was not interested in abstraction, however, and increasingly turned to painting densely worked watercolours integrating classical myth, Celtic legend and Christianity into a complex vision of word and image. This work shows a Christ- and Madonna-like Aphrodite, goddess of love, surrounded by British and German soldiers who seem to worship and yet threaten her. This multicultural work evoking the crucifixion was made in London during the Blitz, and is a dense image of the Mass and of redemption.

1940–41 brought together surrealism, landscape and propaganda (no.201). It is based on his observations and photographs of a dump for wrecked German aircraft at Cowley near Oxford. The German title refers to a dead sea of twisted metal crashing onto a shoreline in static waves under a green moonlit sky. Overhead a white owl swoops over the aerial monsters of the sky, which seemed to Nash to twist and turn in the half-light. Nash was an avid reader of landscape literature including eighteenth-century writers such as William Stukeley, who we have already come across with his interest in megaliths and ancient folklore. Nash, who wrote and illustrated a *Shell Guide to Dorset*, one of his favourite counties, in the 1930s, saw the English landscape as a profoundly haunted one with its own magical powers over human destiny.

This painting almost seems to ascribe the German losses to such a mystical force and its propaganda value, though subtle, was based on a deep patriotic feeling for the land. In 1940 and 1941, southern-county witches actually went down to the coastline during what they termed the Magical Battle of Britain to collectively send a psychic beam of destruction towards the German High Command while scattering ancient 'go away powder' into the sea. This mixture of national pride and occult dabbling was part and parcel of the art of the Neo-Romantic artists, such as Michael Ayrton and John Minton, for whom Nash's moon-drenched vision was a key influence.

## Down the Tube

In London, Henry Moore (who also made images of miners at war-work below ground in his native Yorkshire) produced a remarkable series of drawings of figures in Underground air-raid shelters, revealing a Dantesque world of troglodyte inhabitants (no.202). Supposedly, he had happened on them one night after a dinner party, before the authorities legalised and formalised their illegal initiative, and became obsessed with their visual and metaphorical possibilities. Their ragged clothes and bedding could be seen as shrouds but also as swaddling, and the menace of the tube with its monster trains pushing through the dark tunnels also offered a protection from the menace of the bombing high up above on the surface. The Tube became a strange cavernous burial-chamber-cum-womb with no view for modern men and women awaiting the moment of birth or resurrection. The writer Alex Comfort wrote in 1942 of the wartime population searching for a 'human being-ness', a romantic and anarchic 'alliance for mutual aid', prefiguring some of the maternalistic rhetoric of the welfare state and pointing up how war had collapsed many old class and other distinctions within British

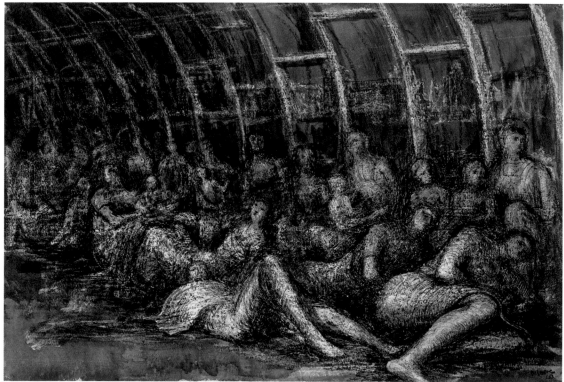

202 **Henry Moore**
1898–1986
**Shelterers in the Tube**
1941
Pencil, pen and ink, watercolour and crayon on paper
38.1 × 55.9

209

society. For Moore there was something of the Celtic myths of buried heroes in his imagery, where bodies and their land are as one, as an art historian has written, 'the once and future organic body of Britain'. Moore later made drawings for the archaeologist Jacquetta Hawkes's book on the deep geological and human past of Britain, *A Land*, in 1951, the year of the Festival of Britain, a celebration of the opening national 'chrysalis' that war propaganda had promised.

Hawkes wrote of Moore's drawings: 'Through his visual similes he identifies women with caverns, caverns with eye sockets, shells, bones and cell plasm drifts into human form.' Such analogies were easily picked up in the shelter drawings by Londoners visiting the National Gallery, where they were shown by the wartime art administrator and the Gallery's director Kenneth Clark in his Trafalgar Square museum, which was otherwise empty – the great collection suitably hidden away in the bowels of a mine in the remote Welsh landscape. Moore, like many artists in the 1930s, had been looking for an audience and a more humanist art to which they could relate. He found it with these drawings and they set him on a course for being perhaps the court artist for the 'New Jerusalem' of post-war socialist Britain, his sculptures finding their way into a myriad public settings and travelling British Council exhibitions around the post-war world.

## 'Exhilarated Despair'

'Like excrement' was, roughly, how one dissenting artist described Moore's ubiquitous sculptures in the post-war period. This was the disenchanted voice of Francis Bacon, who didn't care at all about art doing himself or anyone else good, and had nothing to do with the War Artists' Advisory Committee or camouflage work, preferring to work for his own Ministry of Disinformation. Bacon, the son of a puritanical horse breeder in Ireland, had been a runaway homosexual youth in the 1920s, living for a while in the decadent world of Weimar Berlin and then in Paris, where he came under the influence of Picasso's art. On his return to London he pursued a career as a designer of modernist furniture and rugs, which he later disowned, and entered the heroic drinking and gambling culture of Soho and Fitzrovia to the north of Oxford Street, where he began to paint. Most of his early works were destroyed by the artist although one extant painting was reproduced in Herbert Read's seminal book, *Art Now*, in 1933. Influenced by the Australian Catholic painter Roy de Maistre, Bacon evolved an iconography which was the foundation of his life's work.

Fascinated by photography, film, sexual violence, x-rays, medical textbooks showing diseases of the mouth, classical Greek tragedy, the poetry of T.S. Eliot

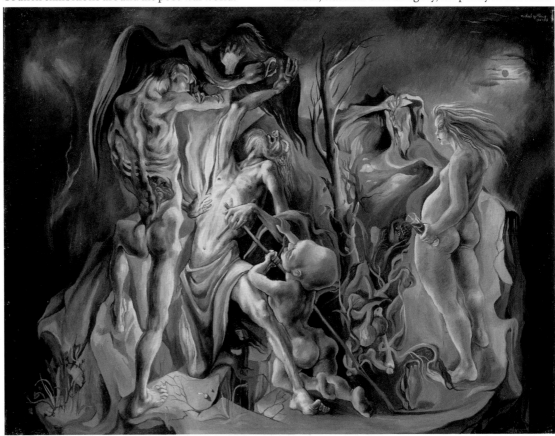

203 **Michael Ayrton**
1921–1975
**The Temptation of St Anthony**
1942–3
Oil on wood
58.1 x 75.2

Michael Ayrton was a central artist of Neo-Romanticism in the 1940s, along with John Minton and John Craxton and, like them, was closely connected to the poets and writers of his generation, for whom he made important book illustrations. Turning to a northern European tradition of the grotesque, Ayrton's painting of St Anthony, with its macabre figures seemingly putrefying under a sickly moonlight, reveals the temptation of sin at the very heart of the natural world. There is a sense of a poisoned and cursed land. Ayrton was connected to an occult group linked to the magician Aleister Crowley, and his Gothic imagination drew on deep unconscious strata of disturbed and morbid feeling.

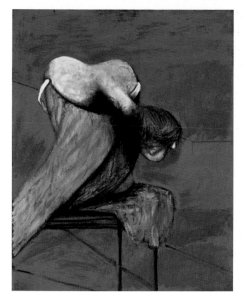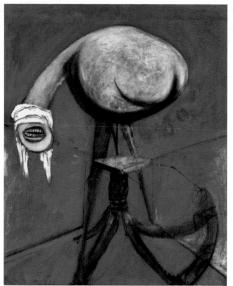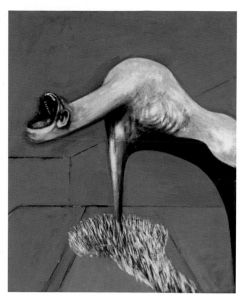

204 **Francis Bacon**
1909–1992
**Three Studies for Figures at
the Base of a Crucifixion**
*c.*1944
Oil on board
each study 94 x 73.7

and many other literary sources – he later said 'assume I've read everything' – Bacon's biomorphic forms were everything Moore's were not. Satanic, agonised, violent and mortal, Bacon's figures are a biological throwback, revealing the original sin at the heart of humanity rather than the Edenic creatures of God striving for harmony. While Moore took his social responsibilities during the war very seriously, Bacon, as camp as Burra in his manners and discharged from duties as an air-raid warden on account of asthma, ran an illegal casino in Millais' old studio. He didn't leave London for the countryside like so many artists and writers, preferring to take his chances in the dark dangers of the blitzed inner city, with its decline into barely contained disorder. He revelled in the blackout of social confusion, increase in mental disorder, insomnia and disease, rather than viewing it as an apocalyptic prelude to the new, fairer society written about by social policy-makers throughout the war. For Bacon life was a big gamble and humans survived through a sense of what he called 'exhilarated despair'.

The masterpiece of this period is Bacon's *Three Studies for Figures at the Base of a Crucifixion* of *c.*1944, exhibited at the Lefevre Gallery in 1945 as news and images of the concentration camps were becoming widely known (no.204). Bacon, an atheist, was drawn to the crucifixion on account, he claimed, of its formal

properties, but it is hard to believe the subject matter was not central to his interests. He always disclaimed any obvious expressive or literary meaning for his work, stressing instead the visceral impact of paint on the nervous system. Although Bacon was certainly after visual immediacy, this advice should be treated with extreme caution by the unsuspecting viewer. Bacon spoke of how his works came from a daydreaming in which hundreds of images linked up, and that he used a triptych format to break them into parts and to disrupt any narrative.

This work carries condensed references – to Grünewald's *Mocking of Christ*, paintings by Picasso and Max Beckmann, Eisenstein's film *Battleship Potemkin*, with its nurse shot in the eye, photographs from newspapers and the Surrealist journal *Documents*, the ancient Greek dramatist Aeschylus and the contemporary scholarship about him. The macabre figures were described by Bacon as 'Eumenides', the fates who, as gloomy children of the night, pursue tragic heroes to their doom across the generations:

repulsive maidens ... those grey
and aged children ...
who are like no seed ever begotten, not
seen by the gods as goddesses, nor yet
stamped in the likeness of any human form.

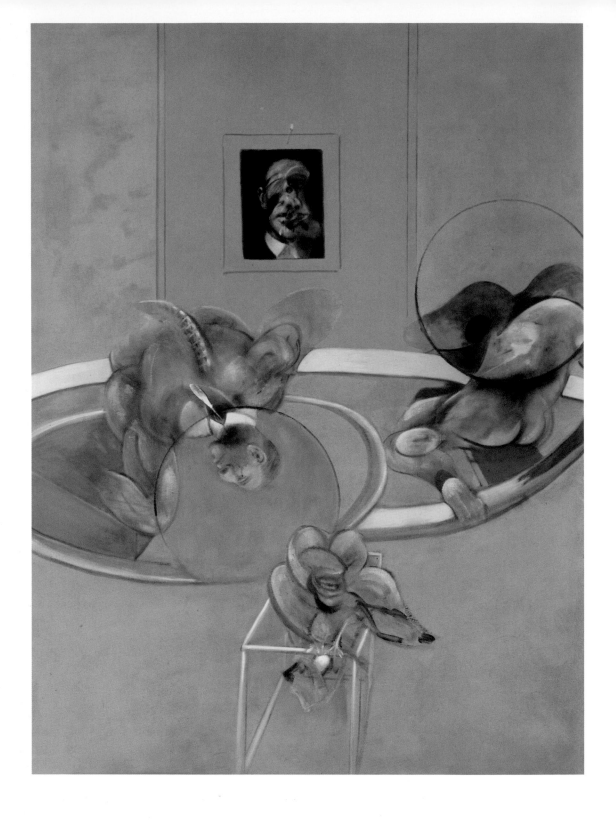

**205 Francis Bacon**
1909–1992
**Three Figures and Portrait**
1975
Oil and pastel on canvas
198.1 x 147.3

Francis Bacon's imagery focused on recurring images and themes throughout his career. The two large figures and the portrait on the wall in this work are based on Francis Bacon's lover, George Dyer, who died in 1971. The bird-like creature on a frame is probably one of the Eumenides, or furies, first painted by Bacon in his triptych of *c*.1944. The circular forms are derived from a book on radiography Bacon often used. Painted on the 'wrong', or rough, side of the canvas, the whole composition has a typically claustrophobic atmosphere, with the figures seemingly trapped and writhing in a sort of tragic merry-go-round. Bacon said that in such images he wished to paint 'the history of the twentieth century'. He has been a major influence on artists of the 1990s.

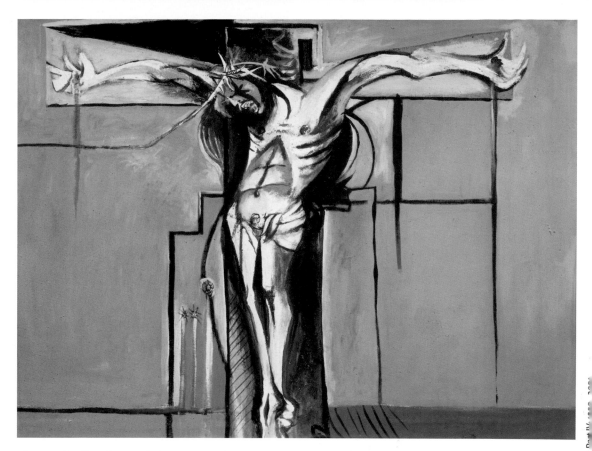

The *Oresteia* trilogy by Aeschylus was an ordering narrative for Bacon through which to interpret his times, with its vision of the 'House of Justice ... collapsed', and its sense that 'there are times when fear is good' and 'there is advantage in the wisdom won from pain.' Bacon finds an image to match the primeval inheritance of evil which the war had unleashed:

> I, disinherited, suffering, heavy with anger
> shall let loose on the land
> the vindictive poison
> dripping deadly out of my heart upon the ground

There was to be no underground resistance to this tragic legacy of sins visited upon the children. Bacon suffuses his work with an orangey-red, echoing the critical book he had read about the plays that stresses the 'sea of inexhaustible dye' in Aeschylus's language matching the synaesthesic line, 'The reek of human blood smiles out at me', which perfectly matched Bacon's aim at an art of the nervous system rather than of mental images.

Like Harry Lime in the film *The Third Man*, Bacon was unapologetic about the ideological premises of his work, saying that 'I think the suffering of people and the differences between people are what have made

great art, and not egalitarianism'. This was not the world Clement Atlee and the landslide of voters who took him to power in 1945 were anticipating. Bacon would have smiled wryly at his admirer Wyndham Lewis's mockery of Mr Gartsides in his short story in *Rotting Hill*, a series of sour fictional views of austerity Britain. Gartsides, a demobilised soldier turned art teacher from Rochdale, naive disciple of Herbert Read and, mistakenly, of Lewis, gushes at Lewis that he wants to enthuse children about modern art and that art is the road to social justice. The disenchanted Lewis inwardly groans, wonders what world he is living in and eventually shows him the door.

## 'Closing Time in the Gardens of the West'

The pessimists, such as the writer Cyril Connolly who gives us our section heading, did seem to have a point. The decade or so following the end of the war saw rationing and shortages continue, political and economic collapse across many parts of the globe, communist revolution in China, Cold War leading to war in Korea, the Suez Crisis which was a defining point in Britain's sense of imperial loss, and a moral panic over the nation's youth. There was a widely perceived stagnation in the arts and Evelyn Waugh was in good historical company in his perception that Britain was becoming uglier and uglier. The sculptures

---

**206 Graham Sutherland**
1903–1980
**Crucifixion**
1946
Oil on board
90.8 × 101.6

Graham Sutherland, another Catholic convert, had been a war artist and also a major precursor and exponent of the Neo-Romantic movement in his landscape painting. This religious image is a study for

Sutherland's painting now hanging opposite a Henry Moore 'Madonna and Child' in the Church of St Matthew, Northampton. Although he shared a studio and materials with Francis Bacon, he had

none of his friend's bleak materialism. He had also seen the horrific photographs of the concentration camps but remained true, just, to his faith. He wrote that the crucifixion is 'the most

tragic of all themes and yet inherent in it is the promise of salvation. It is the symbol of the precarious balanced moment, the hair's breadth between black and white.'

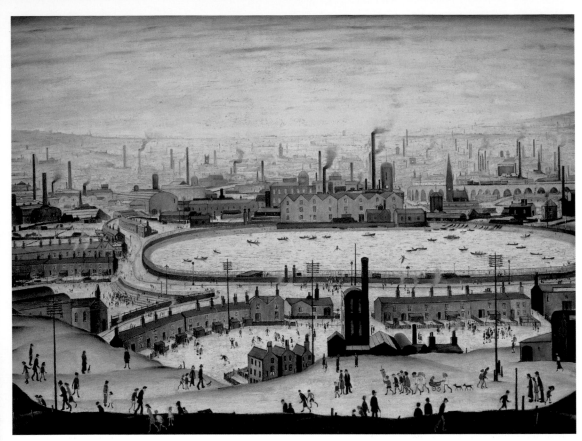

**207 L.S. Lowry**
1887–1976
**The Pond**
1950
Oil on canvas
114.3 × 152.4

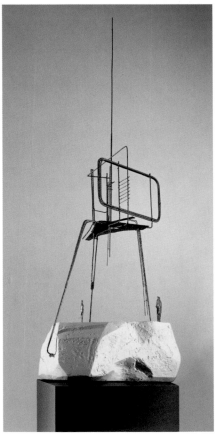

**208 Reg Butler**
1913–1981
**Working Model for 'The Unknown Political Prisoner'**
1955–6
Forged and painted steel, bronze and plaster, 223.8 × 87.9 × 85.4

One of the young post-war sculptors, along with Lynn Chadwick, dubbed by the critic Herbert Read as of the school of the 'Geometry of Fear', Reg Butler made forged and welded Cold War sculpture. This model was the winning entry in an ICA-organised competition for an unrealised monument. Butler intended his work to be erected on the border of East and West Berlin, and for spectators to stand on the 'natural' rock looking up into the man-made pylon structure. Inspired by what he termed the 'supra-human creatures' of wartime radar and radio towers along the British coast, Butler's monument was a tribute to the victims of the Nazi concentration camps. The tower itself was both a symbol of man's capacity for tyranny and of hope within alienation.

214

of Moore and Hepworth, fine as they were, and often intended as images of family cohesion and parent-child bonding as approved by the political and psychoanalytical elite, were totems of an unrealised vision. Teddy Boys fighting in cinemas showing American films in the Elephant and Castle, early signs of football hooliganism and a general taste for all things American were what actually seemed to have emerged from the nurturing wartime Underground.

The Arts Council, a brainchild of the war and formed in 1946 to promote the arts, one of the things the war had been fought for, had a tough job on its hands. As a disillusioned J.B. Priestley wrote in 1949: 'We are a dreary self-righteous people with a passion for gin, tobacco, gambling and ballet. We are a nation of Sabbath-keepers who do not go to church ... We spend so much time arguing about food we have no time to cook it properly. We spend fourpence on our culture, and several million pounds a year advertising it ... We have probably the best children and the dullest adults in Europe. We are a Socialist-Monarchy that is really the last monument of Liberalism.' So began a revived and by then nationwide, if restricted, debate about politics and culture that continues today. The questions raised by Vauxhall Gardens, the Foundling Hospital and the Royal Academy two centuries earlier were alive and kicking. When T.S. Eliot declared in 1948 that 'we can assert with some confidence that our own period is one of decline', he was met with both applause from some and outrage from others who saw him as pouring elitist cold scorn on 'the people'. The art critic David Sylvester was typical of a new breed of intellectual who also wrote sports reports and even a brilliant and mischievous essay comparing Arsenal and Chelsea as popular signifiers of, respectively, the high-culture categories of Realist and Romantic attitudes. The question facing everyone was whether an improved culture could really be engineered by state intervention in a democracy? And what would improvement look like?

### Alone in Coronation Street

Although AIA social realist activism continued into the 1950s, 'the people' of the post-war trough appear perhaps most remarkably in L.S. Lowry's scenes of life in the industrial north painted from his experience of life in Salford and Manchester. Lowry, a lonely rent collector and clerk with some art training, spent his life in seclusion (Cyril Connolly had spoken of 'the resonance of seclusion' as one option for artists though he probably didn't have Lowry in mind), painting in the evenings from his imagination. He created a race of alienated stick people who are dwarfed by their vast industrial setting as they scurry insect-like about their private business. Panoramic

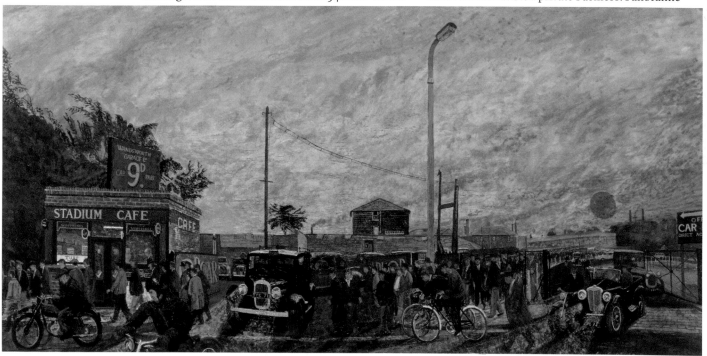

209 **Carel Weight**
1908–1997
**The Dogs**
1955–6
Oil on board
122.6 x 243.8

Carel Weight shows a large, rather mournful crowd leaving Wandsworth Greyhound Stadium under a huge sky dominated by an orange setting sun. Run-down South London becomes the setting for a Turneresque image of declining empire. Intended as a tribute to Frith's 'Derby Day' (no.132), Weight said his picture was not about class differences as all his Londoners seem the same. Rather, it was a piece of powerful post-war austerity mood music.

paintings such as the one that he considered to be his masterpiece, *The Pond* of 1950, have a modernist whiteness suggestive of the haze of industrial smoke and a distance of view which accentuates a sense of unreality (no.207). Almost unwittingly, Lowry created icons that have attracted the avant-garde as much as the wider public, that holy grail lost since the heyday of Victorian art which Coldstream and others were so keen to rediscover. In a sense his paintings are the strongest visible expression of the 'end of landscape' which this period begins to announce. Or at least of the reassuring landscape of the past that Billy Liar was famously unable to leave.

### 'The Kitchen Sink, Too'

The debates about a viable visual arts culture were as intense in the fifties as they had been before the war and, with the new climate of democratised culture, more widely participated in than previously. Read and Blunt were replaced by figures such as John Berger and David Sylvester, who fought bitter feuds over value and meaning through the quality journals of the time. Abstract artists and realists replayed some of the old discussions about elitism and accessibility with a new strain of intellectual figuration and the emergence of Pop art, filling the gap left by a declining Surrealist and Neo-Romantic tendency.

The younger generation of realist artists, looking back to the thirties but also across the Channel to contemporary France, moved from the refined, sometimes attenuated look of the Euston Road painters and towards something far more rough, painterly and impolite. David Sylvester wrote of such paintings that they 'have not got this atmosphere of doing the done thing and please do not spit and gentlemen lift the seat'.

Subject matter, following Sickert's Camden Town stricture for serious art to 'avoid the drawing room and stick to the kitchen', could be of anything, and preferably something physically challenging and visceral. Not Bacon's nightmare modern interiors transposed to the realm of myth, but plain, in-your-face interiors that most Britons inhabited while they slowly moved into the world of Americanised consumer comfort. Sylvester coined a phrase that stuck when he described the Realists as painting 'everything except the kitchen sink, no, the kitchen sink too', echoing the themes of Angry Young Men plays such as Arnold Wesker's *The Kitchen*. Bacon was more in the world of Samuel Beckett by comparison, waiting for Godot rather than the milkman's delivery. John Berger saw the new art as bringing to light 'aspects of nature and life ignored or forbidden by the rule makers'. Herbert Read, realising the 'rule

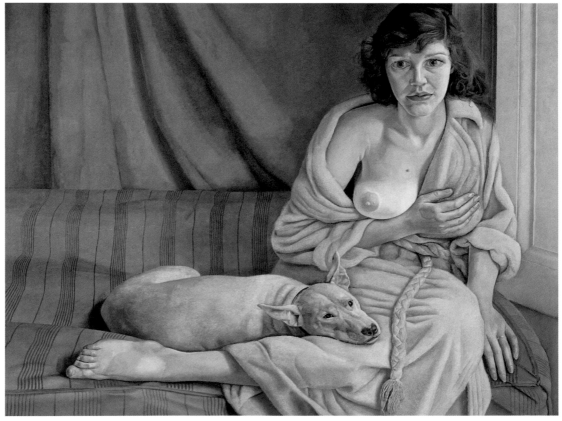

210 **Lucian Freud**
born 1922
**Girl with a White Dog**
1950–1
Oil on canvas
76.2 x 101.6

Lucian Freud was born in Berlin, the grandson of Sigmund Freud, and came to Britain in 1931. Part of the Neo-Romantic scene during the war, Freud drew and painted portraits, still lifes and landscapes with a certain erotic and surrealist edge. This image of his first wife epitomises the tightly drawn, smoothly finished painting that led Herbert Read to call him 'the Ingres of Existentialism'. Its semi-nudity and ambiguous human and animal relationship creates an atmosphere of ordinary things not being quite what they seem at first to be.

makers' didn't just mean Tory MPs and the Royal Academy, retorted by saying that 'if we tear aside Mr Berger's camouflage, we find him saying quite bluntly, like his colleagues in Russia, that art must be illustrative'. And Read, fighting the corner for modernism, be it Bacon or Nicholson, was more or less right. Berger gave up art criticism in 1956, the year of the Hungarian uprising and of disillusion for many leftwingers, later saying that he had concluded that even his 'circus' of Realists such as Smith and Bratby were 'useless' because their works wouldn't help men 'to know and to claim their social rights'. Perhaps more helpfully we can consider the move by the Ealing film studios to space at Elstree, rented from the American film giant MGM, as a sign of the times. Michael Balcon, the Ealing boss, said it would now be a matter of his films quietly representing the 'small man' and the misfit in the face of the Hollywood leviathan.

John Bratby, Edward Middleditch and Peter Coker were key figures in 1950s realism. Coker's image of his young son Nicholas is less concerned with the immediate features of contemporary reality than with a tension between space and flatness and the analogies between his medium, thick oil paint, and the surfaces he paints – the sheep's head, the newspaper, table and so on (no.211).

## 'Talking 'Bout My G-G-Generation'

Craven youth, however, looked at Hollywood head on. The place where most of the vociferous art discussion took place was the Institute of Contemporary Arts (ICA), a multi-arts venue incongruously but tellingly situated in the old home of Lady Emma Hamilton in Dover Street and opened in 1950, the year the Korean War broke out and milk rationing ended. Such an institution devoted to cutting-edge arts programmes had been proposed by Penrose, Read and others before the war, and although their intended sponsor Peggy Guggenheim left for New York, there was now a place where contemporary culture could be seen and discussed. In fact 'contemporary', with its overtone of urgency and utter newness, seemed increasingly to replace 'modern' as a term for recent art. The agenda was set by the old guard rather than the avant-garde, however, and the younger participants looked for a suitable kindergarten to pursue their own ideas. Most of the art commissioned for the 1951 Festival of Britain seemed to confirm their suspicion that Sutherland, Moore and Nicholson were being held up as the most radical art, a view from which they unreservedly dissented. Artists such as Eduardo Paolozzi, Richard Hamilton and Nigel Henderson, supported by the critic Lawrence Alloway and watched with detached interest by the novelist J.G. Ballard, staged a series of

**211  Peter Coker**
born 1926
**Table and Chair**
1955
Oil and mixed media on board
152.4 x 121.9

212

**212  Eduardo Paolozzi**
born 1924
**I was a Rich Man's Plaything**
1947, from Ten Collages
from BUNK
Collage mounted on card
35.9 x 23.8

Eduardo Paolozzi was born in Edinburgh, the son of Italian immigrants. Interned as an enemy alien during the war, he went on to art school and in 1947 lived in Paris. Here he developed his interest in Surrealism,

sculpture and collage techniques. In London in 1949 he became part of the nascent Independent Group. This very raw collage was made in Paris from magazines, cards and other ephemera, often obtained

from American GIs. The links suggested between sexuality, machinery, cheap thrillers and consumer products became standard features of Pop art in the 1950s and 1960s.

**213 John Minton**
1917–1957
**Composition: The Death
of James Dean**
1957
Oil on canvas
121.9 x 182.9

This painting is unfinished and
uncertain in its subject matter.
John Minton was a leading
figure of the Neo-Romantic
movement in the 1940s.
A talented painter and
illustrator, he changed

direction towards a kind of
modern history painting in the
1950s before his suicide, in the
year of this canvas, which he
claimed depicted the death of
the Hollywood star James Dean.
It has been suggested, however,

that the title was an
afterthought, and that the
theme was suggested by a
car crash Minton witnessed in
Barcelona. Dean died in a car
crash at the age of twenty-four
in 1955, and the self-destructive

homosexual Minton may have
identified with the 'rebel
without a cause'. Certainly his
new artistic direction was
mainly at odds with a growing
tendency towards abstraction
or Pop art.

exhibitions, lectures and events that radically changed the direction of contemporary art as they sought a *coup d'etat* over their elders. There was continuity, of course, in so far as the abstract and surrealist ideals of the thirties were powerful ones, and the family and intellectual ties between generations were sometimes close (Nigel Henderson's mother, for instance, was on the fringes of the Bloomsbury circle), but the canon was there to be reshaped and that is what happened.

This was an unprecedented world of a state-funded avant-garde, and a route through which working-class and lower-middle-class artists could create a visual culture based on new and eclectic foundations such as technology, information and communications theory, cybernetics and semiotics. The ideas and processes were as important now as their execution. Paolozzi's famous epidiascope for projecting his massive archive of visual material at Independent Group meetings, and the tackboard that all artists, and teenagers indeed, used to make informal and informative collages, replaced the canvas and frame as the natural vehicles for art. The intellectual few adopted the role of code-breakers.

This younger generation called itself the Independent Group (IG) in 1952, also the year of the start of the New Elizabethan Era. The title sounded a

bit more jazz age than an 'Institute' did, and introduced into their art and discourse, alongside the more familiar biological and scientific references, the alarmingly viral material of American junk culture. This contaminated popular imagery of science-fiction magazines and lurid advertising was a severe challenge to most forms of established taste which, whether traditional or avant-garde, tended to view things within a pyramid of 'high' and 'low'. To take commercial art seriously, be it film or comic books, was unsettling in the extreme, as Hogarth's tactics had been two hundred years before when he staged an exhibition of shop-sign painting. Lawrence Alloway proposed the dismantling of the hierarchy of taste with Michelangelo at the top and Batman at the bottom, and suggested in its place a 'fine art/popular art continuum'. This meant a democratisation of taste in which the motor-car enthusiast's preferences were as valid as those of the Bond Street connoisseur. They were simply the function of a similar faculty applied to different objects. The IG aimed at an inclusive aesthetics with no value judgments, except perhaps that of the advertiser, of an effort being 'exciting', 'interesting' or 'cool'. Not for them the campaigns waged against the horror comics coming into the country waged by an anti-American Communist Party of Great Britain and supported by arbiters of public

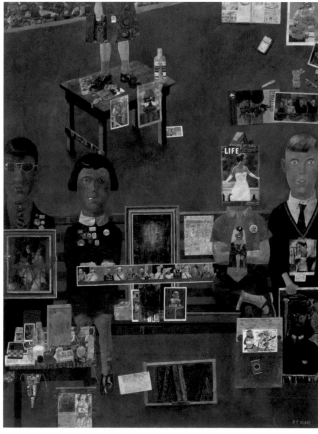

214 **Peter Blake**
born 1932
**On the Balcony**
1955–7
Oil on canvas
121.3 x 90.8

The subject of Peter Blake's busy but sophisticated painting was set for the Royal College of Art Diploma. Based on an American social realist painting seen by the artist in London in 1955, showing workers holding famous masterpieces, Blake's image combines high and low culture, from Edouard Manet's 'On the Balcony', held by the boy on the left, to comics and badges. Blake includes works by contemporaries such as Dick Smith and Leon Kossoff and a reference to the Kitchen Sink realist school in the still life on a table on the left. John Minton's recent death is alluded to in a photograph of him on the pullover of the boy on the right.

216 **'Robby the Robot'** at **'This is Tomorrow'** exhibition
1956

215 **Richard Hamilton**
born 1922
**$he**
1958–61
Oil, cellulose paint and collage
on wood
121.9 x 81.3

literary taste and morals such as the literary critics and latter-day Victorian sages, Richard Hoggart and F.R. Leavis. Was the IG approach the answer to the split between visual artists and their public? Not necessarily so.

### Obscure Objects of Desire

Richard Hamilton was a leading contributor to the highly popular This is Tomorrow exhibition at the Whitechapel Art Gallery in 1956, which was both the apotheosis and the moment of disintegration of the Independent Group, which by then had achieved many of its aims. Artists, architects and sculptors worked together in groups, just, to design a 'house of the future'. The results were baffling and eventually influential through dissemination among art students, especially those at the Royal College of Art, and via the *Architectural Magazine*, which introduced its readership to the so-called 'brutalist' modern architecture of Alison and Peter Smithson, leading lights in the IG. In an age of TV, the opportunities for catching the public's attention were improving considerably. They needed to, with cinema attendances sky high, James Dean a disturbing role model for the young and Elvis Presley topping the charts. Placing Robby the Robot from the box-office hit film *Forbidden Planet*, a science-fiction updating of Shakespeare's *The Tempest*, at the entrance to the exhibition was a masterstroke.

Hamilton's art, influenced by popular graphic art, Futurism, Surrealism and in particular the until then relatively obscure work of Marcel Duchamp, coolly analysed the new visual sphere of consumer culture in what Alloway called the 'age of plenty'. His $he of 1958–61 (no.215) is a peculiarly disappearing image of the housewife as a sex machine, literally so. A fridge door from the new American Whirlpool line is shown open with a Pepsi bottle on the shelf and a freezer compartment. In the foreground a finely airbrushed toaster-cum-vacuum cleaner (a 'toastuum') diagrammatically and humorously demonstrates, as in an advert, the length of trajectory of its spring mechanism. Framed by this arrangement of up-to-date electrical kitchenware is the object and subject of the piece, the ice-cool madonna of the freezer compartment melting into thin air. A joke winking eye is glued to the board above an airbrushed evocation of shoulders and breasts, and below them both a faint thin waist becomes a pair of broad hips in relief, like a Nicholson work revealing its true object of desire. The low-cut dress effect suggests her lower body is turned away from us.

Hamilton, trained as a commercial artist in the 1930s and 1940s, uses many different sources and techniques to deconstruct the language of everyday visual culture. With collaged photos, spray paint and oil paint, he mixes and matches as he needs, to create a primer for the contemporary viewer. With an almost Victorian moral purpose to inform his viewers of their complicity in rendering the woman a sex object, Hamilton arrives at a witty critique of capitalist society. We are reminded of Holman Hunt's contrite streetwalking fashion victim. His intervention is ironically intellectual while enjoying the features of Pop, that is, popular culture, he had enumerated in 1956: 'Popular (designed for a mass audience). Transient (short term solution). Expendable (easily forgotten). Low cost, Mass Produced. Young (aimed at youth), Witty, Sexy, Gimmicky, Glamorous, Big Business.' In other words, everything museum art was not. Where the pre-war avant-garde had assumed a universal human subject, the nascent Pop artists saw subjectivity as a product of an ever-changing technological environment with blurred boundaries between 'self' and 'other' – in other words a difficult context in which to fashion a 'self' at all, as Frith had sensed in painting his duped city office boy a hundred years earlier. Are even your desires your own?, was one central question, and is this fleeting world of images and fragmented wishes an unredeemable mess or a 'house of fun', as one installation at the Whitechapel in 1956 called itself? Could art, let alone architecture, make a difference in the interests of the individual's right to freedom and peace of mind? Was the artist an advertising agent for some obscure intellectual product, or a priest of a new religion?

### Earth Mother

There were other female totems in the city landscape, however. The ideology of abstract art was often taken to be liberating and opposed to the petty confusions of modern life. Mondrian's geometries were blueprints for a spiritual Utopia of perfect balance, and the international Constructivist movement, still alive in Britain as elsewhere in the 1950s, aimed at harmonising aesthetic solutions within a context of a managed economy and social egalitarianism. New buildings and objects would act as part of a reformation of the order of things and, as was hoped in the nineteenth century, improve everyone's tastes and morals. Nothing is that simple though, and abstraction itself was often an investigation of, rather a remedy for, the darkness and chaos of the modern condition – take Jackson Pollock's or Willem de Kooning's art, which found visual moments of respite against the Cold War storm clouds around them.

In the 1950s we can see, as we have throughout our narrative, parallel histories of art. The differences between art practices, however, were now more

profound ideologically and stylistically, although artists of different persuasions rubbed along together and interacted in the normal course of affairs. The appearance of American abstract painting at a number of CIA (not ICA) backed London shows in the 1950s was as important for many as the increasing flood of film, products and advertising that Paolozzi *et al.* had absorbed. The arrival of large, colourful, energetic canvases by Pollock, Rothko and others presented a major challenge to British painters who had been used to Mondrian and Nicholson. New York rather than Paris was now a place to go for art, as well as skyscraper modernity and black jazz.

Aspects of the new American abstraction actually played well with a lingeringly bohemian art culture still much concerned with myth and personal expression, and instinctively disdainful of the hire-purchase world of shiny new furniture and instant gratification. Pollock and Rothko's paintings were psychologically deep and full of references to primitive classical myth and religion, as well as evoking a daring visual freedom expressive of an open society's pioneering energy. Furthermore their 'all-over' (unfocused) composition with flat space and 'push-and-pull' impact on the senses, was as appealing to Alloway and his friends in its new concept of how to organise an artwork, as to those looking for a more romantically sublime effect.

The Scottish painter Alan Davie, more like gypsy Augustus John with his enormous beard than either the 'preppy' or duffel-coated beatnik American style of the IG group, came into contact with Pollock's work on a scholarship trip to Peggy Guggenheim's collection in Venice in 1948. A pioneer of the link between popular music and art, which has become a feature of the art scene since the 1960s, Davie had spent a number of years as a professional saxophonist with jazz bands before becoming a full-time painter. The improvisation of jazz was significant in his artistic formation and he was drawn to techniques such as monotype print-making, which emphasised invention during process.

Davie taught at the Central School of Art in the 1950s, a hothouse of avant-gardism where Hamilton and others taught, often taking, as he recalled, riotous and productive evening classes of 'rough Cockney kids who didn't like art'. His *Birth of Venus*, painted on masonite board, a cheaper support than canvas and used by many artists such as Bacon during a time of austerity, was made using a Pollockesque approach, laying the board on the floor and walking over it to reach all parts (no.217). Mixing his paint with a lot of oil and some sawdust for texture, he worked with broad sweeping gestures, painting over and over again until he got the right effect. There is something of the witch doctor or shaman in his method and imagery, and more

217 **Alan Davie**
born 1920
**Birth of Venus**
1955
Oil on board
160 x 243.8

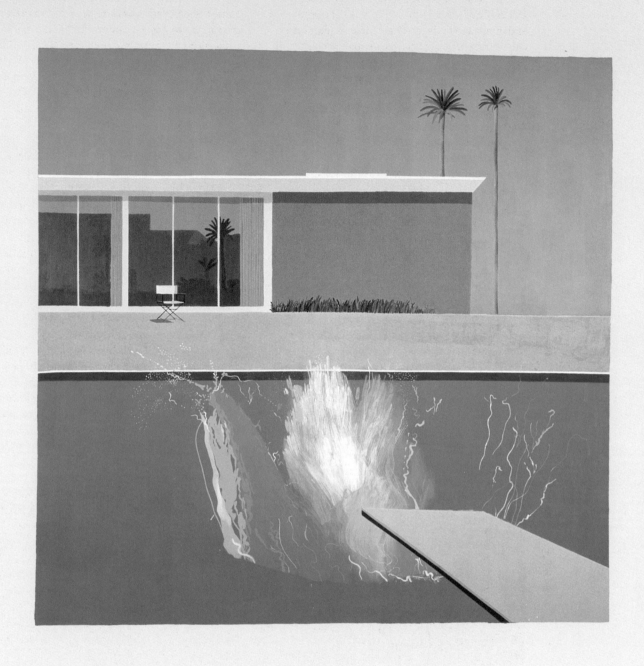

**218 David Hockney**
born 1937
**A Bigger Splash**
1967
Acrylic on canvas
242.6 x 243.8

David Hockney was one of the leading young artists at the Royal College of Art around 1960, and a pioneer of Pop art imagery. Drawing on his own experiences as a homosexual, and on popular culture and the work of French artists such as Jean Dubuffet, Hockney created an art of cryptic and symbolic figuration. By the late 1960s, he had moved to California, where he began to use a more traditionally representational style. Increasingly using photography as part of his creative process, he became fascinated by capturing split-second events such as the splash left by a diver as he enters a pool. This painting, with its eerie lack of human figures and evocation of sudden silence, combines a meticulous attention to observed fact with abstract flat planes of colour. 'A Bigger Splash' was the title of a film about Hockney's life released in 1974.

than a nod in the direction of Zen Buddhist thinking that had been popularised in 1953 by the publication of Eugen Herrigel's *Zen and the Art of Archery*. Davie lectured on Art and Zen at the ICA in 1956. With Surrealist automatism, used by many abstract painters since the 1920s, notably Pollock, Davie loosened the reins of his unconscious so that he could allow imagery to flow freely along his arms, as it were, onto the canvas. Davie was a keen reader of Jung's psychology with its emphasis upon the collective unconscious. He felt it necessary to delve deeper than what he regarded as the superficial social unconscious of Pop art, further even than Bacon who used similar techniques for broadly figurative effects, and down into the belly of more ancient inspiration. He speaks of 'hoodwinking' the conscious mind and insists that his titles are post-hoc poetic interpretations of the paintings once they are finished. Evoking the holy spirit and the sources of jazz, Davie's thinking has many symmetries with Symbolism and with immediate predecessors such as the Welsh painter Ceri Richards whose organic abstractions of the 1940s are every bit as advanced as those of his American peers.

He says of this work: '*The Birth of Venus* has in its vague evocation a distinct suggestion of the primeval womb, birth place, cavern, source of fruitfulness and love – all ideas which did not suggest themselves to me when I was working. But later, the title suggested itself, as associations presented themselves to me – and more than a static image seemed to be there – truly an image of emergence, of becoming fruitful, of birth, the birth of Venus.' The key to reading these works is to have a sense of the cascading transformation of ambiguous signs and symbols like natural forms evolving from one state to another, always retaining the seeds of their dark origins. In a world dominated by men, Davie's elemental woman was from another planet to that of Hamilton's vanishing creation.

### Cornish Renaissance

Much abstraction had an unmistakably shamanic and magical Celtic quality, and it was appropriate that one of its most impressive appearances should have been away from the West End and the encroaching world of television, information overload and shopping. We have already seen previously how the small fishing port of St Ives had long attracted artists – Turner and Whistler had both visited it in the nineteenth century – and it had become home in 1939 to Ben Nicholson and Barbara Hepworth. The primitivism of the environment of west Cornwall was important as well as the feeling that once over the River Tamar one was in a separate and un-English kingdom where new rules applied in life and art and the inspiration of the

persecuted bards could still be felt. The poet John Heath-Stubbs's lines evoke some of the dark appeal of the landscape for emigrants there:

> This is a hideous and wicked country,
> Sloping to hateful sunsets and the end of time.
> Hollow with mine shafts, naked with granite, fanatic
> With sorrow. Abortions of the past
> Hop through these bogs; black-faced the villagers
> Remember burnings by the hewn stones.
> ('To the Mermaid at Zennor', *Selected Poems*, 1965)

This extraordinary power and the related presence of major figures such as Hepworth and the potter Bernard Leach made St Ives an international centre of abstraction in the late 1950s and early 1960s with Rothko and other Americans visiting the artists there.

Patrick Heron, a resident of Cornwall for most of his life, at first reacted unfavourably when he saw Pollock's work in London in the early 1950s. A modernist working in a variation on Cubism at that time, he quickly moved by the mid-fifties, however, towards a full-blown abstraction inspired by New York painting. Heron became the leading spokesman for abstract art in St Ives through his strong personality and political views (he was a conscientious objector during the war), energetic organisational abilities and his literary skills as an art critic, working from his base at his large house located between St Ives and Zennor, Eagle's Nest, with its exquisite gardens and sea views. He was able to engage figures such as the great exponent of Abstract Expressionism Clement Greenberg, who sought out Heron in London in 1954, with whom he shared an admiration for the formalist yet empirical art criticism of Roger Fry. Heron and Greenberg though, in different ways, were rather more interested in significant colour than form. Heron, in part echoing the ideas of Adrian Stokes who was closely connected with the St Ives scene, wrote of colour that it 'is both the subject and the means; the form, and the content, the image and the meaning in my painting'.

He began a series of 'stripe' paintings in 1957 that deliberately used the simple format of stripes as neutral containers for colour, which was to be the focus of experience. Evoking Whistler and early abstract art theory, Heron spoke of the musical connotations of the stripes as 'stratified spatial bars which ascend in chords of different reds, lemon-yellow, violet and white up the length of my vertical canvas'. There was also a more pragmatic reason for the format, as the work illustrated (no.219) was commissioned as part of an interior scheme for a

**219** Patrick Heron
1920–1999
**Horizontal Stripe Painting:
November 1957 – January 1958**
1957–8
Oil on canvas
274.3 x 154.8

**220** Roger Hilton
1911–1975
**Oi Yoi Yoi**
1963
Oil and charcoal on canvas
152.4 x 127

This image is based on Roger Hilton's naked wife jumping up and down on a balcony during an argument and shouting 'Oi Yoi Yoi'. Hilton was part of the St Ives group of artists, and brought to it his knowledge of French abstraction painted in Paris during the 1930s. By the 1960s his work, still characterised by a rough but subtle spontaneity, had strong figurative elements. He wrote that 'abstraction in itself is nothing. It is only a step towards a new sort of figuration', summarising a whole generation's attempt to renew the tradition. His crude and energetic late gouaches and watercolours and his 'Night Letters', written to his wife during his bedridden final years, are a moving record of his aesthetic, physical and emotional fight against terminal illness.

221 **Peter Lanyon**
1918–1964
**Thermal**
1960
Oil on canvas
182.9 × 152.4

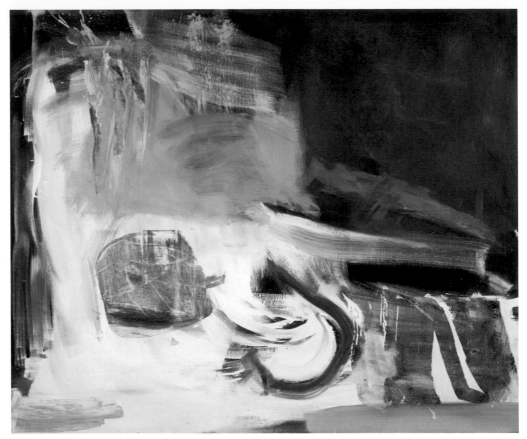

publisher's offices, in which a ceiling of wooden slats acted as a parallel motif for Heron's canvas.

Heron abandoned his stripe paintings when he realised they carried too many landscape and seascape connotations and compromised the pure colour effects he was after. While his painting is rooted in the optical, another St Ives artist found the source of art at the point where the psyche and physiology meet. Peter Lanyon, a native of Cornwall who had been taught by Ben Nicholson and influenced by the sculptor Naum Gabo, and who exhibited at the Festival of Britain in 1951, had a quite opposite view to Heron about the importance of the landscape. His abstract painting is intimately linked to his experience and historical understanding of the landscape, sea and air, sharing much in common with the inner-outer concept we have seen in Barbara Hepworth's sculpture. He also shared an almost 'Pop' interest in space and flight, though of a natural non-jet-propelled variety, and in 1959 he began gliding. The aviator had been a figure of admiration among avant-garde artists and writers before the war, from the Russian abstract painter Malevich to the militaristic fantasists the Italian Futurists, and Lanyon saw flight over the landscape as the obvious next step in his evolution of a new vision. This Icarus-like experience in the clouds, something perhaps Constable, certainly Turner or an eighteenth-

century tourist in search of the sublime might have welcomed, became the chief inspiration for a number of works including *Thermal*, which refers to the invisible current of hot air which takes the glider upwards and which eventually becomes cloud (no.221). He wrote of how 'the air is a very definite world of activity as complex and demanding as the sea', and of the storm conditions and downcurrents connected with the all-important thermal.

Lanyon was fascinated by the psychological as well as meteorological aspects of his experience. Unlike the slow movement of a balloon or the immense speed of an airplane, the glider swoops gracefully through space and as if the body and mind were fully part of its flight. In writing of his ambitions for his painting Lanyon, using an existentialist rhetoric typical of the time, describes his art as 'a recreation of experience in immediacy, a process of being, made now', with the work a 'mark of hand and arm' like the flight of birds 'describing the invisible'. As with Paul Nash's fantasies of flight, and Nicholson and Gabo's abstract work, the aim is to make an abstract equivalent for closely entwined, invisible bodily and mental experience. Lanyon, in pursuit of a Turner-like immersion in the elements, was killed in a gliding accident in 1964. The character of his aerial work was brilliantly evoked in a number of poems by his friend,

the Cornwall-based Scottish poet W.S. Graham, who attributed to his art a way of 'seeing new'.

**An Abstract Situation**

By the early 1960s, abstraction was established as the dominant modernist form in Britain, not least because it was so in the United States and because it had entered the art student's curriculum following reforms in the late 1950s, which moved away from a realist emphasis towards one focused on materials and basic skills. Strangely these Bauhaus-inspired reforms came as a result of a report conducted by the realist painter William Coldstream, who was Chairman of the National Advisory Council on Art Education. A formalist bias was evident in much art of the early sixties, by which time young British artists, supported by Lawrence Alloway, were moving from the heroically expressive phase of abstraction towards something cooler and more concerned with optical effects than with meaning or emotion.

The Hard-Edge style of American painters such as Barnett Newman and Ellsworth Kelly was shown at the ICA in 1960 and led to the formation of a group of painters whose first show was called *Situation*, following on from a 1959 ICA show called *Place*. The rhetorical emphasis was on the immediacy of both making art and of daily experience – 'here are objects, and here they are now', being the message. The catalogue saw the recent developments in America as unavoidable and tending towards an individual rather than national style: 'Not recognisably "British", however, the desire to be British by attempting to isolate British characteristics usually results, when it arises, in a full stop.' By this the author, Roger Coleman, no doubt meant the tendency to read landscape motifs and atmosphere into the work as was often the case with St Ives painting. The Situation artists, such as John Hoyland (no.222) and William Turnbull, followed Clement Greenberg's belief that the artwork aspired to an autonomy and 'objecthood' devoid of narrative, illustration or literary significance. An artwork was an arrangement of colour and form, not a representation. The Situation title, furthermore, emphasised the setting of the art, the self-conscious particularity of the art space.

When the sculptor Anthony Caro visited the USA in the late fifties, he not only saw there the new painting of Kenneth Noland and others, with its large stretches of colour and simple forms, but also the steel sculpture of David Smith. Following his return to London he turned his back on heavy bronze sculpture and brought colour and metal together in a stunning series of works of which *Early One Morning* is a classic example (no.223). Caro, deeply influenced

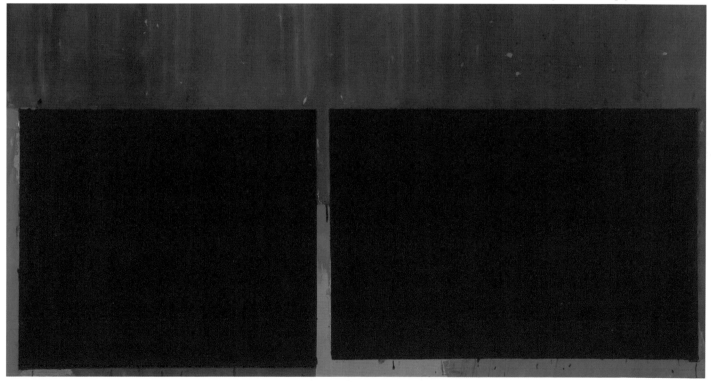

222 **John Hoyland**
born 1934
**17.3.69**
1969
Acrylic on canvas
198.4 x 365.8

John Hoyland's large acrylic-soaked canvases of the late sixties were heavily indebted to his admiration for the abstract paintings of the New York painter Hans Hoffman. The factual title giving the work's date of execution or completion, and the insistence on the flatness of the canvas and the pictorial 'logic' of its relation to the rectangles of colour, other marks and bare canvas, make this a key work of the formalist abstract tendency in Britain, which was indebted to American abstract expressionism. The ideas of the critic Clement Greenberg about the 'autonomy' of the artwork were crucial to the realisation of this form of painting, and to its powerful influence in art schools and the gallery scene in the 1960s and 1970s.

**Anthony Caro**
born 1924
**Early One Morning**
1962
Painted steel and aluminium
289.6 x 619.8 x 335.3

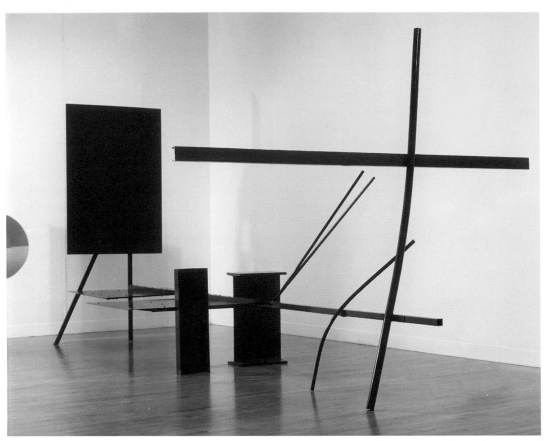

by Greenberg's ideas, introduced an entirely new combination of concepts into modern British sculpture – it was freestanding, horizontal, utterly non-representational and painted in bright colours. It had a feeling of airborne lightness, freshness and freedom as if it had arrived in spite of history, an ambition for his art that Caro held at the time. The steel sheets and girders are welded and bolted together – neither carved nor modelled – and create the effect of an engineer's vision very much in tune with the spirit of the age. The meanings, such as they are, and the titles are always lightly connected to their objects, and are aeronautical rather than bodily although, like Lanyon's paintings, Caro's work provokes powerful physical responses in the viewer. This is particularly brought about through the absence of a plinth or imposing verticality – it is an art that can be walked through as well as around. Caro spawned a generation of sculptors working with abstract form, strong colour and materials such as steel and plastic, mainly based at St Martin's Art School in London, and who became known as the 'New Generation' following an exhibition of that title at the Whitechapel Art Gallery.

### Eating Clement Greenberg

'A room hung with pictures is a room hung with ideas', wrote Joshua Reynolds in the eighteenth century. By

the late 1960s you didn't even need the pictures, and sometimes not even the room.

One man's history is another man's conspiracy. The American Clement Greenberg, for various reasons, has loomed large in British perceptions of art and theory since the 1950s. His dialectical history saw abstract art as inevitable, with the progress from Impressionism through to Rothko and beyond revealing an ever-refining art practice dwelling on the material limits of its own means. Artistic – mainly painting – problems were now visual ones concerned with addressing the flatness of the canvas and, with retrospective panache, Greenberg roped in Titian and other old masters as fellow-travellers of his grand narrative. Anything to do with mimesis, symbolism or political meaning was 'kitsch', a word Greenberg made an ultimate term of abuse. Caro, Heron and others in Britain, including many who taught at art schools, were mainly sympathetic to these ideas. It was a history which left many refugees as well as questions begged.

Pop artists, realists, Neo-Romantics and latter-day surrealists, ordinary portrait painters even, were all obvious casualties of Greenberg's exacting aesthetic and moral standards, which owed so much to Roger Fry. Pop art thrived at the Royal College precisely because it had resisted much of the formalist creed through the fifties. The ICA was too eclectic to adopt

a house style. Dissent, however, was possible, and it grew as the sixties wore on.

There was the Situation group, certainly, but there was also the Situationist International (SI), with British members such as the constantly disappearing *flâneur* Ralph Rumney. The SI, founded in an obscure town in Italy in 1958 as a loose international group, was a strange mix of a Marxist critique of what its Parisian leader Guy Debord called the 'Society of the Spectacle', surrealist intervention and *détournement* (diversions) and a practice of taking '*dérives*', or just plain wandering, around cities. The SI had a hidden but real effect on the intellectual culture of the second half of the 1960s. In the international Fluxus group, with its mail art and other probingly awkward pranks, in the urbanism of avant-garde architectural theory and in the artist Gustav Metzger's *Destruction in Art* moves, we see the fifth column at work. They all required the museum for their full effect because they were founded upon an analysis of social structures and institutions.

There was the radical abstraction of Minimalism – Carl André's *Equivalent VIII*, better known as 'The Bricks', being the famous test case in Britain when it was shown at the Tate in 1977 – which Greenberg could not condone in its extremism and use of non-artistic industrial materials. The simple units systematically deployed as in a highbrow game, such as fire-bricks

and pre-manufactured sheets of aluminium and plastic, had not registered the aesthetic work Greenberg admired in Caro. In their ambiguity and lack of painterly colour they had a subversive quality closer to Duchamp and, strangely, to Pop art than to traditional art, reinterrogating the question of truth to materials that had been a preoccupation for so many decades.

There was a revolution in materials, with some sculptors making objects from soft materials such as felt and other fabrics, later causing museum conservators endless problems with infestation. These were seen as less macho than traditional materials and often more environmentally friendly. They lay on the floor, or hung down walls, transforming expectations about the art object and becoming identified with a critique of gender issues in the visual arts. At a spectacular event for fashionable London society at the Tate in 1968, the year of the student May Revolution in Paris, the sculptor César invited his audience to cut pieces from huge red, yellow and blue foam blobs, each made from sixty pounds (27 kg) of liquid polyurethane that a machine had excreted onto the floors of the Duveen sculpture hall. The artist opined that 'such an event taking place at the Tate in 1968 … is … a cry of hope, the opening of a new way into a pioneer's world'.

And then there was John Latham. Latham has a whole version of history that places his own practice

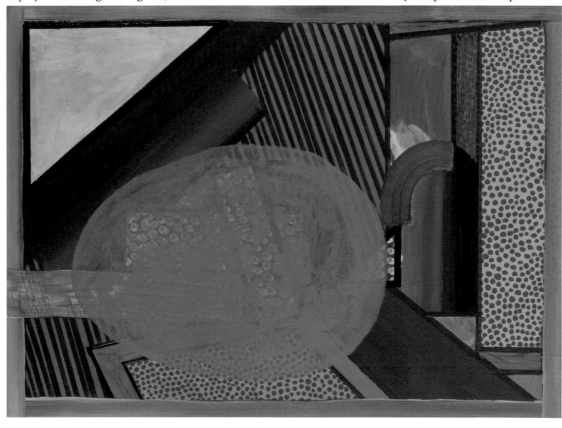

224 **Howard Hodgkin**
born 1932
**Mr and Mrs E.J.P.**
1969–73
Oil on wood
90.9 x 121.6

Howard Hodgkin paints abstract equivalents for personal and social experiences. His works convey densely encoded memories of people, places and emotions through colour. Reminiscent of early modernists such as Henri Matisse, Hodgkin's paintings are a visual realisation of the core beliefs of Bloomsbury culture – formalism and friendship. He painted four portraits of the art collectors Mr and Mrs Ted Powers over a period of eight years. This work, painted on wood like most of his paintings, to accentuate its quality as an object, evokes the Powers' London home. The artist recalled: 'Two sculptures by Westerman, a Brancusi, a Pollock, a panelled wood ceiling, as well as the owners: the wife slipping away to the right and the husband talking in green in the foreground.'

225 **Bridget Riley**
born 1931
**Achaean**
1981
Oil on linen
239 x 202

Subtle content. Bridget Riley is an abstract painter and one of the pioneers of Op art in the 1960s, a movement concerned with visual perception. 'Achaean' draws on Riley's visit to Egypt in 1981. She was fascinated by the ancient Egyptians' use of a fixed pallet. For their famous tomb paintings they used a particular red, blue, turquoise and yellow with black and white, and showed a remarkable ability to use colour to bring about strong feelings of light, vibrancy and life. The painting structure refers to the classical sonata form in music: an introduction, development, reprise and conclusion. The title, however, comes from the archaic name for the Greek peoples.

230

226 **Gerald Scarfe**
born 1936
**Ian Fleming as James Bond**
1970
Lithograph on paper
73.7 x 54.6

Gillray meets Beardsley meets Dan Dare – all on acid. Gerald Scarfe was a pioneering British political cartoonist in the late 1960s and 1970s. In the tradition of James Gillray, his work performs grotesque distortions on his victims. In this case, he virtually assaults the author of the James Bond novels, which had defined a certain kind of stylish but cynical British Cold War hero. Sexuality and violence, phallus and nuclear weapons become psychedelically transformed as a brutal rape is enacted on a fetishised female form. Sperm and blood gush forth from Fleming's guided missile, echoing the spectacular and visceral effects of the films that made Bond a worldwide success.

at the heart of things – art and science, he has claimed, intersected in his work at some point in the 1950s and he has been waiting for the world to catch up ever since. He opposed Greenberg's aestheticism and took drastic measures to publicise this when he and some of his students ate a copy of the American's *Art and Culture* from the St Martin's School of Art library and returned the chewed remains in a glass container. This played on the radioactive term 'culture', of course, and neatly summarised the deep issues at stake.

Latham's chewed-up gesture has become a part of British art history like Hogarth's *Analysis of Beauty* or the Whistler and Ruskin trial. Many sympathised with him, and the Vietnam War, Situationist-inspired student dissent, bra-burning feminism and the rise of the New Left – much inspired by French political and structuralist philosophy – created a climate of radicalism that almost recalls the iconoclasm debates of the sixteenth century in its intensity. Art objects, as Blake and Ruskin had believed, were seen as barometers of social and political values and therefore highly significant artefacts. The commodified artwork in capitalist society, as analysed by Marxist theory, was an agent of a network of forces that meant it could never be an innocent diversion, whether for the rich or the publicly funded not-so-rich. The contradictions of this position now seem clear, but at the time they were

the only questions that seemed worth dealing with, everything else being a bourgeois and individualist illusion. Kenneth Clark's enormously popular TV series *Civilisation*, like Greenberg, became a hated target for those who saw this smooth-talking Oxbridge and Bloomsbury type as an apologist for the 'barbarism' that lay behind Western 'civilised' values. 'Genius' was now a dirty word. In fact the artist, like the author in literary theory, was dead, dying or at least becoming an invisible presence, like Hamilton's sex object vanishing into the changing wave-lengths of a TV tube spectacle, all controlled by the 'hidden persuaders'.

Keith Arnatt's *Self-Burial (Television Interference Project)* of 1969 is a record of an intervention into this *Matrix*-like world of simulated life (no.229). Arnatt's photographs were originally broadcast for two seconds each day over a nine-day period in the middle of German TV schedules, without explanation. He was knocking on a number of doors with this piece: the narcissistic artist-hero, like Turner, say, disappears from his own mythical creation; he disappears on TV, the new dominant visual culture; he disappears into the ground, like a resurrecting Christ figure in reverse; and he disappears into the landscape, one of the the artist's natural habitats for two centuries. Land Art was a burgeoning practice in the later 1960s in America and Europe, with artists making huge abstract sculptural

A HUNDRED MILE WALK

scale 1" = 1 mile          RICHARD LONG 1971–2

Day 1  Winter skyline, a north wind

Day 2  The Earth turns effortlessly under my feet

Day 3  Suck icicles from the grass stems

Day 4  As though I had never been born

Day 5  In and out the sound of rivers over familiar stepping stones

Day 6  Corrina, Corrina

Day 7  Flop down on my back with tiredness
         Stare up at the sky and watch it recede

229 **Keith Arnatt**
born 1930
**Self-Burial (Television
Interference Project)**
1969
Photographs on board
46.7 x 46.7

228 **Bruce McLean**
born 1944
**Pose Work for Plinths 3**
1971
Photographs on board
74.9 x 68.3

Bruce McLean travelled from
Glasgow to London in 1963 to
train at St Martin's School of Art,
which had become the unofficial
HQ of the new generation of
abstract sculptors influenced by
Anthony Caro. Becoming

impatient with what he saw as a
new and stifling orthodoxy, he
turned to work made from ice
and mud, for example, and to
photography and performance.
The body became the focus of his
interests – as it was for his

contemporaries such as Gilbert
and George, Stuart Brisley and
Barry Martin – and his 'event' at
'Situation' in 1971 was recorded
in a set of photographs of which
this work forms a part. It is a
humorous assault on Henry

Moore's sculpture. McLean was
one of the artists represented
at the seminal exhibition of
minimal and conceptual art,
'When Attitudes Become Form',
at the ICA in 1969.

works somewhat in the vein of the eighteenth-century landscape designers, or recording walks using photography and texts made along straight ley lines drawn on maps. Richard Long was the leading practitioner of Land Art in Britain, joining a conceptual approach with the Romantic and Neo-Romantic traditions (no.227).

The cerebral pleasures of maps – a dominant image at the time with artists talking increasingly of 'mapping' things, be it the physical, social or psychic landscape – ran alongside emotional and ecological interests. Arnatt's witty piece is a prime example of what became known as Conceptual art, which flourished throughout the 1970s. The product largely of maverick, art school and ICA activities, it had its roots in Dada and Independent Group sources and attained a paradoxical brief orthodoxy through Arts Council funding and display at major museums and galleries such as the Tate Gallery. It had an urgent sense of politics and was prepared to jettison conventional aesthetic expectations in the interests of the transformation of consciousness. Its problem, as ever with such strategies concerned with the cultural software, was access to the main systems it sought to challenge. The odd TV station might humour it occasionally, but in the main art schools, small galleries and journals were unlikely to bring about the big changes many saw as vital to the world's long-term survival. This was a pre-1989 world of the two power blocs, the threat of nuclear catastrophe and a jaded consensus politics threatened by idealistic terrorists and a drug epidemic among youth. However, because it had a vision, Conceptual art attracted people with serious talent who ended up within the arts establishment as teachers and trustees and, because the great intellectual issues in many ways are so similar, it has retained a currency to this day. The conversation piece has never really died, it has continued in quotation marks and even as quotation marks only.

## Painting is Dead – Long Live Painting

Conceptual art, following Independent Group and other leads, was usually resolutely 'anti-humanist' – that is to say the autonomous individual, the hero of liberal democratic ideology, had been replaced by biologically and psychologically malleable functions of 'the system' living under the delusion of owning a 'self'. Critics wrote of the book 'reading' the reader and of language 'speaking' the person. The visual arts were similarly ideological, and aesthetic responses the product of class and conditioning. Language in particular became a concern for conceptual artists and theorists, such as the group known as Art and Language, who challenged what they saw as the 'dumb' subject of a purely visual, Significant Form. 'Man' was an invention of a linguistic system in a world with no God to guarantee meaning. The great self-fashioning man in the Thomas More mould, already rocking under external pressures, was disappearing speechless into the earth like Hamlet with a script presented by Keith Arnatt's gravedigger.

This frightening version of things was not just anathema to the majority outside the intellectual elite. Throughout the seventies there was a growing reaction to what seemed like a radical orthodoxy within. From the rise of conservative politics and economics to the 'return' of figurative art, beleaguered sections within British culture began to ride a wave of resistance to photographic art, the very antithesis to the craft tradition of individualism, and to works made from ice or steam, to works which were just ideas, to repetitive film and video art that deconstructed the nature of looking, and to performance art, which seemed to have replaced the sculptural object. The problem was to find a new language in this world of language proliferation, to reconnect with 'tradition' without seeming to do a cowardly U-turn of the sort about which the British always feel self-conscious. There wasn't exactly a palace revolution, but rather the growth of an expanded field for art, an eclectic move away from a master narrative, for which the conceptual piece with no name had seemed to be the end of the road.

In Europe and America in the late seventies, a number of exhibitions, with influential catalogues, and curatorial and collecting supporters, signalled a revival of oil painting. This was figurative, expressionist, symbolist painting on a large scale. The result was not only a lot of oil on canvas but also a rewriting of art history and theory. Even Clement Greenberg had a place within Conceptualism as a Satan to its Milton. Now artists rediscovered a past before Manet and Impressionism and, rather than a glut of contemporary information or French theory, were contending with the great canon of Western art that had been the basis of Kenneth Clark's TV series ten years earlier. However, no return to tradition could avoid the consequences of recent art history, and the difficult questions of Conceptual art lurked in the dark corners of the studio. A nervy irony became the prevailing mood.

At almost the very moment the Tate Gallery was embroiled in a celebrated media controversy over its purchase of Carl André's 'Bricks', David Hockney, one of the most famous British artists and one who could claim to have a wide appeal well beyond the art scene, joined forces with his fellow former Royal College student, the painter R.B. Kitaj, and supported the cause of a travelling Arts Council exhibition in 1976 selected by his American friend. Provocatively called *The Human*

230 **Paula Rego**
born 1935
**The Dance**
1988
Acrylic on paper laid on canvas
212.6 x 274

The London-based Portuguese artist Paula Rego paints her memories, desires and fears, creating images of nostalgia, anxiety and sexual fantasy. This work, based on the idea of the 'dance of life', draws on memories of her early married life on the coast near Lisbon. The two men in the painting both echo her husband, the artist Victor Willing, who died the year she painted it. The women, dancing under the female sign of the moon, represent the phases of womanhood and the experiences such as innocence and marriage associated with them. Rego's work has become prominent since the 1980s revival of symbolist figuration.

*Clay*, and first exhibited at that bastion of modernism and Conceptualism the Hayward Gallery on London's South Bank, this show attracted wide attention and became a seminal event in recent British art history. Both artists were figurative, literary, narrative and often autobiographical, even confessional, and engaged with modernist painting, especially the legacy of Cubism, as well as with the old masters. Hockney's work is often concerned with the people and places in his life – typically his homosexuality and California figure large – and Kitaj's (he describes himself as a 'Diasporist Jew) with the complex and tragic fate of Jewish culture in history and with his deep love of the avant-garde tradition in literature. This was self-fashioning with a vengeance, and *The Human Clay*, based on a line from W.H. Auden, sought to stage a rearguard action in the face of what the two artists saw as a cul-de-sac of abstraction and Conceptual art. They didn't buy either the full Greenberg or Latham package, and indicated in their choice of works a living tradition that was waiting to be released and to find new visual connection with the world and out of the grids and empty spaces of severe modernism. They both accentuated the need for a return to traditional drawing skills, which had suffered severe ideological assault during the sixties and seventies and was, since the Coldstream reforms, hard to learn in most art schools.

*The Human Clay* was in many ways an apologia for what has become known as the School of London, a term invoking the School of Paris, stuff of legends, used to embrace painters who have usually dissented from the identification, such as Francis Bacon, Frank Auerbach, Leon Kossoff, Howard Hodgkin, Lucian Freud, Michael Andrews and Hockney and Kitaj themselves. The latter's *Cecil Court, London W.C.2. (The Refugees)*, painted in 1983–4, is a work that embodies many of the London School's characteristic features: it is figurative, though in a post-Picasso way in which space and form are never photographic (no.232). It is concerned with surface, in Kitaj's case a hallmark dry, pastel colouring seemingly scrubbed onto an exposed canvas; it is literary and even philosophical in its subject and manner; it is in a dialogue with past art from a range of periods.

The setting is an alleyway dominated by second-hand bookshops, some run by immigrant Jews, which runs between St Martin's Lane and Charing Cross Road in central London and which Kitaj says he has loved since he arrived in London as an ex-GI in the late 1950s. A character who appears in a number of his paintings as a representative of the Wandering Jew, Joe Singer, is referred to in the shop sign with 'Joe S' on it. This space establishes a dreamlike literary urban 'garden' in which his cast of intellectual Jewish

"TO ME THE WINDOW IS STILL
A SYMBOLICALLY LOADED MOTIF"
DRAWLED CODY

---

**231 Glen Baxter**
born 1944
'To me the window is still a symbolically loaded motif'
Drawled Cody
1978
Relief print on paper, 12 x 11.2

With Postmodernism and the return to figurative art in the 1970s came Glen Baxter. Using a transfigured and dated boy's adventure-story illustrative style, Baxter's oblique art and philosophical references are usually Monty Python-style visual one-liners. Cowboys become North London intellectuals, public school girls psychopathic tricksters. Words and images don't quite fit and all interpretation fails badly.

British art has had much of alternative comedy about it in recent years as it has entered the media mainstream.

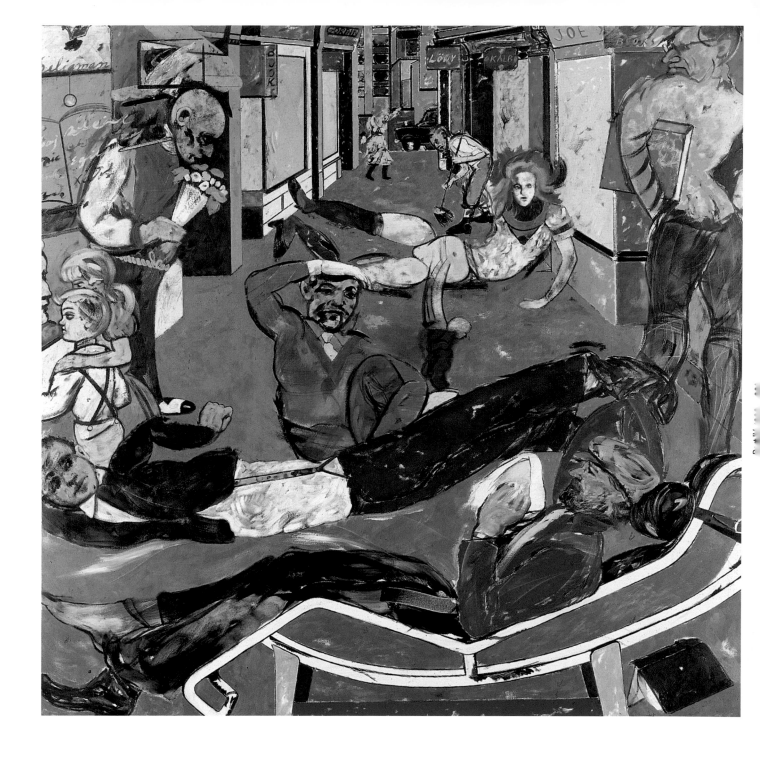

232 **R.B. Kitaj**
born 1932
**Cecil Court, London W.C.2.**
**(The Refugees)**
1983–4
Oil on canvas
183 x 183

**233 Lucian Freud**
born 1922
**Leigh Bowery**
1991
Oil on canvas
51 x 40.9

Lucian Freud, whose work has always been figurative and the development of which has been highly consistent, is usually included among the painters associated with the so-called School of London. His work since the late 1950s has shown a far more painterly handling and has focused on the nude and portrait, although the psychological intensity of the early work remains. This portrait of the unconventional performer Leigh Bowery, who died in 1994, shows him apparently asleep. Freud, who is a fearless materialist in outlook, is fascinated by the challenge of representing flesh and has talked of wanting paint to 'work like flesh'.

**234** **Peter Greenaway**
**Still from 'The Draughtsman's Contract'**
1982
The British Film Institute

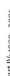

**235**

characters find refuge from persecution. Their extraordinary poses are derived from Kitaj's fascination with 'shabby troupes' of actors from the Yiddish Theatre. They are also based on the suppressed Hasidic Zaddikim, or magical holy men, who are a kind of role model for Kitaj. The figures include the book dealer Seligmann holding flowers on the left, Kitaj's stepfather, recently deceased, on the far right, and a self-portrait wearing his recent wedding clothes, in the guise of a character on the cover of a pulp novel and sitting on a famous chair designed by Le Corbusier. Kitaj wrote in his *First Diasporist Manifesto* in 1989, 'Painting is not my life. My life is my life. Painting is a great idea I carry from place to place. It is an idea full of ideas, like a refugee's suitcase, a portable Ark of the Covenant. Before I run for my train, spilling a few of these painting ideas, I just want to stand still on the platform and announce some of my credentials ... I am a dislocated pretender. I play at being a refugee, at studying, at painting.' It is unsurprising reading such words to learn of the importance, in terms of practice and identity, of Sickert, the arch-poseur and weaver of complex webs of allusion, to Kitaj and many of the other artists of his dissociated, often London-obsessed milieu. Sickert may or may not be a precursor of Postmodernism. Kitaj can certainly be described with this word.

## At Last – the Postmodern Show

There is now Postmodern science, cookery, theology, librarianship, fashion, comedy, football tactics – anything you care to mention. Postmodernism is a term that gained wide currency in the 1980s with particular reference to philosophy, literature, art and architecture, and from there it spread to become descriptive of an entire era and our knowledge of it.

'Post' implies something before it and in this case we speak of 'modernism'. 'Modern' means '*à la mode*', of the time, in fashion, recent if not contemporary. Historically it can refer to as early a period as the fifteenth century. In art it has tended to mean art since Impressionism and in architecture the buildings of international modernism such as those of Mies van der Rohe. Art, architecture and philosophy seem to converge around this term to indicate a particular set of ideas and associated styles. 'Modernism', in art usually meaning the visual forms and ideas Clement Greenberg espoused, for example, carries the general connotation of the enlightenment belief in progress. The faith in reason rather than theology and in the perfectibility of man through political and social change in which the artist had an important role to play, underlie the modernist 'project'. This was centred on an assumption of the historical ascendancy of the West and the universal nature of man. In other words,

**235** **Ian Hamilton Finlay**
born 1925
**'The Arts Council Must be Utterly Destroyed', from 'Posters from the Little Spartan War',** 1982
Linocut on paper, 30.5 x 43.2

A cult figure in his own lifetime, the combative ironist Ian Hamilton Finlay is a Scottish artist and poet who has spent more than thirty years making an extraordinary philosophical garden in the tradition of

Stourhead at Little Sparta, his home in Lanarkshire. The Garden Temple there has been the object of a protracted rates dispute with the local council over its categorisation by the artist as a religious building.

Finlay has turned the argument into a Conceptual work of art. A friend of John Minton and other Neo-Romantic artists in the 1940s, Finlay first gained notice as a Concrete poet in the 1960s. This print, from a series

of linocuts using a classical typeface, is an attack on the Scottish Arts Council, part of a complex cultural and legal 'Little Spartan War', fought by the artist with the help of his 'Saint-Just Vigilantes'.

everything would get better through wisely applied science and technology, as both many Victorians and intellectuals of the 1930s believed.

Just to name a few factors that punctured this particular balloon of high hopes: the Second World War, the rise of non-Western societies, the fear of nuclear holocaust, the 1970s oil crisis, an unnerving loss of faith in materialism as a philosophy and a way of life, and the huge social and cultural changes within the First World consequent upon economic and technological revolutions. Multicultural theory and identity politics have been especially significant within art. The computer and sprawling internet, genetic engineering and new cosmologies transforming our awareness of time and space, were among the obvious changes in science. If there was a modernist 'master narrative', and it is debatable, then the second half of the twentieth century was not a great time for it to maintain its hold on the collective imagination.

Everything seemed to be breaking up and T.S. Eliot, often seen as a modernist poet, had surely composed one of the first great Postmodernist texts in *The Waste Land* of 1922, with its fragments of past and present, of languages and of a disintegrated self. This kind of writing and the ideas of Sigmund Freud became the object of study of philosophers of literature and art, who pointed to the gaps between language and objects,

the uncertainties about meaning, the 'Eurocentric' and non-Western worlds, and conducted a massive deconstruction of Kenneth Clark's Western civilisation. There are many other examples from early in the century, from Picasso to Dada, which undermine the master narrative of Postmodernism itself. However, let us say that abstract art and Cold War capitalism seemed to be a smug duo representative of a world in decline and this, crudely caricatured here, was a useful fiction for intellectuals in search of a better world. We have seen Conceptual art mount a challenge to the established scheme of things and then artists such as Kitaj attempt a revival of something prior to it. Following the triumphal appearance of large international exhibitions announcing a 'new spirit in painting', and the arrival of a class of newly wealthy collectors such as Charles Saatchi, a strange stalemate in the late seventies and early eighties ensued and then the floodgates were open.

The dominant visual medium of the twentieth century, film, has been a central channel for the Postmodernisation of the culture. Its close, even incestuous, links with the fine arts that it has in many respects usurped, are fundamental to an understanding of the most recent, of course ruptured, episodes of our narrative. Many major British film-makers, for instance the late Derek Jarman and Peter

236 **Gilbert and George**
born 1943, born 1942
**England**
1980
Photographs, some
handcoloured, framed
302.6 x 302.6

The flipside of 'Thatcher's Britain' – Arcadian violence and sacrament in the East End of London. Ex-St Martin's students Gilbert and George, a besuited, inseparable pair of teasing art evangelists, have gained an international reputation for their huge photographic works. These grew out of Performance art works and are concerned with the big themes of history art set, Hogarth-style, in the decaying inner city. Here they pose, in their traditional English suits, either side of the English rose, as heroes of street fighting. Above this they appear again as gargoyles, perhaps referring to a deep mythical past of national humour and anger. Gilbert said in 1982: 'In the end we want to think about life, and that's why we are artists. I think that life in England is more painful. To be an artist is more painful.'

237 **Tony Cragg**
born 1949
**Britain Seen from the North**
1981
Plastic and mixed media
440 x 800 x 10

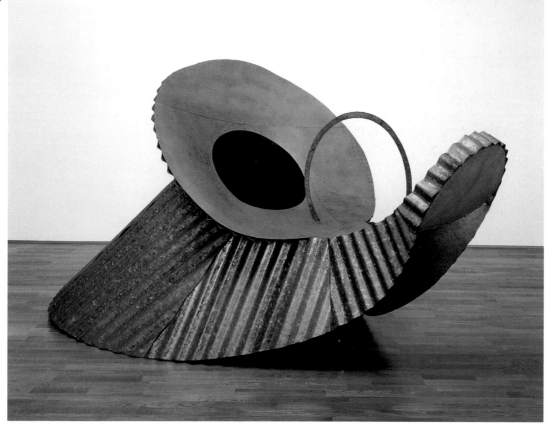

238 **Richard Deacon**
born 1949
**If The Shoe Fits**
1981
Steel
160 x 325 x 184

Another St Martin's student who came through formalism and Performance art in the late 1960s and early 1970s, Richard Deacon uses a range of modern materials, such as steel, rivets, laminated wood and glue to construct works with strong literary and philosophical resonances. This work is one of a series based on the poet Rainer Maria Rilke's 'Sonnets to Orpheus'. It evokes associations with the singing poet's skull or eardrum as well as with pots, pans, shoes and hats – that is, hollow objects which resonate. The title's reference to the Cinderella story remains ambiguous.

Greenaway, were trained at art school in the 1960s. Usually multi-talented and Postmodern by instinct, they have often continued to practise as painters and to construct their films in relation to the visual arts and their histories. This has allowed them a narrative, philosophical and 'state-of-the-nation' approach, which as fine artists they would have found difficult to pursue – and a richly 'composed' celluloid art that film traditions alone could not offer. Greenaway, a near-disciple of Kitaj's art and a maker of Conceptual video art, made *The Draughtsman's Contract* to investigate artifice, history, sex, death, class and metaphysics – to name just a few themes (no.234). Set in 1694, his story of an artist's sexual encounter with his employee's wife is full of references to old master painting and to the grids of modernism. It is supposedly set in the Nadder Valley in Wiltshire – the same area as Wilton House, part of the background of Rex Whistler's Tate Britain restaurant murals.

### Anarchy in the UK

Tony Cragg was a prominent figure among a generation of sculptors, including Antony Gormley and Bill Woodrow, who had been brought up on Minimal and Conceptual art, but who changed gear into a broadly Postmodern practice at about the time Margaret Thatcher began to dismantle the post-war consensus and to introduce aggressive free-market economics. The two developments are related only in a peculiar way, it should be added. Living in Germany since 1977 in the industrial town of Wupperthal, Cragg has much in common with the Independent Group artists both in his interests and in his light-industrial background. *Britain Seen From the North* of 1981, made at the time that social unrest was rife in many British cities affected by new economic policies, is made from multicoloured plastic detritus picked up in the streets of West London (no.237). It is a large wall-based work that is intended to evoke the state of the nation, at first sight as a brashly energetic and modern place, but which, 'seen from the north', from de-industrialised Liverpool, for instance, with its inner-city riots, starts to look like a chimera of fragmented rubbish – literally a 'waste land'.

The street culture of punk rock, which appeared at the time of the essentially mandarin *The Human Clay* exhibition, was a composite and raw response to a vague but real experience of alienation by working-class bands and art student agent provocateurs. Much indebted to Situationist theory, tactics and graphics as well as to Vorticism's *Blast* magazine and to Dada, the weird world of former art student Malcolm Maclaren invented a new form of DIY cultural entrepreneurship. Its sense of an invented self actually has much in

Helen Chadwick's art examines the inner worlds of mind and body, and deals with art history, science and myth using every means available – from chocolate to digital technology. This work is part of a series of lightboxes called 'Meat Lamps', which interrogates the mysterious fact of human incarnation or 'enfleshing'. Chadwick often used her own body to make her art, a marked feature of feminist art practice, and here the suggestion not only of raw meat but of vulnerable genital flesh reflects a search for some light on the nature of the body's interior. The work draws on Chadwick's interest in the forgotten achievements of women, in this case the seventeenth-century scientific philosopher Anne Conway's investigations into the nature of matter – a feminist re-reading of the Royal Society tradition.

**240 Rachel Whiteread**
born 1963
**House**
October 1993–January 1994
Cast concrete
Commissioned by Artangel

241

**241 Damien Hirst**
born 1965
**Pharmacy restaurant**
Notting Hill, London

New tastes. Artists have always been part of the wider culture of architecture, design, music, film – and eating. Damien Hirst and partners created a unique restaurant in Notting Hill, a once fashionably downmarket Soho-overspill area and now expensive haunt of film stars and politicians. The restaurant alludes to a work of his in the Tate Collection as well as to a culture of drug-taking which is so much part of the 'scene'. Hirst has collaborated with pop musicians, made films and generally operated between a number of areas with complete freedom and a post-punk DIY attitude towards his interests. The interior of the restaurant is like an art work in itself, and has little in common with Rex Whistler's gastronomic visuals of the 1920s.

common with Kitaj's exiled imagination, but it had a different focus in its disenfranchised dole-queue ethos and almost Realist immersion in grunge. Johnny Rotten's electrifying, safety-pinned appearances on stages in unlikely and unannounced settings blasting in a mock-Dickensian cockney voice, 'I am an Anti-Christ', had shaken the pop-music world and had a strong effect within art too. Cragg's huge plastic collage, the work of a *bricoleur* or beachcomber philosopher in the rubbish dump, was one visual equivalent registering this impact. While he has a strong moral sense of art's role in investigating the manmade world and providing art 'to think with', Cragg has little Unit-One or even This is Tomorrow optimism to offer.

### 'Neither From Nor Towards'

If Dr Who, that most British of aliens, had landed in his police telephone box in, say, Whitehall in the 1550s, gone off for a few intergalactic adventures for a mere four centuries or so, and broken down again in London in 2001, what differences might he have noticed in the art world? Gone would be most of the portrait painters and their apprentices, the Painter-Stainers' Company, the strict application of regal and religious law to images, the limitation of 'high art' to a few mainly private spaces. Of course he would notice a lot more than art world changes. Cars, computers, the global commercial and internet culture, mobiles, the dominance of the moving image, advertising and a thousand other things John Dee and the earlier Francis Bacon had barely dreamed of in their visions of the great British Empire to come. He would find crowded public art galleries, private art galleries in abundance, artists almost better known by name than through their work and heavily populated art schools encouraging their students in the ways of becoming wise about a complicated market. And of course he would find, among many less fashionable exponents of the traditional modes of portraiture, airplane, locomotive and landscape painting and the popular figurative art of Beryl Cook and David Shepherd – Britart, the world of YBAs (Young British artists) which is as deceptive as the interior of the Tardis but which hadn't appeared out of the blue of time travel.

The art-boom frenzy of the eighties, in which contemporary works went for massive sums of money through internationally astute dealers and the major auction houses, ended up, almost, in a 'bonfire of the vanities' during the economic crash at the end of the decade. London, one of the hubs of the market, was badly affected with bankruptcies and even suicides within the scene. The spirit of Hogarth prevailed, however, and the artists themselves led the revival.

242 **Sarah Lucas**
born 1962
**British Human Toilet Revisited**
1998
Photograph on paper
158 x 153.6

243 **Chris Ofili**
born 1968
**No Woman No Cry**
1998
Acrylic, oil and mixed media
on canvas
243.8 x 182.8

Painting has survived the rumours of its death – in this case in a lurid evocation of identity politics and political tragedy. Chris Ofili's canvas was painted as a memorial to the black teenager Stephen Lawrence, murdered by a racist gang in South London in 1993. The victim's face has been collaged into the woman's tears, and the words 'RIP Stephen Lawrence' can be read painted into the rich phosphorescent surface. Ofili, Manchester-born and of Nigerian descent, makes brightly coloured paintings that deal with the complexities of identity. His work is multi-cultural in technique as well as content – the varnished elephant dung that he applies to the canvas referring to his African ancestry and to the modernist use of unconventional materials throughout the previous century. The title refers to the famous song by Bob Marley.

Relatively free of the examined curriculum straitjacket that has overtaken much education and therefore initiative, art students, recently graduated or still at college, approached the problems they faced with a refreshing aptitude for finding smart and innovative solutions and evolving their own form of 'spin'.

If Chelsea was the fashionable avant-garde quarter in the 1890s, then Hoxton was the in-place in the 1990s, although 'avant-garde' was now an outmoded modernist concept replaced by the term 'cutting edge'. A run-down industrial district, it became home to design studios, dot.com companies, lofts, bars, restaurants and art galleries, and to a new generation of entrepreneurs and self-fashioners. Inner North London was the vortex of a new wave of regeneration and a new breed of artists began to thrive there and in similar neighbourhoods. Sarah Lucas, for example, for long associated with another young woman artist, Tracey Emin, famous for her bed and in-your-face TV outbursts, is a remarkable mixture of North London street kid and visual existentialist philosopher. Her work is often drawn from the abject and discarded aspects of life and culture – tabloid newspapers and cigarettes figure prominently in her imagination – and often adopts a strong feminist or at least 'gender-aware' stance. In British Human Toilet Revisited (no.242), she is shown having a first cigarette of the day, perched on that most Victorian of objects. The body, with its internal and external waste functions, dominates here as Lucas challenges the Page Three pin-up.

A mile or so to the east of Hoxton, Rachel Whiteread applied her trademark device of solidifying empty space to making present the absent but radioactive Victorian past. Her controversial House was a concrete cast of the inside of a whole condemned London nineteenth-century terraced house placed in a public park (no.240). Local councillors objected and it became another media cause célèbre throughout 1993. Raising questions both about housing and poverty and about memory and the national past, it touched a socio-psychological nerve that made it powerfully resonant. Whiteread was awarded a prize of £40,000 by the ex-popstar anarchic burners of a million pounds in bank notes, who called themselves the 'K Foundation' – for being the 'worst artist' in the Turner Prize, which she won that year.

Quite relaxed about whether he was or wasn't a 'bounded, unique, more or less integrated motivational and cognitive universe', to quote the influential anthropologist Clifford Geertz, Damien Hirst put together a show of his and his friends' work in 1988 that moved all the furniture once again. The exhibition was called Freeze – alluding presumably to the new 'cool', to film-stills and to the fact that the show was in a derelict

---

**244 Mat Collishaw**
born 1966
**Hollow Oak**
1995
Video (X)

The draft of the draughtsman. The oak tree, as we have seen, is a powerful signifier of Britain and its deep-rooted history. Collishaw's video installation employs old and new technology to perform a sort of cultural optical illusion. A nineteenth-century camera's beautifully constructed wooden negative carrying case frames a video of an oak tree projected onto etched glass. There is a slightly quaint H.G. Wells 'Time Machine' quality to the mixture of Victorian and recent reproductive methods. As the viewer is drawn into the piece they realise the 'old photo' is actually moving, and that the sound of bleating sheep and wind rustling the leaves gives a sense of some wind or spirit of the past blowing into the present.

police building in the economically blitzed southeast London docks – and was a kind of non-government act of opportunistic regeneration. Hirst and his colleagues were graduates of Goldsmith's College art school which, under Conceptualists such as Michael Craig Martin, encouraged an enquiring and multimedia approach in its students. There weren't really artistic 'problems' anymore, as there had previously been when abstract artists and Conceptual artists saw their work in a quasi-scientific light. The equations were now highly relativised and open to many solutions. They came at the audience from a host of directions, like advertising but not quite. The severe deconstruction of capitalist visual culture that Victor Burgin and others had conducted in the 1970s and early 1980s was turned into something at once far more complicit (many were collected by Charles Saatchi the advertiser) and yet, possibly, more subversive. The avant-garde's disappearance had paralleled the end of the revolution that it had been assumed by many would come, and young artists now occupied a strange dystopian but quite comfortable landscape with no maps to get them home. 'Home', dysfunctional or otherwise, along with a colour supplement of other themes, thus became one of the images which returned to art after a long post-Victorian absence. The YBAs have come along like PRBs, this time on ecstasy and cocaine.

Much British art over the last decade has had a curiously Victorian quality – the subject matter of sex, love and family or other relationships, a slightly sentimental concern with poverty or exclusion, a nervy promiscuity with past styles in art, a highly developed awareness of a mass audience, a nose for finding shocking or taboo subject matter, a rapid Pre-Raphaelite-type move from outsider to insider status. This analogy can go only so far, however. The awareness of the history of modernist art from Marcel Duchamp to Jasper Johns, of the Situationist tradition of gesture and of recent philosophical and cultural theory from Michel Foucault to Jean Baudrillard, the sense of the almost psychotically expanded sphere of communications in a global context, the use of every possible medium, sometimes in conjunction, the number of highly successful women artists, the deadpan, streetwise, alternative comedy attitudes – all these, inevitably, make the 'scene' very much of its time.

The number of artists at work in Britain now, their exploded realm of media and messages and London's status as a, perhaps the, world centre of contemporary art makes it impossible to survey the scene. Let's end, as we began, by looking at one work by an artist – one who works in that most privately herbaceous and sometimes sinister of British studios, the garden shed.

245 **Mona Hatoum**
born 1952
**Incommunicado**
1993
Metal cot and wire
126.4 x 57.5 x 93.5

Mona Hatoum was born in Beirut and this has some significance, as her work is highly serious and has none of the Bash Street Kid post-punk irony of many of her native British near-contemporaries.

Her work, employing all available media, is about a range of questions, from the body and its meanings seen through endoscopy, to political torture represented in minimal household forms. Her work also

examines victimhood in its deepest sense, here using the child's cot to create a disturbed sense of imprisonment and ignored or intended pain. The origins of Rousseau's concept of civilising oppression

are the main theme of this ultimately political work with its metal bars and sharp, taut wires.

246 **Cornelia Parker**
born 1956
**Cold Dark Matter:**
**An Exploded View**
1991
Mixed media
400 x 500 x 500

Everyone can have a piece of the Berlin Wall as a souvenir now. What was once a huge physical structure and the very embodiment of political and cultural divide is now fragments and a fading memory. This is the witty, surreal world Cornelia Parker inhabits and encourages, in its dissipating weirdness, by exhibiting the cigar stub Churchill dropped when he heard the Germans were suing for peace; displaying Alexander Cozens-like 'blot' drawings made from the ferric oxide taken from pornographic video tapes; or making earplugs from the dust in the Whispering Gallery of St Paul's Cathedral and calling them *The Negative of Whispers*. Her imagination is much taken by familiar, often microscopic and overlooked aspects of British life, which she seeks to transform by a sort of imaginative alchemy.

Sometimes the experiments are violent. *Cold Dark Matter: An Exploded View* of 1991 (no.246) was made by filling a garden shed with various objects, including a copy of Marcel Proust's *A la Recherche du Temps Perdu*, as if it were a time capsule for posterity's enjoyment, and then blowing it up in a field with the help of the British Army School of Ammunition. By upbringing a farm girl from the North, in contrast to Sarah Lucas's cockney gamin for instance, she then painstakingly suspended the pieces from a ceiling around a single domestic light bulb. The effect is of a Postmodern

magic lantern show in which time seems to be frozen. Parker has written: 'Life, death and resurrection – we're all experiencing the limbo between life and death. My work is trying to map that in-between space between known and unknown, the constant hovering between two states.' This isn't iconoclasm – or is it? There is no anger or desire to destroy another's visual world as Prynne and Dowsing had felt in the seventeenth century, and yet the piece hinges on the sublime creativity of destruction. The unearthly, almost picturesque, beauty of blackened bits of an old euphonium, a baby carriage, gumboot and splinters of charred wood is possible only through the artist's delicate arrangement of the debris and the setting of the installation.

As at Eton Chapel or in the Tate Britain restaurant, the mysteries of time and place become part of the work's presence and agitation of the individual and collective unconscious, as the artist was only too well aware speaking in an interview in 1996: 'What I love about it is that it is getting older. In a hundred years' time it will be a 105-years' old explosion. The idea that the Tate wants to preserve it … curators have talked to me about conservation, about whether or not it's got woodworm … it's great if it's got wood-worm, because I love the idea that an explosion might have woodworm.' There speaks a true grandchild of the Blitz …

---

247 **Sam Taylor-Wood**
born 1967
**Soliloquy II**
1998
Photograph on paper
165.4 x 248.5 and 32.5 x 248.5

Sam Taylor-Wood uses photography and video to investigate a number of themes, including personal relationships in contemporary society. Her work draws on the history of art, referring here to

Henry Wallis's Chatterton of 1856 (no.124). Her figure, however, seems to be asleep rather than dead. Below we see a 'predella' (a small sequence of images below an altarpiece), with images from the man's

dreams. They are created with a special camera to achieve a 360-degree view, in this case of the Arab Hall at Frederic, Lord Leighton's House in Kensington. Digital technology introduces elements of the main image into

the subsidiary ones. Who, or what, is fashioning the self?

# Chronology
## 1900–2001

**1900**
Sigmund Freud *Interpretation of Dreams* published

**1901**
Accession of Edward VII.
UK population 41.4 million
(USA 75.9 million)

**1903**
National Art Collections Fund founded to prevent works of art leaving Britain.
Wright brothers make first aeroplane flight

**1905**
Les Fauves (Paris) and Die Brücke (Dresden) painters groups founded

**1907**
Origins of Cubism in Paris

**1909**
F.T. Marinetti publishes Futurist Manifesto in Paris

**1910**
Accession of George V.
First *Post-Impressionist Exhibition*, London.
Contemporary Art Society founded to purchase modern works for the nation

**1911**
National Insurance Act.
Der Blaue Reiter group of expressionist and abstract painters, Munich founded

**1912**
*Second Post-Impressionist Exhibition*, London.
*Futurist Exhibition*, London

**1913**
Omega Workshops and Rebel Art Centre, London founded

**1914–18**
*Blast No.1* published

**1914**
First World War

**1916**
Dada movement, Zurich founded

**1917**
Russian Revolution

**1919**
Treaty of Versailles.
Bauhaus, Weimar modernist art, architecture and design school founded

**1922**
BBC founded.
T.S. Eliot *The Waste Land* and James Joyce *Ulysses* published.
Mussolini comes to power in Italy

**1924**
André Breton *Manifesto of Surrealism* published in Paris

**1926**
General Strike in Britain.
Council for Preservation of Rural England founded.
Fritz Lang *Metropolis* film

**1927**
Virginia Woolf *To the Lighthouse* published

**1929**
World Financial Crash.
Museum of Modern Art, New York founded.

**1930**
Wyndham Lewis *Apes of God* published

**1933**
Hitler comes to power in Germany.
Unit One group founded.
Artists' International Association founded.
Herbert Read *Art Now* published.
British Film Institute founded

**1935**
Sidney and Beatrice Webb *Soviet Communism: A New Civilisation* published

**1936**
Accession and abdication of Edward VIII.
Accession of George VI.
A.J. Ayer *Language, Truth and Logic* published.
*International Surrealist Exhibition*, London

**1937**
Euston Road group founded.
Mass Observation group founded.
*Degenerate Art* exhibition, Munich.
*Circle* published to promote international modernism

**1938**
Munich Crisis

**1939–45**
Second World War

**1940**
Walt Disney *Fantasia* film.
Beginning of Blitz (–1941).
Council for Encouragement of Music and Arts founded, becomes Arts Council at end of war

**1944**
Butler's Education Act.
T.S. Eliot *Four Quartets* published

**1945**
Dropping of first atom bomb on Hiroshima.
Karl Popper *The Open Society and its Enemies* published.
Evelyn Waugh *Brideshead Revisited* published.
Labour landslide victory at General Election

**1946**
Institute of Contemporary Arts (ICA), London founded

**1947**
Le Corbusier builds 'Unité d'habitation', Marseilles.
Nationalisation of coal and other industries in Britain

**1948**
West Indian immigrants begin to arrive in Britain

**1950**
Papal decree against existentialist philosophy.
Jean Cocteau *Orphée* film.
Outbreak of Korean War

**1951**
UK population 50 million
(USA 153 million).
Festival of Britain on South Bank, London.
Introduction of 'X' certificate for films for over-16s only

**1952**
Accession of Elizabeth II.
First hydrogen bomb exploded.
Independent Group at ICA founded.
First American abstract expressionist paintings exhibited in London

**1954**
Dylan Thomas *Under Milk Wood* broadcast.
Federico Fellini *La Strada* film.
Bill Haley and the Comets *Rock Around the Clock* single

**1955**
'Flying saucers' first attract wide attention.
Samuel Beckett *Waiting for Godot* first performed

**1956**
Suez Crisis.
*This is Tomorrow* exhibition.
Nikolaus Pevsner *The Englishness of English Art* published.
John Osborne *Look Back in Anger* first performed

**1957**
USSR launches 'Sputnik I'

**1959**
C.P. Snow *The Two Cultures* published

**1960**
Alfred Hitchcock *Psycho* film.
First *Situation* exhibition of abstract art, London

**1961**
*Private Eye* satirical magazine first published

**1962**
Anthony Sampson *The Anatomy of Britain* revealing the 'establishment' published.
Cuban Missile Crisis and serious international tension and fear of nuclear war.
Commonwealth Immigrants Act limits immigration to Britain

**1963**
Profumo Affair contributes to downfall of Conservative government

**1964**
Harold Wilson Prime Minister of new Labour government.
Concern about 'brain drain' of scientists and academics to USA

**1965**
Eric Bedford's Post Office Tower built

**1966**
Cultural Revolution in China.
Arte Povera in Italy.
Michelangelo Antonioni *Blow Up* film

**1967**
Beatles *Sergeant Pepper* album

**1968**
Student riots in Paris.
Lindsay Anderson *If ...* film

**1969**
First moon landing.
Kenneth Clark *Civilisation* and first *Monty Python* series on TV.
*When Attitudes Become Form* exhibition, ICA, London.
Student protests at universities and art schools in Britain.
Ulster Troubles begin

**1970**
Nicholas Roeg *Performance* film

**1971**
Decimal currency introduced in Britain.
Stanley Kubrick *A Clockwork Orange* film

**1973**
UK enters European Community.
USA withdraws from Vietnam.
Death of Pablo Picasso

**1975**
Stephen Spielberg *Jaws* film

**1976**
R.B. Kitaj *The Human Clay* exhibition, Hayward Gallery, London

**1977**
First mass-produced Apple computers for sale.
Sex Pistols *Never Mind the Bollocks* album

**1979**
Margaret Thatcher Prime Minister of new Conservative government.
Terry Jones *Monty Python's Life of Brian* film offends churches

**1980**
Church of England publishes Alternative Service Book

**1981**
Riots in Toxteth, Liverpool lead to plans for urban regeneration.
*A New Spirit in Painting* exhibition, Royal Academy, London.
*Brideshead Revisited* BBC TV series

**1982**
Falklands War

**1984**
Miners' strike in Britain.
Turner Prize established.
Prince of Wales attacks modern architecture

**1985**
Saatchi Collection opens in London.
Richard Rogers builds Lloyd's Building, London

**1986**
Derek Jarman *Caravaggio* film

**1987**
Christie's sells Van Gogh's *Sunflowers* for £30 million, a world record

**1988**
Sotheby's sells Jasper Johns *False Start* for $17 million, a world record for a contemporary artist.
*Freeze* exhibition of Goldsmith Art College students' work

**1989**
Collapse of communism in Eastern Europe.
'Fatwah' announced by Iran against Salman Rushdie

**1990**
Gulf War

**1992**
Francis Fukuyama *The End of History and the Last Man* published, announces end of 'grand narratives' and global victory of free-market liberalism

**1994**
Church of England ordains first women priests

**1997**
Labour Government elected.
English scientists clone a sheep

**2001**
UK population 59.6 million
(USA 275 million).
Terrorist suicide attacks on New York and Washington

# Tate Britain Chronology

**1819**
Henry Tate born

**1835**
The Select Committee of the House of Commons on the Fine Arts raises the question of 'the best means of extending a knowledge of the Arts', and recommends part of the recently founded National Gallery should be devoted to the 'British School of Art'

**1840**
Sir Francis Chantrey leaves his bequest to promote British art through the purchase of works from the Royal Academy annual exhibition

**1859**
The Vernon Collection and works from the Turner Bequest displayed at South Kensington

**1862**
Henry Tate begins refining sugar in Liverpool and later London.
In the 1870s and 1880s Tate uses his enormous wealth for philanthropic purposes such as libraries, hospitals and education institutions and also to purchase contemporary British art. His picture gallery at his home in Streatham, south London is designed by Sidney R.J. Smith

**1867**
John Ruskin suggests site of the Millbank Prison (built in 1812) be used to build a Gallery of British Art

**1889**
Tate offers his collection of British art to the National Gallery. Offer rejected due to 'lack of space'

**1890**
*Times* article states 'the time has come for the creation of a great British gallery'.
Various sites including South Kensington considered for Tate collection

**1892**
New Liberal government proposes Millbank Prison site for a new building which Tate has offered to fund. In spite of the run-down surroundings and poor transport it is recommended for its 'air, light and space'. Early example of culture used for 'urban regeneration'

**1893**
Foundations excavated

**1894**
Sidney R.J. Smith selected as architect for new gallery

**1897**
Prince of Wales opens new 'National Gallery of British Art' on 21 July, displaying 245 works, of which 65 are from Tate's collection. New gallery is 'annexe' of National Gallery.
First Keeper is Charles Holroyd, an artist and pupil of Alphonse Legros at the Slade School of Art. Entrance is free except on 'Student Days' on Tuesdays and Thursdays and first visitors are mostly local and poor

**1898**
Sir Henry Tate dies

**1899**
Nine new rooms open including sculpture gallery with palm trees

**1903**
D.S. MacColl, artist and critic, attacks Tate for having no works by Whistler in the collection. (A Whistler is subsequently purchased in 1905.)
Gallery frequently closed on foggy days in winter due to lack of artificial lighting until 1935

**1906**
D.S. MacColl becomes Keeper

**1910**
New Turner Wing opens to display works from the Bequest formerly held at National Gallery

**1911**
Charles Aitken, former Director of Whitechapel Art Gallery, becomes Keeper

**1914**
Suffragette attack on Velazquez painting at National Gallery leads to precautionary closure of Tate for long periods.
Outbreak of war leads to Gallery's closure.
First official lecturer appointed

**1917**
Some works removed to Aldwych underground station for safety following Zeppelin raids.
Tate acquires own board of Trustees. Tate takes on role as national collection of 'modern foreign' art.
Tate Gallery is used by Ministry of Pensions

**1920**
Tate official name is 'National Gallery, Millbank'.

**1921**
Gallery re-opens with new look, including display of Impressionist paintings on 'modern' pale-coloured walls

**1923**
Boris Anrep's mosaic based on Blake's *Proverbs of Hell* is installed.

**1926**
Four new galleries open to north of site

**1927**
Rex Whistler murals in 'Refreshment Room' first open to view

**1928**
Thames flood causes serious damage to works in basement and deaths among local poulation

**1930**
J.B. Manson, painter, is new Director. He becomes notoriously inefficient, rude and drunken and pursues a conservative collecting policy

**1932**
Tate officially called 'The Tate Gallery'

**1933**
First lavatories installed

**1935**
Electric lighting installed after thirty eight years and allows Gallery to be open later

**1937**
Lord Duveen of Millbank's sculpture hall designed by John Russell Hope opens

**1938**
John Rothenstein, a museum professional and son of painter Sir William Rothenstein, appointed Director

**1939**
Gallery closes. Works of art are removed to various country houses

**1939–45**
Major acquisitions of contemporary British art as well as works by Blake and Pre-Raphaelites.
Tate gardens used as allotments

**1940–1**
Tate hit frequently during Blitz

**1946**
Gallery partially re-opens.
First purchase grant (£2000)

**1949**
Gallery officially re-opened after repairs are completed

**1955**
Act of Parliament makes Tate independent from National Gallery

**1956**
Irish nationalist steals a painting by Berthe Morisot, which is returned

**1958**
John Rothenstein *History of the Tate Gallery* published

**1964**
Norman Reid appointed Director. *Decade 54–64* exhibition, designed by Alison and Peter Smithson, inaugurates a policy of modernising collection and display.
Stone walls covered with white cladding, partitions divide rooms and high ceilings are disguised. Creation of 'British' and 'Modern Foreign' curatorial departments

**1974**
Admission charges introduced for three months

**1975–6**
Visitor figures top 1 million

**1979**
A new extension, designed by Llewelyn-Davies, Weeks, Forestier-Walker partnership, provides a large increase in display space

**1984**
First Turner Prize is won by Malcolm Morley

**1987**
Clore Gallery opens to display works by Turner

**1988**
Tate Gallery Liverpool opens.
Nicholas Serota, former Director of Whitechapel Art Gallery, becomes Director.
New policy of rotating the collection is introduced and the 1960s refurbishments are removed

**1992**
Trustees of the Tate Gallery announce intention to build a new gallery of modern art and therefore to return the Millbank building to its original role as a gallery of British art

**1993**
Tate Gallery St Ives opens

**1996**
Tate acquires Oppé drawings collection of 3000 works

**1998**
Stephen Deuchar appointed first Director of 'Tate Britain', as the new gallery is named in a corporate make-over

**2000**
Tate Britain launched in March followed by the opening of Tate Modern in May

**2001**
Centenary Development opens

# Select Bibliography

The following is a list of books which may be useful in pursuing in more detail some of the areas discussed in this book, including works of general and cultural history.

It is largely devoted to books that pursue a theme rather than to the many excellent monographs available on individual artists. These are probably best unearthed by the simple alphabetical expedient of looking in library or bookshop catalogues. Tate's expanding British Artists series may be particularly useful. The Tate Britain bookshops will be happy to help you with enquiries.

For individual works of art refer to the rapidly expanding and informative Tate website on 'www.tate.org.uk'. Screens can be found in the Gallery.

### General History
There are a number of multi-volume histories of Britain. Here are two that are readily available:

David Cannadine (ed.) *The Penguin History of Britain*, 9 vols., London 1996–

Kenneth O. Morgan (ed.) *The Oxford Popular History of Britain*, Oxford 1998 (this is a single volume based on the 10 volumes of *The Oxford History of Britain*, Oxford 1984)

Also very useful for cultural history dealing with all the arts is:

Boris Ford (ed.) *The Cambridge Cultural History of Britain*, Cambridge (Folio Society edition 1995)

Given the importance of the land and nature in British art and culture the following is a very helpful book:

Keith Thomas, *Man and the Natural World: Changing Attitudes in England 1500–1800*, London 1983

### General Art History
The ultimate reference work is *The Dictionary of Art* (ed. Jane Turner) published by Grove/Macmillan, 1996– in 34 volumes.

For a general background to World and European art the recent *Oxford History of Art* series is recommended. For the history of British art the standard, but now very old, work is the *Oxford History of British Art* series.

On British Art in particular the following single volumes are recommended:

Andrew Graham-Dixon, *A History of British Art*, London 1996

David Piper, *The English Face*, ed. Malcolm Rogers, London 1992

Simon Wilson, *British Art from Holbein to Hockney*, London 1979

Ellis Waterhouse, *Painting in Britain 1530–1790*, London 1978

The 'classic statement' on English art is:

Nikolaus Pevsner, *The Englishness of English Art*, London 1956

For a detailed look at the different artists' areas in the city which dominates this book, London:

Kit Wedd with Lucy Peltz and Cathy Ross, *Creative Quarters: The Art World in London 1700–2000*, Museum of London, exh. cat. 2001

A fascinating insight into popular visual culture in Britain can be gained from:

Sheila O'Connell, *The Popular Print in Britain 1550–1850*, London 1999

### 1477–1545
For a background to the period of particular interest are:

Hans Belting, *Likeness and Presence: A History of the Image before the Era of Art*, Chicago 1994

Eamon Duffy, *The Stripping of the Altars: Traditional Religion in England 1400–1580*, Yale and London 1992

Richard Deacon and Phillip Lindley, *Image and Idol: Medieval Sculpture*, exh. cat., Tate Britain, London 2001

Martin Warnke (trans. David McLintock), *The Court Artist: On the Ancestry of the Modern Artist*, Cambridge 1993

On the Eton College Chapel paintings:

Andrew Martindale 'The Wall Paintings in the Chapel of Eton College' in Caroline Barron and Nigel Saul (eds.), *England and the Low Countries in the Late Middle Ages*, London 1995

On Holbein's image of the More family:

Peter Ackroyd, *The Life of Thomas More*, London 1998

### 1545–1660
For an excellent survey of the art of Britain during the period 1530–1630:

Karen Hearn (ed.), *Dynasties: Painting in Tudor and Jacobean England 1530–1630*, exh. cat., Tate Gallery, London 1995

FURTHER READING:

Margaret Aston, *The King's Bedpost: Reformation and Iconography in a Tudor Group Portrait*, Cambridge 1993

Jim Bennett and Scott Mandelbrote, *The Garden, the Ark, the Tower, the Temple: Biblical Metaphors of Knowledge in Early Modern Europe*, Oxford 1998

Lucy Gent, *Picture and Poetry: Relations between Literature and the Visual Arts in the English Renaissance*, Leamington Spa 1981

Lucy Gent and Nigel Llewellyn (eds.), *Renaissance Bodies: The Human Figure in English Culture c.1540–1660*, London 1990

Ernest B. Gilman, *Iconoclasm and Poetry in the English Reformation*, Chicago and London 1986

Stephen Greenblatt, *Renaissance Self-Fashioning from More to Shakespeare*, Chicago and London 1980

Richard Helgerson, *Forms of Nationhood: The Elizabethan Writing of England*, Chicago and London 1992

Maurice Howard, *The Tudor Image*, exh. cat., Tate Gallery, London 1995

David Howarth, *Images of Rule: Art and Politics in the English Renaissance, 1485–1649*, London 1997

Roy Porter (ed.), *Rewriting the Self: Histories from the Renaissance to the Present*, London 1997

Kevin Sharpe and Peter Lake (eds.), *Culture and Politics in Early Stuart England*, London 1994

David Underdown, *Revel, Riot and Rebellion: Popular Politics and Culture in England 1603–1660*, Oxford 1985

Tessa Watt, *Cheap Print and Popular Piety 1550–1640*, Cambridge 1991

Frances A. Yates, *Astraea: The Imperial Theme in the Sixteenth Century*, London 1975

### 1660–1720
A useful introduction to all the arts is:

Mary Ede, *Arts and Society in England Under William and Mary*, London 1979

FURTHER READING:

Daniel Defoe, *A Tour Through the Whole Island of Great Britain*, London 1724–6: illustrated edition edited by P.N. Burbank, W.R. Owens and A.J. Coulson, Yale and London 1991

Lisa Jardine, *Ingenious Pursuits: Building the Scientific Revolution*, London 1999

Arthur MacGregor, *Tradescant's Rarities: Essays on the Foundation of the Ashmolean Museum, 1683. With a Catalogue of the Surviving Early Collections*, Oxford 1983

Elizabeth McKellar, *The Birth of Modern London: The Development and Design of the Modern City*, Manchester 1999

Iain Pears, *The Discovery of Painting: The Growth of Interest in the Arts in England 1680–1768*, Yale and London 1988

Stuart Piggott, *Ancient Britons and the Antiquarian Imagination: Ideas from the Renaissance to the Regency*, London 1989

John Redwood, *Reason, Ridicule and Religion: The Age of Enlightenment in England 1660–1750*, London 1996

### 1720–1760 and 1760–1800
Background books of particular importance are:

John Brewer, *The Pleasures of the Imagination: English Culture in the Eighteenth Century*, London 1997

Marilyn Butler, *Romantics, Rebels, and Reactionaries: English Literature and its Background 1760–1830*, Oxford 1981

Timothy Clayton, *The English Print 1688–1802*, Yale and London 1997

Linda Colley, *Britons: Forging the Nation*, Yale and London 1992

Elizabeth Einberg (ed.), *Manners and Morals: Hogarth and British Painting 1700–1760*, exh. cat., Tate Gallery, London 1987

Paul Langford, *A Polite and Commercial People: England 1727–1783*, Oxford 1992

FURTHER READING:

John Barrell, *The Political Theory of Painting from Reynolds to Hazlitt: 'The Body of the Public'*, Yale and London 1986

Ann Bermingham, *Learning to Draw: Studies in the Cultural History of a Polite and Useful Art*, Yale and London 2000

Ilaria Bignamini and Martin Postle, *The Artist's Model: Its role in British Art from Lely to Etty*, exh. cat., University of Nottingham and English Heritage 1991

Stephn Daniels, *Fields of Vision: Landscape Imagery and National Identity in England and the United States*, Princeton 1993

Mark Hallett, *The Spectacle of Difference: Graphic Satire in the Age of Hogarth*, Yale and London 1999

Robert W. Jones, *Gender and the Formation of Taste in Eighteenth-Century Britain: The Analysis of Beauty*, Cambridge 1998

Francis D. Klingender, *Art and the Industrial Revolution*, edited and revised by Arthur Elton, London 1975

Miles Ogborn, *Spaces of Modernity: London's Geographies 1680–1780*, New York and London 1998

David Solkin, *Painting for Money: The Visual Arts and the Public Sphere in Eighteenth Century England*, Yale and London 1993

David Solkin (ed.), *Art on the Line: The Royal Academy Exhibitions at Somerset House 1780–1836*, Yale 2001

Beth Fowkes Tobin, *Picturing Imperial Power: Colonial Subjects in Eighteenth-Century British Painting*, Duke University and London 1999

Andrew Wilton and Ilaria Bignamini (eds.), *Grand Tour: The Lure of Italy in the Eighteenth Century*, exh. cat., Tate Gallery, London 1996

Martha Woodmansee, *The Author, Art and the Market: Rereading the History of Aesthetics*, Columbia 1994

### 1800–1850 and 1850–1900
Romanticism strides two centuries and is arguably still with us, whatever 'modernists' may say! A useful background book for the late eighteenth century and early nineteenth century is:

Stuart Curran (ed.), *The Cambridge Companion to British Romanticism*, Cambridge 1993

FURTHER READING:

Anne Bermingham, *Landscape and Ideology: The English Rustic Tradition 1740–1860*, London 1987

David Blayney Brown, Andrew Hemingway and Anne Lyles, *Romantic Landscape: The Norwich School of Painters*, exh. cat., Tate Britain 2000

Mary Cowling, *The Artist as Anthropologist: The Representation of Type and Character in Victorian Art*, Cambridge 1989

Jonathan Crary, *Techniques of the Observer: On Vision and Modernity in the Nineteenth Century*, Massachusetts 1990

Andrew Cunningham and Nicholas Jardine, *Romanticism and the Sciences*, Cambridge 1990

Paul Greenhalgh, *Ephemeral Vistas: The Expositions Universelles, Great Exhibitions and World's Fairs, 1851–1939*, Manchester 1988

Robin Hamlyn, *Robert Vernon's Gift*, exh. cat., Tate Gallery, London 1993

Andrew Hemingway, *Landscape Imagery and Urban Culture in Early Nineteenth Century Britain*, Cambridge 1992

Luke Hermann, *Nineteenth Century British Painting*, London 2000

Robert Hewison, Ian Warrell and Stephen Wildman, *Ruskin, Turner and the Pre-Raphaelites*, exh. cat., Tate Britain 2000

Ralph Hyde, *Panoramania! The Art and Entertainment of the 'All-Embracing' View*, exh. cat., Barbican Art Gallery, London 1988

Richard Jenkyns, *The Victorians and Ancient Greece*, London 1980

Kay Dian Kriz, *The Idea of the English Landscape Painter: Genius as Alibi in the Early Nineteenth Century*, Yale and London 1997

Saree Makdisi, *Romantic Imperialism: Universal Empire and the Culture of Modernity*, Cambridge 1998

Lynda Nead, *Victorian Babylon*, Yale 2000

Martin Postle and William Vaughan, *The Artist's Model: From Etty to Spencer*, London 1999

Elizabeth Prettejohn, *Rossetti and his Circle*, Tate Gallery, London 1997

Elizabeth Prettejohn, *The Art of the Pre-Raphaelites*, London 2000

Thomas Richards, *The Imperial Archive: Knowledge and the Fantasy of Empire*, London 1993

David Robertson, *Sir Charles Eastlake and the Victorian Art World*, Yale and London 1978

Sam Smiles, *The Image of Antiquity: Ancient Britain and the Romantic Imagination*, Yale and London 1994

Alison Smith, *The Victorian Nude*, Manchester 1996

Lindsay Smith, *Victorian Photography, Painting and Poetry: The Enigma of Visibility in Ruskin, Morris and the Pre-Raphaelites*, Cambridge 1992

Julian Treuherz, *Hard Times: Social Realism in Victorian Art*, exh. cat., Manchester City Art Galleries 1988

Martin Weiner, *English Culture and the Decline of the Industrial Spirit 1850–1980*, Cambridge 1981

Michael Wheeler, *Heaven, Hell and the Victorians*, Cambridge 1994

Muriel Whitaker, *The Legends of King Arthur in Art*, London 1990

Andrew Wilton and Robert Upstone (eds.), *The Age of Rossetti, Burne-Jones and Watts: Symbolism in Britain 1860–1910*, exh. cat., Tate Gallery, London 1997

---

**1900–1940**
A useful survey for the whole of the twentieth century is:

Susan Compton (ed.), *British Art in the Twentieth Century: The Modern Movement*, exh. cat., Royal Academy, London 1987

FURTHER READING:
Arts Council of Great Britain, *Thirties: British Art and Design Before the War*, exh. cat., Hayward Gallery, London 1979

Jane Beckett and Deborah Cherry (eds.), *The Edwardian Era*, exh. cat., Barbican Art Gallery, London 1987

Frances Borzello, *Civilising Caliban: The Misuse of Art, 1875–1980*, London 1987

David Peters Corbett, *The Modernity of English Art 1914–30*, Manchester 1997

Richard Cork, *A Bitter Truth: Avant-Garde Art and the Great War*, Yale and London, exh. cat., Barbican Art Gallery, London 1994

Richard Cork, *Vorticism and Abstract Art in the First Machine Age*, 2 vols., London 1975–6

George Dangerfield, *The Strange Death of Liberal England*, London 1935 and 1970

Juliet Dusinberre, *Alice to the Lighthouse: Children's Books and Radical Experiments in Art*, London 1999

Anna Greutzner Robins, *Modern Art in Britain 1910–1914*, exh. cat., Barbican Art Gallery, London 1997

Meirion and Susie Harries, *The War Artists: British Official War Art of the Twentieth Century*, London 1983

Charles Harrison, *English Art and Modernism 1900–1939*, Yale and London 1994

Samuel Hynes, *A War Imagined: The First World War and English Culture*, London 1990

David Matless, *Landscape and Englishness*, London 1998

Lynda Morris and Robert Radford, *The Story of the AIA, Artist's International Association 1933–1953*, exh. cat., Museum of Modern Art, Oxford 1933

Michel Remy, *Surrealism in Britain*, London 1999

John Rothenstein, *Modern English Painters*, 3 vols., London 1952–6 and 1974

Richard Shone, *The Art of Bloomsbury: Roger Fry, Vanessa Bell and Duncan Grant*, exh. cat., Tate Gallery, London 1999

Lisa Tickner, *Modern Life and Modern Subjects: British Art in the Early Twentieth Century*, Yale and London 2000

Simon Watney, *English Post-Impressionism*, London 1980

---

**1940–2001**
Brian Appleyard, *The Pleasures of Peace: Art and Imagination in Post-War Britain*, London 1989

Martin Barker, *A Haunt of Fears: The Strange History of the British Horror Comics Campaign*, London 1984

Louisa Buck, *Moving Targets 2: A User's Guide to British Art Now*, London 2000

Virginia Button and Charles Esche, *Intelligence: New British Art 2000*, exh. cat., Tate Britain, London 2000

Matt Collings, *Blimey! From Bohemia to Britpop: The London Artworld from Francis Bacon to Damien Hirst*, London 1997

Thomas Crow, *The Rise of the Sixties: American and European Art in the Era of Dissent 1955–69*, London 1996

Simon Frith and Howard Horne, *Art into Pop*, London 1987

Graves Art Gallery, *The Forgotten Fifties*, exh. cat., Sheffield 1984

Robert Hewison, *Under Siege: Literary Life in London 1939–45*, London 1977

Robert Hewison, *In Anger: Culture in the Cold War 1945–60*, London 1981

Robert Hewison, *Too Much: Art and Society in the Sixties 1960–75*, London 1986

Robert Hewison, *Culture and Consensus: England, Art and Politics since 1940*, London 1995

David Mellor, *A Paradise Lost: The Neo-Romantic Imagination in Britain 1935–55*, exh. cat., Barbican Art Gallery, London 1987

David Mellor, *The Sixties Art Scene in London*, exh. cat., Barbican Art Gallery, London 1993

Jeffrey Richards, *Films and British National Identity: From Dickens to 'Dad's Army'*, Manchester 1997

David Robbins (ed.), *The Independent Group: Postwar Britain and the Aesthetics of Plenty*, exh. cat., ICA, Massachusetts and London 1990

Julian Stallabrass, *High Art Lite: British Art in the 1990s*, London 1999

David Sylvester, *Interviews with Francis Bacon*, London 1980

Patrick Wright, *On Living in an Old Country: The National Past in Contemporary Britain*, London 1985

---

**Materials, Methods and Conservation**
Tate's Conservation Department is at the cutting edge in the practice of and research into the conservation of artworks. Their most recent publication is full of extraordinary information about many British works of art:

Stephen Hackney, Rica Jones and Joyce Townsend, *Paint and Purpose: A Study of Technique in British Art*, London 1999

---

**Tate, Tate Gallery and Tate Britain**
We are extremely fortunate to have a recent history of the Tate Gallery:

Frances Spalding, *The Tate: A History*, London 1998

There is also:

Krzysztof Z. Cieszkowski, 'Millbank before the Tate', in *The Tate Gallery: Illustrated Biennial Report 1984–86*, London 1986

Robin Hamlyn (ed.), *The Clore Gallery: An Illustrated Account of the New Building for the Turner Collection*, London 1987

John Rothenstein, *A History of the Tate Gallery*, London 1958

John Rothenstein, *Brave Day, Hideous Night: Autobiography 1939–1965*, London 1966

Tate's biennial reports are a mine of information about the works in the collection and the growth of the museum. They are available in the bookshops.

---

**Museums**
People – well, some people – have become as interested in the architecture, displays and meanings of museums as in their contents. This is a fascinating area and a few books to look at include:

Pierre Bourdieu, *The Love of Art: European Art Museums and Their Public*, Cambridge 1991

Carol Duncan, *Civilizing Rituals: Inside Public Art Museums*, London 1995

Nelson Goodman, 'The End of the Museum', in *Mind and Other Matters*, Harvard 1984

Donald Horne, *The Great Museum: The Re-presentation of History*, London 1984

Kenneth Hudson, *Museums of Influence: The Pioneers of the Last Two Hundred Years*, New York 1987

Sharon Macdonald and Gordon Fyfe, *Theorizing Museums: Representing Identity and Diversity in a Changing World*, Oxford 1996

Brian O'Doherty, *Inside the White Cube: The Ideology of the Gallery Space*, Santa Monica 1986

Nicholas Serota, *Experience or Interpretation: The Dilemma of Museums of Modern Art*, London 1996 (pbk 2000)

Peter Vergo (ed.), *The New Museology*, London 1989

Giles Waterfield (ed.), *Palaces of Art: Art Galleries in Britain*, exh. cat., Dulwich Picture Gallery, London 1992

# Works illustrated

All works are from the Tate Collection unless specified otherwise.

fig.1 **Rex Whistler** 1905–1944
**'The Expedition in Pursuit of Rare Meats' mural in the Tate Britain Restaurant** 1926–7

fig.2 **Interior of Sir Henry Tate's house, Park Hill, Streatham, London** 1880s
Tate Archive

fig.3 **A. E. Emslie** 1848–1918
**A Cottage Interior** (detail) 1883
Victoria and Albert Museum

fig.4 **James Boswell** 1906–1971
**The Fall of London: Museum** 1933
Presented by Ruth Boswell, the artist's widow 2000
P11657

fig.5 Bomb damage caused in 1941 to the Atterbury Street side of Tate Britain

1 **Eton College Chapel North Wall** c.1477–87
Eton College, Windsor

2 **Hans Holbein** 1497/8–1543
**The More Household at Chelsea**
Kunstmuseum, Basel

3 **John Bettes** active 1531–1570
**A Man in a Black Cap** 1545
Purchased 1897
N01496

4 **Hans Eworth** active 1540–1573
**Portrait of an Unknown Lady** c.1565–8
Purchased with assistance from the Friends of the Tate Gallery 1984
T03896

5 **Crispin de Passe Senior**
**Elizabeth I** 1596
British Library, London

6 attributed to **Nicholas Hilliard** c.1547–1619
**Queen Elizabeth I** c.1575
Lent by the National Portrait Gallery, London 1965
L00128

7 **Marcus Gheeraerts II** 1561/2–1636
**Portrait of Captain Thomas Lee** 1594
Purchased with assistance from the Friends of the Tate Gallery, the National Art Collections Fund and the Pilgrim Trust 1980
T03028

8 **Artist Unknown**
**Edward VI and the Pope: An Allegory of the Reformation** c.1570
National Portrait Gallery, London

9 **Woodcut from 'The Actes and Monuments' by John Foxe** (London 1570), 11, p.1483
British Library, BL 4705 h 4

10 **British School** 16th century
**An Allegory of Man** c.1596
Presented by the Patrons of British Art 1990
T05729

11 **Nicholas Hilliard** c.1547–1619
**Young Man Clasping a Hand from a Cloud**, 1588
Victoria and Albert Museum

12 **British School** 17th century
**The Cholmondeley Ladies** c.1600–10
Presented anonymously 1955
T00069

13 **Artist Unknown**
**The Daunce and Song of Death** 1568–9, woodcut published by John Awdeley
British Library, London Huth.50.(41)

14 **Artist Unknown**
**The prodigal son story** (c.1600), Knightsland Farm, near South Mimms, Hertfordshire

15 **British School** 17th century
**Portrait of William Style of Langley** 1636
Purchased 1978
T02308

16 **Engraved frontispiece to 'Emblemes' by Francis Quarles** 1635
British Library, C.59.a.21

17 **British School** 17th century
**Portrait of a Lady, Called Elizabeth, Lady Tanfield** 1615
Purchased with assistance from the Friends of the Tate Gallery, the National Art Collections Fund and the Pilgrim Trust 1980
T03031

18 **Inigo Jones** 1573–1652
**Lady Masquer: A Transformed Statue**, 1613
Chatsworth Collection, Chatsworth

19 **Anthony Van Dyck** 1599–1641
**Charles I on Horseback**, c.1637
The National Gallery, London

20 **Peter Paul Rubens**
**Apotheosis of King James I**, c.1633–5, Ceiling of Banqueting House, Whitehall, London

21 **Anthony Van Dyck** 1599–1641
**?A Lady of the Spencer Family** c.1633–8
Purchased 1977
T02139

22 **David Des Granges** 1611/13–?1675
**The Saltonstall Family** c.1636–7
Purchased with assistance from the Friends of the Tate Gallery, the National Art Collections Fund and the Pilgrim Trust 1976
T02020

23 **Nathaniel Bacon** 1585–1627
**Cookmaid with Still Life of Vegetables and Fruit** c.1620–5
Purchased with assistance from the National Art Collections Fund 1995
T06995

24 Engraved frontispiece **'A Treatise of Fruit-Trees … Togeather With The Spirituall Use of an Orchard; or, Garden of Fruit-Trees'**, by Ralph Austen, Oxford, 1653, Bodleian Library, Antiq. E. e. 1653.1

25 **Francis Cleyn** c. 1582–1658
**Samuel's Reproach to Saul** c.1630–5
Purchased 1990
T05745

26 **William Dobson** 1611–1646
**Endymion Porter** c.1642–5
Purchased 1888
N01249

27 **Wenceslaus Hollar** 1607–1677
**William Prynne** c.1645–50
Ashmolean Museum, Oxford

28 **Henry Gibbs** 1631–1713
**Aeneas and his Family Fleeing Burning Troy** 1654
Purchased 1994
T06782

29 **Peter Lely** 1618–1680
**Two Ladies of the Lake Family** c.1660
Purchased with assistance from the National Art Collections Fund 1955
T00058

30 **Henry Anderton** c.1630–1665
**Mountain Landscape with Dancing Shepherd** c. 1650–60
Bequeathed by Hugh Paget 1983
T03543

31 **John Michael Wright** 1617–1694
**Portrait of Mrs Salesbury with her Grandchildren Edward and Elizabeth Bagot** 1675–6
Presented by the Patrons of British Art through the Tate Gallery Foundation 1993
T06750

32 **Godfrey Kneller** 1646–1723
**John Smith the Engraver** 1696
Presented by William Smith 1856
N00273

33 **Mary Beale** 1633–1699
**Portrait of a Young Girl** c.1681
Purchased 1992
T06612

34 **Francis Le Piper** ?1640–1695
**The Combat of Hudibras and Cerdon**
Purchased 1959
T00247

35 **Hubert François Gravelot** 1699–1773
**The Coffee-House** c.1735
Purchased as part of the Oppé Collection with assistance from the National Lottery through the Heritage Lottery Fund 1996
T08905

36 **Edward Collier** active 1662–1707
**Still Life with a Volume of Wither's 'Emblemes'** 1696
Purchased 1949
N05916

37 **Robert Hooke** 1635–1703
**Large fold-out engraving of a flea from 'Micrographia'**, London, 1665
British Library, London

38 **Francis Barlow** ?1626–1704
from Patrick Allan Fraser Album
**Hawks and Owls** mid-1650s
Purchased as part of the Oppé Collection with assistance from the National Lottery through the Heritage Lottery Fund 1996
T08084

39 **Henry Gyles** c. 1640–1709
**Stonehenge** c.1690
Purchased as part of the Oppé Collection with assistance from the National Lottery through the Heritage Lottery Fund 1996
T08901

40 **Francis Place** 1647–1728
**Dinsdale, Durham** c.1678
Purchased as part of the Oppé Collection with assistance from the National Lottery through the Heritage Lottery Fund 1996
T09140

41 **Jan Siberechts** 1627–c.1700
**View of a House and its Estate in Belsize, Middlesex** 1696
Purchased with assistance from the National Art Collections Fund and the Friends of the Tate Gallery 1995
T06996

42 **James Thornhill** 1675/6–1734
**Thetis Accepting the Shield of Achilles from Vulcan** c.1710
Purchased 1965
T00814

43 **James Thornhill** 1675/6–1734
**Ceiling of Painted Hall, The Old Royal Naval College, Greenwich** 1708–12

44 **Balthazar Nebot** active 1730–1765
**Covent Garden Market** 1737
Purchased 1895
N01453

45 **Joseph Van Aken** c. 1699–1749
**An English Family at Tea** c. 1720
Presented by Lionel A. Crichton through the National Art Collections Fund 1930
N04500

46 **William Hogarth** 1697–1764
**A Scene from 'The Beggar's
Opera', VI** 1731
Purchased 1909
N02437

47 **William Hogarth** 1697–1764
**O the Roast Beef of Old England
('The Gate of Calais')** 1748
Presented by the Duke
of Westminster 1895
N01464

48 **William Hogarth** 1697–1764
**A Rake's Progress (plate 7)** 1735
Transfered from the reference
collection 1973
T01793

49 **Chinese export porcelain punch
bowl, Canton, decorated with
Hogarth's 'The Gate of Calais',**
c.1750–55
Victoria and Albert Museum

50 **Louis Philippe Boitard**
fl.1733–1770
**The Imports of Great Britain
from France** 1757
British Museum BM 3653

51 **William Hogarth** 1697–1764
**'Analysis of Beauty' (plate I)**
London, 1753

52 **William Hogarth** 1697–1764
**The Painter and his Pug** 1745
Purchased 1824
N00112

53 **Francis Hayman** 1708–1776
**See-Saw** c. 1742
Presented by the Friends of
the Tate Gallery 1962
T00524

54 **Antonio Canaletto** 1697–1768
**Vauxhall Gardens; The Grand Walk**
c.1751
Private collection

55 **Louis François Roubiliac**
c.1705–1762
**George Frederick Handel** 1738
Victoria and Albert Museum

56 **The Governor's Room in the
Foundling Hospital, Thomas Coram
Foundation for Children, London**
1740s

57 **Joseph Highmore** 1692–1780
**The Good Samaritan** 1744
Presented by C.K. Adams 1955
T00076

58 **Arthur Devis** 1711–1787
**Breaking-Up Day at Dr Clayton's
School at Salford** c. 1738
Purchased 1980
T03103

59 **Joseph Highmore** 1692–1780
**From 'Four Scenes from Samuel
Richardson's "Pamela"'
I: Mr B. Finds Pamela Writing** 1743–4
Purchased 1921
N03573

60 **Allan Ramsay** 1713–1784
**Thomas, 2nd Baron Mansel of
Margam with his Blackwood Half-
Brothers and Sister** 1742
Purchased with assistance from the
National Heritage Memorial Fund,
the National Art Collections Fund
(Woodroffe Bequest), the Friends of
the Tate Gallery, the Mail on Sunday
through the Friends of Tate Gallery,
Arthur Young, Mrs Sue Hammerson
and others
T05494

61 **J. H. Ramberg** 1763–1840
**The Royal Academy Exhibition
at Somerset House** 1787
Engraving by Pietro Martini 1788
The Witt Library, Courtauld Institute
of Art

62 **Thomas Rowlandson** 1756–1827
**A Bench of Artists** 1776
Purchased as part of the Oppé
Collection with assistance from the
National Lottery through the Heritage
Lottery Fund 1996
T08142

63 **Joshua Reynolds** 1723–1792
**Three Ladies Adorning a Term
of Hymen** 1773
Bequeathed by the Earl
of Blessington 1837
N00079

64 **Nathaniel Hone** 1718–1784
**Sketch for 'The Conjuror'** 1775
Purchased 1967
T00938

65 **Thomas Gainsborough** 1727–1788
**Giovanna Baccelli** exh. 1782
Purchased 1975
T02000

66 **Thomas Patch** 1725–1782
**A Gathering of Dilettanti in
a Sculpture Hall** c.1760–61
Collection of the late Sir Brinsley Ford

67 **Matthew William Peters** 1742–1814
**Lydia** c. 1777
Purchased 1986
T04848

68 **James Barry** 1741–1806
**'The Thames, or the Triumph
of Navigation' from 'A Series of
Etchings by James Barry, Esq. from
his Original and Justly Celebrated
Paintings, in the Great Room of the
Society of Arts'** first published 1792
Purchased 1992
T06558

69 **James Barry** 1741–1806
**King Lear Weeping over the Dead
Body of Cordelia** 1786–8
Purchased 1962
T00556

70 **John Singleton Copley** 1738–1815
**The Death of Major Peirson,
6 January 1781** 1783
Purchased 1864
N00733

71 **Henry Fuseli** 1741–1825
**Titania and Bottom** c.1790
Presented by Miss Julia Carrick Moore
in accordance with the wishes of her
sister 1887
N01228

72 **James Gillray** 1757–1815
**'Titianus Redivivus: or The Seven-
Wise-Men consulting the new
Venetian Oracle', a scene in the
Academic Grove, No.1.'**
Published 2 November 1797
by H. Humphrey
British Museum

73 **Gavin Hamilton** 1723–1798
**Agrippina Landing at Brindisium with
the Ashes of Germanicus** 1765–72
Purchased 1982
T03365

74 **George Romney** 1734–1802
**John Howard Visiting a Lazaretto**
c. 1791–2
Purchased 1982
T03547

75 **William Blake** 1757–1827
**Elohim Creating Adam** 1795/c.1805
Presented by W. Graham
Robertson 1939
N05055

76 **Alexander Cozens** 1717–1786
**from Plates 1–16 ('blot' landscapes)
for 'A New Method of Assisting
the Invention in Drawing Original
Compositions of Landscape'
(Plate 11)** c.1785
Purchased 1980
T03179

77 **William Blake** 1757–1827
**Newton** 1795/c.1805
Presented by W. Graham
Robertson 1939
N05058

78 **William Blake** 1757–1827
**'The Simoniac Pope', from 'Dante's
Divine Comedy'** 1824–7
Purchased with the assistance of a
special grant from the National Gallery
and donations from the National Art
Collections Fund, Lord Duveen and
others, and presented through the
National Art Collections Fund 1919
N03357

79 **William Blake** 1757–1827
**Jerusalem (plate 70)** 1804/c.1820
Yale Center for British Art,
Paul Mellon Collection

80 **Joseph Wright of Derby** 1734–1797
**An Experiment on a Bird in the Air
Pump** 1768
The National Gallery, London

81 **Joseph Wright of Derby** 1734–1797
**An Iron Forge** 1772
Purchased with assistance from the
National Heritage Memorial Fund,
the National Art Collections Fund and
the Friends of the Tate Gallery 1992
T06670

82 **George Stubbs** 1724–1806
**The Anatomy of the Horse**
1766
Tate Archive, TAB.1x

83 **George Stubbs** 1724–1806
**Horse Devoured by a Lion** ?exh. 1763
Purchased 1976
T02058

84 **George Stubbs** 1724–1806
**Otho, with John Larkin up** 1768
Presented by Paul Mellon through
the British Sporting Art Trust 1979
T02375

85 **Joseph Wright of Derby** 1734–1797
**Vesuvius in Eruption, with a View over
the Islands in the Bay of Naples**
c.1776–80
Purchased with assistance from the
National Heritage Memorial Fund,
National Art Collections Fund, Friends
of the Tate Gallery, and Mr John
Ritblat 1990
T05846

86 **Joseph Wright of Derby** 1734–1797
**Sir Brooke Boothby** 1781
Bequeathed by Miss Agnes
Ann Best 1925
N04132

87 **Richard Wilson** 1713–1782
**Rome: St Peter's and the Vatican
from the Janiculum** c. 1753
Purchased with assistance from the
National Art Collections Fund and
an anonymous donor 1974
T01873

88 **William Hodges** 1744–1797
**Tomb and Distant View of Rajmahal
Hills** 1782
Presented by the Friends of the Tate
Gallery 1964
T00690

89 **Aerial view of Stourhead, Wiltshire**
c.1730–90

90 **Johann Zoffany** 1733–1810
**Colonel Mordaunt's Cock Match**
c.1784–6
Purchased with assistance from the
National Heritage Memorial Fund,
the National Art Collections Fund, the
Friends of the Tate Gallery and a group
of donors 1994
T06856

91 **Richard Wilson** 1713–1782
**Llyn-y-Cau, Cader Idris** ?exh. 1774
Presented by Sir Edward Marsh 1945
N05596

92 **Benjamin West** 1738–1820
**The Bard** 1778
Purchased 1974
T01900

93 **Thomas Rowlandson** 1756–1827
**Plate 18 of 'Doctor Syntax's Tour
in Search of the Picturesque.
A Poem'** 1812

94 **George Morland** 1763–1804
**Outside the Ale-House Door** 1792
Bequeathed by George Salting 1910
N02639

95 **Thomas Gainsborough** 1727–1788
**Gypsy Encampment, Sunset** c.1778–80
Presented by Frederick John
Nettlefold 1947
N05803

96 **Robert Ker Porter** 1777–1842
**An Ancient Castle** c.1799–1800
Purchased as part of the Oppé
Collection, with assistance from
the National Lottery through the
Heritage Lottery Fund 1996
T08532

97 **Thomas Girtin** 1775–1802
**The White House at Chelsea** 1800
Bequeathed by Mrs Ada
Montefiore 1933
N04728

98 **Robert Mitchell** fl.1782–1810
**Section of the Rotunda, Leicester
Square, in which is exhibited the
'Panorama'** 1801
The National Film Archive, London

99 **Philip James De Loutherbourg**
1740–1812
**The Battle of the Nile** 1800
Purchased with assistance from
the Friends of the Tate Gallery 1971
T01452

100 **after Joseph Mallord William
Turner** 1775–1851
**Birmingham**
Engraved by James Storer 1771–1895
Transferred from the British
Museum 1988
T05890

101 **Joseph Mallord William Turner**
1775–1851
**Snow Storm: Hannibal and his Army
Crossing the Alps** exh. 1812
Bequeathed by the artist 1856
N00490

102 **John Constable** 1776–1837
**Flatford Mill ('Scene on a Navigable
River')** 1816–17
Bequeathed by Miss Isabel Constable
as the gift of Maria Louisa, Isabel and
Lionel Bicknell Constable 1888
N01273

103 **Joseph Mallord William Turner**
1775–1851
**The Shipwreck** exh. 1805
Bequeathed by the artist 1856
N00476

104 **James Catnach** 1792–1841
**Dreadful Shipwreck of the
Francis Mary** 1826
St Bride's Printing Library, London

105 **John Constable** 1776–1837
**Chain Pier, Brighton** 1826–7
Purchased 1950
N05957

106 **Joseph Mallord William Turner**
1775–1851
**Snow Storm – Steam-Boat off a
Harbour's Mouth Making Signals
in Shallow Water, and Going by
the Land** exh. 1842
Bequeathed by the artist 1856
N00530

107 **John Constable** 1776–1837
**Cloud Study** 1822
Presented anonymously 1952
N06065

108 **John Constable** 1776–1837
**Sketch for 'Hadleigh Castle'** c.1828–9
Purchased 1935
N04810

109 **Joseph Mallord William Turner**
1775–1851
**Norham Castle, Sunrise** c. 1845
Bequeathed by the artist 1856
N01981

110 **George Robert Lewis** 1782–1871
**Clearing a Site in Paddington for
Development** ?c.1815–23
Purchased 1975
T02009

111 **Edwin Henry Landseer** 1803–1873
**A Scene at Abbotsford** exh. 1827
Presented by Sir Henry Tate 1894
N01532

112 **George Cruikshank** 1792–1878
**The Worship of Bacchus** 1860–2
Presented by R.E. Lofft and
friends 1869
N00795

113 **John Crome** 1768–1821
**The Poringland Oak** c.1818–20
Purchased 1910
N02674

114 **John Sell Cotman** 1782–1842
**Norwich Market-Place** c.1809
Presented by Francis E. Halsey 1945
N05636

115 **James Ward** 1769–1859
**Gordale Scar (A View of Gordale, in
the Manor of East Malham in Craven,
Yorkshire, the Property of Lord
Ribblesdale)** ?1812–14, exh. 1815
Purchased 1878
N01043

116 **Samuel Palmer** 1805–1881
**Coming from Evening Church** 1830
Purchased 1922
N03697

117 **David Wilkie** 1785–1841
**The Peep-o'-Day Boys' Cabin, in the
West of Ireland** 1835–6, exh. 1836
Presented by Robert Vernon 1847
N00332

118 **William Mulready** 1786–1863
**The Last In** 1834–5, exh. 1835
Presented by Robert Vernon 1847
N00393

119 **John Martin** 1789–1854
**The Last Judgement** 1853
Bequeathed by Charlotte Frank
in memory of her husband
Robert Frank 1974
T01927

120 **Richard Dadd** 1817–1886
**The Fairy Feller's Master-Stroke**
1855–64
Presented by Siegfried Sassoon in
memory of his friend and fellow officer
Julian Dadd, a great-nephew of the
artist, and of his two brothers who gave
their lives in the First World War 1963
T00598

121 **John Ruskin** 1819–1900
**The North-West Angle of the Facade
of St Mark's, Venice** c.1851
Presented by the National Art
Collections Fund 1914
N02972

122 **Dante Gabriel Rossetti** 1828–1882
**The Girlhood of Mary Virgin** 1848–9
Bequeathed by Lady Jekyll 1937
N04872

123 **Ford Madox Brown** 1821–1893
**The Last of England** 1864–6
Purchased 1916
N03064

124 **Henry Wallis** 1830–1916
**Chatterton** 1856
Bequeathed by Charles Gent
Clement 1899
N01685

125 **John Everett Millais** 1829–1896
**Christ in the House of His Parents
('The Carpenter's Shop')** 1849–50
Purchased with assistance from the
National Art Collections Fund and
various subscribers 1921
N03584

126 **William Holman Hunt** 1827–1910
**The Awakening Conscience** 1853
Presented by Sir Colin and Lady
Anderson through the Friends
of the Tate Gallery 1976
T02075

127 **John Everett Millais** 1829–1896
**Ophelia** 1851–2
Presented by Sir Henry Tate 1894
N01506

128 **John Brett** 1831–1902
**Glacier of Rosenlaui** 1856
Purchased 1946
N05643

129 **William Dyce** 1806–1864
**Pegwell Bay, Kent – a Recollection
of October 5th 1858** ?1858–60
Purchased 1894
N01407

130 **George Gilbert Scott** 1811–1878
**Albert Memorial, Hyde Park**
c.1872–6

131 **Henry Alexander Bowler**
1824–1903
**The Doubt: 'Can these Dry Bones
Live?'** exh. 1855
Presented by H. Archer Bowler 1921
N03592

132 **William Powell Frith** 1819–1909
**The Derby Day** 1856–8
Bequeathed by Jacob Bell 1859
N00615

133 **Upper-class group at Ascot in
'The Graphic'** 18 June 1869

134 **William Maw Egley** 1826–1916
**Omnibus Life in London** 1859
Bequeathed by Miss J.L.R. Blaker 1947
N05779

135 **Samuel Butler** 1835–1902
**Blind Man Reading the Bible Near
Greenwich** 1892
The Master and Fellows of St. John's
College, Cambridge

136 **Edward Coley Burne-Jones**
1833–1898
**King Cophetua and the Beggar
Maid** 1884
Presented by subscribers 1900
N01771

137 **Dante Gabriel Rossetti**
1828–1882
**Beata Beatrix** c. 1864–70
Presented by Georgiana, Baroness
Mount-Temple in memory of her
husband, Francis, Baron Mount-
Temple 1889
N01279

138 **Elizabeth Eleanor Siddal**
1829–1862
**Lady Affixing Pennant to a Knight's
Spear** c. 1856
Bequeathed by W.C. Alexander 1917
N03202

139 **Simeon Solomon** 1840–1905
**Sappho and Erinna in a Garden
at Mytilene** 1864
Purchased 1980
T03063

140 **Elizabeth Butler (Lady Butler)**
1846–1933
**The Remnants of an Army** 1879
Presented by Sir Henry Tate 1897
N01553

141 **Aesthetes and Swells contrasted,
'Punch', LXXV** 21 September 1878

142 **Harry Bates** 1850–1899
**Pandora** exh. 1891
Presented by the Trustees of
the Chantrey Bequest 1891
N01750

143 **Walter Crane** 1845–1915
**One, Two Buckle My Shoe,**
London, 1869
The Hornby Library, Liverpool
City Libraries

144 **James Abbott McNeill Whistler**
1834–1903
**Nocturne: Blue and Gold –
Old Battersea Bridge** c.1872–5
Presented by the National Art
Collections Fund 1905
N01959

145 **Atkinson Grimshaw** 1836–1893
**Liverpool Quay by Moonlight** 1887
Purchased 1967
T00902

146 **John William Waterhouse**
1849–1917
**The Lady of Shalott** 1888
Presented by Sir Henry Tate 1894
N01543

147 **Frederick Walker** 1840–1875
**The Vagrants** 1868
Purchased 1886
N01209

148 **George Frederic Watts** 1817–1904
**Mammon** 1884–5
Presented by the artist 1897
N01630

149 **George Clausen** 1852–1944
**Winter Work** 1883–4
Purchased with assistance from
the Friends of the Tate Gallery 1983
T03666

150 **George Clausen** 1852–1944
**Woman in a Mangold Field** early 1880s
Royal Photographic Society, Bath

151 **Frederic Leighton** 1830–1896
**And the Sea Gave Up the Dead Which
Were in It** exh. 1892
Presented by Sir Henry Tate 1894
N01511

152 **John Singer Sargent** 1856–1925
**Carnation, Lily, Lily, Rose** 1885–6
Presented by the Trustees of
the Chantrey Bequest 1887
N01615

153 **Helen Beatrix Potter** 1866–1943
**'The Finished Coat', from
'Illustrations for "The Tailor of
Gloucester"'** c.1902
Presented by Capt. K.W.G.
Duke RN 1946
A01108

154 **Aubrey Beardsley** 1872–1898
**The Fat Woman** 1894
Presented by Colonel James Lister
Melvill at the request of his brother,
Harry Edward Melvill 1931
N04609

155 **Roderic O'Conor** 1860–1940
**Yellow Landscape** 1892
Presented by Mr and Mrs Barnett
Shine through the Friends of the
Tate Gallery 1977
T02113

156 **John Singer Sargent** 1856–1925
**Ena and Betty, Daughters of Asher
and Mrs Wertheimer** 1901
Presented by the widow and family
of Asher Wertheimer in accordance
with his wishes 1922
N03708

157 **Philip Wilson Steer** 1860–1942
**Girls Running, Walberswick Pier**
1888–94
Presented by Lady Augustus
Daniel 1951
N06008

158 **Spencer Gore** 1878–1914
**Rule Britannia** 1910
Presented by the Patrons of British
Art through the Tate Gallery
Foundation 1992
T06521

159 **The Rise of the Film, in
'The Sphere'**
2 August, 1913

160 **The Camden Town Murder,
cover illustration for 'The Illustrated
Police Budget'**
12 October 1907
British Library Newspaper Library
at Colindale

161 **Walter Richard Sickert** 1860–1942
**La Hollandaise** c.1906
Purchased 1983
T03548

162 **Harold Gilman** 1876–1919
**Mrs Mounter at the Breakfast Table**
exh. 1917
Purchased 1942
N05317

163 **Augustus John** 1878–1961
**Washing Day** c.1915
Purchased with assistance from
Sir James Murray 1923
N03730

164 **Augustus John and family
with caravan** c.1909
Private Collection

165 **Gwen John** 1876–1939
**Dorelia in a Black Dress** c.1903–4
Presented by the Trustees of the
Duveen Paintings Fund 1949
N05910

166 **Henry Lamb** 1883–1960
**Lytton Strachey** 1914
Presented by the Trustees of
the Chantrey Bequest 1957
T00118

167 **Duncan Grant** 1885–1978
**Bathing** 1911
Purchased 1931
N04567

168 **Roger Fry at work in the Omega
Workshops** c.1913
Anthony d'Offay Gallery, London

169 **Vanessa Bell** 1879–1961
**Studland Beach. Verso: Group of
Male Nudes by Duncan Grant** c.1912
Purchased 1976

170 **David Bomberg** 1890–1957
**In the Hold** c.1913–4
Presented by the Friends of
the Tate Gallery 1967
T00913

171 **Jacob Epstein** 1880–1959
**Doves** 1914–15
Purchased 1973
T01820

172 **Wyndham Lewis** 1882–1957
**The Crowd** ?exh. 1915
Presented by the Friends of the
Tate Gallery 1964; T00689

173 **Page 11 from first issue of 'Blast'**
July 1914

174 **Walter Benington** d.1936
**Henri Gaudier-Brzeska carving
Hieratic Head of Ezra Pound**
Tate Archive

175 **Alvin Langdon Coburn** 1882–1966
**Vortograph** 1917
George Eastman House

176 **Edward Wadsworth** 1889–1949
**Dazzle Camouflaged Ship
in Dry Dock** 1918
The Imperial War Museum

177 **Christopher Richard Wynne
Nevinson** 1889–1946
**La Mitrailleuse** 1915
Presented by the Contemporary
Art Society 1917
N03177

178 **Mark Gertler** 1891–1939
**Merry-Go-Round** 1916
Purchased 1984
T03846

179 **Stanley Spencer** 1891–1959
**The Resurrection, Cookham** 1924–7
Presented by Lord Duveen 1927
N04239

180 **William Roberts** 1895–1980
**The Cinema** 1920
Purchased 1965
T00813

181 **Edward Burra** 1905–1976
**Harlem** 1934
Purchased 1939
N05004

182 **Eric Gill** 1882–1940
**Inscription 'Ex Divina
Pulchritudine'** 1926
Transferred from the Victoria
and Albert Museum 1983
T03738

183 **Paul Nash** 1889–1946
**Landscape at Iden** 1929
Purchased 1939
N05047

184 **Eric Ravilious** 1903–1942
**The Vale of the White Horse** c.1939
Purchased 1940
N05164

185 **Christopher Wood** 1901–1930
**Boat in Harbour, Brittany** 1929
Presented by Mrs Lucy Carrington
Wertheim 1962
T00489

186 **Edward Wadsworth** 1889–1949
**Regalia** 1928
Purchased with assistance from
the Friends of the Tate Gallery 1982
T03398

187 **Henry Moore** 1898–1986
**Recumbent Figure** (1938) in front of
Serge Chermayeff building
Sculpture presented by the
Contemporary Art Society 1939
N05387

188 **Ben Nicholson** 1894–1982
**1935 (white relief)** 1935
Purchased with assistance from
the Contemporary Art Society 1955
T00049

189 **Alfred Wallis** 1855–1942
**Schooner under the Moon** ?c.1935–6
Purchased 1958
T00219

190 **Barbara Hepworth** 1903–1975
**Pelagos** 1946
Presented by the artist 1964
T00699

191 **International Surrealist
Exhibition** London, 1936

192 **Roland Penrose** 1900–1984
**The Last Voyage of Captain Cook**
1936/67
Presented by Mrs Gabrielle Keiller
through the Friends of the Tate
Gallery 1982
T03377

193 **Eileen Agar** 1899–1991
**The Autobiography of an Embryo**
1933–4

Purchased 1987
T05024

194 **James Boswell** 1906–1971
**Empire Builders** 1935
Presented by Ruth Boswell, the artist's
widow 1977
P01823

195 **Meredith Frampton** 1894–1984
**Portrait of a Young Woman** 1935
Presented by the Trustees of the
Chantrey Bequest 1935
N04820

196 **William Coldstream** 1908–1987
**On the Map** 1937
Purchased 1980
T03068

197 **Humphrey Jennings** 1907–1950
Still from film **'Spare Time'**, 1939,
British Film Institute

198 **Wyndham Lewis** 1882–1957
**The Surrender of Barcelona** 1934–7
Purchased 1947
N05768

199 **John Piper** 1903–1992
**Seaton Delaval** 1941
Presented by Sir Kenneth Clark (later
Lord Clark of Saltwood) through the
Contemporary Arts Society 1946
N05748

200 **David Jones** 1895–1974
**Aphrodite in Aulis** 1940–1
Purchased 1976
T02036

201 **Paul Nash** 1889–1946
**Totes Meer (Dead Sea)** 1940–1
Presented by the War Artists Advisory
Committee 1946
N05717

202 **Henry Moore** 1898–1986
**Shelterers in the Tube** 1941
Presented by the War Artists Advisory
Committee 1946
N05712

203 **Michael Ayrton** 1921–1975
**The Temptation of St Anthony** 1942–3
Purchased 1983
T03611

204 **Francis Bacon** 1909–1992
**Three Studies for Figures at the Base
of a Crucifixion** c.1944
Presented by Eric Hall 1953
N06171

205 **Francis Bacon** 1909–1992
**Three Figures and Portrait** 1975
Purchased 1977
T02112

206 **Graham Sutherland** 1903–1980
**Crucifixion** 1946
Purchased 1947
N05774

207 **L.S. Lowry** 1887–1976
**The Pond** 1950
Presented by the Trustees of

the Chantrey Bequest 1951
N06032

208 **Reg Butler** 1913–1981
**Working Model for 'The Unknown
Political Prisoner'** 1955–6
Presented by Cortina and
Creon Butler 1979
T02332

209 **Carel Weight** 1908–1997
**The Dogs** 1955–6
Presented by the Trustees of
the Chantrey Bequest 1956
T00095

210 **Lucian Freud** b.1922
**Girl with a White Dog** 1950–1
Purchased 1952
N06039

211 **Peter Coker** b.1926
**Table and Chair** 1955
Purchased 1981
T03302

212 **Eduardo Paolozzi** b.1924
**I was a Rich Man's Plaything** 1947
from 'Ten Collages from BUNK'
Presented by the artist 1971
T01462

213 **John Minton** 1917–1957
**Composition: The Death of
James Dean** 1957
Presented by the Trustees of
the Chantrey Bequest 1957
T00140

214 **Peter Blake** b.1932
**On the Balcony** 1955–7
Presented by the Contemporary
Art Society 1963
T00566

215 **Richard Hamilton** b.1922
**She** 1958–61
Purchased 1970
T01190

216 **'Robby the Robot'** at 'This is
Tomorrow' exhibition 1956
Tate Archive

217 **Alan Davie** b.1920
**Birth of Venus** 1955
Purchased 1958
T00203

218 **David Hockney** b.1937
**A Bigger Splash** 1967
Purchased 1981; T03254

219 **Patrick Heron** 1920–1999
**Horizontal Stripe Painting:
November 1957 – January 1958** 1957–8
Purchased 1972
T01541

220 **Roger Hilton** 1911–1975
**Oi Yoi Yoi** 1963
Purchased 1974
T01855

221 **Peter Lanyon** 1918–1964
**Thermal** 1960

Purchased 1960
T00375

222 **John Hoyland** b.1934
**17. 3. 69** 1969
Purchased 1969
T01130

223 **Anthony Caro** b.1924
**Early One Morning** 1962
Presented by the Contemporary
Art Society 1965
T00805

224 **Howard Hodgkin** b.1932
**Mr and Mrs E.J.P.** 1969–73
Accepted by H.M. Government
in lieu of tax and allocated to
the Tate Gallery 1996
T07111

225 **Bridget Riley** b.1931
**Achaean** 1981
Purchased 1983
T03816

226 **Gerald Scarfe** b.1936
**Ian Fleming as James Bond** 1970
Presented by Curwen Studio through
the Institute of Contemporary
Prints 1975
p06544

227 **Richard Long** b.1945
**A Hundred Mile Walk** 1971–2
Purchased 1973
T01720

228 **Bruce McLean** b.1944
**Pose Work for Plinths 3** 1971
Purchased 1981
T03274

229 **Keith Arnatt** b.1930
**Self-Burial (Television Interference
Project)** 1969
Presented by Westdeutsches
Fernsehen 1973
T01747

230 **Paula Rego** b.1935
**The Dance** 1988
Purchased 1989
T05534

231 **Glen Baxter** b.1944
**'To me the window is still a
symbolically loaded motif'
Drawled Cody** 1978
Purchased 1982
P07608

232 **R.B. Kitaj** b.1932
**Cecil Court, London W.C.2.
(The Refugees)** 1983–4
Purchased 1985
T04115

233 **Lucian Freud** b.1922
**Leigh Bowery** 1991
Presented anonymously 1994
T06834

234 **Peter Greenaway**
Still from **'The Draughtsman's**

Contract' 1982
The British Film Institute

235 **Ian Hamilton Finlay** b.1925
**'The Arts Council Must be Utterly
Destroyed'**, from 'Posters from
the Little Spartan War' 1982
Purchased 1983
P07927

236 **Gilbert and George**
b.1943, b.1942
**England** 1980
Purchased 1981
T03297

237 **Tony Cragg** b.1949
**Britain Seen from the North** 1981
Purchased 1982
T03347

238 **Richard Deacon** b.1949
**If The Shoe Fits** 1981
Purchased with assistance from
the Friends of the Tate Gallery 1997
T07321

239 **Helen Chadwick** 1953–1996
**Enfleshings I** 1989
Purchased 1994
T06876

240 **Rachel Whiteread** b.1963
**House** October 1993–January 1994
Commissioned by Artangel

241 **Damien Hirst** b.1965
**Pharmacy restaurant**
Notting Hill, London

242 **Sarah Lucas** b.1962
**British Human Toilet Revisited** 1998
Purchased 1999
P78299

243 **Chris Ofili** b.1968
**No Woman No Cry** 1998
Purchased 1999
T07502

244 **Mat Collishaw** b.1966
**Hollow Oak** 1995
Presented by the Patrons of
New Art through the Tate Gallery
Foundation 1998
T07435

245 **Mona Hatoum** b.1952
**Incommunicado** 1993
Purchased with funds provided
by the Gytha Trust 1995
T06988

246 **Cornelia Parker** b.1956
**Cold Dark Matter: An Exploded
View** 1991
Presented by the Patrons of New Art
(Special Purchase Fund) through
the Tate Gallery Foundation 1995
T06949

247 **Sam Taylor-Wood** b.1967
**Soliloquy II** 1998
Purchased 1999
P78318

# Credits

# Donors to the Centenary Development Capital Campaign

**Founder**
The Heritage Lottery Fund

**Founding benefactors**
Sir Harry and Lady Djanogly
The Kresge Foundation
Sir Edwin and Lady Manton
Lord and Lady Sainsbury
    of Preston Candover
The Wolfson Foundation

**Major donors**
The Annenberg Foundation
Ron Beller and Jennifer Moses
Alex and Angela Bernstein
Lauren and Mark Booth
Ivor Braka
The Clore Duffield Foundation
Maurice and Janet Dwek
Bob and Kate Gavron
Sir Paul Getty KBE
Nicholas and Judith Goodison
Mr and Mrs Karpidas
Peter and Maria Kellner
Catherine and Pierre Lagrange
Ruth and Stuart Lipton
William A. Palmer
John and Jill Ritblat
Barrie and Emmanuel Roman
Charlotte Stevenson
Tate Gallery Centenary Gala
The Trusthouse Charitable Foundation
David and Emma Verey
Coldagh and Leslie Waddington
Mr and Mrs Anthony Weldon
Sam Whitbread

**Donors**
The Asprey Family Charitable
    Foundation
The Charlotte Bonham Carter
    Charitable Trust
The CHK Charities Limited
Sadie Coles
Giles and Sonia Coode-Adams
Alan Cristea
Thomas Dane
The D'Oyly Carte Charitable Trust
The Dulverton Trust
Friends of the Tate Gallery
Alan Gibbs
Mr and Mrs Edward Gilhuly
Helyn and Ralph Goldenberg
Richard and Odile Grogan
Pehr and Christina Gyllenhammar
Jay Jopling
Howard and Linda Karshan
Madeleine Kleinwort
Brian and Lesley Knox
Mr and Mrs Ulf G. Linden
Anders and Ulla Ljungh
Lloyds TSB Foundation for England
    and Wales
David and Pauline Mann-Vogelpoel
Nick and Annette Mason
Viviane and James Mayor
Anthony and Deirdre Montagu
Sir Peter and Lady Osborne
Maureen Paley
Mr Frederick Paulsen
The Pet Shop Boys
The P F Charitable Trust
The Polizzi Charitable Trust
Mrs Coral Samuel CBE
David and Sophie Shalit
Mr and Mrs Sven Skarendahl
Pauline Denyer-Smith and Paul Smith
Mr and Mrs Nicholas Stanley
The Jack Steinberg Charitable Trust
Carter and Mary Thacher
Dr and Mrs John L. Thornton
Dinah Verey
Gordon D. Watson
The Duke of Westminster OBE TD DL
Mr and Mrs Stephen Wilberding
Michael S. Wilson
and all those donors who wish
    to remain anonymous

**Tate Founding Corporate Partners**
AMP
Avaya UK
BNP Paribas
CGNU plc
Clifford Chance
Dresdner Kleinwort Wasserstein
Energis plc
Freshfields Bruckhaus Deringer
GLG Partners
Goldman Sachs International
J. Sainsbury plc
Lazard
Lehman Brothers
London & Cambridge Properties Ltd
London Electricity Group plc and
    EDF Group
Pearson
Prudential plc
Railtrack plc
Reuters
Rolls-Royce plc
Schroders
UBS PaineWebber Inc.
UBS Warburg
Whitehead Mann GKR

# Index

Figures in **bold** indicate pages on which illustration captions appear.

263